ART Management
Entrepreneurial Style

To my students
To Philo Ongering

ART Management Entrepreneurial Style

Giep Hagoort

Fifth edition 2005
ISBN 90 5166 802 3
NUGI 684

Distribution: Eburon Publishers, Postbus 2867, 2601 CW Delft, The Netherlands
Telephone: (+31) 15 213 14 84 • Fax: (+31) 15 214 68 88 • E-mail: info@eburon.nl • www.eburon.nl
Bookdesign: Erik Uitenbogaard (member BNO)

IV

Foreword

With *ART MANAGEMENT Entrepreneurial Style* Giep Hagoort moves to the front ranks of writers on arts and cultural management. He brings to his book a background of direct knowledge of the arts and art history combined with many years of study and practical involvement in arts organizations. He couples this background with a wide-ranging familiarity with the scholarship of general management and organizational strategy. This is the kind of book that only someone with extensive practical experience and the scholars command of the research literature could have written.

Drawing deeply on both his practical experience and scholarship he has written a remarkably original and useful book about how to integrate the best of management theory and practice in the commercial sectors with the challenges of arts and cultural institutions.

Numerous insights in the book will be of immediate help to practicing arts managers. One example concerns the widespread confusion over the distinction between managing and leading. Hagoort rightly points out that each is an indispensable feature of the successful arts organization, and it is critical that the people in charge come to understand the role each needs to play. Using examples, diagrams and case illustrations Hagoort brings alive the most important concepts of modern management theory.

An overarching theme is the meaning and role of strategy. In this as in numerous other things Hagoort proceeds by carefully analyzing both the theoretical and practical dimensions of the topic. His conclusions about the relationship between organization strategy and organization structure are clarifying and original.

For management and organization scholars this book will provide an excellent demonstration of how important concepts and research findings of the management literature can be woven together to help address real issues of leadership and management in arts and cultural organizations. This is not a how to do it book. But for the reflective practitioner it contains insights and an abundance of good common sense about how to deploy leadership and management to more fully realize the potential of the arts and cultural sector for societal benefit.

Archie Kleingartner
Professor of Management and Policy Studies
University of California, Los Angeles

Contents

1 Introduction

3 The structuring of a cultural organization

Preface

"Hunting the Substance, not the Shadow".
Vitruvius

At the start of the 21st century, there is an enormous need worldwide for a high standard of knowledge of management in the cultural sector. Culture here is to be considered as expressions of art, cultural heritage, entertainment and new media. In this specialised area, the development of innovative educational and research programmes has a modest foundation located within a few institutes. If we consider the fundamental intercultural and digital changes at the start of the third millennium, extending this foundation will be a real challenge.

My objective in writing ART MANAGEMENT, Entrepreneurial Style, was to provide a basic knowledge of management within a cultural context to the cultural world. Based on our Utrecht experiences of more than 15 years my colleagues and I have developed a lot of material. This information can be found in this handbook to bridge the gap between management theory and the cultural praxis. Because the cultural world does not function on an island, students, teachers and practical art managers should be aware of the fundaments of this management theory and translate this knowledge into the cultural sector.

Long before the scientific approach to management had been developed in our Western business schools, cultural entrepreneurs such as the Egyptian pyramid architect Imhopet, the Greek theatre director Thepsis (500 BC), the Renaissance artists Leonardo da Vinci and William Shakespeare and the 20th century entertainment pioneer Walt Disney, had shown us the real impact of the organization of creative processes. Knowing this history is also a part of the basic knowledge of art management.

My book Cultural Entrepreneurship, an introduction to art management was published in 1992. A draft English version appeared in 1993, and an authorised Polish version in 1995 (in cooperation with Prof. Emile Orzechowski and Barbara Bezemer-Szefke). Parts of this book are translated into the German and Russian languages. In 1998, the Dutch government declared that cultural entrepreneurship should be one of the cornerstones of the Dutch Cultural Policy 2001-2004.

This new book has its roots in the 1992 publication but has received a totally new identity because of the processing of the results of my Ph.D. research on strategic art management from 1998.

As the reader will see, I have used many examples from a *glocal* perspective. Cases from different parts of the world, rooted in local resources but within the framework of our Global Village. We will elaborate on this glocal perspective in the last paragraph, by means of intercultural network competences.

I do realize that this perspective is highly hypothetical. In my view, it is essential that researchers, teachers, students, participants and practitioners of art management look to the future to understand our complex and turbulent world. This book is to be used and not to be followed.

If my approach helps the reader to form his or her own ideas in a pro-active style, my objective has been achieved.

Upon studying the various chapters and paragraphs, the reader will certainly recognize the justification for dedicating this book to all my (former) students from Utrecht, New York, Berlin, Krakow, Kiev, St Petersburg, Prague, Johannesburg and other lesser known places. They have stimulated me to develop original and practical materials that help them to do their job in what I consider to be the most valuable, inspiring and dynamic sector of our societies.

Just at the final phase of the preparation of this book came the sad news that Philo Ongering, our former student and staff member, had died of lung cancer at the age of 40 years. Philo became a great professional in the field of creativity in organizations and her reputation was recognized by a lot of business organizations. She held workshops for our school in Holland and in Kiev and Krakow, and was a member of the Reading Committee for my Ph.D. research project. In appreciation of her ideas, support and friendship I also dedicate this book to her.

The only thing that remains is to ask the user of this book to inform me (by email <giep.hagoort@central.hku.nl>) about his or her results and to share our experiences.

Giep Hagoort
Utrecht - Koulouloutari
Spring 2000

Acknowledgements

In the last 15 years that I have been strongly involved with art and media management programmes, many people have contributed to ideas on how creative and artistic processes can be served by management and organization. Sometimes it was a simple remark; more often it took place within a longer dialogue. I want to express my gratitude to all of them. The reader will find all associated names in the colophon.

With regard to this book, I particularly want to mention Professor Archie Kleingartner (UCLA,) who has greatly encouraged me by stimulating me to explore the relation between culture and management theory. The reactions of Paula Beck (Witswaterrand University), Carla Delfos (ELIA), Ad Huijsmans (Utrecht School of the Arts), Gerardo Neugovson (consultant, Argentina) and Joost Smiers (Utrecht School of the Arts), to the draft of the first chapter of this book were fundamental to keeping on the right track.

Important contributions came from my (former) colleagues who are real experts in their own fields: Paul van Amerom (knowledge management), Theo van Ballegooy (entrepreneurship), Frans Bosboom (cultural policy), Annelies Boutellier (personal effectiveness), Marijke Broekhuijsen (Creative Forum), Danielle Cuppens (artistic projects), Nelly van der Geest (interculturalization), Dennis Langenhuizen (finance), Dorian Maarse (Action Learning), Eva van der Molen (self management), Dirk Monsma (change management), Dieneke Naeyé (personal change management), Philo Ongering (1960–2000) (creativity and management), Marjanne Paardekooper (internationalisation), Arienne van Staveren (organizational learning) and Wim Warmer (cultural governance).

Without the support of some people, this book would never have reached the final phase. They are: Bert Groenemeijer, Remi Seelaar (central board, Utrecht School of the Arts), Jaap Klazema (board consultant), Ria Douma (library), Marieke Maat (educational suggestions), Marijke Faber (personnel management), Ingrid ten Donkelaar, Betty Kriekaard, Katrien van Weel (secretary) and Han van Doorn (facilities).

Writing a handbook on art management in another language than your own requires the guidance of a highly qualified professional. Laura Haseley (Babel) is such a person but she also worked wonders in stimulating me to fulfil the project. I would also like to thank Gill Bromiley (Babel) for the final editing.

Particularly with reference to the case study of the Theatre Group Amsterdam (TGA), reproduced in the appendix, which was originally a chapter in my Ph.D. research, I would like to mention: Annemieke Roobeek (promotor), Joost Smiers (supervisor), Ton Hokken, Gerrit Korthals Altes, Philo Ongering (1960–2000), Wim Warmer (Reading Committee), Freek van Steen (publisher), Paul van Amerom, Renée Baeten-Jonkers, Martine van Dijk, Margot Gerené, Dorian Maarse, Liz Savage (translation), Karen Zieleman (research assistance). The complete list of people involved is mentioned in the colophon.

Finally of old, Constance Uitenbogaard (organization), Erik Uitenbogaard (design) and my beloved Joke van den Berg. They certainly get the most acknowledgement of all.

G.H.

List of Abbreviations

AAAE	Association of Art Administration Educators
AIMAC	Association Internationale de Management des Arts et de la Culture
ARO	Artists Run Organization
BC	Before Christ
BMA	Brooklyn Museum of Art
CD	Compact Disc
CD Rom	Compact Disc Read only memory
C/D-tasks	Constitute/Dirigete-tasks
CEO	Chief Executive Officer
CSD	Cultural Strategic Dialogue
CV	Curriculum Vitae
ECF	European Cultural Foundation
ELIA	European League of Institutes of the Arts
ENCATC	European Network of Cultural Administration Training Centres
ETC	European Theatre Convention
EU	European Union
FOPOC	Future Oriented Profile Of Competences
F.P.M.G.	Functional.Product.Market.Geography
GAST	Guerrilla for Arts Strategic Teams
GATT	General Agreement on Tariffs and Trade
GNP	Gross National Product
HKU	Hogeschool voor de Kunsten Utrecht/Utrecht School of the Arts
H.O.F.	Hierarchical.Operational.Functional
HRM	Human Resource Management
ICT	Information and communication technology
IETM	Informal European Theatre Meeting
INO	Intercultural Network Organization
ISM	Strategic Management, the Interactive Approach
ISPA	International Society for the Performing Arts Foundation
MA AMMEC	Master of Arts Art and Media Management in a European Context
MAPA	Moving Academy for the Performing Arts
MBA	Master of Business Administration
MIS	Management Information System
NAFTA	North American Free Trade Agreement
NEA	National Endowment for the Arts
NL	The Netherlands
NLG	Dutch guilder
NYU	New York University
PC	Personal Computer
Ph.D.	Doctor of Philosophy
PMC	Product Market Combination
PPP	Public Private Partnership
QM	Quality Management
QuOFTIMoD	Quality, Organization, Facilities, Time, Information, Money, Digitization
PR	Public Relations
R&D	Research & Development
S/W	Strong/Weakness
SWOT	Strengths, Weaknesses, Opportunities, Threats
TGA	Theatregroup Amsterdam/Theatergroep Amsterdam
UCLA	University of California, Los Angeles
UK	United Kingdom
UNESCO	United Nations Educational, Scientific, and Cultural Organization
USA	United States of America
5xP	Product, Promotion, Price, Place, Personnel (marketing-elements)
7xS	Structure, Strategy, Systems, Style, Staff, Skills, Superordinate goals

Positioning

The Moorish general Othello has appointed Cassio, a newcomer from Florence, as his lieutenant, and not the experienced Iago. Othello is a famous soldier and an important military strategist who protects the interests of Venice. Despite his reputation, Iago has to be satisfied with the rank of ancient. The Venetian Roderigo – not a friend of the general – does not understand why Iago follows the Moor. Iago explains his position to Roderigo.

I follow him to serve my turn upon him;
We cannot all be masters, nor all masters
Cannot be truly follow'd. You shall mark
Many a duteous and knee-crooking knave,
That, doting on his own obsequious bondage,
Wears out his time, much like his master's ass,
For nought but provender, and when he's old, cashier'd;
Whip me such honest knaves. Other there are
Who, trimm'd in forms and visages of duty,
Keep yet their hearts attending on themselves,
And, throwing but shows of service on their lords,
Do well thrive by them, and when they have lined
 their coats
Do themselves homage: these fellows have some soul,
And such a one do I profess myself.

For sir,
It is sure as you are Roderigo,
When I am the Moor, I would not be Jago:
In following him, I follow but myself;
Heaven is my judge, not I for love and duty,
But seeming so, for my peculiar end:
For when my outward action doth demonstrate
The native act and figure of my heart
In compliment extern, 't is not long after
But I will wear my heart upon my sleeve
For daws to peck at:
I am not what I am.

(ACT I.1)

1 Introduction

● 1.1 **Important sources**

Learning questions
- Can art history teach us to understand cultural organizations?
- What is the general meaning of management theory?
- Can cultural organizations be characterized?
- What about the function of art manager?

Key words

cultural entrepreneurship	strategy	leadership
art history	structure	life cycle
future orientation	input-transformation-output	cultural organizations
management theory	-feedback	art management positions

Opening incident: *Rembrandt van Rijn*

The famous 17th century Dutch artist, Rembrandt van Rijn, was not only

a talented painter (*Night Watch*, self-portraits) but also a gallery-owner,

art dealer, collector and head of a private academy where he trained his

assistants. Unfortunately, Rembrandt was not so successful in his

business and financial affairs. While Pieter Paulus Rubens, his famous

Flemish contemporary whose works include the *Paris Judgement* and

altarpieces, had a well-organized studio and a well managed network of

rich patrons, Rembrandt became increasingly isolated during his life. Art

historians have tried to find out why Rembrandt's life developed with

such disastrous consequences as personal bankruptcy. Now we know

that it was not due to artistic failure or the policy of the local authorities

of Amsterdam at that time, but rather a vague mixture of personal

qualities such as avarice and an independent attitude in both artistic and

economic matters.

Sources: Svetlana ALPERS, *Rembrandt's Enterprise, The studio and the market*, The University of Chicago Press, Chicago, 1990; Gary SCHWARTZ, *Rembrandt: zijn leven, zijn schilderijen*, Gary Schwarz, Maarssen, 1984.

1.1.1 A long history

This book is about art management, entrepreneurial style. It is intended to give practical, theoretical and conceptual insight into the management of profit and non-profit cultural organizations. The combination of art, culture and management and of theory and practice will, we believe, provide a real aid to those who want to acquire knowledge about running cultural businesses.

The readers we have in mind are people who are involved with educational programmes: students, participants, teachers and programme directors. The reader will find a lot of practical cases, case studies and learning questions, which will aid the understanding of the complexity of art and cultural management.

We also aim to reach artists, leaders and team members of cultural projects, managers of cultural organizations and other professionals who are interested in linking general management issues to the art and cultural sector.

Long before general management was scientifically approached, cultural entrepreneurship was an established practice.[1] Let us look at how a 6th century BC Greek, Thepsis, innovated his theatre organization. Artistically he introduced the individual actor. This *Hypocrites* was the beginning of a performance culture, designed to amuse audiences. After this act of innovation, he experimented with masks, to give the members of a theatre group separate identities. So how were the Greek festivals organized? Just like they are now in Edinburgh, Salzburg, Johannesburg, Bombay, Los Angeles and Amsterdam, for example. A general festival manager managed the whole festival and organized the artistic competition with an independent jury. Additionally , there was of course an annual sponsor, the *choregus*, who financed the festival. During the festival, a project organization was established to manage events and supervise the performances, which were attended by more than 10,000 visitors.

How would it have been possible to manage these activities without being entrepreneurial? Our art history thus provides us with good examples of innovative management of art organizations, innovation being the key word of cultural entrepreneurship. Of course, there are many other well-known and unknown art managers who have cultivated the idea of cultural entrepreneurship. Suger, the 12th century abbot of St Denis near Paris, conducted a 13-year campaign to finance the restoration of his Roman church, which was in a bad state of repair. Suger transformed the church into a gothic cathedral and founded innovative studios where craftsmen from

all over Europe created glasswork, based on new methods of working. Neither let us forget the Renaissance artists such as the Italian all rounder Leonardo da Vinci, the playwright, actor and theatre manager from England, William Shakespeare and the Flemish painter and owner of a well organized art factory, Pieter Paul Rubens. They all combined artistic ideas with economic opportunity and showed that cultural entrepreneurship is a natural part of the artistic and cultural world.

Most art and cultural products need an organizational framework and our predecessors knew this. They founded and managed the first museums, early music and theatre groups, theatre halls, festivals, studios and art schools, long before we realized that art management has to be understood and researched as a specialized area. In this context we may suppose that the strategy behind the painting of prehistoric rocks was the first step towards labour division and coordination, even if we are not yet able to explain how the artist-hunters organized their work and trained new artists to create the magical-artistry of that era.

With this background to art and culture in mind, our objective is to work out how cultural organizations can be managed successfully. In order to optimize management processes within cultural organizations, art managers also have to look ahead and create a unique position. This will be the key to survival in a 21st century dominated by international and digital trends. Figure 1.1 shows the connections discussed.

Figure 1.1 Survival process of cultural organizations

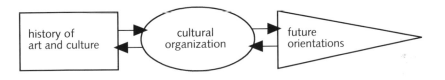

1.1.2 Management theory

It is important to be aware of art history when considering the artistic and management processes that take place in cultural organizations. A second aid to understanding the cultural organizations of the 21st century is management theory.[2] Management theory can be regarded as the basic views on the existence and functioning of organizations. The first concepts of management theory were developed by European scientists during the Industrial Revolution of the 19th century. An important name in this context is Henry Fayol, a French industrialist who worked out an idea about the practice of management. Fayol identified the key areas of the management process as planning, organizing, leading and controlling. Another contribution came from the North American continent. In particular, Frederick W. Taylor's detailed studies of how employees can function in the new factories should be mentioned. Taylor's approach was to analyse the production tasks and work out how these tasks could be rationalized and separated with the aim of maximum efficient production. Because of its focus on the improvement of the performance of individual workers by scientific research and modelling, the work of Taylor et al is known in literature as scientific management.

In the 20th century in particular, management theory became a professional science whose framework can be divided into three core areas: Strategy, Structure and Leadership. Strategy theory explains to us why it is important for an organization to have a clear direction. Structure shows us how power and responsibility are designated in an organization and how they are based on the division of labour and coordination mechanisms. Leadership theory tells us more about the personal responsibility within the management decision-making process and how this responsibility is connected with employees' stakes (motivation) and means (money, goods, location, etc.). The three areas of management theory are illustrated in figure 1.2.

Figure 1.2 Core existing areas of management theory

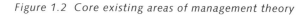
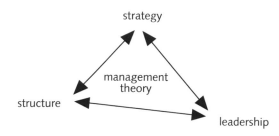

One of the characteristics of management theory is its interdisciplinarity. A lot of mono-disciplines such as economy, sociology, psychology, philosophy, history and technology are needed to understand what is happening with and within organizations.

Recently there has been discussion among a few management researchers, as to whether art as a discipline also contributes to our understanding of management as a system and in practice.[3] The assumption is that art has its own language with which design problems can be solved. The most straightforward example is the question of how we should deal with creativity, at first glance in an artistic framework, but seen in a wider perspective, e.g. organizational development. A second obvious example is analysing the role and mechanics of artistic leadership as an illustration as Patricia C. Pitcher did. She saw a separate visionary leader as opposed to a leader as technocrat and craftsman.[4] A third example is the use of art themes to explain complexities in management. An illustration is the role of the plotting Iago in Shakespeare's *Othello*, written at the beginning of the 17th century (see also box 1.2).[5] Because of the dynamic richness of the sources of interdisciplinary management theory, we should refer to figure 1.2 on the three core areas of management theory as a state of the art model. The main interrelated area of organizational culture (connected with leadership) and the functioning of the organization (with regard to the structure) are implicit to the model. Although this approach is used for this book, we see in the near future a five-core model with its own position of behavioural and organizational culture. This model is shown in figure 1.3.

Figure 1.3 Five future core areas of management theory

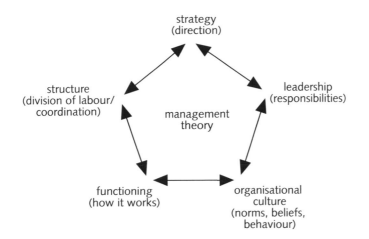

The management theorist or practitioner can use these sources to choose a path for solving organizational problems. The first possibility is to develop a general framework of management in which all kinds of concrete activities can be explained. We call this method deductive. One example is the way in which the American researcher Michael Porter of the Harvard Business School designed his model for competition.[6] This model shows competitive forces that help the manager to find a unique position in the market. The second option is to research concrete facts and figures to establish which general rules should be considered. An example of this approach is Henry Mintzberg's configuration theory for which he used thousands of 'identification' categories of organizational elements.[7] The difference between these two ways of thinking and acting is not very distinct because the deductive approach does not exist in a vacuum. It is influenced by experiences from practice, whereas induction cannot be considered without general 'conceptual' recognition. Deduction should be seen as a more abstract activity - initially at least- and induction focuses strongly on processes in the concrete situation. Management theory can be seen as a convergence of the two.

One basic rule of management theory is that management must be understood as an open system of input-transformation-output-feedback, as illustrated in figure 1.4. This system shows that management is a non-stop process and is dependent on specific circumstances, both internal and external. This means that management theory also has a contingency perspective that says that management has no one-best-way-solution and that managerial solutions depend on a given situation and its specific circumstances. There are general management rules of course but their application must consider circumstances.

Figure 1.4 Management system Input-Transformation-Output-Feedback

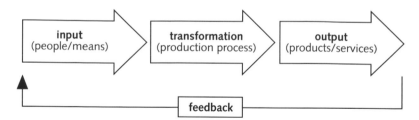

The consequences of this situational approach for practical managers and management researchers are very complex. On the one hand, they have to know and show a professional understanding of the concept of management, and the theories and instruments that can be useful in particular circumstances. On the other hand, everybody generally wants clear decisions and formulae for making organizations more effective and efficient. It will help if we can formulate some criteria for successful organizations. In the literature the following questions are formulated:[8]
1. Does the organization have an appreciated and rewarding position in its environment?
2. Are the employees happy and motivated to do their jobs?
3. Does the organization have an efficient mode of transformation?
4. (More generally) is the organization capable of being flexible and 'ready for the fray'?

To understand (the functioning of) organizations, it is important to consider their phases of growth and development. Many strategic and organizational issues fit the life cycle pattern as illustrated in figure 1.5.

Figure 1.5 The life cycle of an organization

In the birth phase, the organization has a more or less chaotic and spontaneous operational method. The initial concept of the founders, which is familiar throughout the organization, dictates strategy and structure. In the build-up phase the operational method is more structured and strategy focuses on broadening the organizational base. In the build-out phase, the well-structured organization develops a variety of products

and services within several departments. In the re-orientation phase, the organization needs an explicit strategy for the future. Its structure requires revision with the emphasis on flexibility. This model helps us to diagnose the organizational problems or to predict what may happen in organizations over a period of time. As we will see in § 3.2 where we discuss the model in more detail, this life cycle can also be used in the cultural sector.

Most general management theory implicitly focuses on large-scale, industrial and profit-driven organizations. Basic ideas of strategy, structure and leadership are thus given their own economic language and instruments, which is particularly evident in Western and Japanese management literature. Managers, scientists and students should be aware of this fact. If we look at the cultural sector and its small-scale organizations, we need *bicarbonate of soda* to clean the management sources. The prime concern is that art managers will make a lot of flawed decisions in organizing cultural and business processes if they ignore this tacit weakness of general management theory.[9]

Box 1.1 *Alvin Toffler: The Music Factory*
Sometimes the literature also gives splendid examples of how the growth of cultural organization forms can be seen as an illustration of a general management development. Alvin Toffler did so with his typical explanation of music organization in the industrial society of the nineteenth century. In this society, artists and musicians were increasingly dependent on the market mechanism, which influenced the production and distribution where businessmen financed performances and sold tickets to an anonymous audience. An increase in tickets sold meant a higher profit and thus larger concert halls were needed. Larger halls in turn demanded ensembles with stronger acoustics, and thus the modern symphony orchestra was born. Just as the industrial, bureaucratic factories, this orchestra needed a strong division of labour (groups of instruments) and a hierarchical leader, the conductor.
Source: Alvin TOFFLER, *The Third Wave,* Morrow, New York, 1980 (Dutch ed. pp. 37-38).

1.1.3 Can Cultural Organizations be characterized?

It is relatively simple to define an organization as a formal structure in which people cooperate to achieve certain goals. This definition can also be used for the cultural sector, e.g. theatres, orchestras, drama groups, museums, galleries, multimedia firms and art academies. A more basic problem is to define the words art and culture.
In this book we have chosen a pragmatic approach: culture is a collective noun for all the artistic and cultural-'historical' expressions and services that are produced, shown and/or distributed. In this definition, we consider theatre, visual art and design, architecture, music, opera, musical, film, multimedia, cyberart and cultural heritage as examples of cultural expressions and services.
 In this framework, cultural organizations have specific goals, related to production, presentation, distribution or education. This pragmatic approach shows the cultural sector as a patchwork quilt. The framework includes high art organizations such as galleries and symphony orchestras, mass culture firms like huge entertainment companies, amateur art and 'folklore' groups geared towards traditional culture. The following characteristics, which are also shown in figure 1.6, are the core focus of all these organizations.

- The presence of artistic leadership to supervise the creative processes;
- A dominant professional and normative judgement on content and form;
- Small-scale and informal work relations and teams;
- A dynamic environment due to the (digital) influence of different cultural tastes - differences with economic consequences.[10]

Figure 1.6 Characteristics of cultural organizations

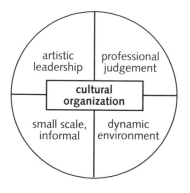

These characteristics have implications for the way art managers apply general management theory to their own situation, as we suggested at the end of § 1.1.2. For example, strongly bureaucratic management systems (forms, reports, long lines, and hierarchy) disturb creative processes. If we ignore the informal organizational culture, artists and other employees will leave the organization and seek workplaces where they can communicate in their own way. In general we can say that cultural organizations - including the cultural industry, which is focused on industrial, more market and technology driven production of cultural expressions (CDs, videos, books) - have their own special identity. Production, presentation, distribution and education in culture are based on freedom of expression, which is recognized in several international treaties and conventions by the United Nations, among others. The cultural products are also protected by general and specific rules and regulations of copyright so that it is impossible to deal with art and culture without respect for the creators. Furthermore, there are usually national and international rules for respecting artistic, cultural and historic values in economic relations and city and regional planning (cultural heritage).

1.1.4 A framework for reflection

If the art manager is successful in realizing an entrepreneurial, cultural organization in which art and culture can be produced, distributed and educational, his/her own pleasure in management will duly increase.

The fact that pleasure in management is under heavy pressure in the cultural sector, is confirmed by research carried out by the American, Paul DiMaggio.[11] DiMaggio has carried out research into the career development and management skills of arts managers from various sectors. Three paradoxes are putting the management in the cultural sector

under pressure. First of all, the general problem that management (focused on a general organizational interest) and profession (aimed at maintaining professional (ideological) quality) form a strong field of tension, in which numerous inconsistencies can occur. The second paradox concerns management within the arts and culture, where we see a lack of consensus about the extent to which a manager should also be a specialist in his/her (original) field. Uncertainty develops because the nature of art management is constantly under discussion, and this affects selection methods and training programmes.[12] The third paradox is related to the tension between the development of a management career and the absence of a clear labour market for art managers: 'This labour market is strongly segmented. (...) Arts administration is a term that describes not a single profession but a family of occupations, each with its own labour market.'

How should we deal with these research results?
In our opinion, it is extremely important to know what really happens in cultural organizations and how these organizations function. Not only the present organizations but also their predecessors show the path of tradition in art management. If the approach laid out in this book is followed, art management has its own identity which can help the (young) art manager to create a balance between pressure and pleasure in his or her day-to-day practice. That is not enough in a sector with its emotional pressure, deadlines, low financial budgets and irregular schedules. It is also necessary to be aware of personal factors to develop self-management. This provides the basis for developing a working attitude in which one's own norms and values define personal potential (see § 4.1.3 about Personal management).

DiMaggio's research is also an opportunity to draw up a list of all the possible functions of an art manager, which will enable us to translate management concepts into more concrete situations and circumstances. The following non-systematic overview, which does not presume to be complete, can help the reader to understand his or her management position.[13]

The only systematization is in the distinction between specific, general and residual positions; a hierarchy in positions has not been introduced.

Management positions specific to the cultural sector,***
art director
artistic director/leader
arts officer
ballet director
ballet master
business leader
choreographer
chorus director
conductor
coordinator of music school department
chief costume studio
chief set decorator
chief theatre technician
director

festival director
gallery owner
head of art/culture broadcasting organizer
head of cultural affairs office
head curator
head of department artistic education
head of theatrical technique
intendant
local art development officer
museum director
music director
opera director
orchestra inspector
orchestra manager
producer
production manager
programmer
stage manager
theatre director

Management positions, common to the cultural sector, ***
accounts manager
administrative director
administrator
CEO (Chief Executive Officer)
chairman
chief doorkeeper
coordinator of volunteers
customer services manager
events officer
financial manager
floor manager
general manager
hospitality manager
head of staff office
head of technical services
head of educational services
head of planning and publicity
house manager
ICT manager
managing director
marketing-sponsoring manager
membership administrator
office manager
personnel manager (HRM)
president

programme director
PR officer
project manager
ticket service manager
webmaster

* associates to these positions
** often combinations of functions

Organizational positions
consultant
fundraiser
interim manager
organizer

Can the people who hold those positions or combinations of positions be said to carry out the function of an art manager? In our opinion the answer is yes, because all the functions mentioned within the cultural sector include a coordination responsibility, i.e. activities have to be brought together, and the people in charge of carrying out those activities have to be guided. In this context, it is immaterial whether the coordination is the main task, or whether it is simply one of many duties, as is quite common in the small-scale cultural sector. It is of utmost importance to be aware when coordination is required and how the coordinators execute their tasks and responsibilities.

It is well known that in the cultural sector, thinking through management issues at a theoretical level is not a real priority. Most research conferences on art management focus on quantitative data processing about marketing and cultural policy subjects on a general level. A lot of attention is also paid to economic, political and social issues and much less to concrete decision-making processes on strategic, organizational and operational levels of art management. A consequence of this weakness is that it may force the manager in the cultural sector to adopt the large-scale management concepts previously referred to, irrespective of his/her involvement in daily events.

In this book, we shall therefore be looking carefully at any link between general management insights and the unique nature of art management. Essentially, we aim to establish an art management approach that not only has a recognized position in general management theory but also creates a framework for reflection and the design of every day practice.

Box 1.2 *Shakespeare's Iago as an important management theme*
William Shakespeare wrote The Tragedy of *Othello, The Moor of Venice* in the early 1600s. In this drama, the black general Othello is misled by his venerable Iago. Iago is very disappointed about missing promotion in Othello's army. This and other more personal reasons lead to Iago's plotting and sub-plotting, finally resulting in the death of Othello's young wife Desdemona, strangled by Othello himself. When Othello comes to

his senses, realizes that he has murdered his wife and finally recognizes the extent of Iago's scheming, he kills himself with his sword.

The plots in this drama have been analysed by management consultants in order to investigate how to deal with people in an organization who have a hidden agenda that only serves their own interest. On the plus side, the Iago's of an organization are very creative at getting things done the way they want. The key question is how we can use this creativity within an organization and still avoid offensive consequences, e.g. serious conflicts and personal injury. Shakespeare's Iago is a beautiful example of how art can support management doctrine of complex themes.

Source: HAGOORT (1999)

Taking this as a point of departure, the Introduction (chapter one) contains some general, current and future reflections on the field of art, culture and management with two dominant external factors: internationalization and the digitization of culture. This chapter provides the reader with the basic knowledge for understanding more specific organizational matters.

Chapter two deals with the strategic management of cultural organizations. Here we examine why a cultural organization should develop a strategy, or a direction, and how this should be done. We shall also be looking at how cultural organizations can innovate their goals and methods in a project based way.

The structuring of a cultural organization is outlined in chapter three. Besides the main questions about labour division, coordination, life cycles, configurations and project management, the process of organizational change concerning organizational culture will also be discussed.

The fourth and final chapter deals with factors that are of importance to the role of leadership in cultural organizations. A new concept of Creative Entrepreneurship will also be presented as a challenge for our third Millennium.

In a separate appendix, a complete case study on strategic formation in a cultural organization, *Theatergroep Amsterdam* - TGA (Amsterdam Theatre Group <www.tga.nl>) is presented. This case study was originally a part of our Ph.D.-research on interactive strategic processes in the cultural field and the main ingredients of the four chapters of this book were used.[14]

A schematic overview of this book is reproduced in figure 1.7.

Figure 1.7 Schematic overview ART MANAGEMENT Entrepreneurial Style

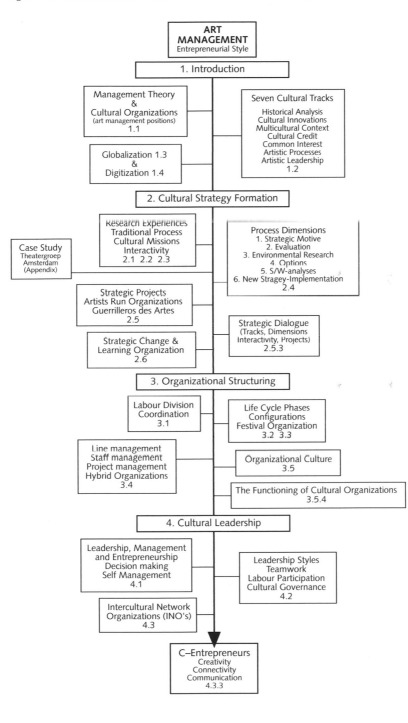

This book differs from most other books on art management because of the integral approach of art and management. In general, we appreciate every document written about the way that we can professionalize cultural organizations. It is also important to keep nourishing international dialogue about high standard art management, with the products of research and practical reflection. It is a disadvantage however that these books are often a collection of contributions of several writers; an integral approach is lacking in these publications. An exception has to be made for William J. Byrnes' Management and the Arts. This book, exclusively written for the American cultural sector, provides the art manager with theoretical and practical applications from all management perspectives: planning, marketing, finance, economics, organizational design, and staffing and group dynamics.

Box 1.3 *Books on art management*
(• theory, •• practice, ••• theory and practice, •••• essay)
1970-1980
Tem HORWITZ, *Arts Administration: How to Set Up and Run a Successful Nonprofit Arts Organization,* Chicago Review Press, Chicago, 1978. ••
John PICK, *Arts Administration,* Spon, London, 1980. ••••
1981-1990
Nello MCDANIEL and George THORN, *Rethinking and Restructuring the Arts Organizations,* Fedapt, New York, 1990. ••••
1991-1999
Friedrich LOOCK (Hrsg.), *Kulturmanagement, Kein Privileg der Musen,* Gabler, Wiesbaden, 1991. ••••
Claus SIEBENHAAR, *Kultur & Management, Positionen, Tendenzen, Perspectieven,* Nicolai, Berlin, 1992. ••••
Giep HAGOORT, *Cultural* entrepreneurship, *an introduction to management* (draft). •••
Phaedon, Culemborg, 1993 (Dutch version 1992, 2nd ed. 1995, Polish version 1995).
Bryan W. BARRY, *Strategic Planning Workbook for Non profit Organizations,* Amherst H. Wilder Foundation, New York, 1994. ••
William J. BYRNES, *Management and the Arts,* Focal Press, Butterworth-Heinemann, Stoneham, 1993. •••
Nello MCDANIEL, George THORN, *Toward a new arts order: Process Power Change,* Arts Action Issues, New York, 1993. ••••
Yves EVRARD (coord.), *Le Management des Entreprises Artistiques et Culturelles,* Economica, Paris, 1993. •••
Craig DREESZEN and Pam KORZA (ed.), *Fundamentals of Local Arts Management ,* Arts Extension Service, Amherst MA, 1994. ••
Hermann RAUHE and Christine DEMMER (Hrsg.), *Kulturmanagement, Theorie und Praxis einer professionellen Kunst,* Walter de Gruyter, Berlin, 1994. ••••
Jennifer RADBOURNE, Margaret FRASER, *Arts management, a practical guide,* Allen & Unwin, St Leonards, 1996. ••
Marian FITZGIBBON, Anne KELLY (ed.), *From Maestro to Manager: Critical Issues in Arts & Culture Management,* Oak Tree Press, Dublin, 1997. •••
Philip KOTLER, Joanne SCHEFF, *Standing Room Only, Strategies for Marketing the Performing Arts,* Harvard Business School Press, Boston, 1997. •••

Th. B.J. NOORDMAN, *Kunstmanagement*, Vuga, The Hague, 1997. ••
Eve CHIAPELLO, *Artistes versus managers, Le management culturel face a la critique artiste*, Métailié, Paris, 1998. •
Giep HAGOORT, *Strategische Dialoog in de kunstensector, Interactieve strategievorming in een kunstorganisatie*, Eburon, Delft, 1998 (with an English summary). •
2000-
Giep HAGOORT, *ART MANAGEMENT Entrepreneurial Style*, Eburon, Delft, 2000. •••

Practical exercises

1. Interview an experienced art manager of a large organization. Try to find out his or her ideas about combining general management concepts with the typical aspects of a cultural organization, as mentioned in this paragraph. Can s/he contribute any new points of view?

2. Look at your newspaper. Does this paper discuss managerial aspects of the cultural sector? Can you see any striking points? Are these points mentioned in the first paragraph of this book? If not, in which paragraph would you like to see these aspects?

3. Read Shakespeare's *Othello* and uncover some other management issues in this tragedy. Look at the roles of the others, the circumstances in which the plots take place and the role of racism.

4. Check out the websites of some cultural organizations. What kind of e-services do these organizations offer? Can you interactively communicate with the cultural organizations? If the answer is yes, let them know your impression of their websites!

Closing case *Endemol*

In 1996 the Dutch entertainment company Endemol (TV productions -80% and live entertainment- 20%, turnover of EURO 290 million), established in 1993, decided to float its enterprise on the stock market to obtain money for their European expansion plans. Endemol is a merger between the two biggest entertainment entrepreneurs in the Netherlands: Joop van de Ende and John de Mol. <www.endemol.nl>

Working in this open financial context with a very strong emphasis on investment groups is totally different from working in a more private and sheltered position as most cultural organizations do. Some risky projects in the live entertainment sector increasingly led representatives from financial institutes and analysts to ask critical questions in the media about the future profits of Endemol. Meanwhile the strategic core business of Endemol became the television sector (soaps, light entertainment programmes, reality TV, game shows), which was very profitable. This development was very difficult for Joop van de Ende as the main former owner of the live entertainment sector of the company. In 1998 he personally separated the Live Entertainment Division from the Endemol-holding and withdrew it from the stock market as well. Joop van

den Ende explained his step to the media as follows: 'Live entertainment became a second carriage and after that I was looking for ways of uncoupling the activities from the company.' After the separation, he could make artistic decisions together with his managers without the external financial influence of the stock market. Joop van de Ende felt relieved and again had room for artistic adventures. A financial analyst was also happy with this decision: 'Endemol is now a more predictable company, 70% of the TV incomes are guaranteed in the near future'. In an interview John de Mol was in general very happy with the situation but expressed some reservations about one particular aspect. He stated that shareholders are only interested in the next-day-rates of their shares. For him creativity will remain the unique strength of the company, 'but no financial analyst will discuss that!'

Case Questions

1. Do you agree with the supposed differences between live entertainment and television?
2. What are the positive and negative aspects of financing culture through stock market floatation?
3. Suppose Joop van den Ende had not separated his live entertainment division from Endemol, what would the probable outcome have been for the future of this division? Do you see alternatives for financing Endemol as a whole (TV and live entertainment)?

Source: Endemol File, Utrecht School of the Arts (Dept. art and media management).

● 1.2 Cultural Tracks

Learning questions
- Are popular culture norms to be found in the cultural sector?
- What other cultural values have a strong influence on art management decisions?
- What is the dilemma of normative art and management focus?

Key words

cultural values	multiculturalism	censorship
historic roots	price mechanism	creativity
innovation	patronage	creative processes
post modernism	cultural capital	artistic leadership
digitization	partnership funding	
mass culture	cultural policy	
high culture	freedom of expression	

Opening incident: *Mayor Rudolph Giuliani of New York and freedom of expression*

In September 1999, the Brooklyn Museum of Art (BMA <www.brooklynart.org>), New York had a real conflict with the mayor of this Big Apple, Rudolph Giuliani. It was about the exhibition *'Sensation: Young British Artists from the Saatchi Collection'*. One of the art pieces was made by Chris Ofili, showing the Virgin Mary, soiled with elephant dung. Mayor Giuliani called this piece of art 'sick stuff' and refused to pay a municipal subsidy to the museum worth $ 7.2 million (EURO 6.5 million) annually - nearly a third of the total budget. The mayor, who was supported by the cardinal of New York, also put forward these arguments: "the government cannot be forced to support obscene art, which offends (catholic) people, and anything that I am capable of doing myself is not art."

Based on the First Amendment (Freedom of Speech) the management of the museum went to the Federal Court and won the case. The judge concluded that the subsidy should be continued because punishment by stopping subsidy is not allowed. In this 'War of Art' the mayor called the judgement 'totally out of control'.

After a period, the museum and the representatives of New York City negotiated the normalizing of their relationship. The result was that the city paid the original subsidy. In the media there was speculation that Giuliani from the Republican Party had attacked the exhibition because of the coming elections (November 2000) for a senate seat for which he, as candidate, needs the catholic votes against his rival Hillary Clinton from the Democratic Party.

Sources: *NRC/HANDELSBLAD, De VOLKSKRANT*, several editions 1999/2000.

1.2.1 Cultural values, popular and more serious[15]

A manager who works in the cultural sector is confronted by all sorts of norms. In his/her effort to design structures for creativity, the art manager has to deal with standard values. These mainly culture-related values influence the way artists and other creative professionals do their job. Some values are very easy to define; others can only be exposed after more intensive research. In this paragraph, we start with some popular cultural patterns. After that, we will work out some more serious values, strongly connected with the content of the previous paragraph in which we discussed the historic aspect of art management. The popular patterns are: bread and games for the people, the show must go on and there's no business like show business.

The Roman emperors gave people bread and games, i.e. while they were being entertained by them, they fed them. Here we are dealing with the political position of culture. Culture is in the sphere of influence of power-hungry rulers and the manipulable need for entertainment of the masses. The art manager should be aware of the extent to which cultural expressions are used for politicians' craving for power. In a story told by Klaus Mann, this pattern is personified in the *Mephisto* of the Nazi-regime.[16] Here the bread and games refers to the risk of artists becoming absorbed in a degenerate power structure.

The show must go on and *No business like show business* underline other elements of the organizational culture of the sector. *The show must go on* means that the performance must be carried out, no matter what the cost (health, money, personal relationships). In the "romantic" tradition of the theatre, dying on stage is the ultimate. In the visual arts there is no death more beautiful than dying with a brush in one's hand. For the running of the artistic company, this idea means that blazing rows are fought backstage rather than on stage. In other words, the date of the performance is sacred. Artists are in general, very reliable when it comes to carrying out artistic commissions.

No business like show business concerns the motive behind the combination of pleasure and money - in that order. Art managers should always keep an eye on this combination. Art managers, whose prime interest is making a big profit are definitely advised to try their luck outside the cultural sector. One director of a German theatre expressed the combination money-pleasure in one of our workshops as follows: We'll do it for fun and not for the money (but for the fun we need the money!).

More deeply, we see cultural values that can be marked as cultural tracks: you can hardly avoid these values in your adventure trip through the cultural jungle of all kinds of tastes, preferences, ideas and emotions. Because these values are important for formulating strategies (chapter 2, appendix TGA case), for structuring the organization (chapter 3) and for acting as a leader within a cultural organization (chapter 4), we will discuss the tracks here in more detail.

1.2.2 First Track: Historic analysis

The essence of this track is that art and management must be fully anchored in a historic view of art. It provides insight into the role and purpose of one's own artistic and cultural choices. This statement was also suggested in the first paragraph, but here it will be discussed more comprehensively.

First, we need to realize that there is no one historic path leading to the understanding of our decisions. The discipline of art history recognizes different ways for dealing with art and culture in the past, which has consequences for our understanding of today's cultural developments. This can be demonstrated by taking two important researchers, Arnold Hauser and Daniel Boorstin, as examples.[17] Both writers have their own way of reporting on the history of art and culture. To Hauser, it is important to see the dominant economic, political and societal circumstances from which art can emerge. In his/her concept of art in a historic context, the artist increasingly becomes an independent person. Not because of his/her genius but because of the external circumstances, i.e. improved economic, social and technological lifestyles. During the Greek and Roman era, this meant more room for expression, which was originally an important weapon for surviving in a dangerous and mystical world. This new space brought for instance the first ideas on *l'art pour l'art* approaches. Boorstin on the other hand emphasizes the individuality of great artists and how they are always creating new expressions based on or in reaction to the old ones. Also in Boorstin's eyes, there are external factors, but it is the genius of the artist to rise above them. Sometimes by eliminating and/or using these

factors as we can see in the case of Giovanni Boccaccio, an Italian writer in the 14th century who created 'the art and living well'- stories of *Decameron*. The background of the popular and commercial *Decameron* was a world confronted by a Black Death epidemic, which killed thousands of people in European cities within a few days.

Of course, one can criticize both ways of thinking. Hauser's view is somewhat one-sided because artists are responsible for creating their own art, while Boorstin is a little too romantic in his idealized concept of the genius of the artist. Here, we try to find out why it is important to be aware of a historic notion. For the art manager it is important to be aware that the identity of his or her art and culture products have historic roots and ties and that this dimension has a more complex nature than Hauser and Boorstin have showed us.

How should we deal with the 'uncertain' value of what we see as 'historic analysis'? The answer is that we need to integrate critical questions into the main decisions a cultural organization has to make. These questions can be formulated as follows.
- Can you explain your art and culture products within an historic art framework?
- Does art history help you in formulating a clear mission for the organization?
- To what extent are you aware of the environmental influence on your organization?
- How does your organization deal with artistic genius?

The process of questioning the historic impact of the cultural organization supports the art manager in a more profound formulation of his or her own artistic and cultural perspectives and ambitions. By doing this the art manager experiences it as a solid foundation enabling him or her to deal with uncertain aspects in the cultural sector.

Box 1.4 *Did Vitruvius (100 BC) write the first art management book?*
Vitruvius was a Roman architect and engineer who lived in the first century BC. He wrote the *Ten Books on Architecture* in which he explained the classic principles of symmetry, harmony and proportion in architecture, and he paid attention to the way architects should be educated. This book played an important role in debates on architecture and was used practically for hundreds of years. For us it is important to know more about what Vitruvius wrote on education as his ideas have not really dated. Knowledge (of many branches) is 'the child of practice and theory'. If one only focuses on theory and scholarship, they *are 'hunting the shadow, not the substance'*. In addition, Vitruvius' warning not to be uneconomical is important: 'the architect does not demand things that cannot be found or made ready without great expense'.
On the other hand, knowledge (based on classical ideas) can also introduce more rigid ideas about modernity. Vitruvius hated decorated pieces that showed unrealistic figures - 'monstrosities' -, which do not exist: 'Such things do not exist and cannot exist and never have existed'.
Source: VITRUVIUS, *The ten books on architecture*, translated by Hicky Morgan, Dover Publications, New York, 1960.

1.2.3 Second track: Cultural innovations

One of the most difficult words of the cultural sector is 'innovation'.[18]

In management theory, we regard innovation as the implementation of totally new products and/or working methods. Innovation is not an organic and separate part of the management process but a strategic choice as to where and how to modernize the organization. As artists know, their products are always the result of a constantly enquiring mind and will never be the same. In other words, by nature the creative world is innovative. Because of this, the difference with the management world seems very clear. However this is only theoretical; in practice it is also the cultural sector experts in particular that constantly discuss the need for renewing art forms. We therefore wish to make clear what we mean by the word innovation in the cultural sector. The first step is to differentiate between the innovative aspects of the arts. On the one hand the artist can develop his or her own cultural language. This is a more subjective approach to the creative process (see § 1.2.7). On the other hand the artist, or a group of artists, can transform a whole system of forms and styles. Only in the last case can one say that there has really been innovative development.

For example the Greek Thepsis, the first theatre director, and the French abbot Suger, as we mentioned in the previous paragraph, were innovative art managers. They created new images that were totally different from the accepted form of expression. In the Netherlands of the 20th century, there was a school of visual arts and architecture called *De Stijl*. This group, which included the well-known artist Piet Mondriaan produced new forms and ideas for the use of primary colours and the creation of harmony without symmetry.

On a more philosophical level, there is a discussion as to whether this innovation can also be seen as a general development of art and culture. This issue is important to the future of art and culture; if there is no general development, art and culture will become increasingly marginalized and obsolescent, as a Western, rather defeatist, post-modern perspective. This would mark the end of the quality indicator, allow the artist to endlessly mix all kinds of genres (new and traditional) and worlds (high art and mass culture) and render art pure entertainment. Jean-Francois Lyotard explains to us that post-modernism is simply a reflection of the dominant modern (visual) art period of the 20th century and that this method of producing art has its own criteria.19 In this post-modern world, artists need new space to express their thoughts, which does not have to imply that post modernism can be seen as the conclusion of art and its progress.

Box 1.5 *Salzburger Festspiele: cultural tradition and innovation*
In 1991, the Flemish cultural entrepreneur Gerard Mortier became artistic director of the traditional *Salzburger Festspiele* in Austria with its mainly conservative content and background <www.salzburgfestival.at>. Mozart has always been the most important artist of this world-famous festival with its strong financial significance for the city and region. Mortier has been trying to innovate the festival by introducing modern artists like the stage producer and theatremaker Peter Sellars, singer David Bowie and film-maker Peter Greenaway. Mortier bases his programme on four categories: 1. Mozart's music, 2. classical music of the 20th century, 3. new music theatre events by modern artists, 4. a mixture of film and pop music culture. This programme is motivated by the need for a young audience and critical discussion about societal phenomena such as pop music and

spirituality. The risky character of his artistic strategy is constantly being criticized by the Viennese elite and local Salzburg shopkeepers. However, fundamentally Mortier knows exactly how to retain the balance between tradition and innovation, which guarantees the continuity of this festival.
Source: NRC/HANDELSBLAD, August 8, 1997.

The difficulty of judging new cultural innovations, can be demonstrated by new cyberart (or electronic art or Internet art). Art experts have no quality criteria for this new art, which is dominated by digital technology and interactivity. In these totally new production and distribution practices, the audience is no longer a spectator but a co-creator on the screen or in virtual space. In the eyes of Nicholas Negroponte, the future of art can only be understood as an integrated process of making, acting and expressing by means of a computer.[20] *Being digital* will be dominated by *e-xpressionists* that are neither pure artists nor spectators; they are both! However, Negroponte's approach to artistic interactivity has been criticized. This so-called interactivity is mainly dominated by programmed instructions, restricted by the limits of a fixed format.

The latest cultural innovations seem to be a mixture of gentechnology and art (*Festival Arts Electronica* 1999 in Linz, Austria <www.aec.at>). The perpetual need for artistic innovation will be combined with the unimaginable eventualities of genetic manipulation. New media artists will cooperate with scientists and the real difference between the art and science of their experimental and controversial projects will disappear.

An important lesson about 'cultural innovation' is the necessity of communicating to the environment what a cultural organization means by cultural 'innovation'. Within the framework we are discussing here, there are three possibilities, as figure 1.8 shows.

Figure 1.8 Three possibilities of art innovation

Based on this insight into innovation, the art manager can diagnose the cultural and artistic practice of his or her organization. If there is no balance between tradition and renewal, s/he has to find out what the reason is. Perhaps the artists are unsure of their ability to realize innovation. Alternatively, there may be a fear in the organization about the reaction of the current audience, which may well be traditional and uncomfortable with new approaches.

1.2.4 Third track: Multicultural context[21]

Art and culture cannot exist without an audience. To the art manager, this statement raises more questions than answers. Do we mean the current audience or a new one? Moreover, what should we do with the contrast between the elite and the masses? In this paragraph, we will not be discussing the functional responsibility at a marketing level. We take it as read that this responsibility of the art manager implies that s/he has to know the audience, that the art manager works towards a full house and that each empty seat is an encouragement to intensify box office tactics.
In this paragraph we will be discussing the societal area of the cultural environment in which people do or do not have the ability to understand and enjoy art and culture in the context of their own cultural background.

There are some sociological and political points worth mentioning about the elite-character of the art world. In this approach, there is a problematic relation between the person in the street and the trained art expressions that are seen in modern museums and theatres. Some observers and critics want to bridge the gap between elite art and the masses. Their arguments focus on the so-called undemocratic situation that only a few people have access to this art world, often supported by public money or funds. Another related issue is that in the (Western) art world only experts can judge the quality of art and that this could make ordinary people feel inadequate. Alternatively, in a more political cultural framework, commentators maintain that high art can lift society out of cultural barbarism. In this way of thinking there is an unspoken prejudice that lower art or mass culture such as the musical or soap-opera have a negative influence on the cultural taste of their audience.

We should realise that the contrast between high culture and the masses already has it roots in prehistoric times. Without the qualified judgement of the prehistoric human being, no hunter-artists who drew animals on rocks, could be considered. The same criteria were used for selecting well-qualified sculptors to decorate the palaces and pyramids of the Egyptian pharaohs, and even the dialogues of the famous Greek Plato had only a small group of active followers at that time. So one can say that in general elitism and culture are two sides of the same cultural coin. More important is the question of whether this means that art and culture must be screened from the mass audience for their own sake. The cultural entrepreneur sees the distance between art products and the masses as a challenge to finding a wider audience. In order to realize the challenge s/he needs to recognize how important it is to inform and educate people just as his/her predecessors did in ancient times. No art manager can ignore this reality.

Is the contrast, however, between elite art and mass audiences the main issue of the 21st century? Let us look more closely at the environment of cultural organizations. In various countries all over the world, we have many cultures that are rooted in minorities. These cultures are regarded as second-rate cultures. The cultural expressions of a dominant, mostly Western-white mainstream ignore this expression. We see this situation in the United States of America where Indians are trying to put their cultural interests on the social and political agenda. We also see this situation in Australia and New Zealand where Aborigines and Maoris respectively fight for respect for their cultural and artistic sources.

In Europe more recently, we have new groups from North Africa and the Caribbean - the so-called immigrants - which were an economic factor but now also have a cultural impact on traditional Western society.

The dominant class of artists and cultural policymakers gives these divergent cultures exotic names such as minority art, immigrant art or multicultural art. This labelling of culture is very negative for the groups concerned and their artists. It places them in a position of apartheid and isolation vis-à-vis the leading dominant cultural groups.

This context - and in the framework of our discussion we can mention it as a real multicultural context - cannot be ignored by cultural organizations. Multicultural here is defined as a climate in which several cultures can exist as non-hierarchical structure. Intercultural can be seen as an exchange or mixed process of different cultures which can produce new cultural disciplines and genres.[22]

How should we deal with this cultural track of multicultural context? It is important for the art manager working in the dominant cultural mainstream to know what is probably relevant to his/her own organization. This relevance focuses on different levels as figure 1.9 illustrates:

Figure 1.9 Different levels of multiculturalism

Organizational level	**questions**
1. Production/Programming	• Do you know prominent artists or creative people from other cultures?
	• Do you want to share work experience with them?
	• Do you want to communicate about cultural assumptions and artistic perceptions?
	• Do you want to inform society about the artistic expression of non-dominant groups?
2. Communication	• Do you know what kind of cultural groups exist in the local or regional society?
	• Do you want contact with non-dominant cultural networks?
	• Will your marketing materials (brochures, booklets) be recognized by cultural minorities?
	• Do you really have respect for cultural diversity?
3. Personnel management	• Is your staff culturally diverse?
	• Do you want volunteers from different cultural groups?
	• Is your Board of Directors culturally diverse?

To conclude, when we talk about audiences in a multicultural context, the focus is not on the classical and universal contrast between elite and mass cultures. This contrast is a dynamic part of cultural life and will always exist in familiar and unfamiliar forms. What really hits us is the transformation of the cultural diversity into artistic and management processes within a cultural organization with artists from the four corners of the earth in

key roles. These artists are the real mediators between cultures from all over the world. Each transformation will be unique. Ignoring the multicultural context can only be a discredit.

Box 1.6 *Jale Erzen: a dialogue with living traces*
Jale Erzen is an art historian, artist and art critic, born in Istanbul in 1945. She is critical of the way dialogue between cultural identities is set up, i.e. mainly between intellectuals, administrators and policy makers. Little is taken to the floor where art is actually practised. 'I feel that a healthy dialogue can only be created on a one-to-one basis, where artists can have personal exchanges. (-) When cultural exposés are held as ready-made shows or in intellectual discussions, they leave no living traces behind them. I think what has to be created is an experimental common ground'.
Source: *ROTTERDAMSE KUNSTSTICHTING* (1993), p. 88.

1.2.5 Fourth track. Cultural credit[23]
What is the price of a painting? $ 77 million (EURO 70 million) for a Van Gogh, *Dr. Gachet's portrait*, and bought by a Japanese businessman? In general, one can say: go to the free market and see how supply and demand functions. You can do so if you have pigs, fruit or eggs, but the experience in the cultural sector is a little bit different. The most distinctive aspect of a free market is the price mechanism between the freedom of production and consumption. In the cultural sector, the artists as producers disturb this mechanism. Even if there is no demand, the artist creates art. His or her mission is not to produce for an anonymous market, but to confront the world with unique and meaningful expressions. Another disturbing factor in the free market is the artist's focus on non-economic factors such as prestige, public attention and a moral sense of doing good.

In the world of theatre, we often see monopolies or oligopolies of theatres in medium-sized cities where these cultural organizations can manipulate the cultural market However, this market power position is not so strong because of the presence of so many substitutes, i.e. sport, TV, video, if the prices increase too much. All these limitations show that the art manager has to deal with a lack of a real free market in the cultural sector.

One old system to correct (or sometimes substitute) market mechanism is the introduction of patronage by private or public parties. Private patronage has been developed in the form of maecenatism (financial support by private parties) and protectorate (an act of stimulating and financing art). On the governmental side of patronage (cities, provinces, national and/or federal states with the help of funds and agencies) we see the instrument of art and cultural subsidies to support the cultural sector.

Coming to an interim impression we can say that the purely economic market- oriented way of thinking makes it virtually impossible to translate artistic and cultural values into money. Thus, we should look for other approaches that can help us to build up financial

value for cultural organizations. This can be done by using Bourdieu's think-construction of *cultural capital*.[24]Cultural capital is based on the idea that in a period of time the (personal) concepts and products of art and culture will create economic value. The artistic entrepreneur or cultural expert generally has an attitude of nonchalance towards economic issues, if s/he does not, this will be labelled as 'commercializing'. Bourdieu says that this is only an external attitude because they know how important it is to convert art into cash for the continuity of their company. This cultural encashment is an important responsibility of the art manager. His or her first task is to look for opportunities to make money out of symbolic goods. Above all the first orientation must be art and culture. If s/he forgets this by changing to an economic orientation, s/he will never create the optimum balance between the cultural and economic aspects. However, because of the nonchalant attitude in the cultural sector, the cultural entrepreneur who deals with money will, in Bourdieu's words, be nicknamed a *scapegoat*. S/he will never satisfy the artist: if s/he thinks too much about culture s/he is a bad merchant, and if s/he talks to much about money s/he is too commercialized and doesn't care about culture.

When we are dealing with this complexity of cultural credit, we need a decision-making instrument that helps the art manager to be an excellent 'scapegoat'. Figure 1.10 shows how art managers can position culture (high art or mass culture) in a financial context (which can be profit or non-profit). This model makes clear that a real free market more or less exists as the marriage of musicals with profit prices or the marriage of gallery art and profit prices. Profit prices here include forms of private patronage and sponsorship. On the other hand, it also makes clear that high theatre art needs subsidies or public funds that have no commercial gain. If a cultural organization, e.g. an avant garde theatre group, wants to make more economic profit from their cultural capital, the direction of its decision can go in two ways (as indicated by A and B). If a cultural organization, e.g. a media organization, focuses more on the cultural impact of its soap opera production, it can choose between two options (as illustrated by C and D).

Figure 1.10 Scheme of cultural and economic positions

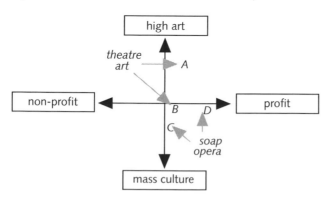

Another issue in this area is the economic impact of the cultural sector. Economic research tries to explain the way cultural activities influence the economic developments in a

country, region or city. The most important questions here are: how many employees are working in the cultural sector and the related, more economically oriented sectors such as cultural tourism and city marketing; what is the expenditure of the visitors of the cultural institutions; what are the investments of the private sector in the cultural area? These approaches seem to be rooted in a desire to be taken seriously by official political circles, - that (subsidized) art is not a luxury in the hands of a small elite. Although it is important to recognize the relation between culture, economics (and economic developments), technology, etc. we should listen very carefully to the economic experts who declared that the real scientific and policy impact of these approaches are very uncertain because the alternatives of spending money on other sectors are outside the horizon of research. What remains are the arguments as to why art and culture as such have an impact on the quality of life and on the way we experience beauty, amusement, cultural roots, unknown worlds and surprising discoveries.

Box 1.7 *Investment Funds: a popular way of financing cultural projects*
In general, there is a view that contemporary art has no profitable impact, with the exception of pieces of visual art of some world famous artists such as Andy Warhol, Jeff Koons and Gilbert and George. In some Western countries such as the United Kingdom and the Netherlands, this idea is changing. In its tax policy, the national government introduces lucrative facilities to private persons to invest in national art films so that it is very attractive to take financial risk in this sector. The tax system offers significant tax benefits to taxpayers participating in the production of a film. His or her total participation is marked as a deduction. The profit of this investment varies between 3 and 30 %. In 1999 the market for independent movies ('indies') was $ 2.5 billion (EURO 2.27 billion) in the USA and EURO 1 billion in Europe.
Another popular form of financing art and art organizations is 'partnership funding'. This method of financing is based on the idea that art organizations should be encouraged to find private sponsors or donors by governmental agencies or non-profit foundations, matching amounts found through sponsorship.
Sources: NRC/HANDELSBLAD, December 24, 1999; *STICHTING KUNST & MEERWAARDE*, Amsterdam, 1999 <www.kunstenmeerwaarde.nl>.

1.2.6 Fifth track: Common interest[25]
The relation between the state and the art and cultural world is not without problems. On the one hand we need governmental support -directly or indirectly - because of the imperfect free cultural market. On the other hand, artists and art managers often have an aversion to governmental pressure on artistic decisions and censorship. If we look at the democratic tradition of the modern state, we can clearly see a fundamental rule of cultural policy. This rule is that the state is at least partly responsible for keeping cultural values alive, with a constitutional respect for freedom of expression. This freedom can only be restricted by a national Criminal Law aimed at protecting general interests and personal integrity. In this way the government protects, supports and finances art and culture while respecting the artistic freedom of artists and their organizations. This includes the right of minorities to have their own culture and to express their own cultural identity, for example. In practice, this support is demonstrated in a variety of ways, both

directly, e.g. subsidies, education and indirectly, e.g. tax policy, employment programmes, exchange programmes, lotteries and non-profit funds.

In many countries such as the Netherlands, United Kingdom, South Africa and Canada, the cultural policy systems have their own councils to advise on subsidizing the arts. Sometimes these councils also have the executive power to finance cultural activities by themselves (British Arts Council <www.britcoun.org>). Another general aspect is the aim towards decentralization of cultural policy. Decentralization means passing the authority of decision-making to lower levels: regions, cities or local communities. A third common area is the use of cultural policy as a tool for foreign affairs. During the Cold War, we saw that the USA and the Soviet system used art and culture as instruments of propaganda. In the post-war period art and culture are increasingly handled by states as promotional tools of national identity.

Box 1.8 *Russian Reality*
It is very interesting to see how since the fall of the communist Soviet system, the Russian Federation, founded in 1990, has been trying to develop a new cultural policy structure. In the former system the Communist Party dominated cultural life and gave detailed guidelines for artists on how to create art. In all the Eastern bloc countries, the communist party held the same position, dominated by Russia. As long as artists respected the instructions of the party, they had a relatively good position with regard to work and income. Cultural life at schools and factories was also very highly developed but, of course, controlled by the state. Traditional and so-called realistic art was the norm; the more modern, abstract design was effectively banned. After the founding of the Russian Federation in 1991 the cultural sector tried to transform its infrastructure into a more open one, based on cultural and economic *perestroika*. In fact it meant that a new cultural policy had to be developed between the federation power on the one hand, and 21 republics, 6 autonomous areas, 49 regions, 10 districts and two cities - Moscow and St Petersburg, on the other hand. Circumstances continued to be difficult because the average income was very low, the government at all levels had a inherent lack of money and above all the Federation had a primitive democratic political infrastructure. The Council of Europe reported in 1997 that in such a situation it was likely that cultural policy would lean towards a more traditional approach: more attention would be paid to cultural heritage and less to new creative initiatives. Another aspect is the priority given to the two big cities, Moscow and St Petersburg, and to a small group of well-known and prominent artists at the cost of the regional cultural developments. In such a situation, dominated by presidential *ukases*, it is not feasible to take governmental measures against the corrupt activities of new financial groups that have been investing in the film and entertainment industry.
Sources: COUNCIL OF EUROPE, *Cultural Policy in the Russian Federation, Council of Europe,* 1997. More specific to the large cities St Petersburg and Moscow: Nina LEBEDEVA, Sustainable partnership: Culture and arts in the preparations of St. Petersburg's tercentenary and creation of a cultural policy, in: *AIMAC'99,* pp. 426-433; Iouri ORLOV, Dynamics of theatre offer in Moscow, in: *AIMAC'99,* pp. 590-594.

Is it possible to find a cultural policy model that creates a profitable and open infrastructure for the cultural sector, and which emphasizes the expression of freedom? Cummings and Katz pointed out that the traditions and the history of policy making create their own unique cultural policy style. Countries with a strong, historic identity such as France and Japan devote themselves to preserving their cultural values. Other countries characterized by new and immigrant cultures focus on different ethnic cultures as in the USA and Canada. The general practice of a governmental system also affects cultural policy. French central bureaucracy has been transformed into a strongly centralized cultural system with the administration in Paris in the dominant position.

Box 1.9 *Les 'Grands Travaux'*
The development of the Cultural 'Great Works' (*Grands Travaux*) is typical of the national French administration in Paris, emphasizing presidential authority. In Paris, the following buildings were established in the last decades of the 20th century.

Building	Architect	Year
Musée d'Orsay	Gae Aulenti	1986
Parc de la Vilette	Bernard Tshumi	1986
Musée des Sciences	Adrien Fainsilber	1986
Institut du Monde Arabe	Jean Nouvel	1987
Opéra Bastille	Carlos Ott	1989
Arche de la Défense	Paul Andreu, Otto von Spreckelsen	1989
Cité de la Musique	Christian de Portzamparc	1994
Grand Louvre	Ieoh Ming Pei	1995
Bibliothèque de France	Dominique Perrault	1995

Source: Françoise BENHAMOU, *L'économie de la culture*, Paris: La Découverte, 1996, p. 60.

The German decentralized *Länder* structure results in a very limited cultural policy at federal level. In Japan, a national Agency for Cultural Affairs functions as an extra-ministerial Bureau within the Ministry of Education, Science & Culture and deals with religious affairs. The National Endowment for the Arts (NEA //arts.endow.gov) in the United States is an independent government agency with its own organizational structure. The NEA finances and supports artistic and cultural activities of individual artists, organizations and cultural agencies. The chairman of the NEA reports directly to the President without the jurisdiction of a cabinet department.

Box 1.10 *Dutch Cultural Policy Document Culture as Confrontation*
An important source for studying national cultural policies is governmental documents. The document of the Dutch Ministry of Education, Culture and Science, *Culture as Confrontation* (1999) is such an example <www.minocw.nl>. The document gives priority to cultural diversity and the participation of young people. Cultural organizations receive extra subsidies if they undertake activities that will bring new audiences to the arts. Other topics discussed are: stimulating cultural entrepreneurship, marketing of the arts, and cultural governance, which focuses on the quality of the Boards of Trustees of private cultural foundations. This document will be used to formulate criteria for subsidizing the arts on a four-year basis. If a cultural organization wishes to apply for a four-year subsidy, it has to produce a strategic plan in writing, which sets out the short-

term aspirations and states why these ambitions justify subsidizing. After independent advice from the Council for Culture, the Ministry considers all the applications. These subsequent decisions are brought together in one four-year document: the Culture Policy Document. At the end of this procedure, Parliament discusses the Cultural Policy Document and the proposed subsidies.
Source: Ministerie van Onderwijs, Cultuur en Wetenschappen, *Culture as Confrontation, Principles on cultural policy 2001-2004*, Zoetermeer, 1999 <a.lemmer@minocw.nl>.

Which conclusions may we draw? Generally speaking, one of the characteristics of democratic nations, the presence of a cultural policy, is based on the freedom of expression. Traditional and historical values also have an impact on the way national cultural policy is organized. In general one can say that choices have been made in the areas of centralization/decentralization, subsidizing heritage culture and new creative art, stimulating the participation of the people, organizing the infrastructure including the (independent) advisory system, and the relationship between private and public cooperation with regard to financing the non-profit cultural sector. If we apply these conclusions to art management, they may be seen as an environmental influence, which may also be described as the Common Cultural Interest. Art managers should be aware that this interest may affect the position and behaviour of their cultural organization. If censorship, for example, restricts the freedom to perform, exhibit or publish, irrespective of the part of the world it is introduced, it is the duty of art managers and their staff to fight it.

One final remark should be made about governmental influence on the cultural sector. It is to be understood that the focus is cultural policy and the way the state subsidizes the arts. However, if we look at the intervention more closely we see a lot more fields in which the government can be involved with the cultural sector.[26] The Ministry of Financial Affairs regulates tax conditions for artists and artists' companies. The Ministry of Social Affairs is responsible for the social income of artists and other workers in the cultural sector. Exported cultural activities and technological innovations are stimulated by the Ministry of Economic Affairs. The Ministry of Education and Science is responsible - also financially - for art education within the standard educational system. The Ministry of Foreign Affairs is responsible for Cultural Treatments. This enumeration can easily be extended with the involvement of the various regional and local governments and with the cooperation of cultural agencies and funds with a pseudo-governmental mantle.

So as we see that governmental influence in the area of culture is multifaceted, it is very important for art managers in the profit and in the non-profit area, to know which governmental measures have or may have a strategic, legal and financial impact on their cultural organization. In practice the art manager often experiences a lack of any integral governmental approach and little coordination or cooperation between the different levels.

1.2.7 Sixth Track: Artistic and creative processes[27]

In Fayol's theory, management may be considered as the process of planning, organizing, leading and controlling. In cultural organizations, this process has to be combined with

cultural and artistic creativity. Only if we recognize the essence of this creative value will we really be able to run cultural organizations successfully.

Creativity has a general and a more specific meaning. In general, we see creativity as an ability to discover or to combine new possibilities. This general concept of creativity is based on four phases as shown in figure 1.11.

With this concept in mind, we can say that a *creative organization* is an organization that uses these four phases for all its decision-making and problem-solving processes. This organization also stimulates a creative atmosphere in which people can take risks and develop new approaches, products and services in their environment.[28]

Figure 1.11 Four phases of creativity

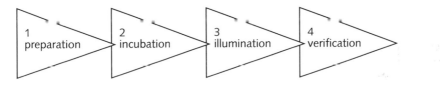

Phase one - Preparation: a period in which we try to find solutions for problems with the help of established methods.
Phase two - Incubation: in the subconscious, irrational ideas for solving the problem are correlated.
Phase three - Illumination: the unexpected but conscious moment in which the problem is solved.
Phase four - Verification: the controlled test to confirm that the original problem really has been solved.

Can we compare this creative process here with the specific artistic process? Artistic creativity is linked to accident, chaos, arbitrariness and unpredictability. Artists have a relatively strong keenness of observation and memory, and the ability to think in analogies and frameworks. More talented artists are also capable of investigating conceptual space and transforming it into new conceptual space with new rules. In order to understand these artistic processes it is important to observe artists who have formulated their own creative experiences.

Truus Bronkhorst, a Dutch dancer and choreographer, explained in an interview what takes place in the process of choreographing a piece.[29] She distinguishes between the following phases.
The starting point of the process is undefined. It may be a word, a costume or a piece of music.

In the brooding phase the limits of the subject become clear. In this phase, new ideas can also be connected with the starting point. Then concentration follows. This means that the idea reaches its concrete form. Sometimes it can happen very suddenly.

The last level is to be called the risk phase: the performance is shown to the audience and the reviews are published. Finally, it will emerge whether the performance had the desired quality. Because of the expectations and of the theatre schedules, Bronkhorst experiences some fear and pressure. This becomes stronger with age and fame.

In other fields, artists have also described their experiences. The famous 19th century Dutch painter Van Gogh generally had a concrete aim and purpose, derived from natural surroundings.[30] What happened however was that his sustainable motifs were inspired at unexpected and unplanned moments.

Roger Sessions was an American composer of the 20th century.[31] He believed that the composer permanently lives in a world of sounds. These sounds become a composition in combination with creative impulses. Sessions outlines three phases.

Inspiration: an unscientific idea of notes and rhythms that produces a musical idea. Inspiration is an impulse that sets creation in motion. The problem here is how energy can be saved for the other phases.

Conception: based on the 'style' of the first phase, the form of the music is now developing. This form is not an expression of conventions or existing standards but a newly created language.

Execution: the composition is performed. After his music is completed, Sessions no longer feels it is his music. It is incomprehensible to him because his aim was the creation of new music and not repetition.

Artistic creativity is not only an individual process. In film and theatre, there are many ways of working collectively. Only artistic teamwork will fashion the film or theatre production into a concrete product. However, of course, without the master hand of the artistic director the production will not reach its final phase.

Box 1.11 *An artistic location as a critical success factor*
It is hardly mentioned in the general management literature, but having a place with its own atmosphere where art can be created is a very important factor in the cultural sector. As artists know, a private and trusted place is a *conditio sine qua non* for artistic production. This place can be inside, in studios, or outside, on streets and squares, in real life or even virtually - on the Internet.
A good example can be seen in the existence of a so-called Artists Run Organization (ARO). Groups of artists of this sort have a clear artistic vision and a strong desire to establish their own space in which they can realize their artistic, mostly experimental ideas. Very often, this space is an empty old industrial building, monumental church or storehouse near a harbour or a railway station. Only in such environments does a spontaneous art world seem to develop. In a lot of modern city planning processes, these buildings disappear without creating alternatives for the artists involved.
See also § 2.5.4 and TGA case (appendix).

The lesson we learn here is that the creative process of the artist is unique. This cultural value cannot be planned by management systems. Only by knowing the nature of this process, can the art manager combine elements of the creative process with the planning process of the organization. It is the responsibility of the art manager to discover a joint interest with which to start the process from both an artistic and a business angle, and to finalize arrangements with theatres, concert halls, museums, galleries and even with financiers and sponsors, without disturbing what is really elusive: artistic creativity.

1.2.8 Seventh Track: Artistic leadership[32]

Artistic leadership plays an essential role in the integration of cultural values in strategy formation and organizational structuring. We have already seen some early examples in the previous text, e.g. the Greek theatre director Thepsis and the French abbot-renovator Suger. In our modern times we also hear some names which stimulate our imagination like Walt Disney, the creative founder of the American Walt Disney entertainment empire[33]; Melina Mercouri, world famous singer, former minister of Culture of the Greek Administration and inventor of the idea of European Cultural Capitals; Peter Sellars, the enthusiastic and socially-concerned former festival director from Los Angeles; Gerard Mortier, the Flemish director of the *Salzburger Festspiele*.

The question is, what are the value-oriented characteristics of artistic leadership within a cultural organization. In this paragraph, we are looking for the real nature of artistic leadership. The elements of artistic leadership that we have discussed can be seen in figure 1.12. Leadership styles in general, e.g. concern for people or concern for production, and the way art managers can put them into practice, will be discussed in chapter four.

Figure 1.12 Elements of artistic leadership

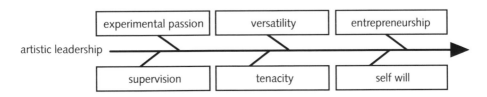

The first element of artistic leadership is *artistic supervision*, which brings unity to art production. Whether the supervision is outspoken or more implicit depends on the contemplated product (building, performance, exhibition, collection, and art education). One of the first examples of an outspoken artistic supervision is the architect Imhopet, builder of the first step pyramid in 2600 BC. Imhopet's supervision stretched from the distant marble-quarries where blocks were cut for the sculptures of Pharaoh Zozer for the pyramid, to the building place where thousands of labourers were working on one single monument.

The second element is *artistic experimental-passion*. Thepis created actors, Suger transformed the Roman church into a gothic cathedral, and Walt Disney designed *EPCOT*, a cultural city of the future. This passion is the core of artistic innovation.

The third element is *artistic tenacity*. Walt Disney illustrated this in a very distinctive way. When first starting out, he hawked his cartoons round the local shopkeepers and finally went bankrupt. After this experience he founded an entertainment company worth more than $ 3 billion (EURO 2.7 billion).

The fourth element is *artistic versatility*. The Renaissance artist Leonardo da Vinci was an expert in the fields of both art and science. William Shakespeare was an actor, playwright and innovator of theatre buildings. Our generation also regards the American artist Frank Zappa as composer, musician, conceptual artist and performer[34], and Madonna as musician, model, movie star and female conceptual performer.

The fifth element is *artistic self will*. Self will means that the artistic leader has the capacity to make a unique impression on the environment. Rembrandt van Rijn did so, as have the others mentioned here in their own way.

The sixth and final element is *artistic entrepreneurship*. This element can be described as the integration of individual practice into a cultural, socio-economic and spatial environment.

All these elements can be found in one single leader or in a team of artistic leaders. The choice depends on situational factors such as the experiences within the cultural organization, its lifetime, the sphere of influence and the complexity of the environment. Perhaps these six elements may be summarized as 'passionate leadership'.

Box 1.12 *Okwui Enwezor: I cannot work to a recipe*
Dokumenta, the most important German art exhibition in Kassel <www.dokumenta.de>, has appointed the Nigerian art historian and former director of the *Johannesburg Biennale 1997*, Okwui Enwezor as artistic director to lead *Dokumenta* in 2002. Traditionally, the artistic director of *Dokumenta* is a prominent Western art expert such as Jan Hoet, Belgium; Rudi Fuchs, the Netherlands; Catharine David, France. For the first time, the *Dokumenta* committee has chosen an artistic leader with a broader, untypically Western orientation. What are the elements of his artistic leadership? Fighting against parochialism, not working to a recipe because that is not challenging, keeping critical dialogue alive, not taking the established routes, seeing the *Dokumenta* as a 'living process' in which questions are more important than answers.
Source: NRC/HANDELSBLAD, June 28, 1999.

1.2.9 Dilemma

A content-oriented approach, expressed here in seven cultural tracks for art management, does not necessarily mean that such an approach is unproblematic and easy to realize. On the one hand, the purpose of management is supposed to be an

added value to prevent uncertainties that can hit the organization, and to take measures to maintain continuity. On the other hand, the artistic content is surrounded by cultural values that are strongly normative and raise a lot of questions rather than providing answers. Gaining insight into this complexity and dealing with the consequences are the cultural-content oriented sparkplugs of the art management engine.

Let us end on a note of caution. A dialogue about cultural values in the field of art management is not a hobby or an exercise in abstract thinking to widen our horizons. Cultural values or *tracks* as they are referred to here, are an inseparable part of a process to create a sustainable and meaningful world of cultural organizations. The TGA case (appendix), illustrates a concrete way of integrating cultural tracks within strategy formation.

Box 1.13 *Henry Miller: I obey my own instincts*
'I haven't the slightest idea what my future books will be like, even the one immediately to follow. My charts and plans are the slenderest sort of guides: I scrap them at will, I invent, distort, deform, lie, inflate, exaggerate, confound and confuse as the mood seizes me. I obey only my own instincts and intuitions. I know nothing in advance. Often I put down things which I do not understand myself, secure in the knowledge that later they will become clear and meaningful to me.'
Source: Henry MILLER, Reflections on writing, in: *GHISELIN* (1952), pp. 178-185.

Practical exercises
1. Look at a newspaper article about the artistic leader of a local theatre. Did s/he mention any cultural values of importance to her/him? Are these values also mentioned in this paragraph?
2. Find out with the help of the library which cultural topics are mentioned in governmental documents. Do you agree with these topics? Give your arguments.
3. Look at some artists' web-sites on the Internet. Can you give some arguments as to why these sites may be considered traditional or innovative?

● 1.3 The global dimension of art management

Learning questions
- What do we mean by globalization of culture?
- How does management theory explain globalization?
- What are the two dominant global factors for cultural organizations?
- What are the reasons behind globalization within a cultural organization?

Key words

global village	subcultures
cultural network	cultural pluralism
culture without borders	levels of globalization
global dimension of management	sustainable art management
global cultural system	international plans
multicultural societies	

Opening incident: *Malinese artists infected by international standards*

The West African country of Mali is one of the poorest countries in the world. Eighty percent of its population of more than 10 million work in the agricultural sector. The industrial sector makes up 15% of the GNP. The cities Timbuktu and Ségou quicken the imagination and some regions such as Dogon give the visitor a timeless feeling. In the cultural field, multiculturalism is an admirable richness with its mud architecture, colourful masks and rhythmic music. From a Western view, one can imagine that globalization is not an issue here because of the absence of financial sources and a weakly developed cultural infrastructure. However, such a thought does not do justice to the entrepreneurial Malinese artists. These internationally oriented artists noticed that there was a lack of professionalism in comparison with international show

business. Aziz Wonder, a reggae-man, considers it necessary to have a manager for consulting, communication and marketing affairs. In his eyes, it is important to ensure a good image in a free market system, both in the West African region and at European festivals. It is the mission of filmmaker Cheick Oumar Sissoko, to establish an African Cultural Centre in the capital of Mali, Bamako. Artists had always used the facilities at the French Cultural Centre, which is in fact the location of the former colonial authority. In his African Cultural Centre, Sissoko wants to realize a stage, a movie theatre, an exhibition hall, a film library, an Internet cafe and a guest house for foreign visitors. It must become a true meeting point for different cultures.

Sources: *L'OBSERVATEUR*, August 3 1998, HERVORMD NEDERLAND, February 5. 2000.

1.3.1 An unqualified theme[35]

The global dimension of cultural organizations is not discussed in most cultural organizations or during training programmes on art management. In most cases, the cultural organization focuses entirely on the local or regional level. Some have a national perspective and just a few of them, mainly in the non-profit opera and symphony sector, art education sector and the profit entertainment sector, play an international role. Besides, who is playing a role in the new 'Global Village', where the cultural organization is a part of a worldwide cultural network with its own norms and unwritten rules about contacts, dominant issues and prominent artists? At the moment just a handful of art managers of cultural events such as Theatre Olympics in Greece 1995, in Japan 1999, and in Russia 2001, and the Art Fair in Basle, Switzerland, with 271 internationally oriented galleries of modern art.

Nevertheless, the globalized area in the cultural field is growing very fast as can be seen from the schedules of Unesco <www.unesco.org>, ECF <www.eurocult.org>, ISPA <www.ispa.org>, AAAE <www.artsnet.heinz.cmu.edu/aaae>, ELIA <www.elia.ahk.nl>, ENCATC <encatc@wandoo.dk>, EFA <www.euro-festival.net> and AIMAC <www.aimac.it> and is to be expected from the borderless nature of culture. There is already, for example, an international repertoire of classical music; we also use the words *world music* and *world dance* for all sorts of non-western sounds and motions; after World War II the words *pop music* were understood all over the world; in theatre and

film studios we have the same methods of working worldwide, and film stars are globally famous. Last but not least, we talk about the *Seven Wonders of the World*, of which the pyramids of Egypt and the Taj Mahal in India are the most prominent cultural expressions.

Box 1.14 *Top classical musicians and visual artists at the end of the millennium*

At the end of 1998, Classic FM , a European radio station, published with the help of listeners, its top 100 of most popular composers. These are the top 10 internationally recognizable popular classics:

1. Vivaldi, *The four seasons*
2. Mozart, *Clarinet Concerto*
3. Pachelbel, *Canon in D*
4. Bach, *Air from Orchestral suite no. 3*
5. Grieg, *Peer Gynt suite no. 1*

6. Mozart, *Die Zauberflöte*
7. Albinoni, *Adagio*
8. Bocelli, *Con te partiro*
9. Mahler, *Symphony no. 5*
10. Mozart, *Requiem.*

In 1999, the German financial periodical *Capital* selected 100 living visual artists on the criteria of the number of exhibitions and publications in art periodicals. The list of the top five is as follows:

1. Sigmar Polke
2. Gerhard Richter
3. Bruce Nauman
4. Rosemarie Trockel
5. Georg Baselitz

The top three 'stars of tomorrow' are: Eija Lisa Ahtila, Nori Mirako and Sarah Sze. The biggest loser is the American Jeff Koons, from 17th to the 40th place.
In the same year, the American ART news published its top list of the most important visual artists of the 20th century. Among them were Joseph Beuys, Salvador Dali, Piet Mondriaan, Pablo Picasso and Andy Warhol. This selection was based on the number of times they were mentioned by a selected group of editors, art critics, curators and art students.

It is understandable of course that, despite the idea of culture without borders, cultural organizations concentrate on domestic or regional seats often dominated by regional and national legislation. It is in this environment that mainly regional artists provide culture for local audiences with local financiers and regional art and folklore culture are important elements of daily life.

In this paragraph, we will see that the cultural world is changing dramatically towards a real global network. Worldwide information and communication technology (ICT, see next paragraph) and the internationalization of the economic market with relation to cultural tourism and entertainment, will cause globalization to permeate the cultural sector and influence our stages, impresario offices, exhibition halls, art management classes and, first and foremost, the cultural preferences and tastes of the population, without exception. The main question is not whether we appreciate this cultural sector but how we can consider our cultural organization in a global perspective.

Box 1.15 *Roberta Smith: The New York Artist is now from Everywhere*
In the New York Times, Roberta Smith explained that in the 1960s a New York artist lived
in New York, worked in New York and had his work exhibited in New York. At the end of
the 90s New York is not a place for living and working but 'more and more a central
'clearinghouse' for a global contemporary-art scene.' From China, Korea and Brazil to
Norway nomadic artists live in New York for a while and show their art as a means of
establishing themselves. In this situation it is impossible to know which artists really live in
New York or who is just passing through. Smith: 'And what's more, it doesn't matter.'
Source: NEW YORK TIMES, April 18, 1999.

1.3.2 Globalization as management issue

In the general management literature, the global dimension of management is indicated
as figure 1.13 shows.[36]

Figure 1.13 Phasing global management

Usually there is a domestic market for small businesses. Resources and homogeneous
products or services are associated with a regional environment. Because management
focuses on economic growth, firms develop a variety of products or services and the
target area increasingly extends nationwide. Based on this experience and dependent on
the scope of its own country, the organization will grow by exporting and being active in
more than one country.[37] In this phase, the resources also have a mixed origin. The next
step is a worldwide marketplace and a multinational business. Resources are required
from all sorts of countries or regions and sales are supported by a strong corporate
identity, adaptable to regional markets. The organizational systems of coordination and
labour division become increasingly complex as a result of multicultural identities,
economic uncertainties and unexpected regional conflicts. The last phase in this
development is to be a global organization in a global business. The headquarters are
historically located in a national system but top management considers itself non-
national, and traditional boundaries are no longer relevant. In this phase, the core issue is
to be a global network player with a dominant worldwide market leadership
(*globalopoles*).

This development is generally dominated by quantitative growth. If we follow through
this way of thinking, the globalization of management can bring worldwide turnover, and
profit and power to the organization; the content of products and services themselves
however, is relatively unimportant and is mainly a tactical issue (on the level of business

units of a global organization). Porter puts this growth into a national framework ('diamond') which creates an entrepreneurial environment for success in the international market.[38] This framework shows that this success depends on four determinants:
1. Factor conditions: skilled labour, infrastructure, the quality of the industry,
2. Demand conditions: the demand for the product on the domestic market,
3. Related and dependent industry: the quality of the supplier industry's competitors
4. Firm strategy, structure and rivalry: the quality of the organization and the domestic competition, vis-à-vis international standards.
 Porter's conclusion is that a firm has to create an innovative environment within the four determinants and that success within the domestic market is the basis of international success.

Finally, we should mention international regulations based on treaties between national states. In general, these regulations are geared to free trade, e.g. GATT, NAFTA, EU and MERCOSUR.[39] A core issue for discussion is the position of cultural goods. Europe, piloted by France, wants to protect these national or regional values while the United States' policy is that all products and services, even the cultural ones, must be subject to free trade. The GATT negotiations in 1999 failed to solve this dilemma.

Because of the normative character of the cultural world and the dominance of its products, which are much more than just tactics (see the previous paragraph about the seven cultural values), the question is what art management means in a global world. The accepted general management approach can help us to find the answers. However, because of the character of the cultural sector, it is necessary to look at the global environment in more detail with a view to understanding precisely what is happening in a cultural context.

1.3.3 The meaning of a global environment
The global environment of a cultural organization has two dominant factors, as illustrated in figure 1.14.

Figure. 1.14 Global dominant factors for cultural organization

1. By pressing a computer button or touching a screen the art manager may be invited to perform at a festival or to exhibit in a museum in a unknown world, far from his or her own location. Cultural competition will also grow enormously. By using Internet and ICT, art dealers and impresarios can arrange for foreign artists and art companies to display their art on foreign markets. In doing this, a Global Cultural System is being formed.[40]

This system is mainly spreading from cultural metropoles such as New York, Los Angeles, London, Paris, Bombay, Hong Kong and Tokyo. In these big cities, artistic and creative standards dominate the taste and design of high culture and applied art. It is typical of this system that preferences have no local origin; architects are working in all the main capitals, classical and pop artists perform at world locations where art managers pay astronomical fees, visual artists are represented in nearly all famous private or public collections. This *Pavarotti-ism* has its own network, often connected with entertainment empires that organize large-scale events and festivals concerning sport or world exhibitions (e.g. Barcelona, Atlanta, and Sydney). Economies of scale make these cultural products and services highly vulnerable to commercialization where economic values dominate cultural values. One possible consequence is the *McDonaldization* of the culture. Another aspect of this cultural globalization is the disappearance of the traditional contrast between high art and low culture. High art will be managed as mass production and low culture will be absorbed through the high tech screens of the elite.

2. As mentioned earlier in this chapter, there is a growing awareness of multicultural society in all parts of the world. Sometimes this society has the same borders as the national state, but often ethnic-cultural groups are regional or transnational. The implications of the multicultural society on internationalization are high. Dominant cultural streams, increasingly based on the Global Cultural System, are confronted with subcultures and their representatives. Sometimes these individualistic subcultures are in danger, because the (Western) media have the youth of today obsessed with their fast-moving music video clips. This problem is recognized by the World Committee for Culture and Development of the United Nations. In its report of 1996, the World Committee stipulates that the culture of groups of people has in the first place a creative function and is a source of progress.[41] Therefore, it is important to respect cultural diversity and cultural freedom, for groups and individuals. Cultural pluralism is in this framework a fundamental principle that means that the concept of *nation* will not be identified with ethnic exclusivity.

It should be clear that it is impossible to conclude what the concrete impact will be on a single, local cultural organization. We may safely say that it is necessary to translate global developments into relevant conclusions for such an organization. This paragraph will thus close with some methical issues about the responsibility of the art manager for developing a *glocal* attitude.

Box 1.16 *The European Context*
In 1993 the European Community of nine West-European countries transformed itself into the European Union (EU <www.europe.eu.int>) and opened its interior borders. At the beginning of the 21st century, the EU of 15 members (Austria, Belgium, Danmark, Germany, Greece, Finland, France, Ireland, Italy, Luxembourg, the Netherlands, Portugal, Spain, Sweden, UK) intended to open its membership to Central and East European countries.
The EU has no specific authority to develop a cultural policy and has to respect the cultural policy of the national states. Its influence is more indirect, in stimulating media, technology, education, regional affairs and employment. One of the recent agreements is that the EU has to consider the cultural aspects of every decision taken. The development

towards a single Europe has led to a greater interest in mutual relations in the former East-West blocs. This is a matter of developing cultural contacts and opportunities for artists to work and perform on Western and Eastern stages.

In the 21st century, the art manager of a European country will be involved with the following issues:

- The influence of a European cultural history, e.g. the main cultural civilizations such as the Renaissance and Modernism, on art management processes. Perhaps it will mark the birth of a unique European approach to cultural entrepreneurship in an open and democratic society.
- The growth of one European Union within Europe as a whole. What kind of regulations will transform the current situation into this unity and what will be our relationship with the Russian Federation and the Ukraine which are also (partly) European?
- The growth of one cultural market in Europe. Will economic competition or cultural cooperation (or both?) between cultural organizations occur? What will this market mean for European, national and regional identities?
- The relationship with North American, Asian, Latin American and African countries. Are we really creating a transparent and accessible Global Cultural System, with respect for indigenous cultures on this planet, or will the EU be a cultural imperialistic power intent on dominating its surroundings?

Source: UTRECHT SCHOOL OF THE ARTS, *Student Handbook MA AMMEC*, 1999-2000.

1.3.4 Why globalization can be important.

In general the most important task of the art manager in the framework of the global discussion is, to determine the importance of globalization to his or her cultural organization. Figure 1.15 shows the different areas of importance: continuity, artistic innovation, competitive advantage and practical reasons.

Figure 1.15 levels of globalization

continuity: globalization as a key condition for survival → artistic innovation: globalization gives impulses to innovate → competition: globalization gives a strategic advantage → practical reasons

The first sub-question is: how important is globalization for the continuity of the organization? A concert hall in a metropolis cannot function without an international web of relations. However, an international website would suffice for a regional museum whose focus is traditional art.

The second sub-question is: how important is globalization as an stimulus for artistic innovation? A youth theatre group can use international impetus to innovate its performances if the national standard is not challenging enough. The result can be an improved and interesting repertoire for the audience and clients such as schools and community centres. The decisive step has to be made by the artistic leader; his or her decision has to suit their artistic processes.

The third sub-question is: how important is globalization to your competitors? A gallery owner with a high level mission but no international ambition, will have to reconsider his/her objectives. Suppose that his/her contacts want to collect international art of the genre exhibited by the gallery. The gallery owner will have a serious problem because the gallery will lose sales contracts. The same situation will occur at theatres. Suppose a theatre in your region offers tickets at reduced prices for theatre performances in foreign cities. This reduction system will give the theatres involved a special and attractive position vis-à-vis non-participating theatres.

Last but not least (4): how important is globalization at a more practical level? An art institute needs special teachers who are not available in their own country, an orchestra cooperates with a foreign orchestra to develop a contemporary music project. Internationally oriented festival organizations create a network for reducing travel and marketing expenses. In practice, there are often various reasons as to why a cultural organization wishes to create an international and thus global dimension.

Box 1.17 *Network Public of European Theatres*
In 1999, the established European Theatre Convention (ETC) launched a *Public of European theatres* network. This ETC project (30 theatrical institutions in 17 European countries) offers local spectators a free visit to one or more of the yearly 350 foreign performances. The project focuses on the four million spectators who are connected with their own local theatre: 'Our experience gives us confidence that languages are not a barrier and that our public is an open, curious and constantly in need of cultural enrichment public. We also know that theatregoers travel a lot and have a large interest in other cultures in Europe'. The European countries are: Austria, Belgium, Croatia, Denmark, Finland, France, Germany, Greece, Hungary, Italy, Luxembourg, Norway, the Netherlands, Romania, Slovenia, Spain, Sweden. <www.etc-centre.org>

Box 1.18 *Dutch MOJO Concerts in American SFX-hands*
Dutch MOJO Concerts, the biggest organization of pop and jazz concerts in Europe <www.mojo.nl>, founded in 1968 by the musician Berry Visser, has been sold to the American SFX Entertainment Company <www.sfx.com>. The annual turnover is NLG 100 million (EURO 45 million). MOJO is a private firm and organizes many festivals such as North Sea Jazz, Pinkpop, Dynamo. The organization also runs concerts for the Rolling Stones and Michael Jackson. MOJO has an 85% share of the Dutch market for foreign pop groups. Leon Ramakers is the owner of MOJO and explains why he sold his shares to SFX: SFX Entertainment is a leading international prime mover for live entertainment

(annual turnover of $ 1.8 billion, EURO 1.6 billion). 'We choose the strongest partner that is also active in the USA and Europe because we want to go international. A few years ago the concert world was in the hands of individual entrepreneurs but this will change dramatically'. Is MOJO a monopolist? Ramakers: 'The real power is in the hands of the artists'.

In Europe SFX has also bought Midland and Apollo (UK), and Telstar (Scandinavia).
Source: NRC/HANDELSBLAD, October 26, 1999.

1.3.5 Going Global; more practical issues

In this section, we will mention some practical aspects that may help the cultural organization in developing a sustainable global art management vision geared to management functions.

- Production: Formulate your artistic vision in relation to your global ambitions. What do you really expect from globalizing the cultural and artistic processes?
- Marketing of your products and services: Analyse the economic, social, cultural and technical conditions which are needed to realize your global ambitions.
- Organization: find out the specific labour and fiscal rules, limitations and government control; does the staff have an international vision?
- Finance: what are the possibilities of private and public funding of globalization, which firms can be interested in bi-national or international sponsoring?
- Cooperation: what is the mission of foreign organizations, do they have a reliable reputation?

The checklist mentioned below may help the art manager to work out his/her international plans.
1. Have I formulated on paper my motives for internationalization and globalization ?
2. How do we communicate our motives?
3. Do we need a project organization?
4. Do we need new skills and tools?
5. Do we need specific documentation (in which languages)?
6. Do we have an international cultural agenda?
7. Where can we find an expert in practical matters (visa, travel information, etc.)?
8. Do we want to be a member of an international or global network?
9. Do we have information about financial, fiscal and legal legislation?
10. Do we know the internationalization policy of the local and national government?
11. Do we have a concrete idea about the traditions and cultural behaviour of foreign countries?

As one can see, internationalization plans are a result of a systematic approach, using research and analysis. In chapter two we will give a more general strategic framework for these kinds of decisions.

Box 1.19 *The Chinese 21st century*

In a worldwide perspective, the 19th century was European, with its Revolutions and Democratic constitutions based on *Liberté, Egalité et Fraternité*.

The 20th century was undisputedly North American. It created a world power in the areas of economics, technology (including military) and media, symbolized by global companies.

As for the 21st century, there is speculation that this century will belong to China with its more than one billion inhabitants, its bureaucratic-entrepreneurial style together with a developing economy and a long and deeply rooted cultural history. In this speculation, the seat of the United Nations in New York will be moved to Beijing.

Sources: See for the future position of China: CASTELLS (1998) and for the position of China in an environmental research: HAGOORT (1998), p. 15.

Practical exercises

1. Obtain a local concert hall programme and demonstrate the influence of global cultural norms. Do you see elements of the global cultural system? What is your opinion of this globalization?
2. Interview a local artist and look for international influences on his/her business practice. Give some practical feedback on how to improve this practice.
3. Form a discussion group with your fellow students and formulate some critical issues on globalization of culture. What can an art manager do with these critical issues?

● 1.4 Digitization of culture

Learning questions
- What is the influence of digitization on organization and management?
- What are the significant periods of the digital revolution?
- Define some critical issues.
- How do we develop digital ambitions for a cultural organization?
- What is the meaning of the Entertainment and Dream society?

Key words

digital revolution	e-communication	connectivity
computer technology	technological culture	entertainment economy
Internet	digital art	story scenario
e-xpressionists	media concentrations	imagination
ict	democracy	
local networks	virtual communities	

Opening incident: *Personal Internet and Website Management*

Nosjon Kwansi, the director of a cultural centre, looks at his diary and tries to analyse how the Internet influences his day-to-day work. In the morning in his office, he sees on the screen of his email box that he has received ten email messages. Three unexpected and important, five expected and two uninvited promotional messages about new cars. During his check, the computer brings "new mail" from a colleague who suggests checking out the website of an international organization that is holding an interesting conference about international co-producing. After a short chat, they decide to visit that conference and use the website forms to register. After more than an hour of the Internet dealing he receives an internal mail to come to the marketing department to celebrate the prizewinning website of his own cultural

centre. During lunch with his new secretary, two mobile messages arrive

in his email box via his mobile. The first was again promotional (Mr

Kwansi hates those kinds of communication!) and the second was an

urgent message to call a prominent artist immediately in order to arrange

a performance. He apologizes for the interruption and talks with the

artist's agent for more than 20 minutes. In the afternoon he gets a report

from an Internet consultant on how to transform analogue ticketing into

a digital system in which theatregoers have a free choice of seat and can

book tickets through a touch screen. At four p.m. his secretary calls him

with an urgent problem: hackers have been trying to open his

Management Information System because the internal and external

network-systems are not wholly separated. Besides this, there was also a

message about a criminal virus that could damage data and text.

At the end of the day, Mr Kwansi is not really satisfied with his digital

experience: too many disturbing messages, too many operational

activities and too little time to reflect on how the Internet can play a

fruitful role in his cultural management processes.

1.4.1 A digital revolution

The digital revolution and its information and communication technology (ICT), which started in the last decade of the 20th century, will fundamentally influence the cultural sector and the other industries.[42] In the previous paragraphs, we have already seen some indications of this theme. One issue is the innovation of art on the Internet with its problem of how to find criteria to consider the quality of interactive Cyberart (§ 1.2.3). A second issue is how the development of digital technology is affecting the growth of the Global Village (§ 1.3.1).

In modern society, we cannot do practical things such as selling theatre tickets, paying artists' salaries, bookkeeping and processing marketing data without using computer technology. Even in situations where cultural managers have no digital office equipment

– which is currently the case in Soweto/South Africa - they do have a digital mobile phone. In their environment with a developing infrastructure, this telephone is an effective communication instrument with the outside world.

Box 1.20 *What we buy on the Internet*
In 1999, The Netherlands, with a population of nearly 15 million inhabitants, had 2.3 million Internet surfers. In the period of April 1998 to April 1999, they bought goods and services worth 1 billion guilders. In 2000, the turnover will be 1.8 billion. An increase of 80%!
The five most popular sales were:

In the private sector	*In the business sector*
1. Software	1. Software
2. Holidays/travel	2. Books
3. Compact discs	3. Hardware
4. Hardware	4. Personal Computers
5. Books	5. PC-applications

<www.multiscope.nl/ecommerce>

We call these decades a digital revolution because of the radical changes in our lives in the fields of time, place and distance. In history we can compare this revolution with the introduction of the printing press in around 1450 by a German, Johannes Gutenberg. This revolution changed the monopoly position of the scribe monks, the one-sided possession of information and knowledge by the church and court, and the elite culture of reading. The digital revolution of the late 20th century has made a similar impact, 550 years later. It should be noted that the story of the invention of printing started much earlier than in Europe. As Jared Diamond told us, in 868 China was already printing books with carved wooden blocks rather than letter by letter from metal as Gutenberg did.[43]

By means of the Internet, which can simply be seen as a global network between Personal Computers,- we send messages and complete documents to the other side of the world. It is not necessary to wait for weeks until contracts, libretti or designs sent by post, have been received by the right people and answered. In the digital world, the same people can see the texts on their own screens within a few minutes. If an art dealer wants to examine a new painting by his/her favourite artist, it can be seen on the artist's personal website. By using PC-cameras the two people can communicate with each other and can make arrangements on line without wasting time. New and unorthodox agencies of young Internet-entrepreneurs offer theatre tickets at much reduced rates and create a competitive advantage compared with the traditional ticket agencies on the corners of the central city squares. Their most urgent question is not how they will sell tickets but how fast their digital services can be tomorrow.

As we saw in the second paragraph, the digital revolution has its own artists: *the e-xpressionists* as Nicolas Negroponte has named them.[44] These artists combine artistic talent with technology and create art on the Internet, which the visitor will transform according to his or her personal situation.

In case we still have lingering doubts about the true impact of the digital revolution, we should look at our education system. The real experts are our own pupils and students who are deeply involved with digitization from childhood. They develop their skills not with the help of a manual, but *learning by playing*. This technological culture is increasingly an integral part of society as a whole. At the start of the third millennium, it is the predominant issue.

Box 1.21 *Digital Game Zone: dead or alive?*
The multimedia industry has created its own unguided missiles: electronic gameplays. These games ask the young user to play criminal and antisocial roles against groups and individuals. As a member of a criminal gang with many enemies, including the corrupt police in your neighbourhood, you will win extra bonus shares if you kill people and steal cars. Artificial Intelligence creates a virtual world in which the user believes s/he is a real member of a real gang community (*smart game character*), supported by Motion Capture Technology and Neural Net Intelligence. In the words of a commentator: 'The story line is non-linear, you can corrode what you want'. <www.vatical.com>

1.4.2. A periodical framework

The digital revolution can be characterized by means of four more or less significant periods with technology as the driving factor. This is illustrated in figure 1.16 and explained below. In this periodical framework, when a product is developed is not relevant. What is relevant however is the use of ICT inventions in society on a large scale.[45] Knowing the history of the digital revolution can help us to understand the situation in which the art manager needs to function and to predict future developments.

Figure 1.16 Periodical framework of the (pre) digital revolution

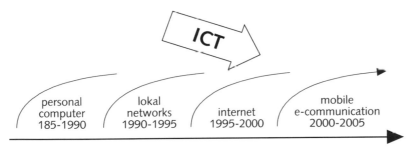

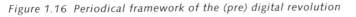

1985-1990: The Personal Computer (PC)
During this period the appetite for the acquisition of a digital machine that helps individuals privately and, in an organizational context, with writing and accounting, cannot be satisfied. The American computer company Apple plays an important role by producing a user-friendly computer (Macintosh) that helps the user by showing on the screen what has to be done <www.apple.com>. Apple also influences the way graphic designers and visual artists deal with new digital technology. An old Science Fiction idea is developed: Virtual Reality, an imaginary world where the spectator is surrounded by

digital sound and images. In this period, the development of software, i.e. computer programs that enable the user to work with the hardware PC, has assumed enormous proportions.

1990-1995: Local digital networks
The next phase is to combine different computers and their programmes. Local networks with several options are created within organizations. We can make a difference between one-sided and two-sided systems. In an one-sided system within an organization, the user can only use the computer for operational reasons, e.g. to print tickets at the box office. In more integrated systems the user can communicate with colleagues within the (network)organization by sending and receiving organizational and functional messages. Another example is the digital Bulletin Board with which organizations and their employees can send and read information on line with the help of a telephone. The software is increasingly dominated by one American enterprise, Microsoft <www.microsoft.com>, which innovates and increases the personal scope. The consequence is that with the integrated, or multimedia use of the computer, text can be supplied with drawings, graphics and images, and distributed to millions of other users. Management Information Systems (MIS) are used by managers within their decision making processes.

In this phase, it is no longer important to know where computers are made. PCs can be built all over the world, a notable contribution originating from Asian firms.

Finally, flexibility, mobility and miniaturization are cornerstones of technological developments. The products are: laptop PC's, organizers, notebooks and mobile phones. Another booming development is the attractiveness of electronic games.
In 1995 the electronic games industry had a worldwide turnover of $ 15 billion (EURO 13.6 billion).[46]

1995-2000: The Internet Phenomenon
We described the Internet earlier as a worldwide network between Personal Computers. A computer, special software and a telephone, cable or satellite connection is needed to communicate, to send e(lectronic) mail and to find information via what is called a *World Wide Web* (www). In the business sector a lot of products and services are developed, which we call E-commerce. The use of the Internet indicates that we have a so-called New Economy where ICT opportunities and fast growing Internet firms cause a steady economic growth.

In the cultural sector we have, e.g. E-publishers, E-galleries and E-theatre tickets agencies, as well as the traditional products of the websites of museums, theatre halls, theatre groups, etc. The Internet phenomenon integrates the TV and the PC resulting in a multimedia communication machine, including CD-ROM, CD-writer and digital camera, which bring home entertainment at any time and place the user wants. A key word is interactivity: the user, visitor or spectator can really communicate with digital neighbours, and is therefore able to influence communication with his/her own information, sound and images. Another aspect is that the individualized entertainment options also have their own profitable equivalent: pay-per-view, video on demand, etc.

2000-2005: E-communication culture
At the start of the third Millennium, communication between people and organizations with the help of their networks will mainly be digital. The Internet, or Electronic Highway, provides all sorts of services with the private home as the starting point. All the materials and machines are ingenious and ICT oriented; sensors will translate personal signals into preferences for shopping, entertainment, news and information. Digital Assistants or Interface Agents, programmed in the PC, supervise the information flow and the selection procedures. These digital workers take care of the news you need, for example, order your food to suit the occasion and plan your leisure time.
Digital communities will replace the real communities but with one difference: these communities are global and not primarily limited by ethnic, cultural or other identities. Members of digital communities do not pay attention to differences between high art and mass culture, between producing and consuming, between non-profit or profit culture. What they enjoy is *artainment*. When people are on the road, they are fully equipped with digital communication means, which are interwoven with smart clothes and personal ornaments such as watches. Because of the combination of new technology and the need for new entertainment experiences, special space and deep-sea tours are increasingly possible. Tele and videoconferences and meetings are dominated by digital communication systems, which reduce analogue travelling. On-line learning and distance learning are important techniques of universities and other professional training centres. Passwords, e-cards and other methods are replaced by voice recognition as a means of identification. Connectivity is the key word in this world.

1.4.3 Critical issues

The digital revolution will transform the convenient cultural sector into a hybrid world of electronic multimedia, and subsequently an addiction to the Utopian digitization of culture. This will not help the art manager who is also responsible for a cultural infrastructure that provides cultural values from the past on the one hand, and non-digital cultural expression that is on the other.

Even if the art manager is a leader of a multimedia artists' group or the manager of an Internet firm, it is important to reflect on the context of his or her daily decisions about culture, technology and management.

The critical issues we wish to discuss now bring this context closer to art management. We translate the critical issues into two hypotheses as figure 1.17 shows.

Figure 1.17 Critical issues on the digital revolution

1. People living in the technological culture, ask for moments in which art and culture have pure expression. A theatre play or a symphony, played by real artists with a tangible location and a social atmosphere, will retain a special place in cultural life. Of course, the marketing of this event will be managed by so-called digital smart agents and the Internet and perhaps the real-life visitors will also be members of a digital community, though their focus is non-digital art. An extra argument to respect this pure expression is the creation of a real social-human event where people can meet each other and have their non-smart dinners. This will mean that the traditional theatre and concert halls have to cater for these social needs. Another consequence is that these cultural centres, which are mainly located in large city centres, can be anywhere as long as they are safe and easy to reach (by private or public transport). We can expect that the living cultural centres also have educational institutes where pupils and students are educated in non-digital instruments and in regional or folklore art.

2. In the media, the economically driven fusion of internationalization and ICT will result in there only being a few global players.[47] Mainly American media concentrations, e.g. Time Warner/America Online <www.warner.bros>, AT&T/Media One <www.att.com>, Viacom/CBS <www.cbs.com>, Disney Company <www.disney.com> and some European companies, e.g. Bertelsmann <www.bertelsmann.com> will globally dominate the information and entertainment sector with their daughter companies in the fields of ICT such as the Internet, new media, mobile communication, cable and satellite. For the cultural sector there is one real critical issue: the concentration of power. A few firms controlling the production of images, sound and expression with their emphasis on copyright can limit the autonomous position of artistic and creative workers. Another aspect is the threat to regional cultures. We discussed this aspect in the previous paragraphs under the title of multiculturalism.

Box 1.22 *Democracy and Cyberspace*
In Cyberspace Reflections, Herman E. van Bolhuis and Vicente Colom mention seven major concerns about the influence of ICT, multimedia and cyberspace on the established systems of democratic structures and representations.
The core issues of these concerns are:
1. Accessibility of Internet networks
2. The ability of every citizen to understand the Internet
3. The right to know which data is processed
4. Controlling the power of multimedia manipulation
5. The right to privacy
6. The prevention of social exclusion
7. The protection against software which sniffs around personal hard disks.
A problem in respecting democratic ideas in cyberspace is the terms 'public' and 'private'. In cyberspace freedom of speech and the expression of thought are important individual rights, but who will protect the society and its inhabitants against racism, discrimination and downright commercial manipulation?
Source: Herman E. BOLHUIS, Vicente COLOM, *Cyberspace Reflections*, European Commission, DG XII, Social Research Unit, 1995 <h.van-bolhuis@mhsg.cec.be>

Box 1.23 *Abolition of Copyrights?*
Joost Smiers, director of the Centre for Research at the Utrecht School of the Arts, stated that it is important to discuss the abolition of copyrights, which are now mainly in the hands of the transnational cultural conglomerates. In his eyes, this economic concentration of power and rights damages free artistic and cultural developments, on local and global level. In general, art and culture are not an expression of the individual genius artist but have their roots in the historical developments of culture. If (Western) conglomerates claim their collected copyrights for profit reasons, they hinder artists and developing countries in processing existing cultural expressions and creating new ones. One of the alternatives could be to establish a cultural fund, fed by tax from companies that use the expressions of artistic values for their own purpose. With the financial support of such a fund, artists and developing countries will be stimulated to contribute to free cultural living.
Source: Joost SMIERS, A Choice of no Choice for Artists and Third World Countries, in: *Iwalewa Forum*, 3/99, Bayreuth, 1999, pp. 5-38. See also Smiers' invitation to participate in a digital forum <www.hku.nl/cvo/forum/>.

1.4.4 Fallow Land: the digital position of a cultural organization

With the critical issues in mind, we can see that the art manager needs a way of evaluating the position of his or her cultural organization in the digital field for the coming years. The following elements need to be considered, as figure 1.18 shows.

Figure 1.18 Management model on Internet

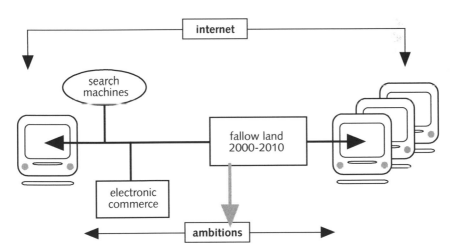

First, we start with the Internet. The whole process of this digital communication is part of our society. Sometimes an art manager thinks s/he can banish the digital revolution, because of the rich history of art and culture. As we have seen in this paragraph, this mainly defensive attitude is an *idée fixe*. A more positive and pro-active approach is

accepting the Internet and looking for a fruitful use of this new medium, e.g. to collect data and information about relevant subjects. If an art manager's knowledge of the Internet is underdeveloped, it may put his or her cultural organization in a vulnerable position. The second element is the digital quality of our organization. This issue has two levels: one, the quality of the equipment (hardware, integrated software, smart programs summarized by 'connectivity') and two, the quality of the staff's competence to innovate the digital communication. The third element is the relation with all sorts of Internet-networks: virtual communities, knowledge domains, links and digital communication squares. This element is highly self supporting, democratic and easy to maintain. The fourth element is the digital ambition of the cultural organizations. These ambitions are related to the measure of relevance of the Internet to the organization. Because of the dynamic character of the digital revolution, the cultural organization will recognize that these ambitions should be seen as "fallow land". What needs to be done within the next ten years?

If there is a very strong relevance, say level 5, which means that the digital revolution affects all the management functions (production, marketing, finance, personnel, R&D), the organization will have to fundamentally rethink its mechanics by designing a new scenario for the future. Because of a strong need of knowledge and experiences, is advisable to look for partners with an Internet background. If the relevance is very weak (e.g. level one), so that there is hardly any connection with the management functions, it will suffice for the organization to evaluate its position and keep its equipment and products in good repair. Figure 1.19 explains the different possibilities on a scale of 1 to 5.

Figure 1.19 Differences to Internet relevance

Level	Relevance	Action
1	Very weak - hardly any connections between the Internet and management functions (e.g. an amateur music group with social goals)	evaluate your position, pay attention to equipment
2	Weak - the Internet is used for a website and email (e.g. regional museum with a local focus)	as level 1, do research into future trends to prevent unwelcome surprises
3	Average - the Internet plays a modest role in the communication with the outside world (e.g. Theatre hall with E-communication via the Internet)	as level 2, formulate optional E-experiments to create a strong position
4	Strong - the Internet is essential for functioning at all levels (e.g. Ticket Agency)	integrate e-communication in the whole organization; check own E-competence
5	Very strong, the cultural organization cannot exist without the Internet (e.g. production of Internet Art)	Rethink the mission of the cultural organization, create a future scenario based on digital connectivity, work with Internet-oriented strategic networks

1.4.5 The Entertainment and Dream Society

In this chapter, we have discussed some basic knowledge of art management. We have added some dominant environmental aspects about globalization and digitization. What will be the future of the cultural sector, bearing all this information in mind?

Michael J. Wolf, a leading consultant to the world's top media and entertainment companies, predicts a worldwide entertainment economy[48] <wolf@entertainmenteconomy.com>. At the end of the 20th century in the United States and United Kingdom the volume of an entertainment sector dominated by the mass

media, was much larger than the steel or financial industry. This E-sector is not just *culture* but the driving wheel of the global economy. Every company wants to draw the attention of the consumer and the only way to do so is through multimedia entertainment. In this battle for consumer attention, the E(ntertainment) sector will provide the content: *There is no business without show business* with its ability to harness creativity. Wolf also sees that the current dominance of the American Moguls such as Disney Company and Warner Bros. is temporary. The E-industry of Bombay, Hong Kong and some European countries such as the United Kingdom and Italy will integrate on a worldwide basis.

Box 1.24 *Walt Disney Corporation dominates world leisure park market*
On the world list of theme parks the first five places are occupied by the American Walt Disney Corporation <www.disney.com> (based on yearly visitors):
1. Tokyo Disneyland (Japan): 17.459.000
2. Magic Kingdom (USA): 15.200.000
3. Disneyland Anaheim (USA): 13.450.000
4. Disneyland Paris (France): 12.500.000
5. Epcot (USA): 10.100.000
In Europe, Disneyland Paris (France) occupies the first place. In Wolf's eyes, the creative content is the key to Disney's success; the rest is business as usual.
Sources: NRC/HANDELSBLAD, February 5, 2000, WOLF (1999)

Rolf Jensen, director of *The Copenhagen Institute for Future Studies* <www.cifs.dk>, concludes that the Digital Information Society of the 20th century emphasized the value of academic learning and rational thinking: 'The logic of the knowledge society permeates our set of values.'[49] The purpose of this Information Society, with Bill Gates as an icon, is automation of all kinds of cerebral and sensory work, just as the Industrial Society with the Henry Ford icon did with manual labour. The consequence of this is that the Information Society, by definition, will abolish itself. After a few decades of the 21st century, a new society, *The Dream Society*, will come into existence. It is based on the post materialistic Story Scenario, in which people are geared to feelings, experiences and stories. *The Dream Society* appeals to stories concerning the following six market profiles:
1. Adventures
2. Togetherness, Friendship and Love
3. Care
4. Who -Am-I?
5. Peace of mind
6. Convictions
Because of the dominance of these sets of emotions, technological products and services of the Western world are as such no longer important. All consumer goods have to symbolize a story with which the consumer is able to identify. The core capacities of Dream organizations are creative thinking, aggressive decision making and fresh ideas. In this Dream Society, imagination - not information - is the core instrument of communication, both locally and globally – in other words *glocally*.

*No doubt, the creative organization in a digital environment will play a key role at the
start of the 21st century. This conclusion can take the art and cultural organization to a
position of advantage. In the next chapter, an integrated idea of strategic art
management for survival in a non-stop changing world will be discussed.
Strategy is the keyword to enrich this discussion.*

Practical exercises

1. Choose a gallery and find out its digital strategy. In which phase of the digital
 revolution does it operate?
2. Surf the Internet to try to find a new cultural Internet firm and describe its e-
 commerce. What can a traditional cultural organization learn from this new venture?
3. Interview the head of the Student Affairs Department of your college or university and
 formulate some rules for the protection of privacy within the digital practice. What is
 your opinion of this protection?

Closing case *A management game on Culture on the Electronic
Highway.* A management game for students of art and media
management
In the nineties just a few articles had been written on the relevance of the
Electronic Highway (the Internet) to the cultural sector. Generally speaking, no
art manager knew in practice how to deal with this new phenomenon. The staff
of the graduate programme art and media management of the *Utrecht School
of the Arts* <www.hku.nl> asked some media experts to help them to gain
insight into the specific relation between information and communication
technology (ICT) and the management of cultural organizations. The impact of
this support was that the staff decided to take this issue for the annual
management game. The aim of the management game is to strengthen the
strategic thinking of the students by learning-by-doing. During the course of the
game, which lasted three days (and sometimes nights), the students as strategic
teams were responsible for developing and implementing strategic options in
interaction with two or three other (cultural) organizations. Students in the final
phase of their study were the leaders of the teams. In total 20 students and
three staff members were involved. The whole game was supervised by an
alumnus who actually had a training firm.

Digital cities
In the mid-nineties, discussion (in Western European countries) focused on
digital cities. Digital cities are virtual places on the Internet with a website in
several locations. A digital city has an information square with a map, which
helps visitors to find their way to virtual locations where they can find texts,
images and links to other sites. These visitors are generally people with access to
a computer and a modem and a member of a specialized institute of higher
education. The digital city was designed by a group of volunteers with a strong

affinity with the new technology. In most cases, these groups had developed their ideas during visits to the USA where groups of volunteers are very active with this grassroots technology without dominant commercial firms.

The management game
One problem is that one cannot copy the real world in the classroom because of a lack of real experiences. Thus, a part of the game was to develop new strategic knowledge and skills. The game focused on a regional city (*Schenbag*) with a lot of cultural institutes and a university. Within this city, there were some initiatives to design a digital city. The core issue was who gets the support of the municipality. This local government has a vague idea that is important to have such a digital city but lacks the knowledge to start. At the start of the game, there were the following parties:
1. The city of Schenbag with two sub-parties: the department of Cultural Affairs and of Economic Affairs,
2. The local educational institutes,
3. An international grass roots publisher,
4. A platform of cultural organizations including artists runs organizations.
The city of Schenbag invited the other parties to develop strategic business plans based on the idea that a democratic digital city had to be created with an open access and as a result of cooperation between the commercial and the non-commercial world to finance the investments. With these business plans on the table, the game got its dynamic level: missions were redefined, coalitions started and were broken, and artists' groups played a central role or were marginalized.

The learning results
Students (and staff) learned that strong positions of established organizations, e.g. the international publisher, were threatened by new coalitions. The defensive publisher did not want to invest or cooperate in the new digital area because of the idea that the Internet was just another hype and strategically unimportant. Another significant point was that the cultural institutes were dominated by the innovations of artistic leaders and this position disappeared very fast the moment these leaders changed their positions: the digital mentality was only present at a personal level and not in the company as a whole. As one of the results of the game, students formulated some topics that were important for directing cultural organizations towards the scope of the Internet. That was very new to the cultural sector at the time (1995). These topics mainly focused on marketing issues: to inform the audience with the help of websites, to react via email, etc.

Reflection
Staff and students were very enthusiastic about the way the management game helped them to find new art management practices. However now (2000) we can say that we missed some important developments: the commercialization of the Internet, interactive e-commerce, and the global integration of ICT and 'content'. We still thought that the Internet would develop upwards as a

democratic infrastructure that supports the cultural sector in gathering and distributing information, and that the art manager would have to be alert, especially in the marketing field.

A few years later we deepened our experience by taking the subject e-commerce in the cultural sector. Then we started the management game with different cultural organizations with a view to developing a business plan for a dot.com of an American and European alliance. Here we learned that thinking in traditional disciplines such as theatre, music and visual arts is very problematic because e-commerce in the cultural sector is mainly focused on new ways of networking, ticketing, packaging, and producing new digital art.

The appreciation of the students was always very high because they experienced the dynamic pleasure of cultural strategic and communication processes.

We also found that our management games stimulated staff and students to be pro-active in their educational strategy and to create new digital projects in close contact with the cultural sector (web design, digital communication projects such as *Digit@l The@tre F@ctory*, thesis-research).

Case Questions

1. In the mid-nineties (in Western European countries), a lot of people and institutions thought that the government was finally able to control the development of Internet and the so-called digital cities. This is now referred to as the misunderstanding of the digital revolution. Can you explain it?
2. In the management game, groups of artists played an active role. What could be a specific contribution of these groups to their coalition partners in the digital age?
3. Artistic leaders (again) held a dominant position during the negotiations and decisions. How can a cultural organization emphasize the benefits and avoid the weak aspects of such positions in the framework of digitization of culture?

Source: Giep HAGOORT, *Cultuur op de electronische snelweg - een strategisch management game*, in: *Vakblad Management Kunst & Cultuur, Amsterdam*, 1995-2 (This text was also presented by Ad Huijsmans at the ENCATC meeting, May 2000). Thanks to Willem Wester, supervisor of the management games of the *Utrecht School of the Arts*.

1 Daniel BOORSTIN, *The Creators, a History of Heroes of the Imagination,* Random House, New York, 1992, Giep HAGOORT, *Strategische Dialoog in de Kunstensector, interactieve strategievorming in een kunstorganisatie,* Eburon, Delft, 1998; Arnold HAUSER, *Sozialgeschichte der Kunst und Literatur,* Verlag C.H. Beck, München (Dutch version, 1975).

2 Ricky W. GRIFFIN, *Management* (sixth ed.), Houghton Mifflin Company, Boston, 1999; D. KEUNING, D.J. EPPINK, *Management & Organisatie: Theorie en Toepassing,* Stenfert Kroese, Houten, 1996; Alfred KIESER, Herbert KUBICEK, *Organisation,* Walter de Gruyter, Berlin, 1983.

3 Giep HAGOORT, *Kunst en management,* Research paper, Utrecht School of the Arts, 1999.

4 Patricia C. PITCHER, *The Drama of Leadership,* John Wiley & Son, New York, 1997.

5 See also for interesting approaches and illustrations: Pierre GUILLET DE MONTHOUX, *Estétique du management, Gestion du beau en du sublime de Kant à Gadamer,* L'Harmattan, Paris, 1998; Terry SULYMKO, Business is the Best Art, in: *AIMAC Proceedings '99,* Helsinki School of Economics and Business Administration, Helsinki, 1999.

6 Michael E. PORTER, *On Competition,* Harvard Business School Press, Boston, 1998.

7 Henry MINTZBERG, *Mintzberg on Management,* The Free Press, New York, 1989.

8 KEUNING, EPPINK (1996), pp. 28-31.

9 See for this discussion: Jo CAUST, Is the audience more important than the arts? in: *AIMAC'99,* pp. 15-22; Graeme EVANS, The arts organisation: Managing change or changing the management?, in: *AIMAC'99,* pp.42-52; Annukka JYRÄMÄ, Johanna MOISANDER, Knowledge and Expertise in the contemporary art markets, in: *AIMAC'99,* pp. 74-82; Michihiro WATANABE, Arts management and dilemmas in cultural policy, in: *AIMAC'99,* pp. 483-495.

10 HAGOORT (1998), p. 19.

11 Paul DIMAGGIO, *Managers of the Arts,* Washington, 1988, p.18.

12 Paola BECK, *The arts & Culture Management Programme in South Africa,* Conference paper Arts Centre Management Training, Johannesburg, 1999; Paula CLANCY, *Managing the Cultural Sector, Essential Competences for managers in arts, culture and heritage in Ireland,* Oak Tree Press, Dublin, 1994; Giep HAGOORT, Joost SMIERS, *In dienst van de gekte, bevindingen over twee jaar onderwijs in kunstmanagement,* (Centrum voor Kunstmanagement), Utrecht, 1986; Susumu KOBAYASHI, Toshie YAMAZAKI, Survey on the status quo of arts management training in Japan: training conditions from the participants'perspective, in: *AIMAC'99,* Helsinki, 1999; Ritva MITCHELL, Rod FISCHER, *Professional managers for the arts and culture? The training of cultural administrators and arts managers in Europe, trends and perspectives,* Circle/Council of Europe, The Arts Council of Finland, 1992; Hermann RAUHE, Kulturmanagement als management fur Kunst und Kultur, in: *Kulturmanagement, Theorie und Praxis einer professionellen Kunst,* Walter de Gruyter, Berlin, 1994; Michihiro WATANABE, Arts Management and dilemmas in cultural policy, in: *AIMAC'99,* Helsinki, 1999; Brann J. WRY, The relation between education and practice in arts management in the U.S.A., in : *Workdocument Arts Management; escaping from the bounds,* Utrecht School of the Arts, 1990.

13 Among other periodicals we used ARTS BUSINESS, the magazine for arts professionals, Cambridge <www.arts-buisiness.co.uk>

14 HAGOORT (1998), chapter 5.

15 HAGOORT (1998). Originally the popular values were mentioned in Cultural Entrepreneurship, chapter 1 and the more serious in my Ph.D. report, chapter 4.

16 Klaus MANN, *Mephisto, Roman einer Karriere,* Verlag Ellermann, München, 1976.

17 See note 1.

18 HAGOORT (1992), par. 2.4, MARY CLOAKE, Management, The Arts and Innovation, in: *From Maestro to Manager* (1997), pp 271-295, see also note 1, the examples were described in my Ph.D. research.

19 Jean-Francois LYOTARD, Defining the postmodern, in: *The cultural Studies Reader*, Routledge, London, 1993.

20 Nicholas NEGROPONTE, *Being digital*, Coronet Books, London, 1995.

21 Charles TAYLOR, *Multiculturalisme*, Boom, Amsterdam/Meppel, 1995. ROTTERDAMSE KUNSTSTICHTING, MED URBS VIE, Rotterdam, 1993. UNESCO, *Our Creative Diversity:* Report of the World Commission on Culture and Development, Paris, 1996.

22 Nelly van der GEEST, *Starting points for intercultural education*, Utrecht School of the Arts, Centre for Intercultural Studies, Utrecht, 1999.

23 William J. BAUMOL, William G. BOWEN, *Performing Arts: The Economic Dilemma*, M.I.T. Press, Cambridge, 1981; Peter BENDIXEN, *Einführung in die Kultur- und Kunstökonomie*, Westdeutscher Verlag, Opladen/Wiesbaden, 1998; CAUST (AIMAC'99), pp. 15-22; James HEILBRUM, Charles M. GRAY, *The Economics of Art and Culture: An American Perspective*, Cambridge University Press, Cambridge, 1993; Arjo KLAMER, *The value of culture, On the relationship between economics and arts*, Amsterdam University Press, Amsterdam, 1995; Harold L. VOGEL, *Entertainment industry economics: A guide for financial analysis*, Cambridge University Press, Cambridge, 1993.

24 Pierre BOURDIEU, *Opstellen over smaak, habitus en het veldbegrip*, Van Gennep, Amsterdam, 1989, pp. 120-141; Pierre BOURDIEU, *The Field of Cultural Production*, Polity Press, Cambridge, 1993.

25 E. BOEKMAN, *Overheid en kunst in Nederland*, Bijleveld Utrecht, S.a; COUNCIL OF EUROPE: *European Programme of National Cultural Policy Reviews*; Milton C. CUMMINGS and Richard S, KATZ, *The Patron State: Government and the Arts in Europe, North America and Japan*, Oxford University Press, New York, 1987, MINISTERIE VAN ONDERWIJS, CULTUUR EN WETENSCHAPPEN, Cultural Policy in the Netherlands, Sdu, the Hague 1998; Joost SMIERS, *Rough Weather. essays on the Social and Cultural Conditions for the Arts in Europe in the 1990s*, Utrecht School of the Arts, 1995; UNESCO (1996); Joyce ZEMANS, Archie KLEINGARTNER (ed.), *Comparing Cultural Policy, A Study of Japan and the United States*, Altamira Press, Walnut Creek, 1999.

26 See also. WATANABE (AIMAC'99), pp. 483-495.

27 Margaret A. BODEN, *The creative mind*, Little, Brown and Company, London, 1990; Edward de BONO, *Lateral thinking for management*, Penguin books, London, 1971; Sybren POLET, *De creatieve factor: Kleine kritiek der creatieve (on)rede*, Wereldbibliotheek, Amsterdam, 1993.

28 GRIFFIN (1999), pp. 472-474; J.B.R. GASPERSZ, *De creatieve organisatie*, Nyenrode University, Breukelen, 1999.

29 Truus BRONKHORST, Truus Bronkhorst tells Bronkhorst Truus, in: *Theaterschrift* 3, Brussels, 1993.

30 Jan HULSKER, '*Dagboek van Van Gogh*, Meulenhoff, Amsterdam, 1970.

31 See note 1.

32 Ron GROVER, *The Disney Touch: How a Sharing Management Team Revived an Entertainment Empire*, Business One Irwin, Homewood, 1991.

33 Frank ZAPPA, Peter OCCHIOGROSSO, The Real Frank Zappa Book, Poseidon Press, 1989.

34 Manuel CASTELLS, *End of the Millennium, The information age: economy, society and culture*, Volume III, Blackwell Publishers, Malden, 1998; SMIERS (1995), Joost SMIERS, Marieke van SCHIJNDEL, *Ruimte aan verscheidenheid, Kunst en kunstonderwijs in lokaal en mondiaal perspectief*, Utrecht School of the Arts, 1999;

35 GRIFFIN (1999), pp. 132-165.

36 See also: Carl Arthur SOLBERG, Kultex – Export promotion of culture products from Norway, in: *AIMAC'99*, Helsinki, 1999.

37 Michael E. PORTER, *The competitive advantage of nations*, MacMillan Press, Hampshire, 1990, p. 71.

38 BOEKMANSTICHTING, *Trading Culture, Vatt, European cultural policies and the transatlantic market*, Boekman foundation, Amsterdam, 1996.

39 Abram de SWAAN, *Perron Nederland* (Alles is in beginsel overal), Meulenhof, Amsterdam, 1991, NATIONAL GEOGRAPHIC SOCIETY, *Global Culture*, Vol. 196, No 2, August 1999, Washington, 1999.

40 UNESCO (1996).

41 NEGROPONTE (1995); Don TAPSCOT, T*he Digital Economy: Promise and Peril in the Age of Networked Intelligence*, The McGraw-Hill Companies, 1996; Manuel CASTELLS, *The rise of the network society, the information age: economy, society and culture*, Volume 1, Blackwell Publishers, Malden, 1996; Ben TIGGELAAR, *Internet Strategie, Concurrentievoordeel in de digitale economie, theorie & praktijk,* Addison Wesley, Amsterdam, 1999.

42 NEW YORK TIMES, April 18, 1999.

43 NEGROPONTE (1995), pp. 219-226.

44 Another aspect is the generalization of the framework. As we all know the digital revolution is dominated by the USA. It has its own periods, which are a few years earlier than shown in figure 1.16. Giep HAGOORT, *Bericht aan de digitale onderklasse*, HvU Press, Culemborg, 1996. See also: CASTELLS (1996), chapter 1.

45 NEGROPONTE (1995), p. 82.

46 UNESCO (1996).

47 Michael J. WOLF, *The Entertainment Economy, how mega-media forces are transforming our lives*, Random Houde, New York, 1999. See also: B. Joseph PINE II, James H. GILMORE, *The Experience Economy, Work is theatre & every business a stage*, Harvard Business School Press, Boston, 1999.

48 Rolf JENSEN, *The Dream Society, how the coming shift from information to imagination will transform our business,* McGraw-Hill, New York, 1999.

Context

Iago is looking for an opportunity to disparage Othello. The ancient knows that Othello has just secretly married the beautiful Desdemona, senator Brabantio's daughter. Iago suggests to Roderigo, who had intended to marry Desdemona himself, to warn Brabantio that the Moor, in the words of Iago and Rodrigo a 'thick-lip', 'black ram', 'lascivious Moor', 'wheeling stranger', had stolen his daughter. Uproar ensues and Iago disappears to supposedly inform Othello of the senator's anger. Brabantio wants to go to the Senate with a complaint about the abduction of his daughter. Othello explains to Iago that there is nothing to fear because of his love for Desdemona.

Let him do his spite:
My services which I have done the signiory
Shall out-tongue his complaints. 'Tis yet to know,
Which when I know that boasting is an honour
I shall promulgate, I fetch my life and being
From men of royal siege, and my demerits
May speak unbonneted to as proud a fortune
As this that I have reach'd; for know, Iago,
But that I love the gentle Desdemona,
I would not my unhoused free condition
Put into circumscription and confine
For the sea's worth.

(ACT I,2)

2 Strategy formation in the cultural sector

2.1 See how the land lies[1]

Learning questions

- What is the main contribution of strategic management to an organization?
- Describe the current situation on strategic art management.
- Why is it important to do research in the field of developing strategies?

Key words

strategy	non-economic values	context
strategic formation	planning process	content
strategic management	creative process	process
underdeveloped strategies	Dutch research results	

Opening incident: *The Fox' bed of the Dogon People*

If the Dogon People, who live in a region of Mali, West Africa want to know what the future holds, intend to travel for a long time, etc., they consult a Fox' bed with the help of a fortune-teller. This person, of a certain age, prepares a piece of ground just outside the village and divides it into small squares. Within these squares, he lays out the question or problem by designing marks and symbols using small pieces of wood and little heaps of sand. The next step is to spread peanuts all over the squares. The following morning, the fortune-teller looks to see

whether a fox has taken the peanuts and what tracks it has left. By

analyzing these tracks, the fortune-teller can formulate statements about

his client's plans. He also gives advice on how to deal with unpredictable

situations and unexpected developments and whether a sacrifice is

necessary. The fortune-teller's knowledge of the village community and

his long experience of life are central to his advice.

Source: Afrika Museum, Berg en Dal, The Netherlands <www.afrikamuseum.nl>

2.1.1 Strategic management

Strategy is direction - that is what we indicated in the first chapter. Strategic management, the term given to the whole specialized area, is the process of tuning the organization to its external environment and developing competences and abilities to keep this process functioning at a professional level. Strategy formation as a core issue of strategic management, is the process of developing a direction and realizing this direction. The main contribution of strategic management is to keep the mission alive and to enable the organization to realize its future. The three strategic levels are shown in figure 2.1.

Figure 2.1 Three strategic levels

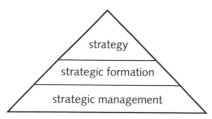

In our 21st century, strategic management has a scientific approach with its own methodology and instruments. In this paragraph we will discuss the main points of strategic management and examine the current stage of development within the cultural sector.

The concept of strategic thinking has a military origin. In the classical Greek metropoles, one of the magistrates was elected strategist (*strategoi*) and held the position of commander.

Rather popular among modern strategic thinkers is Carl von Clausewitz' standard book On War (1780-1813). This Prussian member of the military developed the idea that moral and psychological aspects have to be processed in formulating goals. In his eyes, the strategic success factors are dominated not only by formulae but usually also by personal competences. As we saw in the previous chapter the artistic entrepreneurs such

as Suger who lived in the Middle Ages, the Renaissance artists Leonardo da Vinci, Shakespeare, Rubens and the 20th century entrepreneur Walt Disney were strategists as well. Therefore, because of these prominent predecessors, the real question is not why we should develop a professional strategic art management, but how.

The birthplace of current strategic theory is located at the American business schools (MBAs). Its objective is the systematic research of the position of the organization in its external environment. Nowadays contributions to this specialized area come from all over the world with particular contributions from Canada, Western Europe and Japan.

Box 2.1 *Strategic Management: which researchers were consulted in the cultural sector?*
At the end of the twentieth century, mainly American literature on strategic management was a booming business. The need for ideas as to how organizations can develop a sustainable direction in a turbulent environment and create a profitable future position seemed to be insatiable. In the research papers of AIMAC'99 (International conference on arts & cultural management) this literature was only given a modest airing. The following writers on strategic management were consulted more than once in the section Management of Culture:
Mintzberg: ••••
Hamel and Prahalad: •••
Pettigrew: •••
Handy: ••
Porter: ••
Source: AIMAC *Proceedings '99*, Helsinki School of Economics and Business Administration, Helsinki, 1999.

2.1.2 The current situation

The current situation regarding professional strategic management in the cultural sector can be considered as underdeveloped, in both theory and practice. It is mainly in American publications on the non-profit art organization, that strategic management is seen as formal, often traditional in the sense of a bureaucratic planning process as formulated for the big industrial firms. Based on this approach, strategic management is worked out as a systematic operation with a strategic plan as a result, at least on paper. In this context the approaches are never or only occasionally compared to each other, which means that there is no common frame of reference that explicitly takes into account the specific characteristics of strategy formation within a cultural organization. Practice is mainly presented by means of 'examples' that emphasize the unstructured process of strategic management. Little attention is given to the connection between individual experiences and generally accepted theories about strategic management and strategic processes.

The first attempt to describe the specific nature of strategic planning in the cultural sector came in 1993 when Benjamin M. Bank and Valerie B. Morris published a research paper on the strategic process in five non-profit art organizations.[2]

This research showed that in general, art organizations have no structurally developed strategic practice, their missions were not externally oriented and the strategies did not

focus on a cultural position in their environment. A few of the art organizations published a strategic plan but did not verify or evaluate their strategies. In *Le Management des Entreprises Artistiques et Culturelles*, edited by Yves Evrard of the French HEC and published in 1993, strategic management is based on Porter's economic models.[3] Because of the non-economic value of art and culture the book asks us to take into account some typical characteristics such as the short duration of cultural production, the uncertain position of artistic leaders, the demand nature of cultural production and the tension between the tastes of the audiences and the artistic development of the artist. Because of these characteristics, general (economic) strategic methods that are useful for strategic thinking need to be bent a little towards cultural organizations. In 1995 Jeanette Wetterström reported on a case study of the Royal Opera in Stockholm, Sweden, in which as Porter, she reflected on the economic-quantitative methods of strategy formation with its rational production of goods and services with reference to the artistic working methods of a performing art organization.[4]

She noticed that it is important to consider some qualitative factors such as the aesthetic experience of the audiences, artistic coordination of creative processes, and the relation between individuals and groups within the production process and critical judgement. These factors, mainly internally oriented, need to be processed if a cultural organization is to develop its strategy.[5]

Another researcher on strategic management, Stephen B. Preece, published a paper in 1999, based on the *Miles and Snow typology* translated to the performing art world. This typology has three possible strategic basic positions: Defender (keeping a well-known market position), Prospector (having a strong innovative position) and Analyzer (a position between the first two ones). If the position of a cultural organization is unclear, the position can be defined as that of Reactor, which is not really a position of choice. In his translation of the model to the performing art organization Preece points out four variables to be measured in a chosen position: Reputation, Resources, Authority and Autonomy. At the end of his paper, he mentions another important 'variable': the mission of a cultural organization. Preece presents no empirical data to test the valuable impact of the adapted Miles and Snow typology.[6]

Arts Planning, a Dynamic Balance, written and published by Nello McDaniel and George Thorn in 1997, can be seen as a critical assessment of the planning process in American (non-profit) art organizations.[7]

This mainly qualitative evaluation shows that the planning process is dominated by board members and is focused on getting a grant. This planning is ritualistic and has become 'the aspirin of the arts'. It has barely any relation to the artistic activities for which the professional art leadership is responsible. The problem of this planning process is that its model suggests that it can predict the future and that this future can be managed by detailed plans, goals and activities. In reality, the artistic activities of the organization have little to do with planning practice. In the writers' view, the strategic process has to be conceptualized as a creative process based on circles: 'This process is a unique combination of vision, creativity, intuition, and collaboration offset by craft, technique, accountability, discipline, and use of time and resources.' They believe that this process should be central to the planning process and can bring stability, based on a dynamic balance between external and internal factors. Figure 2.2 illustrates this idea.

Figure 2.2 McDaniels'/Thorn's Planning Circles

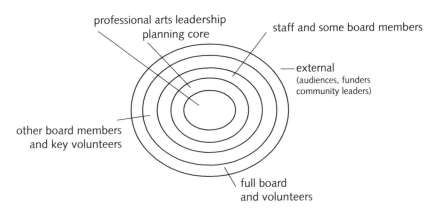

2.1.3 Some Dutch research experiences[8]

As a result of research and training activities at the Utrecht School of the Arts, we can formulate some general conclusions about the way that art managers develop their strategies in their own organizations. These conclusions can be summarized as figure 2.3 shows.

Figure 2.3 Research results on strategic management in the cultural sector

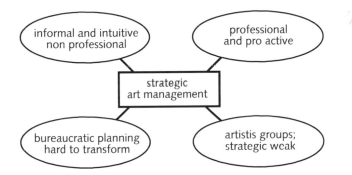

- Art managers with a lot of artistic work experience do not use a methodological framework to develop their strategic management. The strategy formation process is an intuitive and informal activity with limited participation of the employees. One of the consequences is a defensive attitude when the art manager is confronted by structural trends such as digitization, internationalization, privatization or multiculturalism.
- Art managers, mainly with a cultural and management background, who systematically apply the strategic management concepts, create a special position for their art organization with advantages in the fields of innovation, location, sponsoring and marketing. These organizations also have a more flexible structure, create strategic alliances and have a pro-active learning culture.

- Artists groups without managers in their organization show a strongly flexible and creative way of working at an operational level (productions, projects, activities) but need support at an organizational (management functions) and strategic level. Because of the lack of quality on these two levels, keeping the organization of the groups going is time consuming. The specific circumstances that concern strategy processes in artists groups will be discussed in § 2.5.4.
- Art managers who were confronted with unexpected turbulent changes of the environment such as the decline of the Russian Soviet System and heavy cuts in art subsidies in the Western societies, kept their (bureaucratic) experienced albeit not pro-active approach to organizational issues for a long period of time.
 Because of the need for theoretical and practical information on how to develop entrepreneurial strategies within cultural organizations, we launched a more fundamental research project on strategy formation processes in 1993. Much of this chapter is based on this research, including the action research oriented case study about *Toneelgroep* (Theatre Group) Amsterdam (TGA).[9] <www.tga.nl>
 As mentioned earlier a full report on this case can be found in the Appendix.

2.1.4 Elaboration

In the next paragraph (2.2), we will discuss the need for and purpose of a cultural mission. As we will see, this mission is the substantial fundament of strategic management. Paragraph 2.3 deals with the idea that it is important to find out how strategies are formulated: Top-Down, Bottom-Up or Interactive. The process dimensions of strategy formation are dealt with in paragraph 2.4. These dimensions make it possible to design a unique strategy for a cultural organization. Paragraph 2.5 discusses the project form as a practical way of formulating and realizing strategies. Implementation is a key word to this approach. In the final paragraph (2.6), the accent will lie on strategic management as change management in a turbulent environment. The approach in this chapter is based on Andrew Pettigrew's analytical framework with its three dimensions Context, Content and Process as illustrated in figure 2.4.

Figure 2.4 Analytical framework

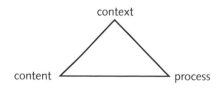

context

content process

The contextual dimension has two aspects, internal and external. The internal context deals with structure, organizational culture and strategic performance. The external context mainly contains competitive and environmental factors that may influence the strategic decisions. These decisions are the core issue of the Content which focuses on mission (cultural values, beliefs) and more concrete cultural goals. The Process dimension shows the way strategies and strategic goals are formulated and implemented.

Practical exercises

1. Take three totally different organizations from within or outside the cultural sector. Try to find out whether these organizations have a formulated strategy and who formulated it.

2. Discuss with the director of the local art museum the quality of the strategy. How important is the art manager's own environment to this strategy?
 Suppose an artists group wants to know more about strategy formation. Which three important issues do you mention to them?

Closing case *A new museum director*

Situation 1: Staff meeting

Alfons: The last four weeks, our staff has discussed more than a hundred times the need for a new director to take our museum to a higher level.

Ron: What do you mean 'to a higher level?

Alfons: Sorry, I did not want to dismiss our work...

Zirry: But you did. The words 'to a higher level' are yours.

Alfons: Let me explain what I mean. Last week one item dominated our session: what should be the profile of our new director? As we all know, we had many problems with Gilbert and we were very happy with his announcement that he was leaving our museum. In my opinion, he was a friendly and honest man but lacked a lot of managerial...

Zirry: Please let's not talk about management again. We are here for the quality of the collection and the creation of interesting exhibitions. That's not management, that's culture.

Ron: Oh Zirry, you know that is nonsense. If we want to organize fine cultural projects, someone will have to support us practically and find extra money to finance the catalogues.

Alfons: Please let me finish. To me it is important that this museum is led by a competent director. A competent director is a person who tries to put the museum on the cultural agenda, enables the city council to enjoy our exhibitions, and stimulates the audience to visit us. It is also important that he...

Zirry: or she

Ron: I think the most important thing is that the new director will create a professional environment so that we can do our jobs. It is absolutely unacceptable that we have to call in all kinds of volunteers to help us. The director should be responsible for the personnel and we have to concentrate on the quality of the collection.

Zirry: You can blame Gilbert for the adverse situation but in fact he was a real expert of the 18th and 19th century and talking with that man about the uniqueness of our own paintings was a wonderful experience.

Alfons: I agree that Gilbert was a real expert but as a director, one has to have more qualities. You are also responsible for the quality of the museum's organization and its future.

Situation 2: Board meeting

Chairman: Good evening ladies and gentlemen.

Welcome to our board meeting. The agenda has one important issue: the vacant position of the directorship. The second issue is a confidential memo from the city council about subsidy.

Let us discuss the problems with the director. As I informed you earlier by letter, it has been agreed that Mr. G. Young should leave the organization. The financial consequences have been set out in the appendix. The most important reasons for asking him to leave were the serious financial and personnel problems of the restoration studios. We discovered that the director really had no idea about the background and circumstances, nor how to solve the problems.

Thesaurier: If we want to find a new man...

Member: ...Or a woman

Thesaurier: Of course, I have no problems with that! In seeking a replacement, we have to remember that we cannot pay such a high salary and that the new director will have to agree to a lower amount.

Member: Sorry, but that's not a good idea. Our museum needs a high standard candidate with a strong cultural and managerial background. We cannot accept a person from the country. He or she has to appeal to a specific network. A candidate of that sort is only to be found in the big cities or abroad.

Secretary: If we want to sketch a profile, we will have to emphasize that the new director must have sponsor relations. With our current subsidy and income which is still 20 % of our budget, we need a more entrepreneurial person.

Member: You forget the cultural aspects of this function.

Chairman: Please, let our secretary finish her statement.

Member: I just want to point out that a museum director is not a manager like the manager of a corner shop. The most important thing is to appoint a person with a cultural vision. The management of the museum is more the task of the museum staff, and our board will control that.

Chairman: Do you agree that the new director should be able to develop a strategic plan for the future of the museum? Our previous plan dates back 10 years.

Thesaurier: Mr Chairman, as you know I have to leave now but I want make one remark about the City Council's confidential memo. I think the Council is blackmailing our Board with the cut in subsidy. I propose that we ignore this memo, give priority to appointing a new director and develop a new strategic plan, as the Chairman suggested.

All: Agreed!

MEMO (CONFIDENTIAL)

To: Museum Board

From: City Council

Subject: Reduction of subsidy/investigation

Dear Sir, Madam,

As the City Council has informed your museum, the Council is dissatisfied with the way you are trying to stimulate young people and immigrant groups to visit your exhibitions. We wish to remind you that this issue was discussed with your director one year ago. Since then, you have produced a lot of paperwork, but the real figures speak for themselves. Last year the number of visitors declined and just a few members of ethnic groups attended. Because the desired results have not been forthcoming, the City Council has no option but to reduce the museum's annual subsidy of EURO 1.5 million by 15 %. A formal letter to this effect will be sent within a few weeks.

The Council also wishes to inform you that some Council members have argued that it is desirable to have an independent body investigate the management processes at your museum. The Council intends to discuss this item with a delegation of your board.

Yours faithfully,

City Council

Case Questions

1. Examine whether the two parties share the same idea about the new director. Why do you think people have different opinions? Try to explain. What has to be done to find a solution?
2. Who emphasizes the strategic role of the new director more accurately: the staff or the board?
3. Try to formulate a competence profile (see figure 4.18 for a model) for the new director. What are your ideas about the balance between cultural ideas and economic possibilities within the framework of this case?
4. Do you agree with Thesaurier's proposal to ignore the City Council's memo?

2.2 A cultural mission

Learning questions
• What is the mission of a cultural organization?
• What do some management researchers say about the mission?
• What are the practical steps towards formulating a cultural mission?

Key words

mission
sense of direction
cultural values
mission statement
vision

social goals
discipline
missionary organization
fundamental purpose
not a slogan or a motto

behaviour pattern
acceptance

Opening incident: *Frank Zappa's vision and mission*

Composer, musician, theatremaker, songwriter, conductor, pop guitarist,

art manager, team player and above all satirist, the Italian-American

Frank Zappa (1941-1993) was all of the above. Zappa combined his

creative life as an artist, with a critical attitude to the strongly commercial

societal values, which he called hypocritical. Zappa's writings targeted

spuriousness and insincerity, not only at the top end of society but in all

places and all sorts of communities, black and white, rich and poor,

winners and losers, male and female. He managed his firm as an artistic

entrepreneur in his own studio with the help of a small (family) team.

Here, vision (looking to the future) and mission ('why we are here') can

hardly be separated. The most powerful explanation of Zappa's

vision/mission can be found in :

THING-FISCH

 'Fo y'all departs, I jes' wish to say in conclusium,

as matters o'dis gravity gen'rally require some

type o'philosomical post-scription, dat what y'all

have witnessed head tonight were a TRUE STORY-

only de names o' de poptatoes have been changed

to protect de innocent.

GALOOT CO-LOG-NUH! DON't BUY IT, PEOPLES!

Dis have been a public service ernouncemint.

Wave good-night to de white folks, 'DEWLLAI'

RHONDA: This is SYMBOLISM, HARRY!

HARRY:not the stuff 'Freckless' lets out!

RHONDA: THIS IS SYMBOLISM! Really Modern, Harry,

HARRY: Take your hand off that chain, honey!

(curtain, the end).

When Zappa died in 1993, the firm's creative production machine

came to an end. The mission of the new firm (The Zappa Family Trust)

is rooted in the artistic heritage by reproduction and exploring

copyright and loyalties.

Source of the texts: THING-FISCH, Album notes by Frank Zappa (1984).<www.zappa.com>

2.2.1 A cultural mission is necessary

The mission of an organization tells us about the overall reason of why this organization has the right to exist.[10] It is a fundamental reason with an internal impact on employees, volunteers and board members, and an external impact on clients, financiers, etc. Permanent changes in the environment, the growing complexity of the management process, and the need to give expression to the cultural, social and economic values in which the organization believes, demand such a mission. Goals, structures, regulations and schedules are useful instruments, but they do not provide the art managers with a model on which they can base their frequent decision making activities. However, a

mission also has an impact in non decision-making processes such as *Sun & Fun* in the organization, motivating people to achieve optimal performances and displaying a keenness for carrying out both routine manual work and intricate strategy work. A main characteristic of the mission is that it gives a sense of direction to the people involved, at all levels of the internal and external environment of the organization. The mission is the *alpha & omega* of the strategic processes of an organization.

To a cultural organization with a strong normative culture, the mission is an important gauge of its performance. The mission can combine cultural values, see paragraph 1.2 about cultural tracks, and organizational beliefs. In order to communicate about the overall purpose, organizations formulate their missions in a mission statement. A mission statement can be written in a few sentences but it is also possible that the mission statement consists of some paragraphs.

Box 2.2 *Mission Statement Utrecht School of the Arts*
'Art can best be experienced, practiced, studied and produced in a stimulating and innovative environment. This is what the Utrecht School of the Arts provides. The School offers a wide range of courses which train talented, motivated students to become artists, teachers, musicians, designers, art and media managers, writers and actors. Besides first-degree courses and internationally acknowledged Master of Arts courses, the School also offers foundation courses, post graduate courses and contract education. In artistic and didactic terms, the School is both traditional and innovative in its approach. As well as the traditional ways of practicing art and acquiring skills, experimentation, research and the innovation of art and technology form the cornerstones of the education programmes. The School stimulates students to learn at an individual level. Students work in ateliers and studios, where they are supervised by lecturers and tutors. Students and lecturers have the opportunity of exploring new horizons within their own area of discipline. The School stimulates this by means of projects, teamwork and interdisciplinary education. The School contributes to the cultural life of Utrecht and the surrounding area. The School attracts foreign students and lecturers. Students also have the opportunity to spend part of their time studying abroad. The quality of education meets international quality standards. The School guarantees that graduates possess the qualities needed to pursue a professional career.'
Source: UTRECHT SCHOOL OF THE ARTS, Strategic Documents, 1999. <www.hku.nl>

A mission differs from a vision. A vision is the artist or manager's personal view of the organization's future position. In this respect, the personal vision and the organizational mission are basic instruments of strategic thinking. A vision-in-motion and a mission-as-fundamental-monument are however, not one and the same.

2.2.2 Several views

Igor Ansoff, the Russian-born American founding father of strategic management, takes the view that a mission has to express not only the economic goals but also the social.[11] To Ansoff, this mission is a list of aspirations that the organization, in agreement with the stakeholders, wants to pursue. Having formulated these aspirations the management has to translate them into goals that in turn dominate organizational behaviour.

The American chief-guru Peter F. Drucker takes the non-profit sector as a mirror for the business sector in dealing with missions. In his eyes, this profit-driven sector can learn a lot from the non-profit sector where missions lead to action-oriented strategies and bring discipline to an organization. If an organization functions without a mission, Drucker foresees a dispersion of activities.[12]

Henry Mintzberg, a prominent Canadian researcher of strategic management processes, sees a mission as something to create.[13] To Mintzberg, a mission only has a chance of success in a value-oriented organization. Entrepreneurs of young and dynamic organizations have such a mission, but the typical Missionary Organization which is fully dominated by ideology, also has a system of values and beliefs that distinguishes the organization from others.

2.2.3 Practical tips

Andrew Campbell and Kiran Tawadey carried out research on a few hundred mission statements.[14] Based on their results they suggest some tips for formulating a clear mission statement. To realize a mission, four main questions have to be answered.
1. What is the fundamental purpose of the organization, what is its justification?
2. Which economic rationale will be realized?
3. What are the beliefs within the organization?
4. Which patterns of personal behaviour are expected?

A mission statement, with its diverse forms, is not an organizational slogan (e.g. *We are the best*) or a promotional motto (e.g. *Let's make things better*). Furthermore, it takes time to find the right words and to formulate the cohesion of the words in order to establish an optimal mission statement. If a cultural organization wishes to have a clear cultural mission or needs the current mission to be reformulated, this process can take more than one session in the strategic process.

Box 2.3 *Mission statements, some examples*
- Our gallery wants a policy which is directed at discovering and facilitating the discovery of visual art in all its modes of expressions, with quality and integrity as the common denominator
- The mission of our dance group is presenting significant national and international developments in dance and contributing to their development, thereby crossing geographical and disciplinary borders
- Our black theatre is dedicated to the support of a professional theatre company, the presentation of works that dramatize and enrich the Black experience, and the development of a broad based audience
- To perform classic, contemporary, and cutting-edge dance with virtuosity, energy, and artistic excellence to local, domestic and international audiences (...) to challenge, educate, entertain and thereby enrich our audiences
- To present in an attractive setting artistic festival events of excellence and diversity; to provide a unique opportunity to advance the professional capabilities of gifted, young performers; to promote actively the appreciation of the performing arts among all the

people of the (...) area; and to provide and maintain an inviting and comfortable setting for performers and patrons.

Sources: HAGOORT (1993); Philip KOTLER, Joanne SCHEFF, *Standing Room Only, Strategies for Marketing the Performing Arts,* Harvard Business School Press, Boston, 1997, p. 53.

Finally, we would like to give some practical suggestions for realizing an optimal mission of a cultural organization as indicated in this paragraph.

- A cultural mission statement has to be valuable, unique and recognizable. If there is another organization that has or may have the same mission, the statement cannot give a sense of direction. The first step of the formulating process can be to mention key words of the mission rather than trying to formulate the final version in the initial stage.
- A cultural mission is inspiring, internally to the employees and board members and externally to the financiers, audiences and spectators. A cultural organization without an inspiring mission is nothing more than a technical construction.
- A cultural mission is a little abstract and philosophical and has a perspective of more than five years. Objectives and goals are geared to concrete situations with a time span of 3 to 4 years.
- A cultural mission states the financial purpose: profit or non-profit.
- A cultural mission specifies the main target groups and formulates the relationship between the organization and its external environment.
- A cultural mission stipulates the behaviour pattern within an organization. Each employee should know what is expected of him or her. The cultural mission offers a framework for artists and other professionals to share the same values.

To realize a mission statement successfully, its acceptance within the organization will require special consideration. In general, strategic management is the responsibility of the top management of an organization. This does not imply that the involvement of the other parts of the organization with the formulating process has to be limited to this top level. As we will see in the next paragraphs, the acceptance of strategic decisions will be stimulated within a participative organizational atmosphere. Ideas about these methods of strategy formation will be discussed in the following paragraph.

Practical exercises

1. Visit a gallery in your region and look at its building, programme, staff and website. Formulate a cultural mission according to your impression. Ask the marketing manager to comment on this mission. Discuss the results.
2. Philips, the Dutch electronics company says: 'Let's make things better'. Find out if this sentence can be a part of a mission statement.
 Explain how it is possible that a mission can be attractive to totally different groups such as financiers and employees.

● 2.3 An interactive approach

Learning questions
- Which forms does a traditional strategic process have?
- What is the meaning of interactivity?
- What are the ten schools of thought on strategic management and which are important for the cultural sector?

Key words

annual planning	top-down and bottom-up
programming	cross-section
ad hoc development	the internet
interactivity	ten schools
grass roots strategies	configuration school

Opening incident: *Artists opinions about strategic projects*

At the beginning of each strategic process, we ask artists to give their opinions about the strategic project that will be executed within their organization. Four reactions are reproduced here.

- I have no experience with strategic processes. It is quite strange but as an actor, you have your role and the meetings with the artistic leader and that's all. I really do not know what is going on behind that. But I want to join the strategic group as I am very curious as to what will happen. What can we do with our creativity? I think it is necessary to target the media; we have to co-produce with the broadcasting organizations. That will be our new market.

- I heard of your project but was very sceptical about whether strategic management models can be applied in an orchestra organization. Each music season has its own character and plans are too predictable. The scheduling of well-known singers is already a terrible job. On the other

hand, I have comments on our organization: we have insufficient contact with society, we are too close and not open to newcomers. If I look at our talented ensemble the strategic project cannot fail but we have to develop our own process.

• Within the strategic project I want to look at our company very critically. This is the first time that we have made our strategy plan with a team of colleagues, so we have to learn how to do it. My expectations are very high, both artistically and on the business side. In fact, we should reconfirm our position as an independent modern art museum.

• I honestly do not believe in a joint strategic process. Usually the artistic leader makes the decisions and that is his or her responsibility. Throughout my career that is what I have emphasized. Artistic leader, please make your decisions, on the repertoire, on the roles we have to play, the way we have to do it and the places we have to appear. The rest is relatively unimportant to me. The administration has its own responsibility for arranging supporting activities and paying my salary.

2.3.1 The traditional process

If we research more extensively the way in which cultural organizations develop their strategies intuitively without processing professional and methodological possibilities, we can see the following three traditional patterns.[15]
1. Annual planning
2. Programming
3. Ad hoc development.

The annual planning approach is perhaps the best-known method of strategy-making practice in the cultural sector.[16] The main initiating party is the subsidizing government, locally, regionally or nationally, bank or fund which requires a budget and a plan on a yearly basis as a condition for financing the annual activities. This financier can also be a

private organization, e.g. bank or main sponsor. Plan and budget, two key documents in this approach, are the framework for translating the most important decisions in the management areas of production, marketing, personnel and accommodation. In general, the financier has a formal format that has to be used to formulate the annual plan and budget. A positive aspect of this kind of strategic planning is that the organization is forced to make its strategic goals explicit, even if these goals are only short term. Another advantage is that plan and budget stimulate professional development of the management functions such as production, marketing and finance. However, plan and budget are often a weak cast of the richness of the strategic ideas within a cultural organization that is dominated by the entrepreneurial attitude of cultural leaders. Because of the limits of the bureaucratic formats and the focus on finance, annual planning is not really a full strategic process about future ambitions. Planning also has a conservative effect. The yearly planning takes the existing situation as an example and adjusts the financial requests on the basis of this example. It is a method, which boils down to more of the same every year.

Programming, as another traditional way of strategy making, centralizes the cultural programme of an organization as a strategic document. We see this strategic practice within cultural organizations that are not as closely confined by the straitjackets of external bodies. In this case, the management of cultural organizations concentrates on its own activities and, in so far as those activities cannot be covered by private income, a financial contribution or subsidy is applied. To exaggerate slightly: the draft programme-booklet of the season is provided with an accompanying letter and a budget and sent off. Many art managers of flexible cultural festivals work this way. It creates the opportunity to react spontaneously and to adapt the programme to external circumstances. The management of cultural centres also uses more or less this kind of strategy making, often in combination with the yearly planning as mentioned earlier. Another division that uses the programming approach, is independent producers of film and theatre productions. Besides having their own small basic financing, these producers attempt to arrange the financing by means of contributions from banks, funds or authorities. If support for the programming, mainly presented as a project, is not forthcoming, the project-activities are then continued all the same, albeit in a strongly adapted form. In this situation, the non-profit organization is very similar to the profit production organization. The strength of the strategic programming is its simplicity and the need for a flexible, result-oriented mentality. A weak point of the programming approach is that constantly putting programme-activities first can interfere with a longer-term orientation. The strategic process is so obsessed with deadlines, premieres, production dates, etc. that it has little or no idea about strategic developments that affect the functioning of the organization in a structural way. The programming process is often characterized by a certain amount of capriciousness, where a lot is left to the concurrence of circumstances. Working out sub-strategies in areas such as marketing and personnel is often left undone.

The third traditional way is the ad hoc development, by far the most adventurous strategy approach. This process is characterized by spontaneous idea development. Ideas about activities are transformed into parts of plans that are occasionally directed at specific projects with societal or political motives such as emancipation, cultural minorities, education and internationalization. The attractive aspect of this strategic process is that it can lead to cultural productions even on a small scale. With the support

of a small number of dedicated sponsors (often in the form of limited facilities), a project-oriented organization is quickly able to position itself on the cultural market. The major disadvantage is that ad hoc development is rather unstable. The elements of this instability are: the chance of encountering a sponsor, receiving a once-only ad hoc subsidy and the constant uncertainty about being granted a welfare benefit. These three ways of traditional strategy making can also be seen as a practical life cycle process as illustrated in figure 2.5.

Figure 2.5 Life Cycle Process of traditional strategy making

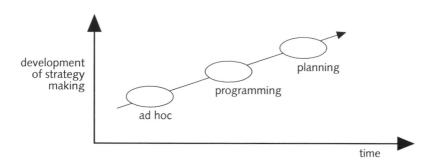

In this cycle, a new cultural initiative takes the form of a project with an ad hoc development of strategy making. After a period of time the strategic process becomes more focused on a complete programme of activities. As the practice of programming is increasingly being implemented, the traditional strategy process may be dominated by external authorities that are able to introduce a more bureaucratic planning approach with plans and budgets.

2.3.2 Interactivity

The three strategic processes outlined here are mainly related to a poorly structured method. As we have seen, these processes have some weak points through which strategy formation remains at an underdeveloped professional level. One of the weakest points of the traditional processes is the purely incidental use of ideas and experiences within the organization. Especially in the situation of programming and planning of established cultural organizations, the strategy process is mainly dominated by the top of the organization with neither motivation nor structured input on the part of the employees and operational staff members. The informal organizational culture has hardly any influence on this one-sided practice. The lack of participation within what we call the Top-Down approach has some negative consequences. First of all the cultural organization misses the knowledge which can be found with people throughout the organization such as groups of artists, technical studios, marketing departments, volunteers' committees. These people have a lot of ideas about how the organization deals with the needs of internal and external parties which can be used in the strategy formation process. A second negative consequence of the Top-Down approach is the minimal involvement of employees and volunteers in the strategic decisions that are

often aimed at changing the current position of the organization. Here, a strange paradox is that strategic decisions of change are the domain of the top management but the changes themselves have to be realized by several groups at the bottom of the organization. Theory and practice on implementation issues have shown that many strategic decisions about the future of organizations are not realized because of a lack of information and motivation.

Is the purely Bottom-Up approach the solution, i.e. that the strategic process starts at an operational level? The plans of the various employees and/or departments are listed and then merged into a single strategic plan at management level. This approach has one important aspect: people are strongly involved in the strategic decision-making process and are the owners of the new direction. However, a huge problem is that this kind of strategy making is very internally oriented and has an immutable respect for the position the organization has realized. In practice, we see that less attention is paid to new structural developments in the environment and that these developments are not processed in the strategy formation. These developments are often seen by top management, but in a Bottom-Up approach, this management has a more supporting role.

Box 2.4 *Mintzberg's Grass Roots Strategy*
An example of the Bottom-Up approach is the Grass Roots Model of Strategy Formation. Mintzberg describes this model as follows:
a. Strategies grow initially like weeds in a garden; they are not cultivated like tomatoes in a hot house.
b. These strategies can take root in all kinds of places, virtually anywhere people have the capacity to learn and the resources to support that capacity.
c. Such strategies become organizational when they become collective, i.e. when patterns proliferate to pervade the behaviour of the organization at large.
d. The processes of proliferation are not necessarily conscious; likewise, they are not necessarily managed.
e. New strategies, which may be emerging continuously, tend to pervade the organization during periods of change, which punctuate periods of more integrated continuity.
f. To manage this process is not to preconceive strategies but to recognize their emergence and intervene when appropriate.
This model is strongly connected with new, innovative organizations and is almost impossible to introduce into existing organizations. Nevertheless, it will help us re-think the traditional top-down planning practice as mentioned earlier.
Source: MINTZBERG (1989), pp. 214-216.

To conclude, neither the Top-Down, nor the Bottom-Up method is fully satisfactory. Figure 2.6 illustrates this conclusion.

Figure 2.6 Problems of the Top-Down and Bottom-Up methods

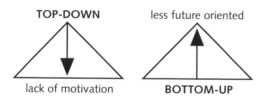

Can we find a way of working which compensates for the negative aspects of the two methods without losing the important contributions of the operational level and the impact of the top management with respect to the typical informal aspects of a cultural organization? The answer is: yes, by means of interactivity. The idea of interactive strategic approaches was worked out in the early nineties of the last century by Annemieke Roobeek, a Dutch professor on strategic management and complex transformation processes. She started strategic projects in the industrial area and elaborated with success the interactive concept also in the governmental area and the third sector (*Strategic Management, The Interactive Approach* – ISM).[17]

Interactivity means, in Annemieke Roobeek's eyes, that the strategic process emphasizes the necessity of a Democratic Dialogue within an organization about the explicit balancing of internal strategic themes and developments in society (this dialogue will be discussed in detail in § 2.5). The platform is formed by a strategic team of not more than 15 members which is called a Cross-Section. In this team, a general knowledge of the management and the management theory and specific, local knowledge of all the team participants provided the key to strategic problems. The cross-section mobilizes its members from operational and functional levels. The participation is based on the experiences and insight of the members and not on hierarchical positions, as shown in figure 2.7.

Figure 2.7 Interactive Cross-Section

In the appendix, the TGA Case Study is centred on this strategic process of interactivity. In the strategic Cross-Section of the Theatre group Amsterdam the following positions were represented: Board of Trustees, Board of Directors, actors, studios, staff and two researchers/supervisors. As we can see, this interactive strategic team has no traditional structure such as top, middle and operational management. The Cross-Section is responsible for formulating a strategy and an implementation plan taking into account the formal authority of the Board of Trustees. At the end of the process, this board has to translate the strategic choices into formal decisions. Because of the functional involvement of one or two trustees, it is just a formality. During the whole strategic

process, this team is also responsible for the communication with the internal and external parties involved. The interactive character of the process can easily be digitized with the help of ICT networks. The digital decades of the 21st century will enable interactivity to facilitate contact with all kinds of groups outside the organization and to form discussion groups about strategic choices the cultural organization should make.

Box 2.5 *Strategy formation on the Internet*
In 1998, the Utrecht School of the Arts wanted to transform its art and media management course into a more innovative educational programme with four specialized areas: art management, media management, cultural events and cultural services. The new programme should create more space for individual possibilities and collective teamwork for the students. The faculty formulated 10 statements about the strategic content of the new programme and sent them to 100 selected personal email addresses via the Internet. Within 24 hours (in a weekend!) 10 reactions came back with all kinds of suggestions and comments. These 10 reactions were again distributed via the Internet. Within one week, the faculty got 25 reactions that were very useful in positioning the new programme. Stimulated by the direct, spontaneous and interactive way of working, some people involved offered themselves as guest lecturers or members of external panels. After finishing the whole strategic plan, which was really based on the email messages, the *Art & Economy* course, received the support of the cultural sector and the Dutch Ministry of Education.
Source: UTRECHT SCHOOL OF THE ARTS, *Uit de kunst geregeld*, Utrecht, 1999.

2.3.3 Schools of Thought

Having explored some strategic-management issues and before we discuss the process dimensions of strategy formation in detail, it might be useful first to examine how the principles of strategic management are more generally perceived. For this purpose, we can use the differentiation of the ten schools of thought as outlined by Henry Mintzberg.[18]
These ten schools are:
1. The design school, based on the metaphor of architecture. Its most famous instrument is the SWOT analysis.
2. The planning school, oriented on a formal, detailed way of working. Keywords here are: Plans and budgets (represented by Ansoff).
3. The positioning school, driven by economic research and analytical choices. The most important issue is to profitably position the organization within a competitive industry (represented by Porter).
4. The entrepreneurial school, dominated by the visionary leadership of the entrepreneur. The strategy is to look for a specific niche in the market.
5. The cognitive school, which is a mental process. The strategy, including the vision, is formed by the limited thinking process of the manager.
6. The learning school, emphasizing learning by doing. This way of working is an emergent process with individual and collective results.
7. The political school, based on the interests of the groups involved inside and outside the organization. The strategy is a result of the negotiation process of conflicting parties.

8. The cultural school, driven by a collective pattern of values. This internal normative way of thinking and acting produces a missionary strategy aimed at the outside world.
9. The environmental school, which is a passive approach. The environment as leading party will push or pull the organization into a strategic position.
10. The configurational school, as a combination of all the preceding schools. Because each organization has its own history, configuration form and environment, the strategy of change is unique in the framework of time and place.

This difference in the way strategies are formed can help organizations in diagnosing and optimizing their own strategies. In general in the cultural sector with the accent on intuition and informal practices, aspects of the entrepreneurial, learning and cultural schools are strongly recognizable. As we saw at the start of this chapter the development of the American strategic practice in a more systematic way initially focused on the design and planning school. The professionalization of strategic practice in the cultural sector can be supported by using the configurational school (looking for an unique process) with the support of some core issues of the positioning school (finding an unique position in the cultural market). This configurational school is strongly connected with the organizational configurations that are also elaborated by Mintzberg.[19] These configurations are discussed in chapter 3 (§ 3.3).

Box 2.6 Strategy Paradoxes
With the different schools of thought in mind Bob de Wit and Ron Meyer, two Dutch researchers and authors of internationally recommended text books on strategic management, point out the paradoxes that influence both research and decision making processes on strategic management. These paradoxes - ten in total - create different definitions of strategy making. Both researcher and strategic manager should be aware of the impact of the paradoxes if s/he is to resolve the conflicting aspects to realize synthesis. In doing so, a strategist will in essence be creating a unique competitive advantage.
The ten paradoxes are:
1. Logic and Creativity: Strategic thinking
2. Deliberateness and Emergentness: Strategy formation
3. Revolution and Evaluation: Strategic change
4. Markets and Resources: Business level strategy
5. Responsiveness and Synergy: Corporate level strategy
6. Competition and Cooperation: Network level strategy
7. Compliance and Choice: The industry context
8. Control and Chaos: The organizational context
9. Globalization and Localization: The international context
10. Profitability and Responsibility: Organizational purpose.
Sources: Bob de WIT, Ron MEYER, *Strategy, Process, Content, Context,* West Publishing Company, St Paul, 1994; Bob de WIT, Ron MEYER, *Strategy Synthesis, Resolving strategy paradoxes to create competitive advantages,* Int. Thomson Business Press, London, 1999.

Practical Exercises

1. Interview a management consultant and find out his or her impression of the quality of strategic management in the cultural sector. Try to figure out which quality criteria are implemented.
2. Take the strategic plans of some cultural organizations. Are these plans the results of an interactive approach? In which way do the plans explain the working method?
3. Go to the library and chose some books on strategic management. Try to find out to which strategic school the writer belongs. Do they suggest any innovations of strategic management? Discuss the suggestions.

● 2.4 Strategic Process Dimensions

Learning questions

- Why is it important to have a Strategic Motive as the first step of the strategic process?
- What kind of process dimensions do we have within the strategic process?
- What are the outlines of a Strategy Plan and an Implementation Plan?

Key words

strategic motive	evaluation	benchmarking
process dimensions	portfolio matrix	value chain
strategic sketch and rhythm	environmental factors	quality management
situational factors	future trends	future direction
process architecture	scenarios	strategic plans
swot	reactive and proactive	implementation

Opening incident: *Rotterdam - Cultural Capital 2001*

The discussion took place on the back seat of a municipal limousine from Antwerp (Belgium) to Rotterdam in 1993. The minister of culture for Rotterdam and the city chief officer for cultural affairs talked about the idea of putting Rotterdam on the cultural agenda of the European Union to become Cultural Capital for one year. It was not an easy discussion because such an event demands over NLG 50 million (EURO 23 million) above the regular city budget and on a European level there are a lot of

other large cities with the same strategic ambition. The intention to become Cultural Capital of Europe was mentioned neither in the cultural policy documents of the city council, nor in the discussion in the Rotterdam cultural sector. Without the support of the local council members and the directors of the cultural institutes, the idea will not become reality - a grass roots strategy is needed, they conclude while approaching the Erasmus bridge over the Maas, the main river which connects the World Harbour Number 1 with the North Sea. Therefore, they started informal discussions with representatives of the main political party and with some opinion leaders in the cultural and business sectors. The idea was mentioned during local elections and finally the ambition was formulated in the Policy Document of the leading parties of the newly elected council. After this strategic milestone, the second had to be formulated: to get the support of the National government to influence the European bureaucracy. A budget was formed to promote this campaign. After some years of luck and some disappointments the joint ministers of culture of the European members decided to bestow the title of European Cultural Capital 2001 to two cities, both harbours: Rotterdam of the Netherlands and Oporto of Portugal. That was in 1998. Under the motto 'Rotterdam is many cities', a period of preparation could begin <www.rotterdam01.nl>.

Source: UTRECHT SCHOOL OF THE ARTS, Educational documents of MA AMMEC, 1999/00.
Thanks to Kees Weeda, City of Rotterdam.

2.4.1 Strategic Motive

In the strategy formulating process, which can be classified as Top-Down, Bottom-Up and Interactive, and influenced by elements of the ten schools of thought, we can distinguish six general key-process dimensions. Based on these six dimensions - all connected with the mission statement - the strategy or direction of an organization can be developed (or discovered, e.g. in the environmental or political school) more concretely. More simply, these dimensions can also be seen as six steps. The beauty of this approach lies in its flexibility. Although the first step must always be the *Strategic Motive*, the subsequent steps with the exception of the last, may be taken in any order, as long as they are all completed.

The *Strategic Motive* makes two things possible:
1. To identify in a short period of time all the core issues which make it important to develop a new strategy,
2. To design a project in which the other five process dimensions can be executed.

The Strategic Motive, which is unknown in the general strategic management books,[20] is absolutely essential because of the tendency of cultural organizations to be informal and small-scale. The Strategic Motive means that at the very beginning of the strategic process all relevant elements must be identified. These elements concern the existence and functioning of the cultural organization, including the quality of the cultural tracks as discussed in § 1.2. All these elements are mentioned in box 2.7.

Box 2.7 *Checklist Strategic Motive*
Strategic Sketch:
- formal reasons for developing a new strategy
- spontaneous strategic patterns
- hidden strategic agendas
- sustainable mission/competitive position
- nature of reaction of leadership to turbulence
- impact of cultural tracks such as artistic leadership, creative processes
- unwritten new strategic options
Strategic Rhythm:
- learning experiences
- timing of the process
- resistance/quality of the organizational culture
- role of strategic schools
Situational Factors:
- nature and size of the organization
- position in the Life Cycle
- profit or non-profit end
Process Architecture:
- matching sense of urgency with process planning
- project approach
(result: an Initiative Project document)

This Strategic Motive tries to tackle the black box character of the strategic process as discussed in many strategic management publications. Based on a general method the experience was that the process in practice was an opaque event. It was, for example, unclear what the influence of the organizational development was on the strategic decision-making process. Moreover, what should we do with a SWOT analysis when new, unexpected developments arise during the formulating process? So, the Strategic Motive is an important instrument for clarifying the main issues and openly formulating the strategic agenda. The second aspect of the Strategic Motive is to make clear what the process will be. Because of the relevant information collected during the Strategic Motive, we can design the other process dimensions in a concrete step by step approach. Once the Strategic Motive has been implemented as the first step, we can use a standard model like that of figure 2.8, to realize the following steps:

2. Evaluation of the activities (what is our strategic profile?)
3. Environmental Research (what are the most relevant external trends?)
4. Option Formulation (what are the alternatives for the future position?)
5. Strong/Weak analysis (what are the strong and weak points of the organizations, what are our competences?)
6. Strategic and implementation plan (what are our strategic choices and how can we implement them?).

Figure 2.8 Six Process Dimensions

1 strategic motive. 2 evaluation. 3 environmental research. 4 option formulation.
5 s/w-analysis. 6 new plan/implementation.

In this process, the cultural tracks (§ 1.2) play an important role. Some process dimensions as mentioned here demand special attention to particular cultural values. The Strategic Motive is connected with the quality of Artistic Leadership (§ 1.2.8). During the Evaluation, you need to check the relationship with the Historical Analysis (§ 1.2.2). Multicultural Context (§ 1.2.4) and the Common Interest (§ 1.2.6) are important to the Environmental Research. Focusing on the Option Formulation, the cultural track of Cultural Innovations (§ 1.2.3) plays a key role. If a SWOT analysis is put on the agenda, the quality of the artistic and creative processes (§ 1.2.7) are a significant aspect of research. During the sixth and final dimension, all relevant cultural tracks can influence the strategic choices and their implementation. As will be illustrated in the TGA-case study (appendix), the Strategic Motive will also influence the sequence of the steps. Based on the information collected, it will be clear in which order steps 2, 3, 4 and 5 have to be taken to create a process that fits the concrete circumstances. Suppose an organization has a few strong strategic options in mind and that the involved people really want to talk about it. It is advisable to start with dimension 4 after the Strategic Motive, instead of step 2 (Evaluation). If, during the Strategic Motive, the strategic team

strongly feels that the most important move is to research environmental trends on account of a lack of knowledge, the process can proceed directly with the research (step 3) after the Strategic Motive.

This flexible design process has to guarantee that all the steps will to be taken, because all these steps are essential dimensions with their own contribution to strategy formation.

Box 2.8 *SWOT analysis*
SWOT is an acronym of Strengths, Weaknesses, Opportunities and Threats. In general, SWOT analysis, an essential instrument of the design school, is the best known instrument of strategic management and combines internal factors and external factors. Within the mission of the organization, strategic choices are based on the exploitation of opportunities and strengths while the threats are neutralized and the weaknesses avoided. The popularity of this instrument is its simplicity: the relevant core factors have to be examined as a single frame of reference, as the example of a regional theatre shows here.
Strong
- Motivated staff
- Sponsors

Weak
- No marketing strategy
- No innovation on programming

Opportunities
- More leisure time
- Increased income of the audience

Threats
- Multimedia home videos
- A new theatre in the neighbourhood.

This SWOT analysis makes clear that in this case the theatre organization has to develop a strategic plan for renewing its performance and to create a strong marketing strategy for interesting performances. The problem with SWOT analysis is that it deals with the current situation. The environment becomes increasingly complex and dynamic and in these circumstances, the strategic choices have more to do with vision and future than with past and present. However, for pedagogical reasons or in more stable and simple environments a SWOT analysis can be useful.
More about the SWOT analysis: HAGOORT (1998).

In the Strategic Motive dimension, interactivity with its open dialogue (see the last paragraph) will be put into practice. This tailor-made approach to the strategic process has more chance of success in realizing strategic results than the Top-Down or solely Bottom-Up approaches. Finally, it is important that the organization should be aware of the limitations that stand in the way of the development of a strategic plan. These limitations can occur at three levels:
a. Financial limitations: large organizations have more financial potential for research than small ones. In general, the possibilities are very limited in the cultural sector. Some Board members can voluntarily help to supervise the process.

b. Organizational limitations: if the organization is in deep financial crisis, mission and continuity are in real danger, and it will be virtually impossible to develop a strategic process. Here, radical crisis management intervention is called for.[21]

c. Qualitative limitations: Do the management and employees have the required capacities and skills to develop strategic management? If not the organization needs to be supervised by external consultants.

The organizational form of the strategic process is a project form as the checklist at the end shows. We will discuss this form of organization in § 2.5.

2.4.2 Evaluation

The Evaluation is intended to create insight into the effectivity of the current activities. We want to gain insight into:

- what has determined the success of the activities?
- why no success has followed?
- why planned activities were not carried out?
- why unplanned activities were carried out?

The result is a strategic profile that may beg the question of whether or not the existing strategy suits its environment. If the activities are successful and do suit the environment (see dimension 3) and the organization believes they will also be successful in the future, there is no so-called 'strategic gap'. There are some useful instruments to research this. One of them is the economically oriented Product Portfolio Matrix of the Boston Consulting Group. The method is based on an analysis of products using four typologies that work as follows.

Q.1 *about obscure activities* - 'question marks': what is the financial base of the activity; can we picture this activity in the future?

Q. 2 *about promising activities* - 'stars': will this activity lead, in the short term, to a financially healthy activity?

Q. 3 *about strongly profitable activities* - 'cash cows': how long will this activity be able to function as a cash cow?

Q. 4 *about strongly unprofitable activities* - 'bad dogs': when do we stop this activity?

In order to answer these questions effectively, we must know whether the activity is in a growth market because of the perspective of the decisions. It is also important to consider whether the market position of the particular activity is strong or weak. The answers have to lead to decisions that are to be taken in the final step 6 (New Strategy/Implementation). These decisions are: ditching, investing, innovating and abandoning. Figure 2.9 illustrates this Matrix.

Figure 2.9 Product Portfolio Matrix Activities

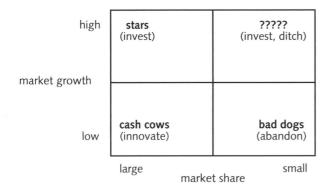

The Product Portfolio analysis is mainly economically oriented. In the cultural sector, it is important to combine cultural with economic arguments, as we did in § 1.2.5 (Cultural Credit). For example, bad dogs, i.e. poetry events with a small audience, may be financially written off but still of some value to the cultural organization in very specific situations and in relation to the mission. This value may be related to the cultural image of the organization, to the symbolism of the mission and/or to its characteristic appearance in the cultural market. On the other hand a cash cow, i.e. a well-known classic drama, may still be financially interesting but can steer the cultural organization towards a process of cultural stagnation. Which path is finally taken, depends on the one hand on the content of the cultural mission and on the other on the extent to which the organization must comply with its own income norms. Another instrument to evaluate one's strategic profile is the analysis of the Product-Market-Combination (PMC). In this approach, the cultural products or services are aimed at parts of the cultural market, e.g. youth theatre performances (product) and families with small children (market). All the activities of a cultural organization can be considered as a collection of core PMCs. In the Evaluation step, critical questions about quality and quantity of these core PMCs need to be answered. At the end of the Evaluation, conclusions have to be drawn about future steps. Which activities, or PMCs, will be continued and which will be stopped? The conclusions are contributions to the discussions in step 6 where we will end the strategic process with a strategic and implementation plan.

2.4.3 Environmental Research

As we have already seen, the orientation to the environment is characteristic of strategic management. The question is how this orientation should be set up. The environment is considered from the point of view of (the mission of) the organization, but then at a safe distance. One of the ways of securing this distance is to divide the environment into fields, and to chart these fields based on a few fixed, future oriented trends. In the cultural sector, we distinguish eight fields as figure 2.10 illustrates.

Figure 2.10 Eight fields of environmental research

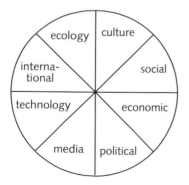

We research this because we wish to have insight into the trends that will influence the existence and/or functioning of the cultural organization or parts of it. By means of some key questions in each field, we can establish what kinds of issues we want to research.

Cultural

Which trends are there in the field of art and culture, which shifts can be observed, which influences are taking effect, what is the current cultural relation between art and entertainment, where does multiculturalism create new art practices?

Economic

Which financing channels present themselves, which developments are there as regards sponsoring, which coalitions have developed with industrial parties, which financing possibilities have developed between culture and the tourism industry, which venture capital groups are active?

Social

Which income fluctuations can be seen, which social groups assert themselves, do we see changes in the composition of the population, which changes occur in the area of social participation, are there any changes in the patterns of cultural consumption? What kind of influence do big cities have on daily life?

Technological

Which technological innovations affect the cultural sector, which position does technology assume in the cultural business, which Internet-products and services present themselves, what is the connectivity-impact of the digital revolution on my audience?

Media

Which public and commercial trends are arising between culture and the media, what influence is exerted on the cultural market, where do new relations lie, which trends can be seen in the viewing and listening behaviour, what kinds of media concentrations do we see?

International

Which international and global connections present themselves, what influence affects the relation between our country and other countries, is this influence significant to culture, can new economic areas such as MERCOSUR, NAFTA, GATT bring new opportunities to my cultural organization?

Political

Which changes are there to be seen in the political system, which movements are taking place between politics and culture, which power groups are asserting themselves, which changes do we see in the relation between the various administrative levels?

Ecological:

Which links do we see between nature and culture, between environment and art, which developments (or coalitions) can be observed in both fields?

It makes sense to classify the material as hard or soft. Hard facts describe situations based on statistical material, e.g. how many inhabitants will our city have in 2010?; soft facts refer to data from academic and professional dialogue.

The results of the environmental research should be considered as parts of one complex puzzle. Because of our need to foresee some structural trends we see combinations of issues which we can call development lines within the environment of the cultural organization. Based on our research of more than two hundred trends, five of these lines are evident at the start of the third millennium.[22]

1. Digitization of culture (see also § 1.4)
2. The existence of subcultures of nomad and elite groups
3. The growth of flexible, increasingly virtual financial networks ('rush-money')
4. The growing contrast between global multimedia and regional folklore
5. A growing cooperation between nature-activists and eco-artists.

Ansoff shows us that there is a relationship between developments in the environment ('turbulence') and the strategic management approach.[23] He distinguishes five levels of turbulence, from 1: stable, to 5: very surprising. In a repetitive environment, management can be focused on stabilization (level 1). When there are surprising factors, management needs to be very creative to find a strategic response (level 5). Ansoff's approach to the five levels is summarized in figure 2.11.

Figure 2.11 Ansoff's five levels of turbulence

Character turbulence	Management approach	Activity
1. Repetitive	Stabilization	Controlling
2. Organic Growth	Reactive	Production
3. Change	Anticipation	Marketing
4. Discontinuity	Entrepreneurial	Strategic acting
5. Surprise	Creativity	Flexible operations

Answering the question of how the turbulence can be qualified, Ansoff uses two sub-questions:

1. Is the changeability of products strong/weak,
2. Is the predictability of the future high or low?

If the relevant technology has an important influence on the two questions, e.g. a strong changeability and a low predictability, the organization is confronted by turbulence level 4 or 5. In this case the management approach has to be very creative and its production company very flexible.

In a research paper published in 1994, we came to the conclusion that in the Dutch cultural sector the turbulence level was between 3 and 4.[1] In other words, the cultural sector was confronted with changes but not with unpredictable surprises. The problem was that most of the art managers (in Western Europe) had a reactive attitude (see level 1 or 2) rather than one of anticipation or strategic entrepreneurship. This led to a management development programme to stimulate strategic thinking and strategic acting within cultural organizations.

If the environment of a cultural organization is very complex, the strategic team can use the scenario technique to formulate its strategy. This technique is useful for forming an impression of future situations from the perspective of the existing situation.[24]

It also helps in asking ourselves questions about which strategic measures ought to be taken in order to recognize certain future situations. Once we understand these scenarios (compare this with the scenario technique used in shooting films), we can then critically discuss, and if necessary adapt, certain parts of our present strategy. For the development of scenarios, one could start with a trend, a framework, a goal or a contrast. There are two conditions for the scenario technique: reliability - the data used must be correct: verifiability - the mode of operation must be consistent and easy to understand. For the development of strategy, it is important to contrast various scenarios. This will enable us to understand how there are various ways to reason back to the future. Besides the future images, it is also a question of elaborating on issues that must be dealt with in all the scenarios to be developed.

Box 2.9 *Three EU Scenarios*
To clarify the application of the scenario technique, let us take one example from the cultural field. The case in question is where the cultural/political emphasis will (have to) be put in the Europe of tomorrow. Will the cultural policy deviate from what we now see? What do cultural organizations have to take into consideration? This question is not easy to answer, because very little is known as yet about cultural politics at a European level, other than testing national regulations against the mainly economically-oriented treaty of the European Union (EU). By including a cultural paragraph, the EU countries have declared, however, that national governments are bound to their own cultural policy, but that this policy may not obstruct the development of a single European Community. The cultural institutes will have to develop their own idea of possible changes. To help them, three scenarios can be developed:
a. EU cultural policy concentrates on urban metropoles (EU Metropoles Scenario)
b. EU cultural policy concentrates on cultural and economic regions (EU Regions Scenario)
c. EU cultural policy concentrates on European top initiatives and top projects such as Cultural Capitals (EU-Top Scenario).
The fixed agenda points in the three scenarios should be: where is the emphasis in the EU cultural policy and what consequences do the future images have for the management of cultural organizations that focus on Europe? The results of scenario planning can be processed within the strategy formulating process.
Experience shows that this scenario-technique has some positive effects:
• the people involved become attentive to future developments;

- it breaks down taboos in the development of policy;
- it has a strong learning effect on the developers of scenarios (learning to think in terms of alternative images of the future);
- advocates and opponents come together in working out the pros and cons of a strategic option ;
- it works as an eye-opener for the compilation of the political agenda.

Up to now, the cultural sector has almost never worked with the scenario technique. This technique can still be a support to the strategic team in developing or strengthening strategic management. After all, by using the scenario technique, the identification of future, complex developments, becomes an integral part of management responsibility. Part of this responsibility is the reduction of uncertainties and the development of new options. There is, however, no way of guaranteeing that the scenario technique will lead to actual success.

2.4.4 Formulating Options

While the previous steps are still explicitly based on material (evaluations, analyses, and documents), when formulating options the persons involved are expected not to let themselves be restricted by preconditions, (rooted in) positions and prejudices. Options here are free choices for rich future opportunities. Options are especially characterized by something new and different. Bearing in mind the impressions from the first three stages with the unwritten options as mentioned in the Strategic Motive, this stage must ensure that the organization applies all inventiveness and creativity present to achieve completely new possibilities for the organization. Examples of such long-term options are: to create new art in connection with the Internet, to establish new avenues in new areas and to establish strategic alliances. It is a method of making the cultural organization aware that its status quo is not so much an applicable norm as a variable object.

Box 2.10 *Strategic Alliances*
In the cultural sector all kinds of cooperation forms are developed. Within a strategic approach, some forms of cooperation are more essential than others, according to three aims: co-optation, co-specialization and co-learning. Here the criteria are the long-term strategic focus and creating added value to the strategic partners (from the art and business world). So there are cooperations with a cultural-organizational content may lack a real strategic impact: co-programming, co-producing and co-financing of these operations. Strategic alliances are involved with the following issues:
• to develop or innovate a new series of cultural expressions and services
• to develop new competences
• to create chain activities to strengthen a position in the cultural market
• to form a network to establish new standards of quality (of products and processes)
• to develop a finance programme for the continuity of the organization.
All these strategic alliances can have a simple contract form in which the most important conditions are regulated. It is also possible that a strategic alliance has its own legal identity in the form of a joint venture with its own management structure.
Union organizations, mostly mentioned as networks of cultural or educational institutes,

can also be seen as strategic alliances. The purpose of these alliances is to present themselves to the political authority and to support each other with information and new knowledge. The development of network organizations will stimulate the growth of strategic alliances.

Sources: Yves L. DOZ, Gary HAMEL, *Alliances Advantage,* Harvard Business School Press, Boston, 1998, KOTLER, SCHEFF (1997).

Formulating options is not possible if a strongly politicized situation exists, where coalitions of interest groups develop to protect threatened management positions. In such situations, creativity does not get a chance. To stimulate this creativity, Gareth Morgan has suggested that we need self-made images and drawings based on metaphors, which reflect experiences and future ideas from all levels of the organization.[25]

These images break the mental and hierarchical obstacles within an organization which make it impossible to express its own ideas. What is more, this imagination can help employees unskilled in strategic thinking to use creativity to communicate their fundamental values on the future of the organization.

Strategic Options can also deal with the future position of the organization in the cultural market. Michel Porter has developed a method of analyzing this (competitive) position in comparison with the other positions.[26]

This (again economic) method discusses five competitive forces of which the results can be used to position the organization in the future. These five forces are (illustrated by examples of the cultural sector):

1. Threat of new Entrants (on the Internet it is very easy to communicate about e-cultural products and services)
2. Bargaining Power of Suppliers (famous and well-known artists have a strong position but the position of less known professional artists is very weak)
3. Bargaining Power of Buyers (an association of theatres can negotiate with production companies)
4. Threat of Substitute Products or Services (When we go to a theatre event, the substitutes are plentiful: sport, cinema, home entertainment, visiting friends)
5. Rivalry Among Existing Competitors (while one museum in the region has no competition, top museums in metropoles function in a highly competitive world). The five forces are shown in figure 2.12.

Figure 2.12 Five competitive forces

These analyses can stimulate strategic options that will give the cultural organization a strong position with respect to (in)dependencies, innovations and partnerships. C.K. Prahalad and Gary Hamel have criticized these kinds of approaches because strategic choices are mainly focused on current positions and SWOT analyses that have almost no strategic impact in the long term.[27]

These approaches also take the industry as a given situation, rather than one situation that can be changed by strategic options. The two researchers take another strategic focus by saying that strategic choices have to change the structure of the industry or create totally new industries in which the organization will have an intellectual leading position. Strategy formation is not about creating a balance between the organization and its environment but creating new environments and disturbing the balance of others. That is not to say that this 'strategic stretch' is important to all the cultural organizations. Prahalad and Hamel's approach is developed for organizations that already have a market leadership position. Generally speaking, the advantage of this approach is the way in which you can consider the future of the cultural sector and what kinds of future positions you wish to realize.

Once all the interesting options (in the sense of relevant to the organization and its strategy) have been surveyed, an order based on priorities may be regarded as a conclusion of this step. It may be noted that the Option Formulation step does not discuss internal options for (re)structuring the organization and/or (re)designing an organizational culture. These measures are the domain of the next step.

2.4.5 Strengths and Weaknesses (SW-) Analysis

The image that art managers and artists have of their organization can be rather different from the image that others may have. Employees and volunteers see their organization mainly has a place where operational activities such as performances, exhibitions and art lessons are carried out. In their view, the organization runs smoothly and successfully if the (standardized) procedures do not produce too many malfunctions and the material and immaterial rewards are good. Middle managers like the heads of the costume departments and coordinators of the marketing section, judge the organization particularly on the way in which the organization provides support in translating strategic ambitions into operation. The way in which the cultural organization takes the experiences and ideas of middle management into consideration also plays a role here. This group is also affected in its judgement by career development possibilities. Customers and participants judge the organization by the extent to which expectations (regarding products and services) are met and agreements fulfilled.

This brief indication provides sufficient evidence to state that an organization can be assessed on various points and from various perspectives. It is important to have a set of fixed criteria for this assessment, for example on the basis of:

- The management functions as such (programming, financing, marketing, personnel, R&D, etc.), or:
- The results of these functions in relation to strategic goals, or:
- The functioning of its coordination and labour division mechanism with respect to the strategic ambitions (see the key-elements in chapter 3), or:
- The quality of the core competences of the organization, or:
- The nature of the organizational culture (see § 3.5).

It is advisable to present the results of this analysis to an external panel to prevent incorrect images being used. These images can obscure the management's view of the reality of the organization.

A SW-analysis of a cultural organization can follow the research as indicated in this paragraph. To be really complete, we should also know the quality of the artistic and creative processes as mentioned in the sixth cultural track in § 1.2.7.

Box 2.11 *Benchmarking; Value Chain and Quality Management*
The SW analysis can be supported by benchmarking. Benchmarking is the process in which the organization makes clear its qualitative ambition to be better than its competitors. Comparison of key indicators is important in this process. Within this framework, we can use the Value Chain that has been developed by Michael Porter to create competitive advantage. This chain is a collection of activities to create products and services. Each activity has its own characteristic and can be measured - based on costs and added value - as a weak or strong element of the whole. Porter makes a distinction between primary and support activities. The five primary activities are: inbound logistics, operations, outbound logistics, marketing & sales and service. The four support activities are: infrastructure of the organization, Human Resource Management, Technology Development and Procurement.

Another instrument for benchmarking is to compare the elements of Quality Management (QM). Under the condition that the top of the organization supports QM, the four core issues of QM are:
1. The participation of the employees: do they contribute to Principles & Practice of quality of products and processes?
2. The quality of the materials: what standard is demanded and does the organization guarantee this standard?
3. Technology: is there a need for automation of the processes, does the organization have state of the art technology?
4. Methods: is the organization working most efficiently?
 Sources: GRIFFIN (1999), chapter 21; PORTER (1998).

By carrying out a SW-analysis, we hope to gather relevant information about whether we can start up new strategic positions and whether we can introduce improvements. Sometimes preconditions can be changed (accommodation, finances, personnel); in other cases we are dealing with non-programmable preconditions (climate, urban environment, national borders).

2.4.6 New Strategy and Implementation Plan

Based on the results from previous steps, the strategic team has an idea of which strategic conclusions and cultural values are of importance for future direction. This is a matter of strategy for both the near future and for the long term.

The previous steps provide us with:
a. a sense of urgency, based on the Strategic Motive;
b. an understanding of the extent to which the organization (successfully) carries out the primary tasks;

c. an understanding of the environment's influence on the organization and information about promising circumstances for the strategy of the organization;

d. an understanding of new, future oriented options, including the pros and cons these options have;

e. an understanding of the organization's strong and weak competences, with a view to filling in new strategic activities.

The new strategic choices now start to become clearer. A few of them will focus on the long term (more than 5 years), e.g. building of a new location, establishing a strategic alliance with foreign companies. Other choices are oriented on the primary production and programming processes. Besides the continuation of existing activities, final decisions are made about the cancellation of activities and initiation of new activities. The new strategy may also be to put out some internal, non-core activities such as bookkeeping, catering and cleaning because a specialized firm can do them for a lower price. The new core (or primary) activities in combination with the desired pre conditions of finance, marketing, personnel, R&D, etc. can now be formulated. When an organization formulates a new strategic plan, it is important to realize that the quality of the plan should be seen in the framework of the organizational Life Cycle as discussed in paragraph 1.1.2 (figure 1.5). The general rule we have seen said that the direction of the organization also depends on its phase: spontaneous strategies dominated by the founders at the beginning, and well structured strategies in the build out phase, may be followed by a re-orientation on strategy and structure.

If the organization is so large that it has several departments that are coordinated by headquarters, there are two levels of strategy: the 'Grand Strategy' for the whole organization and the decentralized strategies of the departments or divisions. This so-called division form will be met in paragraph 3.3. The Life Cycle will be discussed more deeply in paragraph 3.2.

Finally, the new Strategy Plan, in the form of a document including a general time schedule and budget, goes to the highest decision-making bodies for establishing formalized strategy decisions. The main criterion for such a formal decision is the question whether the formulated strategy makes the cultural organization more capable of being flexible and 'ready for the fray', which was one of the four criteria determining successful organizations (§ 1.1.2).

To realize the strategic decisions, the organization needs an Implementation plan. Both documents, the Strategy Plan and the Implementation Plan, will now be discussed.

A Strategy Plan should have the following outline:

1. Introduction of the organization; why a new mission and a new strategy are needed.

2. Positioning of the organization; what is the current profile?

3. Important trends in the environment; what will deeply influence the organization?

4. The future; what are the main strategic choices in a framework of cultural values, products and programmes in relation to (new) cultural audiences?

5. The consequences of the new strategy in the field of management processes, namely

a. Finance (budgets) e. Location

b. Personnel f. Digitization

c. Marketing g. R&D

d. Internationalization.

6. The desired organizational structure and culture.
7. The schedule and Implementation outline.

Box 2.12 *Basic management functions in the cultural sector, a checklist*

Production (annual budget:)

1. Activities, derived from a clear cultural mission
2. Programmes in a multicultural context (relation with marketing)
3. Balance between tradition and innovation
4. Co-production with artists groups on a *glocal* basis
5. Product Market Combinations (PMCs)

Programming (annual budget:)

1. Programming in a digital, glocal and multicultural context, derived from a clear mission
2. Co-programming and co-producing
3. Supporting activities (education, community programmes)
4. Communication with new audiences
5. Product Market Combinations (PMCs)

Finance (own income: sponsoring: funds: subsidy:)

1. Profit, non-profit or mixed form targets, as proposed in the cultural mission
2. An annual budget within a four-year plan
3. Co-financing and matching possibilities
4. Strategic price guidelines (relation artistic ambitions and financial possibilities)
5. Sponsoring strategy

Marketing/Communication (annual budget:)

1. Cultural market research, cultural portfolios
2. Audience development in a multicultural context
3. 5 x P (product, price, place, promotion, personnel)
4. Internal and external communication activities (with the help of the Internet)
5. Evaluation programmes

HRM: 5 x R (annual budget:)

1. Recruiting
2. Rewards
3. Responsibilities in a stimulating environment
4. Resources (space, time, money, etc.)
5. Relationships (interaction between creative and other professional people)

Location (annual budget:)

1. Comfortable space for artistic and creative processes
2. The cultural impact of the environment on the location
3. Safety and risk management
4. Stimulating atmosphere
5. Multifunctional and digitally equipped (arts and supporting activities)

Sources: Dick HENDRIKS, Grondslagen marketing in the cultural sector, in: *Handboek Management*

Kunst & Cultuur, Samsom Stafleu, Houten, 1990.; Archie KLEINGARTNER, The Five 'R's of Managing Creative Employees in the entertainment media, in: *Management development in a creative environment*, Utrecht School of the Arts, Utrecht, 1991; David A. DECENZO, Stephen P. Robbins, *Human Resource Management* (6th Ed.), John Wiley & Sons, New York, 1999.

In order to design a new optimum structure of the organization and stimulate a strong organizational culture it is necessary to know the key elements as discussed in chapter 3.

An Implementation Plan should have the following elements:
1. Artistic and cultural priorities with time scale;
2. Financial targets with time scale;
3. Responsibilities and tasks within the organization to realize priorities and targets;
4. Communication, both internally and externally, including the desired leadership style (see chapter 4);
5. Social agreement with rules about changing the job description and dismissal;
6. Training programme, focused on new knowledge, behaviour and capabilities;
7. The project organization of implementation, including time for feedback and evaluation.

In the next paragraph, we will see how strategies can be realized with the help of a project organization.

Sometimes if an organization is concentrated on the personal entrepreneurship of the owner in an initial phase, we do not use the concept of Strategy Plan but a Business Plan Model for the setting up of a new firm.

In this plan, the new entrepreneur needs to explain the following items.
0. Personal details and C.V.
1. What is the Strategic Motive and Business Philosophy (mission) of the new organization?
2. a. What are the key PMCs (Product Market Combinations), and b. how should they be marketed?
3. What are the main financial sources?
4. What is the legal form?
5. What are the strong and weak points of the entrepreneur?
6. What is the investment budget?
7. What is the first, second and third year working budget and clearing budget?
8. Cooperative partnership?

With this Business Plan, the new entrepreneur discusses the financial perspectives with his or her bank or private financiers. A lot of galleries, theatre production companies, designers' studios and Internet firms have been started in this way.

Box 2.13 *Working Budget of a performing artist*
(first year part time, private firm)

Turnover

Solo performances	17.000	
Workshops	10.000	
Sponsoring	3.000	
Total turnover		30.000

Business costs

Location	4.000	
Transport	500	
Materials	3.000	
Promotion	4.000	
Representation	2.000	
Office costs and insurance	8.000	
Depreciation	1.000	
Total business costs		- 22.500

Gross Result		7.500
Minus		
taxes	0	
private draw	7.000	
Total deduction		- 7.000

Over (Capital)		500

With the end of the New Strategy/Implementation step the strategy process based on key dimensions of strategic management in the hands of a strategic team, is finished. In the next paragraph, we will integrate these dimensions within interactivity, based on a project approach. This will mean that the key dimensions show us the knowledge domains of strategic management and that project driven interactivity is the real vehicle for creating direction. In the next chapter, we will throw more light on this project approach.

Practical exercises

1. Speak with an officer of a local art agency and discuss the way art managers use process dimensions as a tool for strategic management. What are the results?
2. Carry out an environmental research of a performing art organization with the help of the eight environmental fields. Are there significant trends to be noted?
3. Analyze an Implementation Plan of your organization (e.g. your school). What are the main issues of this plan in comparison with the outline in this paragraph? If there is no plan, how does the management implement new strategic choices?

● 2.5 Interactive strategic projects

Learning questions
- What are the phases of a project? What are the seven layers of the organizational control relevant to the strategic process?
- What does a Cross-Section look like? How should we organize a strategic Cross-Section in connection with the project methodology?
- What are the key issues of a Cultural Strategic Dialogue?
- How can an Artists Run Organization develop strategies?

Key words

project method	acceptance	strategic dialogue
project phasing	strategic project team	artists run organizations
organizational control	action research	artistic and strategic actions
cross-section	democratic dialogue	change
strategic key dimensions		

Opening incident: *Informal lobbies at a strategic project*

As leader of the strategic project team, Jane feels really uncomfortable. In the middle of the preparation phase, the team discusses the environmental issues. Up to this point, each member was very satisfied about the new working method: non-hierarchical, direct and open. Jane notices that Peter, general manager of the firm - a multi media company, increasingly dominates the dialogue. Not only with a stream of papers with information about trends and development but also as a participant in the discussion. This development has a few dramatic consequences. The other participants are less motivated to exchange ideas or give comments on what they hear. However, the real negative experience is that nobody dares to give counter pressure. The result is that Peter's negative opinion about the use of the Internet for multimedia development ('The Internet is just another trick of the high tech industry

to make profit') will remain. In the lobby the comments of the

functioning of the project team and project leader become louder. One

of the issues is that the members do not feel capable of doing

environmental research. Another issue is that some members have new

and more creative ideas about using the Internet in the multimedia

processes. Some other members suggest that Peter's top-down approach

has to be re-introduced because this approach was clear and - in their

eyes-effective. To Jane the last thought seems to be very strange. All the

team members were enthusiastic about working together and sharing

strategic options without giving special attention to Peter's general

management position, and now there is a complex problem we want to

change our approach? After consultation with a colleague who works in

another firm, Jane decides to talk to Peter about the unwelcome

situation. Her colleague suggests that she needs to make some notes in

order not to lose her path during the meeting.

2.5.1 The project approach[28]

The Strategic Motive can be seen as the first step in the formulating process. Suppose that the cultural organization decides to develop a new strategy as one of the results of this Strategic Motive, all the relevant factors in this first step will be analyzed. This process is a dynamic event as contrasted with the traditional, more ritualistic processes. It will be executed every time the organization undergoes a new Strategic Motive to develop a new and unique future image for the organization. Most strategic management books are unclear about the way the key dimensions have to be organized. A step-by-step method supposes a concrete way of working, but in the cultural reality with its constant pressure to perform, exhibit, educate and demonstrate artistic and cultural expressions, we need a more elaborate method, which is the project method. There is still another reason to follow this route because of the importance of interactivity, see § 2.3.2, as a unique and significant way of working within the strategic process.

In general, project management has two methodological aspects:
1. The Phasing, and: 2. The Organizational Control.

In this paragraph, we will discuss the fusion of the chief lines of project management with the strategic process. In § 3.4, we will work out the project methodology in a more organizational way.

The phasing has six general parts:
1. Initial phase: what is the idea to be realized and what are the (contextual) reasons?
2. Preparation phase: what is the content of the commission/project and what are the project plan and project budget?
3. Development phase: what are our detailed working plans to create a project result?
4. Production phase: how can we execute the working plans and realize the project result within a given scenario?
5. Functioning phase: how well does the project function?
6. Follow-Up phase: what did we learn and what would we do better in the future?

Each phase has its own final document, processing the relevant key dimensions of the strategic process and relevant cultural tracks, which is called a *decision paper*, as illustrated in figure 2.13.

Figure 2.13 Strategic Project Phasing

Project Phases	Final Project Document	Strategic Key Dimensions
1 Initiative	Initial document	Strategic Motive including cultural statements such as artistic leadership and cultural mission, at the end: start of the strategic team
2. Preparation	Project plan and Budget	Strategic Motive including the interactive project way of working,
3 Development	Project Programming and Research Results	Start Evaluation phase, Environmental Research, Option Formulating and SW-Analysis including the quality of artistic and creative processes and other cultural tracks
4. Production	Project result	Strategic Plan/ Implementation Plan
5. Functioning	Implementation plan	Strategic Plan/ Implementation Planning
6. Follow-Up	Evaluation Report	Implementation Planning

The Organizational Control of project management means that the project will function in practice and the project result will be realized on time. The Organizational Control has seven layers (*QuOFTIMoD*) which are present in each phase of the project:

1. The Quality of the project result (to be formulated in the initial and preparation phases)
2. The Organization of the project (to be set up in the preparation phase)
3. The Facilities, needed to realize the project (with an emphasis on the development phase)
4. The Timetable (the more concrete form of planning within all phases)
5. The Information and Communication (these are aspects throughout the whole project)
6. The Money (mainly focused on the budget in the preparation phase and control during other phases)
7. The Digitization (to set up a computerized information flow to be completed at the beginning of the preparation phase).

This QuOFTIMoD needs to be applied within a strategic formation process. The results can be seen in figure 2.14.

Figure 2.14 Organizational Project Control within a Strategic Process

Organizational Control	Relevant to the strategic process
1. Quality	• The expected quality of the strategic plan (strategic choices) in connection with cultural tracks (see § 1.2) • The quality of the future image of the cultural organization • The quality of the cultural mission
2. Organization	• The composition of the strategic project team • The profile and appointment of the Project leader • The division of project tasks • The organizational project culture
3. Facilities	• Space • Computers • Planning materials • Catering
4. Time	• The planning time line • Deadlines and Milestones • Decision making process
5. Information/ communication	• Information channels and media • Communication plan • Meetings with the company members • Public Relations

6. Money	• Project budget to finance project activities
	• Costs of personnel
	• Controlling

7. Digitization	• Project and Group Software
	• Internet sources
	• Intranet possibilities

2.5.2 The functioning of a Cross-Section

Within a small and medium sized cultural organization (< 50 people) the strategic project team (usually about 12 members) and the Cross-Section as described in § 2.3.2 are mainly the same. This team starts after finishing the Strategic Motive and ends with the Follow-Up phase. According to Roobeek's interactive concept, the Cross-Section character can be explained as a team with all kinds of experience and knowledge within the organization without a hierarchical structure. Members of the project team are oriented on a strategic result as indicated in the Strategic Motive as the first step. This project team designs a project plan and a budget for the project in the preparation phase which need the formal approval of the Board of Trustees or Directors. Within this project plan Phasing and Organizational Control are worked out in more detail which means it is known how the communication will be set up, internally and externally. This team is also responsible for the strategic key dimensions (Evaluation, Environmental Research, Option Formulation and SW-analysis) which will be executed in a flexible order, to suit the situational factors. During this process the project team has to contact the members of the company as well as important stakeholders outside the company.

Two aims are important here:
1. To gather information. Strategic debates deal with values, norms, facts and points of view about the relation between the cultural organization and its environment and future. This information, in connection with the research results is an essential contribution to the quality of the strategic result.
2. To create an acceptance for process and result. If the stakeholders are not involved with the strategic process the strategic plan as a result of this process will have a foundation too shaky to be realized. A lot of problems will come about during the implementation if strategic choices lack the acceptance of artists, employees, volunteers, audience groups and other stakeholders.

In large cultural organizations the strategic project can be led by a small strategic project team (about five members). Nevertheless, during the preparation and production phases it is important to found a real Cross-Section with approximately 15 members including the project team members. The way of working will, of course, be interactive and based on open dialogue. In this Cross-Section which can be seen as a *Laboratory of the Future*, as Roobeek called it, knowledge of different levels will be connected to a new domain. Local knowledge based on experience within the organization and general knowledge of strategic management will be streamed into one strategic direction. The strategic research and the strategic choices can be carried out by pairs, which are members of the Cross-Section. These pairs communicate with people in their environment, inside and outside

the organization. Within the meetings of the Cross-Section the results of the pairs will be spoken. During the strategic project the strategic team should organize one or more company meetings to inform colleagues about the progress of the strategy formation. These meetings can also be used to communicate about the strategic position of the organization and options for how to tackle the future. The interactive way of working also brings a framework for training and education. If the members of the Cross-Section want to develop knowledge about specific cultural values, strategic dimensions or the project methodology it is easy to realize. Within the organization the strategic project team can organize some short workshops or lectures, supervised by internal or external experts. These activities are also part of the Laboratory of the Future (see also § 2.6.2 on organizational learning).

The two situations are shown in figure 2.15.

Figure 2.15 Strategic teams in small, medium and large sized cultural organizations

Small and Medium Sized Cultural Organizations (< 50 employees)	**Large Sized Cultural Organizations** (> 50 employees)
• Strategic project team and Cross-Section are the same bodies, 12 members involved • Pairs • Company meetings • Learning workshops	• Small strategic project team of 5 members • Cross-Section team with 10 members extra during the preparation and production phase, in total 15 members including the project team • Pairs • Company meetings • Learning workshops

2.5.3 The Cultural Strategic Dialogue

Interactive strategy formation within a cultural organization demands a competence, whether it comes from within or outside the organization. This competence has three aspects, which corresponds with Pettigrew's analytical framework: Context, Content and Process. The competence on the contextual level aims at the insight into environmental trends and the translation of these trends into cultural options. The content competence focuses on strategic choices related to cultural values and the results of evaluation and SW-analyses. The process competence demands an ability to lead strategic teams and to develop *process architecture*, which is a result of combining strategic process dimensions and interactive project management. Inside the organization a member of the Board of Trustees or Directors can supervise this interactive process. Within a large organization the head of the Personnel Department can play this key role. If there is no internal person to take this job, the organization can look for a supervisor outside the organization, such as a management consultant or a well-experienced faculty member of an art or business school. Within the interactive approach this supervisor needs to develop an action research practice because it is desirable that the external expert is a member of the

strategic team and takes equal responsibility for the whole process. A *condicio sine qua non*, is an artistic or cultural profile of the supervisor. If this person lacks a strong cultural affinity, s/he will not be able to bring together the cultural and the management world.

The Cross-Section has a flat, non-hierarchical structure in which all members take responsibility for the success of the formulating process. This will not be easy. First, not every member has the same tools and skills in strategic thinking. Because of this it is important to organize short learning activities if necessary. Second, the influence of the presence of the artistic and business leader within the strategic team is officially equal but in reality not. For instance, if the artistic leader or a prominent artist contributes to the discussion, his or her words are more dominant than the contribution of an employee of the costume workshop even if the latter has more work experience. To ensure that the Cross-Section takes the contributions of everyone seriously without taking the hierarchical position into account, we can consider the rules of the so-called *Democratic Dialogue*. This dialogue was developed by Börn Gustawson, a Scandinavian research er into Industrial Relations.[29]

The core issues of this dialogue are:
- The process is an exchange of ideas and arguments between all the members.
- It is not enough to have the possibility to participate, participation must be active and stimulated by others.
- Work experiences of the members are the most important criteria for participation.
- Each member should be able to understand the themes.
- Each member should accept that the arguments of others may be better and that conflicts of ideas are often inevitable.
- The way of working has to be criticized by all members.
- The dialogue has to produce concrete step by step decisions and implementation activities.

Because of the importance of the open, result oriented dialogue character within the cultural organizations - which is much more than a debate and an exchange of arguments - we can call this interactive way of strategy making a *Cultural Strategic Dialogue* (CSD). This CSD is supposed to be a valuable alternative to the traditional, underdeveloped way of strategy making as can be seen in the cultural sector in many places. The CSD is also more concrete than the dynamic planning model as described by McDaniel and Thorn (§ 2.1.2). This model takes the artistic planning process as a metaphor for strategic planning but misses the cohesion of the strategic dimensions and is unclear about an interactive project based methodology.

We end this paragraph with figure 2.16 of the CSD, which can be seen as a summary of the project based interactive strategy process including the six key process dimensions. A complete case study on the application of the Strategic Dialogue is included in the appendix.

Figure 2.16 Cultural Strategic Dialogue

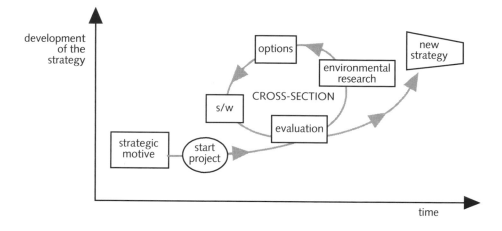

2.5.4 Strategy formation of Artists Run Organizations[30]

Special attention should be paid to the way Artists Run Organizations (AROs) should develop their strategies. An ARO can be described as a collective of artists with an expressive mission focused on an art form, genre or stream. AROs usually have a small number of members, often not more than ten, and show a flexible organizational structure in which all the artistic and managerial tasks are spread among the members. In most cases there is also a very concrete reason to cooperate: the urgent need for space to work together and to create experimental art and interdisciplinary activities including bar and restaurant facilities to generate income. AROs differ from the pioneering organization with a strong artistic entrepreneur who makes the main strategic and organizational decisions by him or herself. What does an ARO not have in comparison with the usual art organization? The ARO has no hierarchical structure with a general manager at the top and operational people at the bottom. The structure is flat; decision-making models are based on a one-man, one-vote system. The most important issue is to communicate about artistic content, internally and externally. The strategy planning is a copy of the artistic decision-making process: the best idea will be executed and the collective is the creator. This way of strategy making approaches the so-called ad hoc development as discussed in paragraph 2.3.1, but there is an important difference: the spontaneous ad hoc style is mainly a certain phase in a life cycle while the collective way of working of the AROs is a structural way of thinking and acting.

Box 2.14 *Some typical problems of Dutch Artists Run Organizations*
In the Netherlands at the end of the nineties of the 20th century there were 150 AROs
(*kunstenaarsinitiatieven*) with their own networks. The artists groups play an important
innovative role mainly in the big regional cities that have a weak cultural infrastructure. In
the beginning the organizational climate was very spontaneous which was supported by
the architecture of the occupied old buildings. Within 10 years the need for
professionalization (organizing, planning, financing) also brought a technocratic, less
passionate atmosphere to a few initiatives. Some members have a regular salary, financed
by a small subsidy from the local government and the accent lies on schedules and formal
tasks and less on experimental activities. Generally speaking, these developments are the
exception. In most cases AROs can be seen as the breeding-places of new culture.
Financially these places have weak positions which stands opposite to the societal artistic
meaning.
Source: Impressions based on a special item of *Kunstenaarwijzer*, 2000.

If we look at their strategic practice, AROs have a permanent struggle for survival. On
the one hand these groups are strongly oriented on artistic expressions - *hic et hunc* -
with an organizational mentality which supports this, on the other hand the (financial,
political and infrastructural) world outside demands a long term focus. It is clear that the
discussed ways of strategy formation, even the interactive one, should be adapted to the
specific circumstances in which AROs function.
 Some tips can be given to strengthen their strategic approach.
- Translate the entrepreneurial artistic mission into a one-issue strategy and avoid the
 making of bureaucratic strategy plans. A group of visual artists that focuses on
 landscape art can take a specific region or area as its hunting ground. A mime
 ensemble with no particular structure can develop a strategic alliance with some other
 theatre groups with the same artistic attitude to support each other in the field of
 finance, marketing and management.
- Organize short feedback processes with the help of action researchers. It is important
 that AROs can use knowledge and insight without creating an over-structured
 planning process. Art management schools have ideal circumstances to make their
 information available to artists groups. In this context action research means that
 teachers and students form teams with the artists groups to develop their one-issue
 strategies. Here, we see a similarity with the guerrilla tactics as will be discussed in
 paragraph 2.6.3. In all cases the Strategic Motive will explain the range of the one
 issue strategy and the corresponding need for supporting activities.
- Divide your energy between artistic and strategic actions. If a balance between these
 two aspects is missing, the struggle for survival will exhaust the group. It is important
 that the members of the group share their experiences in an experimental way.

Box 2.15 *GAST for Artists Initiatives, a proposal*
GAST is an acronym for Guerrilla for Art Strategy Teams. GAST is a proposal within the
Department for Art and Media Management of the Utrecht School of the Arts. With
GAST the school wishes to support small and young artists initiatives. The activities will
be undertaken within the educational programme of strategic management. A few
students and their teacher supervise an artists group very directly and intensively. As soon

as the artists group feels itself be master of the strategic issue, the supporting team can withdraw. The intention is to form GASTs in several art management schools, to create a network of guerrilla action researchers, and to develop a new domain of knowledge.
Source: HAGOORT (1999)

Practical exercises

1. Suppose your organization wants to set up an interactive Cross-Section to develop a strategic action plan (see the Strategic Motive), who will be asked to participate in this Cross-Section? Justify your choice.
2. Analyse a strategic plan of a cultural organization. How does the organization implement its cultural and economic ambitions?
3. Interview a newly founded group of artists. Do they recognize the proposed method of strategy formation? Which aspects do you consider as new and innovative?

2.6 Strategic change[31]

Learning questions

- How can we explain resistance to change? What are the three phases of change?
- Why is it strategically important to create a learning organization?
- What are the specific circumstances in which it is important to initiate guerrilla strategic art management?

Key words

strategic change	crisis management	unwritten rules
resistance	learning organization	single loop learning
diagnose, goal,	7S model	double loop learning
change-phase	cultural strategies	
turn around management	guerrilla actions	

Opening incident: *Quarterly of a change agent*

Dirk Monsma is interim manager of *Kunstweb*, an Amsterdam centre for the arts which offers hundreds of courses in all fields of the arts, except music <www.kunstweb.nl>. Kunstweb was a problematic organization when Dirk Monsma took charge. After a merger of several cultural organizations, serious financial and organizational problems dictated the

agenda. The artists were individually motivated but needed more guidance; a clear future vision was missing. Monsma wrote a quarterly about his change management.

In September 1997, the new chairman of Kunstweb asked Monsma to be interim manager. Because of the combination art, education and management innovation, he accepted.

In December 1997, Monsma formulated his priorities: solving urgent problems in the fields of finance and location, the strategic discussion in spring, and then the organizational structure of Kunstweb.

In March 1998, a strategic concept was written and a small team of talented people was formed. The task of this team was to organize strategic workshops in May. In this period the interim manager combined clearing up the mess and building a new future.

In May 1998. Monsma paid attention to an integral approach: strategy, style, staff, culture, structure and systems. The weakest point was the systems (rules and procedures) which dominated the day-to-day operations. Monsma asked himself why he could not really get a grip on this.

September 1998: again problems with the procedures. Things went wrong even when the number of participants and courses grew by 20% and new innovative and multicultural and new media actions had been undertaken. With the help of Mintzberg' approach the structure of Kunstweb would be based on Product-Market Combinations which

would end the isolated positions of the individual professionals.

In December 1998 Dirk Monsma wanted to create real organizational

changes to support the strategy. Newly appointed heads of the

departments were responsible as managers of change. There was again a

need for discussion about the content of the professional work. A special

Cross-Section was formed to discuss the new way in the future.

When Monsma evaluated his change management he noticed that it is

important that the day-to-day systems are able to function. His

conclusion is that an interactive strategic dialogue only can be developed

if the organizational systems and responsibilities function as an important

framework.

Source: Dirk MONSMA, *Kwartaalboek van een veranderaar of het weven van een web*, in: *Vakblad Management Kunst & Cultuur*, 1998, Nr. 4.

2.6.1 Change and resistance

In a more turbulent environment, the strategy plan of a cultural organization often has a strong internal impact on the existing relations, positions and functions. Suppose a significant part of the current but more or less outlived artistic activities will be scratched by a Top-Down decision to the benefit of new cultural expressions, the artists involved will not easily accept this change. Most strategic practices until this point have not been based on interactivity with its high potential for carrying out strategic decisions with broad support of artists, creative professionals and volunteers. Therefore, we need to see how to deal with strategic change in such circumstances.[32]
A key word in the change process is resistance -resistance to supposed *reasonable changes*; resistance to so-called *right decisions*, and resistance to the way purported *logical strategic choices* are implemented by managers. In the case of large organizations in which strategy formulation and implementation seem to be two separate worlds with a lack of real consultation and communication, people on the organizational and operational level have their own points of views as to what is reasonable and logical. They have developed their own artistic and cultural ideas on how to work and why this work is important to them. Especially if this work is rooted in art education and practice over a long period of time, it is absolutely understandable that these people defend their work against changes. In a wider perspective, Ansoff explains resistance as a reaction to loss of historical behaviour, an established organizational culture and an existing power

structure. This resistance grows more if a gap exists between people's perception of the organization and the reality in which the organization is found. In these sorts of situations it is difficult for the employees to see that weak but significant signals will have a strong effect on the existence of the organization, and the importance of taking strategic action to guarantee the future of the organization as a whole. Success in the present does not necessarily mean that the organization will have success in the near future.

If the strategic patterns are not an organic result of a grass root strategy or an interactive way of working, resistance to change should be taken very seriously. Based on this starting-point, three phases can be distinguished in the practice of organizational change:

1. the diagnosis phase
2. the goal phase
3. the change phase.

The important element in the diagnosis phase is to draw up a good problem definition: what is the state of affairs, and what is the problem? Analysis of bottlenecks provides the necessary information here. In this phase, one also pays attention to the willingness to change in the organization and to a high or low potential for change. The key words for a low potential for change are: no confidence in the management, no clear (or only a defensive) strategy and objectives, weak organizational culture, obscure structure, large-scale, poor operating profit.

In the goal phase the desired future situation on organizational and/or operational level is formulated and worked out. It must become clear what change is being aimed for. A conclusion is reached by considering several alternatives.

The change phase is the process in action; a selected change plan, including the interventions to be applied, must lead here to actual results. This phase can also be managed with the help of the project methodology, as pointed out earlier. In any case it is worth mentioning that the diagnosis phase is already part of the solution of the organization problem. After all, if the bottlenecks have been identified and understood, adequate, viable solutions can then be suggested.

Box 2.16 *The 7S Framework*
Thomas Peters and Robert Waterman developed a model to understand organizational change. Their central idea is that success for change is an interaction between seven elements, all starting with S: Strategy, Structure, Systems, Style, Skills, and Superordinate Goals, as figure 2.17 shows.

Figure 2.17 7S framework

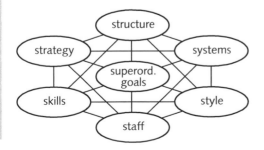

Structure: tasks and coordination
Strategy: anticipation of the external environment
Systems: procedures within the organization, formal and informal
Style: how people work and manage
Staff: the quality of the people
Skills: the capabilities within an organization
Superordinate Goals: a set of values and aspirations.
If an organization wishes to change, e.g. their systems, the other six variables and their interrelations as shown need to be analyzed. In practice this model is also used as an instrument for a SW-analysis within the strategic process.
Source: Bob de WIT, Ron MEYER, Strategy, Process, Content, Context, West Publishing Company, St Paul, 1994, pp. 176-182.

Thomas G. Cummings and Edgar F. Huse warn, however, against using this concept of diagnosis, as it contains too strong a suggestion of the medical approach: examine the disease, and prescribe something that will bring about a recovery.[33]

An organizational diagnosis is much more a matter of cooperation, in discovering and analyzing the backgrounds of organizational problems. Cummings and Huse point out that managers think less in terms of problems, and more in terms of developments. They want to link the present functioning of the organization, based on effectivity considerations, to the discovery of new opportunities (not problem oriented but development oriented). Special attention should be paid to crisis management which means that the organization is in real danger and strong management interventions are needed (see paragraph 2.4.1). In those cases interactive processes can not be executed. Crisis management in large organizations requires, in almost all cases, external guidance or interim management.

Box 2.17 *Practical illustrations about change*
Introduction of group lessons at the music school.
'The management has decided to offset the municipal cutbacks through group lessons. In the new schedules we saw that the director had assigned us three pupils, instead of one. We think he does not understand what instrumental education is all about. The department has written a letter, stating that it will not cooperate with the introduction of group lessons. For quite some time, there had been discussions with the director about the introduction of group lessons. Many people in the school doubted whether you could still teach in groups of three. We are now trying, in consultation with the board, to introduce group lessons in order to offset the consequences of the imposed cutbacks. The board will organize a special school meeting to discuss the pedagogical aspect of group lessons.'
• Core tasks
'The board considered it desirable that we formulate our core tasks as a group. The very concept 'core tasks' itself already raised a lot of suspicion. Was it a disguised reorganization? Were there new cutbacks on the way? After a few weeks of talks, we decided to hold a strategy day. Together with a member of the board who is an organization consultant, we have drawn up a programme. We have spoken about many subjects and I know now that the formulation of core tasks is necessary in order to clearly state what you want to achieve.'

• Turn-around management

'The board indicated in its development plan that the departments had to present their studio facilities in a more customer-friendly way and that the indirect costs (amongst others, staff) had to go down. It was also indicated that the heads of departments had the final responsibility in this matter. The development plan did not mention the way in which we had to put this completely new working procedure into practice. It was also not clear which exact amounts were involved in the operation. The development plan was no more than a paper with good intentions. In the end, we suffered even more losses that year.'

2.6.2 Organizational learning

Strategic change also has to deal with the learning culture within an organization. With interactive change processes, learning by doing is a central concept that creates a broad acceptance to change. If a gap exists between the current knowledge and what is needed for new competences, we can position this learning by doing it in a more conceptual framework. Here the key word is organizational learning, which was developed by Chris Argyris.[34] This American researcher is a prominent expert on how organizations develop their learning potential to innovate and change working methods. His starting point is the distinction between *single loop learning and double loop learning*. Within routine activities there is mainly a single-loop learning process: managers and employees correct their mistakes using well-known methods to provide solutions. For instance the project leader draws up a timetable because he misses setting up clear deadlines in the planning. The correction of this fault by consulting the project methodology is not complicated. If an organization has to change their working methods more intensively, managers and employees have to create innovative practices without the fundament of established rules. Suppose a city theatre wishes to establish a new cultural summer festival, all the people involved need new knowledge, skills and tools to realize this event. The experience shows that those people uselessly try to use their routine single loop approaches to solve new problems. The reason for this is the need for a short-term focus and the fear of realizing new long-term targets that are surrounded with uncertainties and personal loss of face. Within strategy implementation processes, organizations would be aware of the distinction between the two learning approaches and stimulate the double loop learning process. This can be realized by four steps.

1. To make clear the difference between routine problems and the norms and values on which these elements are based
2. To give feedback within a practical, case study approach to discuss issues as yet undecided
3. To give support if people try to find out new methods of working
4. To supervise people who want to share their new approaches with other people in the organization.

These steps are important for individuals from all layers of the organization: top, middle and base. If the general director does not participate in new learning processes personally, s/he will undergo negative experiences and achieve inferior results in changing the organization. Organizational learning can also be seen as a fundamental strategic advantage. In this context the organization itself is a learning experience which

enables the organization to be more innovative and creative than its competitors. This concept is named *learning organization* and is developed by, among others, Peter Senge.[35]

Five 'disciplines' for such a learning organization are:
1. See the organization as a holistic system
2. Master your own personal vision as to what the organization should be
3. Find out the mental models that influence the way of thinking and acting
4. Create a collective vision that encourages individual efforts
5. Form teams to develop a dialogue and interactive processes.

These disciplines help organizations on the one hand to locate learning barriers and on the other to constantly upgrade employees' talents, skills and knowledge. The added value of the learning organization is that new knowledge which is obtained by employees needs to be shared with others. This happens in the day to day practice but it is also important to facilitate and supervise this process as a more structural way of working. The problem with the learning organization is that managers expect results in a short time, say within one year. Because of the fundamental approach of the concept the advantage is more focused on the long term. This difference in expectations can bring disappointment to managers and employees. Another problem is the way the results of the learning organization can be measured in an organizational context, e.g. openness, renewing and intelligence. The rule of thumb here is for the people themselves to set appointments for the judgements of progress.

Finally we should discuss so-called *unwritten rules* in the organization which make it impossible to change. Peter Scott-Morgan says that unwritten rules are based on the contrast of two worlds: the official world of documents, plans, programmes and organizational rules, and opposite to the formal world, the concrete world of the organization meaning how managers and employees are really rewarded in the field of promotion and salaries.[36]

If the norms in concrete situations differ from the formal ones we speak of unwritten rules. These rules are the real barriers for strategic change. If unwritten rules are identified, a dialogue can then take place as to how these rules can be restructured more constructively. A condition for success is that new rules should be translated into individual targets. The three discussed approaches can be seen in figure 2.18

Figure 2.18 Learning within an organization

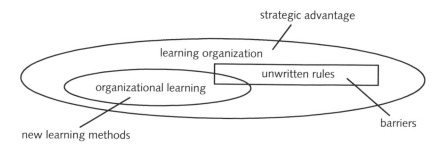

Box 2.18 *A method for fundamental strategic changes*

Sometimes a cultural organization finds itself in a very high turbulence environment while the management functions, structure, organizational culture and leadership styles are not suited to this turbulence (say turbulence level 4-5 versus management approach 1-5). If the organization wants to survive, the necessary changes will be very dramatic. An external supervisor can help apply the following method for this kind of fundamental change:

1. Point out the Unique Strategic Motive of the strategic change (see paragraph 2.4.1). Analyse the learning potential and the unwritten rules and start a change project.
2. Create interactively (internally and externally) a clear Cultural Mission for the near future (see paragraph 2.2) and translate this mission into (first) cultural and (then) economic ambitions.
3. Develop and apply Future Profiles of Competences (FOPOCs) for groups of employees and team leaders (see the example in box 4.4). Ensure a 100 % consensus on the interpretation of the profiles within the organization. If an employee has no commitment to the new competences, negotiations have to be initiated to end the working relationship.
4. If there is commitment: establish an environment for Experimental Learning to work on the basis of new competences (mainly in result oriented project forms - see paragraph 3.4). Mix learning activities with basic knowledge (*learning roads*) and more individual teams of action learning (*learning tracks*).
5. Celebrate Successes and Results and create an organizational culture within which each employee can be a real Hero in his or her own field. Organize also open Farewell Parties for those who cannot accept the new FOPOCs and want to explore opportunities outside the organization.

Sources: Utrecht School of the Arts, Working documents *Vier Grote Steden, Utrecht Centrum voor de Kunsten*, 1995-1999 (in cooperation with Dieneke Naeyé, René van der Kolk, Trudy Verhoeff and Astrid Vrolijk).

2.6.3 Guerrilleros des Artes

We will end this chapter about strategy with a special change method: guerrilla art management.[37]

So far, we have argued that it is important to develop interactive ways of working to successfully realize cultural strategies. We also discussed in this paragraph how to deal with resistance to strategic changes in a Top-Down structure. We have also seen that learning experiences are relevant to the need for change.

In the cultural sector we also have groups of artists, creative professionals and art managers who want to change situations in a more or less hostile environment, e.g. a dynamic art policy department in a bureaucratic and conservative governmental culture, an entrepreneurial marketing section in a traditional theatre, a pro active committee of artists in an old fashioned museum, and an avant garde festival organization in an a-artistic region. These groups cannot use the techniques and methods as discussed here because of the current incapacity of the environment to move into more reliable directions. In these cases and only as an *ultimum remedium* one has to develop guerrilla action to realize strategic cultural changes. The core tactic of a guerrilla manager is the

exact choice of a part of the whole in which success is guaranteed. *Guerrilla* does not aim at the complete organization, sector or region, but at a significant area.

Box 2.19 *Multimedia guerrilla action*
A library of a school for higher education wishes to digitize their data. This change has been managed in a traditional way: describing the desired situation, a design, an implementation plan and a schedule. The implementation is in the hands of the head of the library. An employee of the automation department is also involved. Halfway through an employee of the library and one from the automation department develop an idea on multimedia. They wish to transform the library into a multimedia centre in which the students have the possibility to collect information and to consult knowledge domains on their own via the Internet and new media. Resistance comes from the head of the library and the head of the automation department: a multimedia centre is not mentioned in the project plan and has no budget in the overall corporate financial planning. After a period of disappointment the two employees start a guerrilla offensive. They talk with students, open to change teachers and researchers and have meetings with some suppliers for sponsoring a pilot project. There is also an informal talk with one of the members of the Board of Directors to adapt the investment policy. After three months the two start their pilot and with in 6 months they have their own section with budget and a small team to put all the learning modules on the Internet.

Some changes with a great strategic impact cannot wait until the formal procedures and plans are followed. With a strong eye for detail, the original idea got a chance because of its links between what is officially going on and more general developments in the environment of a project or organization. By using guerrilla tactics free artists groups have realized new accommodation for their studios, alternative exhibition rooms and unexpected art happenings in the status quo art sector. So maybe the change disposed guerrilla management is more present then in any other societal field.

For successful guerrilla art management it is important to consider the tips as illustrated in figure 2.19

Figure 2.19 Tips for successful guerrilla art management

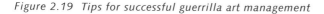

offensive actions and retreat
using communications channels
operational succes
clear vision and mission

art guerrilla base camp

- There is no art guerrilla base camp without the domination of vision and mission. If it is unclear why cultural innovations are necessary the actions will fail after a short period of enthusiasm and pioneering.
- Guerrilla actions create operational success. If the artists and the employees within an

organization have no idea what the changes are all about, they will turn away. An important issue for guerrilla management is to anchor the first results within the official systems and programmes.

- Art guerrilla management makes use of the existing communication channels. It is important to publish in official newsletters, art magazines, professional periodicals, etc. Prominent opinion leaders are asked to express a positive opinion on the desired changes.
- Offensive action and retreat go hand in hand. Guerrilla art groups operate in an hostile environment, it is important not to become isolated from its own base camp. As soon as cultural innovations are in real danger, a retreat has to be undertaken.

We end this voyage of discovery of strategic management in the cultural sector with this summary of a manual for *guerrilleros des artes,* but what should we do with a cultural direction without a vehicle to arrive at one's destination? In the following chapter we will find answers to this question.

Without doubt these answers are focused on one point: the cultural organization.

Practical exercises

1. Write a paper about a case on fundamental strategic change of a concrete cultural organization and discuss the following items:
 a. What is the Strategic Motive?
 b. What are the new profiles of competences?
 c. What are the implementation results?
 Suggest some improvements on the way strategic changes should be realized.
2. Ask some art managers how they manage training needs within their organization. Which of the elements shows the idea of a learning organization?
3. Organize an interview with some well-experienced artists of an Artists Run Organization. Ask their opinion of guerrilla art management. What are in their opinion the Organization pros en cons of this method of strategic change management?

Closing case *Privatization of provincial cultural institutes*

Ms Anna Burki, director of the non-profit Foundation Regional Theatre, and Mr Stevano Tradi, director of the Provincial Centre for New Media (part of the County organization), received a letter from the County Council with a request to participate in a Council workshop to discuss the intended privatization of provincial cultural institutes. In that letter, the Council outlined the reasons for privatization:

1. A reduction of subsidy because of the new Cultural Policy plan to prioritize new artists initiatives and to reduce subsidies to existing institutes. In some cases, the subsidy will be withdrawn completely if market initiatives can take over the cultural activities.
2. To improve the quality of art management in the fields of financing and marketing.

3. More generally: to concentrate governmental activities on *core businesses* and to create more independent institutes (and not to run Provincial Centres such as the Centre for New Media).

Their first reaction was to refuse to participate in the workshop. Both directors were shocked by the letter with its remarks on cuts in subsidies and the negative comments on their management quality. They knew that there were ideas on changing cultural politics but as usual: 'anything can be put on paper'. Now with the letter in their hands they realized that the new policy is very real and that the workshop signals a new beginning.

Ms Burki and Mr Tradi arranged a meeting with Ms Irna Bho, a consultant in the area of societal entrepreneurship, who pointed out various examples of privatization:

1. To sell governmentally owned organizations to a (new) private, market driven company
2. To make over governmentally owned organizations to a (new) private, non-profit organization under some structural conditions, i.e.
 a. the non-profit organization receives an annual subsidy
 b. the cultural goods stay in the hands of the governmental authority (i.e. the collection of a museum).
3. To establish new governmental bodies with a more independent management structure with its own targets to secure its own income, but under the umbrella of the national, provincial or local government.

Ms Bho also explained that a complex privatization process (in general) will take four years and that strategy making, organizational structure, and culture and leadership will change dramatically. She concluded that privatization happens in all sorts of societies and for all kinds of different reasons but that there is one bottom line: to reduce subsidies to large institutes and to concentrate governmental policies on core activities such as safety, legal infrastructure, and environmental development.

After that meeting Ms Burki and Mr Tradi could not agree on whether to participate in the workshop. Ms Burki's independent theatre with a budget of EURO 1.5 million receives a provincial subsidy of 60%, the rest of their budget is own income (35 % box office and 5 % sponsors). Mr. Tradi is financed by the County with an annual budget of EURO 0.7 million, and has a personal income of 5%. All kinds of educational activities in both organizations (youth performances and small workshops) are free.

Ms Burki, impressed by the information of Ms Bho, sees some advantages of participation in the workshop: one can have influence on the process and one will be well informed. 'Dear Stevano', Ms Burki said, 'I think you are afraid, you are thinking of your own comfortable subsidized position. The time has come for cultural entrepreneurship. So, you must do what you feel best, but I think I will participate. I can always leave the workshop at any time I want!'.

After that conversation, Mr. Tradi got a telephone call from an old friend who is head of the New Media Department of the local art academy, to talk about

some internships. After making an appointment, Mr Tradi realized that cooperation with the New Media Department could be one of the solutions and that he should point out some scenarios.

Ms Burki met a prominent representative of the County Council over a drink at the opening of an exhibition and discussed the situation with him informally.

'Anna', the man said, 'You have to think about yourself. As you know, the New Media Centre has a clear cultural mission but is expensive and has no real relations with wide audiences. Let me say one thing: If you make a strategic plan in which you give media activities a clear position, you will receive 60 % of the existing subsidy of Mr Tradi's centre, which now belongs to an elite group of artists. The only condition is to bring new media to local people and to cooperate with local new media businesses. I may have some interesting contacts for you.'

Mrs Burki could not give a reaction because the man was already talking with some other people. On her way home, she felt very confused. She did not want to be a traitor to Stevano, but on the other hand she has some outspoken ideas on interdisciplinary art and culture and this would be a fantastic chance. She realized that the time had come to develop some future scenarios.

Case Questions

1. Do you know any other reasons for privatizing cultural institutes? What are they? Do you know any other forms of privatization? Which?
2. What are the decisive factors (on cultural and management level) for Ms Burki's successful participation in the workshop?
2. What should be the strategy for both directors: cooperation or competition? Use a SWOT approach to find an answer.

Special class assignment:

Divide your group into two sections, theatre and new media. Each section works out some (no more than three) scenarios as suggested in the case. Present the results and discuss which is the most profitable from a concrete cultural and financial perspective. Use the facts and figures below.

Non-profit Foundation Regional Theatre (founded in 1947)
Mission: To entertain the people in our region with a mixed programme of traditional and contemporary theatre performances.
Special activity: interdisciplinary festival at the opening of the cultural season
Annual budget: EURO 1.5 million, EURO 0.9 million subsidy (60%)
Box office/buffet: EURO 0.5 million (35%)
Sponsoring: EURO 0.1 million (5%) mainly by a local Internet Firm
Personnel: 30 employees (EURO 35.000 per employee)
Average occupation of seats: 80%
Management Quality rating on a scale from one (low) to five (high): 3.5.

Provincial Centre for New Media (founded in 1991)
Mission: no written mission statement; the director's vision is that 'multimedia arts speak for themselves.'
Special performance: international recognition as a high standard Internet art centre.
Annual budget: EURO 0.7 million
Box office/buffet: EURO 0.035 million
Sponsors: none
Personnel: 10 (EURO 35.000 per employee)
Average attendance: 45 visitors
Management Quality rating on a scale from one (low) to five (high): 2.

Note: the director is a well-known multimedia artist and was asked by the County Council to establish a new centre.

Case References: Peter B. BOORSMA, Annemoon van HEMEL, Niki van der WIELEN, *Privatization and culture, Experiences in the Arts, Heritage and Cultural Industries in Europe*, Kluwer Academic Publishers, Dordrecht, 1998; Giep HAGOORT, *Verzelfstandiging culturele instellingen*, Research paper, Utrecht School of the Arts, 2000; Lydia VARBANOVA, Privatization of culture: comparative analysis of arts sectors in selected Central and Eastern European countries, in: *AIMAC'99*, Helsinki, 1999, pp. 472-482. Thanks to Fons Disch, City of Alkmaar.

1 The text of this chapter is mainly based on Giep HAGOORT, *Strategische dialoog in de kunstensector, interactieve strategievorming in een kunstorganisatie*, Eburon, Delft, 1998.
2 Benjamin M. BANK, Valerie B. MORRIS, Strategic management in non-profit arts organizations: an analysis of current practice, in: *AIMAC Proceedings '95*, Paris.
3 Yves EVRARD (coord.), *Le Management des Entreprises Artistiques et Culturelles*, Economica, Paris, 1993.
4 Jeannette WETTERSTRÖM, In search of strategy: some reflections on a case study at the Royal Opera in Stockholm, in: *AIMAC'95*, p. 383-392.
5 A method to process cultural values within strategic management is applied in the appendix of the TGA case study.
6 Stephen B. PREECE, Strategic management types and the performing arts organization: an adaptation of the Miles & Snow typology, in: *AIMAC'99*, pp. 109-115.
7 Nello MCDANIEL, George THORN, *Arts Planning, a dynamic balance*, Arts Action Issues, Brooklyn, 1997.
8 UTRECHT SCHOOL OF THE ARTS, Educational and research documents; Students, Staff members and Lecturers, Department for Art and Media Management (1990-1999).
9 See note 1.
10 Giep HAGOORT, *Cultural Entrepreneurship, an introduction to arts management* (Draft), Phaedon, Culemborg, 1993, par. 1.3; HAGOORT (1998), par. 2.2.4.
11 Igor ANSOFF, *Implanting Strategic management*, Prentice Hall, Cambridge, 1990, p. 122.
12 Peter F. Drucker, *Managing for the Future, the 1990s and beyond*, Truman Talley Books, Dutton, 1992.
13 Henry Mintzberg, *Mintzberg on Management, Inside our strange world of organizations*, Free Press, New York, 1989, pp. 221-235.
14 Andrew CAMPBELL, Kiran TAWADEY, *Mission & Business Philosophy: Winning Employee Commitment*, Heinemann Professional Publishing, Oxford, 1990.
15 HAGOORT (1993), chapter 2.
16 HAGOORT (1998), chapter 1.
17 For the first time the interactive concept was used in our Ph.D. research on the cultural sector. Annemieke J.M. ROOBEEK, *Een race zonder finish: De rol van de overheid in de technologiewedloop*, VU Uitgeverij, Amsterdam, 1988. Annemieke J.M. ROOBEEK, Technologie en democratie, Inaugurele rede Nijenrode Universiteit voor bedrijfskunde, in: *PEM*, 1991, p. 705-718. Annemieke J.M. ROOBEEK, Strategisch Management van Onderop, in: *Ecocratie, Op weg naar waarde-vol Op-organiseren*, Van Arkel, Utrecht, 1994. Annemieke J.M. ROOBEEK, 'Strategic action research' in de praktijk, in: *De toekomst van de sociale interventie*, Wolters-Noordhoff, Groningen, 1995. Annemieke J.M. ROOBEEK, Mariska M.F. de BRUIJNE, *Strategisch Management van Onderop: Een action research projekt over democratisering van de strategische besluitvorming in de Nederlandse industrie*, Universiteit van Amsterdam, Amsterdam, 1993.
18 Henry MINTZBERG, Bruce AHLSTRAND, Joseph LAMPEL, *Strategy Safari. A Guided tour through the wilds of strategic management*, 1998.
19 MINTZBERG (1989).
20 This dimension was one of the main results of my Ph.D. research, HAGOORT (1998), pp. 82-89, see also: Margot GERENÉ, Het opstarten van een strategieproject, paper Utrecht School of the Arts, 1996.
21 Deborah HAYES, Proactive Crisis management strategies for arts organizations, in: *AIMAC'99*, pp. 54-65.

22 HAGOORT (1998), pp. 12-17.

23 ANSOFF (1990), pp. 30-31.

24 Kees van der HEIJDEN, *Scenarios, The art of strategic conversation*, John Wiley & Sons, Chichester, 1996.

25 Gareth MORGAN, *Imaginization; the art of creative management*, San Francisco, 1993.

26 Michael E. PORTER, *On Competition*, Harvard Business School Press, Boston, 1998.

27 Gary HAMEL, C.K. PRAHALAD, *Competiting for the Future; Breakthrough strategies for seizing control of your industry and creating the markets of tomorrow*, Harvard Business School Press, Boston, 1994.

28 Harold KERZNER, *Project management, a systems approach to planning, scheduling, and controlig* (6th ed.) John Wiley and Sons, New York, 1998; Jan VERHAAR, *Project management, Een professionele aanpak* (2e druk), Boom, Amsterdam, 1999 (An English version is available at the Amsterdam School of the Arts).

29 ROOBEEK, de BRUIJNE, (1993).

30 Giep HAGOORT, *Strategievorming van kunstenaarsinitiatieven*, Research paper, Utrecht School of the Arts, 1999.

31 Rosabeth MOSS KANTER, Barry A. STEIN, Todd D. JICK, *The challenge of organizational change; how companies experience it and leaders guide it*, 1992.

32 See for some examples within the cultural non-profit sector: Graeme EVANS, The arts organization: managing change of changing the management, in: AIMAC'99 Helsinki, 1999

33 Thomas G. CUMMINGS, Edgar S. HUSE, *Organization Development and Change*, West Publishing Company, St Paul, 1993, p. 85

34 Chris ARGYRIS, *On Organizational Learning*, Blackwell Publishers, Cambridge, 1992.

35 Peter SENGE, *The Fifth Discipline, the art and practice of the learning organization*, Doubleday, New York, 1991. See also: Paul van AMEROM, *Lerende organisatie/kennis management*, Research paper, Utrecht School of the Arts, 2000.

36 Peter SCOTT MORGAN, *The Unwritten Rules of the Game*, McGraw-Hill, London, 1994.

37 Jay Conrad LEVINSON, *The Way of the Guerrilla, Achieving success and balance as an entrepreneur in the 21st century*, Houghton Mifflin Company, Boston, 1997.

Motive

Iago's action to discredit Othello backfires and Brabantio fails in the Senate. The general gets an order to protect Cyprus against the Turks. Desdemona will accompany her husband in the presence of Emilia, Iago's wife. Under Othello's leadership the Turks are beaten. During the victory celebrations, Iago encourages Cassio to drink and fight. Othello is not impressed by his behaviour and reduces his lieutenant directly.

Iago asks Desdemona to plead with Othello to give Cassio's his original post back. Drawn by Iago, Othello sees this request as a sign of his wife's amorousness towards Cassio. Iago constructs his intrigue and manipulation with a stolen handkerchief. This handkerchief is given to Desdemona by Othello as a symbol of his love before it accidentally falls into the hands of Cassio. Othello plays the injured party to Desdemona. The unsuspecting Desdemona explains to Emilia the possible cause of Othello's state of mind.

Something, sure, of state,
Either from Venice, or some unhatch'd practice
Made demonstrable here in Cyprus to him,
Hath puddled his clear spirit; and in such cases
Men's natures wrangle with inferior things,
Though great ones are their object.
'T is even so;
For let our finger ache, and it indues
Our other haelthful members ev'n to that sense
Of pain. Nay, we must think men are not gods,
Nor of them look for such observancy
As fits the bridal.

(ACT III, 4)

3 The structuring of a cultural organization

3.1 Basic principles

Learning questions
- What are the two principles of an organizational structure?
- What are the four steps of an organizational design process?
- Which four orientations of a cultural structure can be considered?

Key words

structure	functional orientation	staff manager
labour division	product orientation	span of management
coordination	market orientation	
design of functions	geographic orientation	
organisational design	line manager	

Opening incident: *Cultural Centres in Central and Eastern Europe*

In 1995, the *Culturelink* periodical published a special issue based on research into post-communist, community-oriented cultural centres in Central and Eastern Europe. More than half of the centres still have governmental status while a quarter did not answer the question. Another unanswered question (one in six) concerned the freedom to programme. About one quarter said they were not autonomous. Two-thirds of the centres were mainly financed by the state; other income sources were scarcely developed. The staff was largely professional and not all specially educated. Exchange and (international) networking were

hindered by a lack of money and regulations. In 50% of the cultural centres, the question about European networking remained unanswered. In general, the centres were worried about their current situation because of a lack of money and a fragile economy, but optimistic about the future in which they could develop their non-profit activities in a more autonomous climate. The researchers did not investigate the organizational structures. It would not, however, be difficult to imagine how our colleagues at the cultural centres involved, need power of endurance and great insight to transform old structures into new.

Source: CULTURELINK, Network of Networks for Research and Cooperation in Cultural Development, *Cultural Centres in Central and Eastern Europe*, special issue, 1995. <www.culturelink.hr>

3.1.1 Sources of the structuring process

A cultural or artistic organization may have a bright cultural mission and a clear strategy but if the labour division and coordination are underdeveloped, it will be almost impossible to realize the mission. The organizational issues have already been discussed, though not from an organizational perspective. In the previous chapters we considered the main characteristics of a cultural organization (§ 1.1.3), discovered some dominant cultural values as creative processes and artistic leadership, developed the idea of S/W analysis of an organization and saw how internationalisation and digitization can influence working procedures. Furthermore, we explained the project management form as a methodology for strategic actions and discussed the concept of a learning organization for a sustainable result. However, the analysis of the cultural organization itself and the question of how to optimize its functioning, have not yet been discussed.

In this chapter, we will focus on how cultural organizations are structured by applying general rules of organizational design. We will combine these rules with typical work experiences within the cultural sector, and its primary professional process of production, distribution and education in cultural expressions (goods and services).[1]

In general, management theory assumes that 'structure follows strategy'. This rule is based on the concept that only if we recognize our bearing, will we be able to design a structure in which activities centre on using plans and concrete activities to realise strategic objectives. Applied to the cultural sector, we see that the richness of art and culture has brought creative structures that are more durable than the existing objectives. We have already mentioned the Greek Festivals of 500 BC, which have the same

worldwide structure *grosso modo* as our modern cultural festivals (§ 1.1.1). Orchestras, museums, theatre groups - they all have worldwide organizational schemes that are much older than their strategic plans. Hence, general trends that are not strongly connected with unique strategies will affect the organizational forms. Here we mean organizations referred to as 'network organizations', 'virtual organizations' and 'intelligence organizations'.[2] These words express some common experiences of how organizations, with their turbulent environment caused by globalization and digitization, should work in the 21st century. So, in this chapter on the one hand we will be examining the cultural organization as an expression of a cultural mission, and on the other we are aware of historical forms in the cultural sector. We should recognize that these two worlds are not divided by a clear straight line as figure 3.1 shows. The strategic impact on cultural organizations cannot be divorced from the way cultural labour has been coordinated in the past, while the organizational structure connected with the creative processes not only stimulates but also restricts the strategic possibilities.

Figure 3.1 Strategy and history, sources of the organizational structure

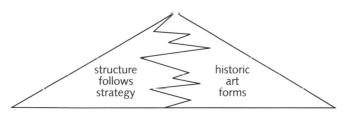

3.1.2 Labour division and coordination

The structure of any organization, including a cultural organization, is based on two principles.[3] 1. The division of labour, and 2. The coordination of the activities. The first principle centres on the question of who in the organization develops production activities. The second answers the question of where the responsibility lies for tuning all the activities to one performance related to the strategic goals. Mintzberg calls these principles 'opposing requirements'.[4] While the purpose of the division of labour is to develop concrete, separate tasks taking into account cost and time efficiency, the general application of coordination is to realize unity and accomplish the activities with the emphasis on effective management. Figure 3.2 illustrates these divergent courses.

Figure 3.2 The divergent courses of structuring principles

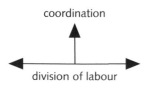

As we will see in this chapter, the difficulty of combining these requirements should be seen in the context of the organization's life cycle and size, the structural components

that are present in each organization and the organizational culture as a potentially 'binding' factor.

Before we discuss these themes, it is advisable to explain how the division of labour and coordination functions within the organizational process. We will start by formulating the general method, and follow up with an example from theatre praxis.
This structuring process is effected in four stages:[5]
Stage 1: List which activities are fundamental to achieving the objectives (labour division aspect):
Stage 2: Group relevant activities together and indicate which activities require direct coordination (coordination aspect):
Stage 3: Translate the coordinated activities into logical areas (labour division aspect):
Stage 4: Arrange the logical areas in a formal structure (coordination aspect).
The process is shown in figure 3.3

Figure 3.3 Structuring process

Using an example from the world of theatre, we can explain what the four steps specifically entail. A group of dramaturges wants to independently stage a series of plays by Shakespeare over a long period. Once the objective has been defined, a sustainable organization must be designed.
The first step is to make an 'arbitrary' overview of all sorts of activities that needed to be performed. The results of this brainstorming session are as follows.
1. looking for a translation
2. renting a studio
3. drawing up a rehearsal schedule
4. selecting actors
5. setting up contacts with producer
6. drawing up a planning schedule
7. engaging a set designer
8. arranging technical theatre aspects
9. keeping track of costs
10. organizing publicity
11. establishing a budget
12. looking for financiers
13. contacting theatres
14. organizing meetings
15. arranging the first performance

In the second step, we want to group all the activities within a coordination framework. In this phase, we try to find out the cohesion of activities that are strongly connected and can be seen as nodes within the working process. The results are listed below.

Coordination A

1. looking for a translation
4. selecting actors
5. setting up contacts with producer
7. engaging a set designer
8. arranging technical theatre aspects
15. arranging the first performance

Coordination B

2. renting a studio
3. drawing up a rehearsal schedule
6. drawing up a schedule
14. organizing meetings

Coordination C

10. organizing publicity
13. contacting theatres

Coordination D

9. keeping track of costs
11. establishing a budget
12. looking for financiers

In the third step we should form logical areas based on the coordination nodes A, B, C and D. The importance of this step is that activities and coordination really will function, so we are looking for ways of optimalisoptimizing the organizational structure. The logical areas ofin this example are:

A: Artistic aspects
B: Planning
C: Marketing
D: Finances.

 If we are to apply this model in reality, we should consider that the theatre group is a small sized organization and it is therefore important to bring coordination nodes together. Now we have two options .

Option 1: Linking marketing to artistic aspects (A and C), and linking finances to planning (B and D)

Option 2: Linking planning to artistic aspects (A and B), and linking finances to marketing (C and D).

 To make a calculated decision, it is necessary to formulate ideas about artistic leadership (see § 1.2.8). Based on these ideas the group can make a final decision.

 In the fourth step we have to set up a formal structure which makes clear who is finally responsible for coordination and labour tasks.

 Each step can be graphically represented as figure 3.4 shows.

Figure 3.4 Designing an organization

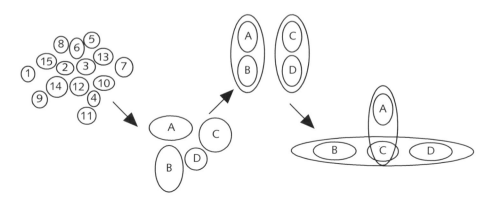

The steps we have taken so far make it clear that division of labour and coordination are aimed at efficient and effective use of time and manpower, but that is not all. New activities that we have not yet mentioned, and which we will encounter while working on the theatre production, must also be handled through the organization now set up. We could classify new activities under numbers 16 to 20. Now that we have used the method of division of labour and coordination, we can indicate who is responsible for which activities.

	New activities	Execution by
16.	setting up an accounting system	B
17.	keeping track of income and spending	D
18.	final decision to go ahead	A/C (option 1)
19.	recruiting new employees	A/C (option 1)
20.	having publicity material designed	C

If no clear division of labour is made, and the coordination is not properly worked out, there will be constant confusion about the execution of (new) activities, which will in turn hinder the creative processes within the cultural organization.

3.1.3 Observations about the cultural sector[6]

In the method presented here, we have ignored the fact that we are perhaps dealing with experienced and/or well-trained art managers, who already intuitively understand the way in which cultural, technical and organizational activities are divided and coordinated. The steps presented are mainly intended to provide insight into the method of structuring. Even if we are confronted with complex cultural organizations, it is desirable that we understand the basic rules of designing an organizational structure that specifies who is involved with executing activities and who is responsible for coordination. We have taken into account that within the cultural sector people often bear several responsibilities, e.g. a general art manager is also involved as head of the programming

department, and the head of the art marketing department also coordinates the voluntary work, etc. So, if a cultural organization should turn out in practice to be running chaotically, and artists, other employees and art managers feel that the division of labour and coordination might not have been properly arranged, this method is particularly suitable for improving the situation. The various different departments of an organization (e.g. administrative, domestic, artistic) can also be (re)structured, according to the four-step method.

In the organizational praxis of the cultural sector, we find various structuring systems worked out in more detail and sometimes mentioned in the management literature. This elaboration can also help increase our understanding of the design.

To avoid missing activities during the first step, we should concentrate on essential activities and not on their method of execution, which is more a subject for the S/W-analysis. The overview should also be carried out irrespective of personnel, because the employees' performance is a matter for Human Resources Management (HRM). Special professional sources may be used to survey the various activities required, in so far as experience and training are missing from the list of activities. Collective labour agreements and other labour regulations also contain information about these activities.

A rough and ready way of listing is copying the activities of a cultural or artistic organization whose labour division and coordination is similar to that pursued. The counter -argument to this approach, is that the people involved have little concept as to the first step of structuring the organization.

During the second step, we have to take cost efficiency into account. If we consider the activities under Coordination A, it is possible that, while specifying the content in greater detail and within a larger organization, we discover that some activities can be classified as less important than others, such as organizational activities versus operational activities. In that case and because of the cost of labour, we shall have to introduce extra Coordination - but on a lower level.

Within very small cultural organizations, the second step also deals with the content of functions. In general, functions are a common objective of a number of coherent tasks. The specification of a function contains a description of characteristic tasks, authorities and relations. A definitive function specification can only be formulated once the fourth step has been completed. In any case, social considerations like reasonable daily workload, vulnerability, and job satisfaction have to be taken into account. Detailed descriptions must be avoided, as this hinders flexibility.

The logical areas that we set up in the third step can be forged from ideas on creative and managerial processes within the organization. The historical roots of the activities are also relevant in this phase. Each small theatre group can be seen as a functional organization (F-organization within management theory): from input (actors, text and money) via production to performance. This F-orientation, as shown in figure 3.5, can be seen in a lot of cultural organizations. A museum needs products and articles, holds exhibitions and invites people to visit these exhibitions. A concert hall contracts music ensembles and orchestras, programmes their performances and markets these programmes.

Figure 3.5 F-orientation

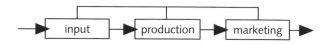

A medium or large-scale organization may have other orientations such as Product (P-organization), Market (M-organization) and Geography (G-organization).

Let us assume that the theatre group develops activities like youth theatre and repertoire theatre. The F-orientation becomes a P-orientation as we can see in figure 3.6.

Figure 3.6 P-orientation

Another example is a theatre with more market-oriented activities. Besides the theatre, group will manage educational activities and a café. In that case, we shall have to abandon the P-orientation in favour of the M-orientation. This situation is illustrated in figure 3.7.

Figure 3.7 M-orientation

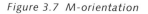

Suppose that the theatre group in our example wishes to have locations in four parts of the city (north, south, east, and west). Their organization then assumes a G-orientation. Figure 3.8 illustrates this.

Figure 3.8 G-orientation

After indicating logical areas, the organizational structure (or hierarchy based on coordination) must be formally established in the fourth step.

Small organizations based on the F-criterion have a simple structure, as we can see in figure 3.9.

Figure 3.9 F-scheme

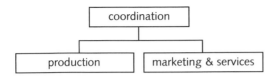

Figure 3.10 shows a complex organization that contains several orientation criteria. These large-scale organizations have a formal line structure connected with /their? basic forms and concentrated on the primary activities, e.g. theatre, education, café, and a staff structure, which can be seen as the sum of supporting activities, e.g. bookkeeping, marketing, secretarial (mainly part of an F-orientation). A manager who runs a department of primary activities is called a line manager, while the supporting manager is named a staff manager. A line manager has decision-making authority and a staff manager has an advisory authority. The organization depicted in the chart is that of an educational art centre with stage facilities.

Figure 3.10 A complex organization within a formal structure

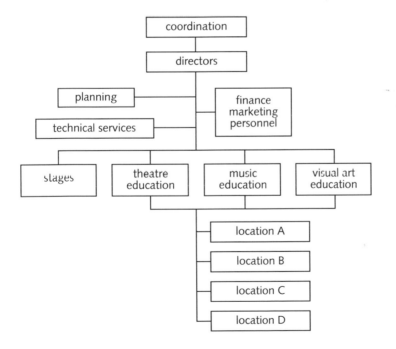

Special attention should be paid to the span of management (also called as the span of control). This coordination issue centres on the question of how many employees' managers are actually capable of guiding and coordinating. While there are no fixed numbers, a total of 4-60 employees can be considered when dealing with routine work,

and 8-10 employees in the case of intensive professional work. If problems occur with regard to the span of management, it will be necessary to examine whether these problems concern a function that is too difficult (either in general or right now), or with the personal performance of the executive in question. To investigate the options and problems, Griffin lists factors that influence the span of management.[7] These factors are:

a. Competence
b. Physical Dispersion
c. Non-supervisory Work
d. Required Interaction
e. Standardized Procedures
f. Similarity of Tasks
g. Frequency of New Problems
h. Preferences.

These factors mean that establishing the span of management is a matter of analysing the tasks, performance and personal capacity of both manager and employees.

As we will see in the next paragraphs the formal, hierarchical structure of figure 3.10 is not always flexible. If cultural organizations have structures like this, and in a lot of opera houses, art education schools and cultural centres this chart is more or less standard, questions can be asked as to how these organizations are able to develop innovative projects, totally new activities and flexible cooperation with other organizations.

3.1.4 Further elaboration

The purpose of this paragraph is to examine the fundamental structure of organizations. The two principles discussed are division of labour and coordination, in the framework of cultural organizations with their typical history and characteristics. These last two factors mean that the structuring process is not a mechanical one but is influenced by the original, founding industry.

In this chapter, this approach will be developed with a view to explaining how cultural organizations evolve (paragraph 3.2). Then we will discuss the basic components of organizations, which may be used to categorize organizational forms (Mintzberg's configuration theory). This is also useful for the cultural sector (paragraph 3.3). In the later paragraphs, we deal with specific themes such as project, network and hybrid organizations (3.4) and organizational culture (3.5), which colour the performance of the cultural organizations.

Practical exercises

1. Visit your local museum and try to find out the orientation on which the structure of the museum is based. Can you explain this orientation with regard to the theory?
2. Find an advertisement in which a cultural organization is seeking a new general artistic director. Analyse the text and draw the structure as suggested in the advertisement. Give comments on the results.
3. Interview a general manager of a media (production) organization and discuss the way this organization has set up the span of management. Which aspects can be seen as relevant?

Closing case *Office for Visual Arts in the initial phase*

After a few years of individual activities, five visual artists from different disciplines decided to combine their art practices. Their aim was mainly business oriented: to generate income by means of cooperation in the field of office management and marketing. The first step was to discuss the idea behind the new organization. Do we also cooperate in an artistic direction? How much money do we invest? What would be the personal involvement of the artists? The following elements are the cornerstones of their organization. The group hires a room in the centre of the city. There, visitors can see some visual art and consult documentation and information about the five artists. There are also facilities such as tables, chairs, telephone/fax, a PC, etc. The office is occupied five days a week. Each artist has a set day to manage the office. To finance the initial investments and to pay the rent, the artists contribute EURO 100 per month. The legal form of the office is a partnership, which means that all the members are personally responsible for the costs of the organization.

The organizational and marketing activities are specified as follows:

- to contact the target group (enterprises, large non-profit institutes, collectors, architects, city councils from the region);
- to keep the documentation up to date;
- to run financial affairs;
- to organize the monthly meetings and to take care of the planning (see the organizational chart below).

After a year, the group has an evaluation session. The following points dominate the agenda:

1. The financial results are very variable and reflect the way the artists manage their contribution individually. One is more motivated than the others, two partners like this method of combining art and business and three have real doubts about their contribution. This doubt relates to attitudes to dealing with business people (see list below). Two artists make a small profit and the others do not (see overview below).
2. The room costs a lot of money (EURO 300 per month) and has no added value. Most meetings are held at clients' offices and not in the hired room.
3. During the office meetings of the last two months, some scenarios were discussed:
 a. To look for new partners in the field of new media
 b. To find a main sponsor
 c. To merge the office with some other Artists Run Organizations
 d. To restructure the organizational and marketing tasks and find a business leader to run the office.

Organizational chart:

Overview of income created by the office (figures in EURO for the first year):

artist	contribution	turnover	gross result
1. Painting	1.200	1.000	- 200
2. Sculpture	1.200	20.000	+ 18.800
3. Ceramics	1.200	800	- 400
4. Glass	1.200	9.000	+ 7.800
5. Drawing	1.200	500	- 700

List of business contacts/commissioners
Law firm X
Law firm Y
Constructor
Retailer
City Council
Bank
Insurance company
Accountant

Case questions

1. Look at the partnership's organizational chart. State the advantages and disadvantages of the structure. Suggest ways of redesigning the existing organization to compensate for the disadvantages.
2. What are your arguments for and against asking a business leader to run the organization? What would be the impact on the partnership if a business leader were responsible for the day-to-day activities. Is it necessary to keep the hired room?
3. Suppose you were involved with preparations for the evaluation session. How would you prepare this meeting and what does the evaluation agenda look like?

Case Reference: Utrecht School of the Arts, Working Document *Zakelijke kennis beeldende kunsten*, Utrecht, 1988.

3.2 Life cycle of art organizations

Learning questions
- What are the main situational factors of a growth and development cycle?
- What can be seen as the life cycle of a cultural organization?
- Do all cultural festivals have a so-called festival phase?

Key words

growth and development	strategy phase
phases of life-cycles	festival phase
idea phase	crises at termination
structure phase	transition

Opening incident: *New organizational drawings*

The municipal theatre has a good cultural reputation. Programming is of a very high professional standard and during the annual celebration of the anniversary of the city, this theatre is the dynamic centre of all sorts of activities, all appreciated by locals and tourists alike. Staff and performers are satisfied with the labour conditions, which is an important issue of the organizational culture. Tasks are well structured and the managers of the several departments are skilful with open attitudes. If employees want to follow courses on new developments in the area of theatre techniques, marketing or audience development, the intendant (general artistic manager) supports this need for organizational training. During a trip to some foreign theatres, organized by a few colleagues, the intendant sees some structures that are unknown to his organization. He notices that his theatre does not have an innovative group or department to strengthen the creative atmosphere and to revive some of the activities. He also realizes that his organization does not have

ongoing network contacts and that the experiences of the annual

celebrations are not used structurally.

With these and other questions in mind, he roughly draws a new theatre

organigraph on the back of his paper. (Fortunately, he had followed a

few graphics' courses in the past). Would his staff recognize the new

structure in his drawings?

3.2.1 Situational factors

As we discussed in § 1.1.2, in order to understand organizations it is important to consider their phases of growth and development as important situational factors. The pattern of the life cycle of an organization has the following four phases, see the representation in figure 1.5:

Figure 1.5 A life cycle of an organization

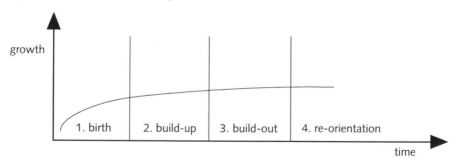

In this paragraph, we explain the details of this model, which enables us to anticipate problems in the organization.

By studying patterns that correlate with growth and development, diagnoses and solutions can be worked out to prevent (complex) problems leading to crises and discontinuity. The various models are based on research into the actual behaviour of organizations (the inductive method), or on assumptions and general ideas about the development and existence of organizations (the deductive method).

The distinction between growth (in a more quantitative sense) and development (in a more qualitative sense), derives from the Dutchman B.C.J. Lievegoed.[8] As regards the development of organizational forms, Lievegoed sees three basic phases: the pioneering phase, the differentiation phase and the integration phase. These phases, including their transitional problems, can be briefly characterized as follows:

a. Pioneering phase
 • pioneer/entrepreneur is central
 • economically oriented

• person-centred organization

If the management does not pay attention to its qualitative development, 'disintegration through complexity' will occur. By anticipating the second phase, the differentiation phase can prevent organizational and strategic problems.

b. Differentiation phase

• logical organization structuring
• standardization and specialization
• hierarchy and delegation

At the end of this phase, there is a chance of 'demotivation through bureaucratization'. To prevent this main problem, the management can introduce the integration phase.

c. Integration phase

• merging of economic, technical and social objectives
• sources are: creativity, innovation, and joint effort
• marketing-oriented.

For Henry Mintzberg, power is the dominant factor when trying to understand the development of organizations.[9] Mintzberg links this power to the phase in an organization's life cycle: birth, growth, maturity, decline and (possibly even) death. In Mintzberg's view, this is not a matter of automatic development but of pointing out conversions. As organizational forms shift, a certain type of transition is evident. This transition can be characterized as Formation, Development, Maturity and Decline.

These shifts manifest the following features:

Formation: from non-existence to entrepreneurial form
Development: from entrepreneurial form to institutionalization
Maturity: from institutionalization to closed systems
Decline: can occur at each previous transition; if the power relations in maturity are politicized, decline will certainly set in, if they are not, then revitalization is possible.

Mintzberg considers it a problem that organizations in decline are often artificially propped up. In his view, organizations in serious decline should die off to make place for new initiatives.

The ideas discussed here are relevant to the cultural sector to the extent that they help us to understand the bottlenecks in the functioning of (non-profit) cultural organizations. This is a view shared by Th.B.J. Noordman, who describes three phases based on Lievegoed et al., in his publication *Kunstmanagement* (Art Management).[10]

1. Pioneer phase;
2. Investment phase;
3. Continuity phase.

The attractive aspect of his model is that it especially helps the art manager that is just starting out, to develop a practical perspective on cultural organizations.

In the Pioneer phase, the central person is the artistic entrepreneur. In this phase, a small group of assistants and board members assists this entrepreneur, who also takes care of the business aspects. The organizational structure is the project form. In this phase, the artistic idea of the pioneer has to be proved viable.

After five to seven years, there will come a moment in which the artistic power is no

longer sufficient. The project organization will change into a more structured one and some people will leave the organization. This investment phase demands structuring, and the function of business leader will be introduced. Five management areas can be recognized: location, marketing, technology, transport and automation. In the third phase, the cultural organization becomes anchored in the environment. A general art manager with expertise in cultural marketing, is responsible for the whole organization. Consistency is an important word with respect to organizational design and strategy formation. The organization in this continuity phase often has a monopoly position in an artistic, financial or geographic context.

3.2.2 A life cycle for cultural organizations

In the day to day practice of the cultural sector there is a need for a more integrated and detailed model in order to understand the development of cultural organization in more or less balanced circumstances, without sudden changes, such as the unexpected departure of an artistic leader or an unforeseen economic crisis. This model has elements of those discussed, but also deals with coherent strategic, organizational and leadership aspects. The basic elements of the model were published for the first time in 1992.[11] Since then this model has been developed and used in a lot of circumstances, thus proving its benefit.

Each phase in this model has the following core elements:
 A: Starting point of the phase
 B: Dominant factor for development
 C: The way strategies are formulated
 D: Main organizational characteristics
 E: Duration
 F: Cooperation and leadership.
Crisis: if the organization does not enter the next phase, a crisis will damage the organization, with the risk of discontinuity.

The outline of the development of cultural organizations is based on four phases: the Idea phase (an Idea as starting point, pioneering - (a) a really new organization or (b) constructed and based on parts of existing organizations such as a merger), the Structure phase (the organization needs a more structured way of working; the idea settles in as a mission), the Strategy phase (the structured organization and the environment have to be tuned to each other on a new level), and the Festival phase (the future of the well developed organization will be based on a flexible, innovative form). By incorporating the above views, these phases look like this (figure 3.11):

Figure 3.11 Four phases of a cultural organization

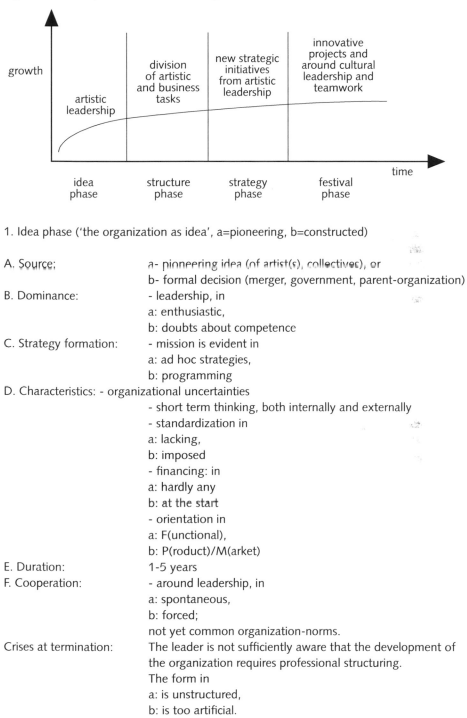

1. Idea phase ('the organization as idea', a=pioneering, b=constructed)

A. Source: a- pioneering idea (of artist(s), collectives), or

 b- formal decision (merger, government, parent-organization)

B. Dominance: - leadership, in

 a: enthusiastic,

 b: doubts about competence

C. Strategy formation: - mission is evident in

 a: ad hoc strategies,

 b: programming

D. Characteristics: - organizational uncertainties

 - short term thinking, both internally and externally

 - standardization in

 a: lacking,

 b: imposed

 - financing: in

 a: hardly any

 b: at the start

 - orientation in

 a: F(unctional),

 b: P(roduct)/M(arket)

E. Duration: 1-5 years

F. Cooperation: - around leadership, in

 a: spontaneous,

 b: forced;

 not yet common organization-norms.

Crises at termination: The leader is not sufficiently aware that the development of

 the organization requires professional structuring.

 The form in

 a: is unstructured,

 b: is too artificial.

The organization is not qualitatively feasible and lacks long-term financing. If this problem is not identified, the decline of the organization sets in. A coup might save the organization. External rescue in

a: none,

b: based on financial or political grounds.

2. Structure phase ('the organization as structure', the difference between 'a' and 'b' has disappeared)

A. Source:	- need (i.e. desire or necessity) for structuring
	- need for continuity through organic extension of organization and programme of activities.
B. Dominance:	- labour division and coordination, planning.
C. Strategy formation:	- annual planning/programming, mission and objectives are clear and based on the original ideas of the first phase
D. Characteristics:	- division of responsibilities
	- team work as well as hierarchy
	- own standardization and methods, professionalization
	- financing is growing towards association to long-range planning
	- P(roduct) or P(roduct)/M(arket)-orientation
E. Duration:	4-10 years
F. Cooperation:	- in departments, leadership, also as a facilitator is required, growthof a common organizational culture.
Crisis at termination:	Organization starts suffering from automatism, quality and professionalization of the management are out of focus and positions are defended.
	Innovation gradually disappears, leader becomes part of the problem. Standardization becomes bureaucratization.
	If the organization does not weather the crisis, liquidation may follow and the management will be too weak for decisive action.
	In this crisis, survival is possible if external financiers initiate a new idea phase, or force the organization towards a strategy phase.

3. Strategy phase ('the organization as strategy')

A. Source:	- strong signals from the environment
	- initiatives from new artistic leadership
B. Dominance:	- environment
C. Strategy formation:	- developing strategic management, often traditional
D. Characteristics:	- permanent organizational change between line and staff management
	- long-term thinking

- quality development and measurable results
- flexible financing
- M(arket)/P(roduct)-oriented

E. Duration: - 4-15 years

F. Cooperation: - in teams, recognizable organizational culture
- leadership mainly strategically oriented
- internal steering by management teams

Crises at termination: Here again, strategy development assumes bureaucratic forms, organization gives groups insufficient space. Environment is analysed, especially on the basis of political factors, neglecting marketing. Organization dies off and is liquidated (or is kept going by the political environment for as long as it lasts).
A coup, including interim management, can save the organization from ruin. Possible third party takeover.

4. Festival phase ('the organization as festival')

A. Source: - the need to use ideas from persons and teams as power plants
- the need to have the content completely determine the form

B. dominance: - mobile structures, international networks

C. Strategy formation: - new practices, e.g. interactive strategic management

D. Characteristics: - fragmentary organizations
- periods of rest and strong turbulence alternate
- absence of staff functions, flexible labour relations
- innovation
- financing per project, minimal overhead

E. Duration: Long periods of a festival phase can be alternated with the concentrated strategy phases

F. Cooperation: - around leadership and in autonomous work forms

G. Crisis: existence of crises at termination: the organization is not sufficiently aware of the presence of hard management instruments like planning and project-financing.
Management falls back on function structuring as coordination instrument.
Dynamic forces cannot be incorporated, because periods of rest are not taken into consideration.

Box 3.1 *Organizational developments, some examples*

From Idea phase to Structure phase
Independent TV production companies are often clustered around a producer/owner. They can survive in the restless environment if they see to it that they structure their organization and give it a more stable basis. Pot-shots, in the form of investments that

are too rapid and extensive, and counting on an unrealistic rate of growth, bring the organization to ruin. The lack of qualities of the founder/owner to structure his or her organization is also a risk factor.

From Idea phase via Structure phase to Strategy phase
Mergers of institutions in the field of art education, bring the organizations involved into the idea phase. This phase is necessary for incorporating the formal models, imposed from above, and transforming them into more suitable structures. If the merged organizations are well run, and the persons involved are strongly focused on the organization having a single identity, it will then be possible to let the idea phase quickly pass into a strategy phase, via the structure phase. A cutback on the part of the financiers can sometimes help to clean up the organizational remnants of the original institutions.

From Structure phase to Strategy phase (and back to the Idea phase?)
The Dutch Ministry of Culture is working towards the privatization of State museums. These museums are currently undergoing a transition from the structure to the strategy phase.
Once the strong ties with the ministry are severed, the museum organizations will be thrown upon their own resources. Depending on the guidance of this process, and the quality of the management in power, it is possible that some museums will remain stuck in the structure phase, or fall back into the idea phase.

From Strategy phase to Festival phase
A well-structured theatre organization with a well-defined strategy is aware that the digital future demands a more outspoken cultural position of the theatre organization. During interactive sessions, managers, artists and other creative professionals decided to decentralize the organization into self supporting teams around the main tasks of the organization (performances, production, education, hospitality). They also created funds for innovative projects in which the employees work together with new theatre makers. The existing management team transformed itself into an open and creative platform with coordination and strategic tasks.

3.2.3 Evaluation

In the chapter on strategic management, we postulated that many organizations in the cultural sector should concentrate on developing strategic management, but that the intensity with which organizations develop this management depends on their phasic position. Even in the Idea phase and the Structure phase, elements of interactive strategic management can be implemented. For organizations that have already been in the structure phase for quite some time, the Strategy phase is a question of survival.

At first glance, all cultural festival organizations are in the festival phase.[12] If we look more closely, however, we see that these organizations often do not manage to progress from the idea phase for a very long period, and even then are not able to introduce any structuring. These organizations are not capable of concentrating on a systematic development of strategic management. Rapid changes in leadership, both artistically and in a business sense, are perhaps to blame for this.

It is important to reiterate that while growth and development models are useful instruments for diagnosing and understanding organizational problems and issues, they cannot be seen as a universal elixir. We should always look at the specific situation of a cultural organization, its artists and leadership, especially if an organization is in transition between one phase and another. The growth and development model is just a new story about the cultural organization beast. Perhaps it is possible to classify this beast as a whole and to 'play the menagerie' within a new and more specific framework. This brings us to Henry Mintzberg's configurations, which will be discussed, in the next paragraph.

practical exercises

1. Look for illustrations of each of the four phases of the life cycle for cultural organizations. Do you see new characteristics that are not mentioned in the model?
2. Research a well-established cultural organization. Analyze its life cycle and formulate some forthcoming aspects. Suggest solutions to possible problems.
3. What is the negative impact of our thinking on cultural organizations, if life cycle models are applied mechanically?

3.3 Configurations

Learning questions

- What are the organizational forces according to Mintzberg? What are the coordination mechanisms?
- Which configuration forms can be considered?
- Which configuration forms suit the cultural sector best? How should we deal with mixed configuration forms?

Key words

organizational forces	technostructure	divisionalized
basic characteristics	operating core	missionary
strategic apex	entrepreneurial	political
middle line	machine	configurations in the
support staff	professional	cultural world

Opening incident: *The whole organizational story of a mime artist*

The mime artist leans back in his chair; he has almost finished working

out his new performance. A lot still has to be done before the first

performance can be staged. He writes down the tasks on a slip of paper

and he then contacts friends and acquaintances to ask them to help.

After a few weeks, he realizes that some of the problems seem familiar. A lack of planning had also caused him trouble, at the start of his mime career a year ago. There must still be a copy of the planning outline lying around somewhere. Taking his earlier experiences into account now means that preparations run more smoothly. Anyway, why does everyone always keep asking him what has to be done?

The whole organizational story is contained in this mime artist's situation. In the formation of organizations, we follow a method that leads from a set of tasks to a formal structure. We then use knowledge about growth and development of organizations to improve our understanding of those organizations. If necessary, we apply corrections to the form obtained, on the basis of our understanding. Finally, we design organizations with an optimal fit to the objectives and activities we want to realize.

3.3.1 Five plus two basic characteristics

Henry Mintzberg has made an unparalleled effort to trace coherent characteristics.[13] He scrutinized the concept of cooperation between people and, after analysing hundreds of organizational elements, he discovered five basic characteristics which, to a greater or lesser extent, occur in every organization. These 'five organizational forces', influence the organizational behaviour, the structuring process, the strategy formation and the way the organization deals with its environment.

Schematically represented (figure 3.12), the five forces have a particular location within the organization.

Figure 3.12 The five organizational forces

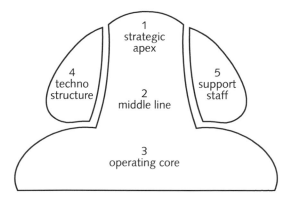

Behind these forces, various functions can be identified:
1. *Strategic apex*: the hierarchical top management of the organization.
2. *Middle line*: the middle managers between the top and executive employees.
3. *Operating core*: executive professional employees.
4. *Technostructure*: members of staff who ensure standardization of the work.
5. *Support staff*: members of staff who support managers and executive employees.

Although Mintzberg considered the five forces as a fundamental quality of each organization, he also saw five organizational forms in which one of the five forces has a dominant position. This position functions as a basic feature for a corresponding structure that can be seen as a basic form or a configuration.

In his book *The structuring of organisations*, he detailed these five configurations. Later, in *Mintzberg on Management*, he added another two, one based on an ideological force (Ideology as the collective values and norms, also called *organizational culture*) and one on political conflicts.
These configurations are (the titles used in his earlier publications are in brackets):
• Strategic Apex brings an *Entrepreneurial configuration* (Simple structure)
• Technostructure brings a *Machine configuration* (Machine bureaucracy)
• Operation Core brings a *Professional configuration* (Professional bureaucracy)
• Middle line brings a *Diversified configuration* (Divisionalized form)
• Supporting staff (with the operation core) brings an *Innovative configuration* (Adhocracy),
and two others:
• Ideology brings a *Missionary configuration*
• Politics brings a *Political configuration*.

In order to understand when and why a particular configuration - with its corresponding coordination mechanisms - can be ascertained, the following situational factors have to be taken into account:
Age and size: e.g. formalized structures are an expression of age, formalized behaviour is connected with large organizations

Technical systems: e.g. using complex machinery, the organization needs a lot of staff members (technical and support staff)

Environment: e.g., a complex environment demands a decentralized organization

Power: e.g., external control of the organization brings a centralised structure. Coordination mechanisms (based on the requirements of division of labour and coordination) must prevent the organization falling apart through power struggles. With this in mind, Mintzberg sees the following six methods, which are selectively used by configuration:

A. Mutual adjustment, especially in the innovative configuration,
B. Direct supervision, especially in the entrepreneurial configuration,
C. Standardization of work processes, especially in the machine configuration,
D. Standardization of outputs, especially in the division configuration,
E. Standardization of skills and knowledge, especially in the professional configuration,
F. Standardization of norms, especially in the missionary configuration.

Figure 3.13 shows the connection between the dominant configuration force and the influence of the coordination (except F in which everyone functions according to the same set of beliefs).

Figure 3.13 Five corresponding coordination mechanisms

3.3.2 Configuration in key words

We will summarize the five plus two configurations here in a few key words.

a. Entrepreneurial configuration (simple structure)

The (often charismatic and centralist) leader is the most important strategic and organizational factor. Direct supervision is one of the organization's governing systems; few or no staff functions, limited middle management. The environment is dynamic but not complex. The entrepreneur intuitively strives to find specific niches in the market and pays less attention to the structuring of his or her organization.

b. Machine configuration (machine bureaucracy)

The need for standardization of production processes dominates the whole organization. The staff has a strong influence (technostructure/ planning). Consequently,

the organization has little decentralization, but extensive middle management. The environment is stable. Bureaucratic strategic planning systems are dominant, sometimes disturbed by strategic revolutions in which the organization creates new products.

 c. *Professional configuration* (professional bureaucracy)

There is a need for the standardization of knowledge and skills. This standardization is developed not inside but outside the organization (in schools, universities, and educational programmes). Staff is reduced to suppress heirarchical control. There is a need for support. The organization is decentralized. Global strategies at the administrative top serve as the framework for professional activities. The environment is complex at the bottom on the professional level, but stable as a whole.

 d. *Diversified configuration* (divisionalized form)

Managers in organizations aim to strengthen their own (decentralized) divisions or departments, both organizationally and strategically. These are then assessed by a small (strategic) summit as regards results. A small workforce supporting the Headquarters focuses on strategic positions in several, often different markets in turbulent circumstances (*corporate strategies*).

 e. *Innovative configuration* (Adhocracy)

Supporting staff members (initiators) and the operational core work together to realize market-oriented innovations on a project base. The coordination of strategy and projects is effected through adjustment (learning processes, Bottom-Up 'grass roots strategies', see also box 2.4). The environment is complex and dynamic.

 f. *Missionary configuration*

Having a mission, charismatic leadership and decentralization based on collective norms, the missionary organization's objective is to dominate the environment.

 g. *Political configuration*

In this configuration, no single dominant coordination can be recognized; relations have become politicized and are no longer productive. All the political parties are fighting to rule the organizations. Strategy and structure are the results of a political arena.

In his research, Mintzberg discovered that in 50% of the organizations studied, a pure form of a configuration was evident. In other cases, he saw mixed forms of two or more configurations. In order to use the configuration theory in practice, the manager, researcher or student has to establish which part of a mixed organization a specific configuration form can be considered and its influence overall.

3.3.3 Configurations in the cultural world

Which configurations can generally be seen in the cultural world?[14] To answer this question we need to relate the characteristics of cultural organizations (figure 1.6 in § 1.1.3) with the nature of the five basic configuration forms as elaborated in this paragraph.

 The matrix in figure 3.14 shows the results. A relationship is marked with a plus (+), a strong relationship is indicated with two plusses (++), and negative (or counter-productive) relationship is marked with a minus (-). An empty space means a neutral relationship.

Figure 3.14 The relation between cultural organizations and configurations.

Characteristics Of cultural organizations>	A. Artistic leadership	B. Professional judgement	C. Small scale, Informal	D. Dynamic environment
Configurations				
1. Entrepreneurial	++	+	++	++
2. Machine		-	-	-
3. Division*	+			+
4. Professional		++	+	+
5. Innovative		+	++	++

* The Division configuration always has a large-scale form and is used in the media and entertainment industry. The starting point of the matrix is the strategic position of the departments (a decentralized division).

The matrix shows that there is a strong relationship within the entrepreneurial and innovative configuration. This confirms that the quality of the strategic and organizational processes can successfully be researched and improved within the framework of these configurations. Complications can be seen between the Top-Down oriented artistic leadership (with direct supervision) of the entrepreneurial form, and the Bottom-Up cooperation of staff members and operating core based on (interdisciplinary) projects of the innovative form (with mutual adjustment). It is highly likely that the effect of these complications can be neutralised by the positive relationship with the professional configuration, which means that leadership and cooperation are influenced by professional norms, attitudes and working methods.

The relationship with the division configuration is positive-neutral and needs to be considered in specific circumstances. If the division form is used in the cultural sector, one should realize that the nature of cultural organizations demands entrepreneurial, innovative and professional space.

There is a negative relationship with the bureaucratic oriented machine configuration. This means that if a cultural organization is highly dominated by technical planning processes, the professional creativity may be lost.

The missionary and political configurations are not mentioned in the matrix. This is because these (new) forms have a specific place in the configuration framework. Mintzberg says that the two configurations can be placed above all the others. Within organizations, there is a weak or strong ideology (organizational culture) and sometimes each organization can become a political organization if several groups (connected with one of the five organizational forces) have conflicts about strategy and working

processes. In the cultural sector, cultural organizations with their cultural mission and the presence of cultural values are nearly always a missionary organization with a story to tell.

To conclude, in the cultural sector we often have mixed forms of configuration with the accent on entrepreneurial, innovative and professional forces that will influence the organizational design process and the use of coordination mechanisms, among others. The missionary nature of cultural organizations can contribute to the development of common shared values.

Box 3.2 *The cultural festival configuration*
The cultural festival is a well-known organizational form for organizing cultural activities in a short period of time and usually with a special theme. This festival form has two natures. During the festival activities, the organization is under strong pressure to meet deadlines, and to communicate with all sorts of people (guest artists, special visitors, press, panels and committees, audiences, employees and volunteers). In this situation, the innovative organization can be very useful because cooperation and problem solving are important. Under this kind of pressure, it is also important to have some tochnostructuro to plan facilitios and to bo curo that trancport and omorgoncy corvicoc aro punctual. On the other hand, the quality of programming demands strong professional involvement. Before and after the festival activities the festival organization often has a small organization with the festival director as entrepreneurial centre and a few team members around him or her. They develop and evaluate the festival activities and are responsible for the strategic and organizational processes. This festival configuration is to be seen in figure 3.15 (the permanent festival organization is printed in bold).

Figure 3.15 Cultural Festival configuration

Mintzberg's ideas are especially important because of the various fundamental perspectives he presents. Although apparently closed systems are used (6 basic forces, 7 configurations), the content of the systems provides the necessary space, especially for exploring deviations, regrouping them and recognizing combinations of patterns in concrete practical situations. In each observation, separate patterns can be found based on Mintzberg's more detailed elaboration.

Nevertheless, we should try to prevent art managers and others from making statements such as 'my organization is a machine bureaucracy'. Any expression that contains the verb 'to be' is fatal to the application of Mintzberg's ideas and above all fatal to the development of the individual imagination. Mintzberg argues that the design of organizations is a question of Lego: combine and converge until you have created your own unique organization.[15]

Practical exercises

1. Read a strategic document of a large cultural organization. See if there is a relation between strategic goals and the organizational structure. What is your impression?
2. Interview a few experienced artists and try to find out which impressions they have about the relation between their work and the coordination mechanisms. What is their opinion about coordination?
3. Surf on the Internet and look for new (cultural) organizations. Can you discover an innovative configuration? Discuss your experience in the classroom.

3.4 Project organization

Learning questions

* What is the meaning of a line, staff, matrix and project organization?
* What are the four dimensions of project management and what are the phases and organizational control of the project methodology?
* What are the outlines of an Initial Report, Project Plan, Project Budget, Project Planning Scheme and Evaluation Report?
* What are the contours of a hybrid organization?

Key words

line and staff	matrix organization	software
project methodology	project organization	communication
phasing	dimensions of result,	project documents
organizational control	space/time, context	hybrid organization
elements (QuOFTIMoD)	and interaction	network structure

Opening incident: *Project uncertainties*

After studying management, Peter went to work for a large festival

organization as a member of several project teams. His task for one of

the projects – i.e. the organization of a special meeting of the

educational board members of the local schools – is to write a Project

Plan. In fact the Initial Report of the former marketing manager was not very clear and contained a lot of open questions. This was justified because there had not previously been educational work within the festival organization. In his project handbook, he read a lot about how to set up a project but dealing with uncertainties in the design phase was a question that puzzled him. It seemed that the project approach was written for experienced project leaders but not for an art manager just starting out. He remembered his mentor Eileen, who was a student too and who had enjoyed a fruitful internship at a complex production company. He called Eileen, who now works at a training centre, and asked her how to overcome the uncertainties that were giving him a strong uncomfortable feeling. Eileen's suggestion was to formulate the uncertainties in each phase of the project. Some issues would remain ambiguous at the beginning of the project. If they were not connected with the core targets of the project, they would not cause problems in this phase. Peter listed these uncertainties and concluded that cooperation between the main school boards was much more important than drawing up a detailed programme of what to do during the meeting. This gave Peter a better starting point for the organization of the project.

3.4.1 From Line-Staff via Matrix to Project organization

In view of the top, middle and bottom layers, each of Mintzberg's configurations has a vertical line structure. This is the structure of an organization characterized by the functioning of line managers. Besides this line, we have a horizontal staff management

geared to technostructure and support. Because of the presence of the entrepreneurial and innovative configuration in the cultural sector, the management line is short and the staff range is small. Within this structure of line and staff management, we also have a form of project management.[16] In figure 3.16, the three management positions are explained very simply.

Figure 3.16 Line staff and project management

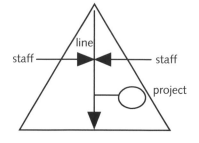

In the cultural sector, a lot of unique activities are produced with the help of a project form. We use this model when making performances, exhibitions, festival programmes, events and marketing campaigns. This means that we should study the relation between staff and line management and project management very carefully. The management model of projects has already been discussed in § 2.5.1 where we explained that the project form suits the organization of the strategic process. We also discussed the project methodology, which incorporates the phasing of a project as figure 3.17 shows.

Figure 3.17 Project phasing

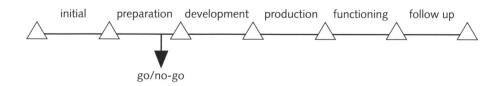

1. Initiative: from Idea to Initial Report
2. Preparation: from Initial Report to a Project Plan (with a GO or NO GO)
3. Development: from a Project Plan to a Production plan
4. Productions: from a Production Plan to a Production Programme
5. Functioning: from a Production Programme to a Functioning Programme
6. Follow up: Evaluation Report
 The Organizational Control elements QuOFTIMoD are: 1. Quality, 2. Organization, 3. Facilities, 4. Time, 5. Information/Communication, 6. Money and 7. Digitization.

There is generally a clear combination of line, staff and project management in a professional organization with a light division structure, and an organization that

develops into a more or less innovative structure. In those cases, the line structure has a dominant position supported by staff, but throughout the organization, there are projects that are not connected with the divisions of departments. These projects have their own relation with the board of directors. This structure, which is called the Matrix organization, is shown in figure 3.18.

Figure 3.18 Matrix structure

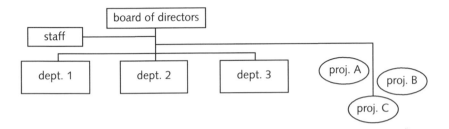

Several variations of a matrix organization are possible. The matrix organization may be directed towards the temporary execution of target activities; it can also be related to the entire production process and give project managers ultimate responsibility. In that case, the organization is completely split up into an independent line organization with its own departments and an independent project organization. This form can be seen in innovative art education centres with a lot of diverse activities. The unity of coordination is then achieved exclusively at the strategic level as illustrated in figure 3.19.

Figure 3.19 A matrix organization with an independent project organization

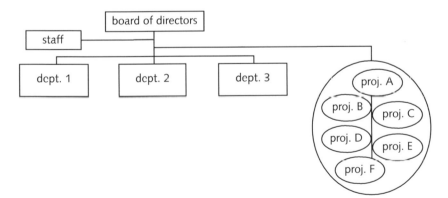

If the line organization disappears and the formal structure is completely determined by projects, we then speak of a projects organization. This projects organization has a small central staff for the planning and management of the basic resources (people and means). An Art Agency organization is often managed in the form of such a projects organization, in which the community activities to be realized form the projects. Figure 3.20 forms an example of a highly flexible structure of this type. Because of the

disappearance of the line structure, this cannot be a matrix structure. Here we see a strong similarity with the ad hoc configuration as outlined by Mintzberg (see previous paragraph).

Figure 3.20 A projects organization

If a line organization is to be transformed into a matrix organization, Griffin says that the matrix form is especially functional in the following three situations: [17]

a. When there is pressure from the environment (and the departments are not able to produce and market in such circumstances);
b. When large amounts of information have to be processed (which is too much for the process capacity of the single departments);
c. when there is pressure for shared resources (using the knowledge of the whole organization).

As a contrast to the advantages mentioned in the literature, he also mentions some disadvantages. Both are included in the following list:

advantages
• flexibility
• improved motivation and commitment
• personal development
• human resource development
• bridges between departments
• ation disadvantages
• problems with loyalty between departments and projects
• risk of chaos and anarchy
• complex group decision-making processes
• more time to coordinate

The confusion in a matrix can exist at both management level and employee levels. If employees are working in existing departments as well as in project groups, problems may develop concerning the division of authority between department and project managers. The problems can have unpleasant consequences: to whom are the employees accountable regarding the time they invest, and which manager ultimately assesses their performance? In practically all cases, it is advocated that the authorities and the coordination should be set down in writing, at the start of a matrix organization and/or when establishing project groups. This avoids as much confusion as possible.

The matrix organization constitutes an important supplement to (and sometimes, correction of) the pure line organization. We can also find examples of opposite trends. Management of a matrix organization with a complex project-organization form demands a lot of energy and time, even if management is supported by ICT. In this case, the management can reduce the complexity by restructuring the working processes. Projects and some departments can combine with a new line and staff organization. Sometimes the environment can be so turbulent that more flexible forms are needed. These new, *network organizations* will be discussed at the end of this paragraph.

Box 3.3 *Projects in small organizations*

In the project management literature, most attention is paid to large projects within complex organizations. The cases are often in the areas of constructing and computing firms. Harold Kerzner sees some typical aspects concerning projects in small organizations. Projects in these organizations generally have a duration of maximum of 12 months, there is constant communication between the team members, a few departments are involved and little time is spent on reporting. Some of his remarks are very relevant to the day-to-day cultural sector. These remarks are:
- the project managers wear various hats (e.g. project manager, line manager)
- the projects have limited resources
- the project manager must have a better understanding of interpersonal skills
- the project manager has shorter lines of communication
- small organizations do not have a project office to facilitate the projects (with know-how, procedures, etc.)
- projects in small organizations are less computerized.

The cultural organization can identify typical issues concerning these remarks and try to prevent problems during the implementing process of project management.

Source: KERZNER (1998), pp. 431-433.

3.4.2 Four Project management dimensions

To create successful projects within an existing organization it is important to consider four dimensions.[18] These dimensions are: 1. Result, 2. Space/Time, 3. Context and 4. Interaction. If these dimensions are taken into account, projects have an ideal framework. The Result dimension is focussed on the formulation and realization of the results of the project. The Space/Time dimension deals with the phasing and organizational control of projects (QuOFTIMoD), which corresponds with the project methodology. The Context dimension is aimed at the environment in which the project results are to be implemented and adapted. The Interaction dimension considers the social relationship, within and outside the project team. Figure 3.21 shows this framework.

Figure 3.21 Four Project Management Dimensions

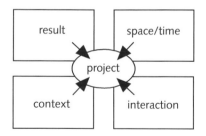

The dimension Result symbolizes the importance of project management. Whenever an organization has to realize an exclusive performance within a short space of time and with limited resources, project management should be implemented. Special activities as part of an existing department's standing programme can be realized more routinely. The implementation of project management means that uncertainties can be managed and reduced and guarantee a result-driven method of working with a clear division of labour and project leadership. The Result dimension is also related to the description of quality criteria for the project result. If a project team has no concept of the Result dimension, it will be very vague about the expectations of the final results and how the results may be implemented in the organization. This dimension also nourishes the expectations of the team, individually and as a group.

The Space/Time dimension targets project methodology (phasing and organizational control QuOFTIMoD). In each organization, there should be formats and protocols for creating a productive formal atmosphere in which systems and procedures help the working methods of the project. In many cases and in non-complex situations, simpler phasing is enough. This phasing for, e.g. organizing a small festival, can be as follows:
1. Initial phase, with an initial report ('why should we organize a small film festival?');
2. Design phase, with a project plan and budget ('what is the core issue of the festival?');
3. Preparation phase, with a scenario ('how should we prepare the festival?');
4. Realization phase, with a programme ('when will what be done during the festival');
5. Evaluation phase, with a evaluation report ('what are the results?').
In the next paragraph, the documents in question will be discussed in detail.

In practice, there is a problem between the Initial phase and the Design phase. If an Initial Report is unclear as to context, purpose and project aims, and the global management control elements are not mentioned, it will have a strong negative impact on the quality of the Project plan of the design phase. In those cases, the target project is more a *mission impossible* for the project leader and his or her team.

Special attention should be paid to the use of ICT within the phases of the project. In a project plan one needs a ICT-plan detailing when and how to use this technology.

Box 3.4 *Project management software*
In the cultural sector project members use their usual software for word and data processing for their day-to-day project work. In this way they are easily able to produce work reports, planning lists, calendar dates, marketing material, budget plans and cost

control reports. It is advisable to create some general formats so as not to waste time and to create clear overviews. Software on a higher level gives analyses, rescheduling reports and re-planning documents if changes are processed. On this level the project manager is the main decision-maker with regard to the use of classified software and is thus responsible for protocols. The highest level is integrated software for multiproject organizations, which provides complex interconnections, cross-project monitoring reports and multi-planning schedules.

The criteria for using software are: design and printing quality, quality of charts, facilities in the fields of planning, budget, marketing, personnel, learning possibilities, ease of use, contextual matters such as hardware and software environment, using the Internet and intranet and financial resources. A special website <WWW.project-manager.com> provides a lot of information on project software, it names the following programmes:

CA-Super Project 3.0
Microsoft Project for Windows, 4.0
Milestones, Etc. for Windows, 1.5
Project Scheduler 6 for Windows
Time Line 6.1

Sources: KERZNER (1998), pp. 674-683.

The success of a project is not only based on a fruitful application of the project methodology but also on an accurate analysis of the environmental context on a fruitful application of the project methodology. In this context the project result will be accepted or rejected. The context may change, e.g. a marketing project on current audiences might start with a lot of attention from the board of directors but during the project planning the focus of the board turns to other issues like potential audiences. The ongoing project would be given less priority implying that the board was not really interested in the results and their implementation.

If a project leader or project team notice that their project is going to vanish into thin air they should put it on the management agenda, and ask for a clear explanation as to its importance.

Sometimes external parties influence the way project activities are accepted. A project can also be redundant because of an important decision by a sponsor, a financier or the government. If a project leader has a good relationship with the principal, both can discuss the new strategy. Perhaps the project can be transformed to realize the its original purpose,as stated in the Initial phase. In this case, a new Project plan and budget have to be produced (going back to the design phase). If the context dimension is well managed, the organization will be more open to implementing the project results. A Power field analysis can be useful for this.[19] This analysis focuses on external parties that have (political) influence on the progress of the project. By carrying out this analysis the project team should list the parties and their stakes with a positive project result. This method gives the project team insight into the quality of the support and possible opposition. It also gives information about the rules of the game on how to deal with projects. Based on this information the project team can develop coalitions to neutralise the effect of the opponents.

The Interaction dimension deals with the communication within the project. This communication, which means a clear and open line between senders and receivers of

messages, plays an important role between the project leader and the team members. Several factors of influence on project communication should be considered as figure 3.22 shows.[20]

Figure 3.22 Influence on project communication

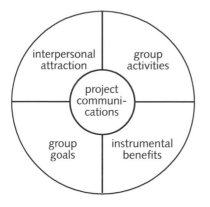

Interpersonal attraction means that a team member feels comfortable and motivated because s/he appreciates the other members. There are several reasons for that: common attitudes, personalities or economic standing. Another important issue is to create and enjoy group activities. As an individual, you are on your own; teamwork is a key word here. Project communication will be stimulated by clear and valuable goals. Even if the activities are not so enjoyable - knocking on doors for money - team members are motivated because of the common goals. The last aspect is the instrumental benefits. Team members have their own reasons for joining a team. Project communication can become very difficult if the project leader and the team members do not have insight into these interests and project experiences or other factors may stimulate new chances in the organization or new contacts outside the organization.

Another issue of project communication is the quality of project leadership. A project leader is primarily a result-oriented manager (see also Box 3.5). However, at the beginning of the project a project leader should pay attention to the well being of the team members. If a positive project culture is established, the project leader can change this style into a more task-oriented approach. In chapter 4, we will discuss leadership styles in more detail.

3.4.3 Project documents

Within project management of a certain complexity, some important decisions have to be made about the content and future of the project. This decision-making process needs formal documents as mentioned above. These documents (Initial Report, Project Plan, Project Budget, Project Planning Scheme and Evaluation Report) will be outlined here.

Initial report

The Initial Report contains the justification for the project, which means that the organization is striving for an unparalleled result with limited time and money. This report has the following elements:

1. Practical information (date, title, name of the writer, staff involved, the commissioner (if there is one), address, phone and fax number and email address)
2. Theme of the project and generally expected results
3. Explanations about motives and background
4. Relation with current strategic goals and other projects
5. Results of environmental research: who needs the project results?
6. Basic ideas on how to finance the project
7. Global phasing
8. Ideas about project leadership and project membership (qualities, quantities)
9. How to communicate the report; decision-making process
10. Organizational control (QuOFTIMoD):
 a. Quality standards on the results
 b. Organization: authority, tasks and responsibilities
 c. Facilities: main characteristics
 d. Time: important deadlines, see also point 7
 e. Information/communication: main guidelines
 f. Money: Indication of Personnel costs, Activity costs, Organizational costs and how to finance these costs, see also point 6.
 g. Digitization: how to use the PC and software in the project.

Box 3.5 Profile of a Project leader

We asked some participants on our management courses to define project leadership. The results were

Social attitude:
1. Pulling yourself in the position of the other
2. Viewing, listening, hearing
3. Open mind
4. Giving space to others
5. Humour

Human factor:
6. Stimulating one's qualities
7. Motivating team members
8. Being critical
9. Creating trust
10. Keeping a special eye on individual interests

Production and organization:
11. Stating expectations and results
12. Formulating priorities
13. Separating main tasks and details
14. Designing a communication structure
15. Decision making

Negotiating:
16. Creating clear positions
17. Being alert
18. Dealing with compromising and win win situations
19. Knowing others' interests
20. Formulating concisely

Project plan

If the Initial report is accepted by the commissioner as an important direction of the future activity (possibly with some corrections), the project has to be expanded in the design phase. This will be done in the project plan, often written by the proposed project leader. In this plan, less attention is paid to the justification because the commissioner has already accepted the original idea. The document can be more concrete on the following issues:

1. Practical information (date, title, name of the intended project leader, names of the project team, the commissioner, address, phone and fax number and email address).
2. Project aims: which desired situations have to be realized?
3. Project results: what has to be realized?
4. Short summary of the environmental and organizational context.
5. Definitions of the key words
6. Phasing and the decision making planning
7. With which networks will the project be connected?
8. Financial planning: headlines, sources, who does what?
9. Communication plan: how should we communicate with the key target groups?
10. Organizational control:
 a. Quality: elaboration of goals and products or services
 b. Organization: position of project leader, tasks of the project team members
 c. Facilities: descriptions of the facilities (rooms, secretariat, communication instruments, and materials) needed
 d. Time: more detailed planning (based on a time line): activities placed in time
 e. Information/communication: which methods can be used to inform the stakeholders internally and externally?
 f. Money: Budget (see the next document) the organization of the financial function (who is authorised to spend the money?), control function.
 g. Digitization: the development of digital possibilities including intranet and the Internet.

A Project plan with its budget is a formal project document. Based on this document the principal has to decide: GO or NO GO.

Project budget

Personnel costs:
1. Salaries (team, employees)
2. Fees (external professionals)
3. Personal transport (between home and place of work)
4. Voluntary costs (free tickets, coffee)
5. Training

6. Insurance (accidents)

Management costs

7. Initial expenses (documentation)
8. Accommodation (desk)
9. Secretariat (materials)
10. Insurance (fire, theft)

Activities

11. Materials (to realize the expected results)
12. Special commissions
13. Marketing (publicity costs, printing, representation costs)
14. Transport
15. Insurance (materials)
16. Accommodation (special needs, such as tents)
17. Copyright
18. Safety services
19. Catering
20. Production costs

Financial plan

21. Contribution of the organization itself
22. Sponsoring
23. Subsidies
24. Own income (tickets, merchandising, paid services)

In the cultural sector, it is an *idée fixe* to start with a 100% guaranteed budget. The project could start with a GO in a situation with a minimum of 60% secured costs. Financial planning has to ensure a balance between financing the costs of the first phase and getting money for the other 40%.

Box 3.6 *Holland Kiev Festival 1992*
The Utrecht School of the Arts in cooperation with art managers in Kiev, the capital of the Ukraine, worked for more than one and a half years on the preparation of a cultural festival in Kiev in 1992. When the festival took place more than forty artists (musicians, visual artists, dramaturges and art education teachers) contributed to the programme. The aim of the festival was to support the Ukraine's cultural democratization process after independence from the Russian Federation.
The initial budget totalled half a million Dutch guilders (EURO 227.272). In the beginning, government agencies and funds reacted frostily to the idea of supporting the project financially. An important reason was the ignorance of the situation in the Ukraine and doubt as to the impact of the festival on cultural life. Dutch business firms that had recently become active in Kiev were also very reluctant to sponsor this adventure. Another problem was the support policy of the European Union. From the moment the Berlin Wall fell in 1989, the European Union supported the East European countries in establishing an economic free market and a democratic infrastructure, but the independent republic of the Ukraine with more than 50 million inhabitants was not mentioned in the list of countries supported.
Finally the budget closed at NLG 150.000,- (EURO 68.181), excluding the many

contributions of co-producers and the money from the Ukrainian party.
The festival was very successful. A cultural dialogue between Ukrainian and Dutch artists and art education teachers was established during a two-week programme. The evaluation report bears testimony to the large number of cultural ambitions that were readjusted. Without a solid and realistic basic budget and an cast-iron budget discipline to control the finance, the festival would have been a financial fiasco.
Source: FOUNDATION SPECIAL PROJECTS, *Holland Kiev Cultural Festival 1992*, (Project leader: Ferry Simonis), Utrecht School of the Arts, 1993.

Project Planning Scheme

what	Jan	Feb	Mar	Apr	May	Jun	Jul	Aug	Sept	Oct	Nov	Dec	who
qualit													
-													
-													
-													
-													
organi													
-													
-													
-													
-													
faciliti													
-													
-													
-													
-													
time													
-													
-													
-													
-													
infor													
-													
-													
-													
-													
mone													
-													
-													
-													
-													
digitiz													
-													
-													
-													
-													

Project Evaluation Report

The project result has been realized. The project is nearly over. In the Evaluation report, the project leader renders an account of the project to the commissioner. On the one hand, the report can discuss all the organizational control factors and on the other, it could make suggestions as to how to deal with the project results. Some comments can also be made on how the organization can support projects in the future.

The outline of an Evaluation report might look like this:

1. Practical information (date, title, name of the project realized, name of the project leader, names of the project team, the commissioner, address, phone and fax number and email address).
2. Project aims: what has been realized?
3. Project results: which results have been realized within the organization?
4. The finished phasing and the quality of the decisions;
5. The reactions of the target groups and stakeholders
6. Organizational control (QuOFTIMoD):
 a. Quality: judgement of the results
 b. Organizational structure: how it worked
 c. Facilities: satisfaction with facilities
 d. Time:Was the planning realistic?
 e. Information/communication: were the people involved satisfied with the information and communication?
 f. Money: a report on the financial results (vis-à-vis the project budget).
 g. Digitization: satisfaction about the use of digital options.
7. Conclusions about the project in relation to the key issues of the Initial report.

 If the Evaluation report is accepted by the commissioner, the project leader is unburdened from his responsibility. This means that s/he has rounded off all the organizational and financial obligations, organized a farewell party for the project members and the network organizations, had an interview in the newsletter of the organization and probably also in periodicals and newspapers.

3.4.4 Hybrid organizations

In this paragraph, we have been discussing the line, staff, matrix and project organization, all based on division of labour and coordination. There are some organizational forms such as the innovative (ad hoc) configurations, the projects and festival organization that might merge to form what is called the hybrid organization.[21] In this organizational form, the orientation principles on which an organizational design is based are no longer clear. Perhaps it depends on their life-cycle phase and the environmental turbulence, but a more rational explanation is that several new factors (such as digitization, internationalization and a higher level of professionalization of –management, project or otherwise) strongly influence the traditional organizational design. Supporting these organizations, strong but flexible teamwork assisted by ICT is a critical condition for realizing goals, but it is not clear how strategies and organizational structure at a corporate level will develop. These organizations certainly have a network structure in which the project groups are strongly related to groups of customers, co-producers and suppliers. Sometimes the network organizations also have a more virtual

character: professionals who have a digital relation with a core team, subsequently join the team as a temporary subcontractor if a project has to be executed. Here the organizational structure is totally dependent on the projects and their need for human resources. In these hybrid organizations, in which we can partly see the flexible cultural world, the problem is not the organic division of labour but the necessity for coordination, including the development and division of management functions such as strategy formation, finance, marketing, and the development of staff functions such as technostructure and support. All these responsibilities are part of the coordination requirement and have to be accepted. In the cultural sector the artistic leadership has incorporated a lot of these aspects into his/her work but if as network organizations seem to show, there is no specific level of coordination, the continuity of this kind of organization is uncertain. Again, the team structure will mostly solve coordination problems on an operational level in an organic way, but the organizational and strategic decision-making process needs to be more structured. We believe that the cultural festival structure, as illustrated in figure 3.15 can be used to elaborate this general problem of hybrid organizations. In chapter 4, we will formulate a new concept to approach and handle this problem.

Practical exercises

1. Take your local cultural festival programme as a project case and examine the project phases. Does the festival management use project documents for their decisions?
2. Try to find out how your organization (or school) evaluates its projects. Do they have written criteria? Suggest some improvements if needed.
3. Look for a matrix organization within and outside the cultural sector. Compare the two structures and their coordination mechanisms. What are your findings? Discuss the results with the management.

3.5 About Organizational culture and functioning

Learning questions
- What is the organizational culture in relation to organizational structure?
- How can we measure organizational cultures?
- How can we describe an informal organization?
- What is the relation between structure, culture and organizational functioning?

Key words

organizational culture	voluntary work	functioning on input-output
constant change	informal culture	level
national, corporate and	informal leaders	organization as black box
professional culture	underorganized organization	organizational storytelling
dimensions of culture	working processes	

Opening incident: *What is going on here?*

Trudy, a young teacher at a dance school was asked to assist the management team of the school for a few hours a week. Her task was to prepare the team meetings and to coordinate the agenda. She appreciated her job because it gave her the opportunity to find out how cultural organizations function. Some situations were really shocking. Despite the fact that the experienced educational leader had the formal power, the decisions were being made by the administrator, who was a very ambitious person. In fact, few decisions were made during the formal meeting and most outside the meeting. For instance, a decision about the renewal of the curriculum was more a question of informal sessions with a few teachers and the educational leader than the subject of a formal meeting of the management team. Another issue was the annual budget for the school, which is a department of a large college. When the educational leader requested more details, the administrator

suggested that the issues were not important and were the subject of his

consultation sessions with the central financial staff. What really

surprised Trudy was the way the formal admission panel functioned. The

voice of but one dominant teacher was decisive while the other teachers

played no important role. Even when this teacher used unreasonable

arguments, there was no corrective response forthcoming. Trudy wanted

to read some formal documents about the structure of the school, the

way decisions have to be made and the responsibilities of some formal

bodies, but where should she begin? The educational leader thought that

the central office had some organizational regulations but he had not

seen them for some time. The administrator was very surprised by the

question and believed that Trudy was criticizing him because of some

disagreements with a colleague. Disappointed by these reactions Trudy

picked up her usual work and distributed the agenda for the next

meeting.

3.5.1 What is organizational culture?

According to Griffin, organizational culture determines the *feel* of the organization.[22] Some organizations are viewed by their employees as cold, uncaring, harsh, impersonal and formal. Others are perceived as warm, caring, personal and informal. In all probability, Griffin says, the design of the organization and its culture are highly interrelated. Where Griffin uses the word 'feel', Mintzberg, as mentioned earlier in this book (paragraph 3.3.1), uses the word *ideology* as a collective of norms and beliefs. This ideology can be so strong that strategy-making and organizational design are dominated by it. Our conclusion is that because of its cultural mission, cultural organizations have strong characteristics of a so-called missionary organization.

Despite the lack of a common definition and the breadth of the subject, the concept of organizational culture is essentially described in the management literature as the set of values, norms and beliefs about the way in which people in the organization work with each other and with their managers. For the proponents of the culture-approach, it is not enough that we outline our strategy and adjust the organization to this strategy. It is also

important that we start to understand this cooperative culture in the organization, within strategic and organizational frameworks. The concept of culture is used here in a general sense and should not be confused with the artistic cultural expressions that are produced and/or distributed by cultural organizations. We should be aware that the combination of words *management* and *culture* can have different meanings. Generally speaking, the management literature discusses culture in the sense of organizational culture. It depends on the context of the sentence whether the word *culture* has a more specific, artistic meaning.

If the organizational culture makes a positive contribution to the quality of the organization, then it is qualified as strong. If the organizational culture causes problems in the realization of strategic and organizational goals, we speak of a weak organizational culture. In the latter, the organizational culture will have to be altered.

Organizational culture has two specific functions.[23] The first is providing fixed patterns for solving coordination problems; the second function is the reduction of uncertainties when employees are confronted with new situations.

In the previous paragraphs we have dealt with various management issues and elaborated on these issues in the context of the cultural sector. Explicitly, but more often implicitly, statements were made about the cooperative culture and the way in which this can be strengthened in the cultural sector. In summary, these individual contributions to the perspective of the organizational culture are:
- positive positioning of the identity of management in the cultural sector gives a sense of self-esteem;
- the explicit formulation of a cultural mission for one's own organization makes it possible to head towards a unique objective together;
- the formulation of identifiable objectives supports the achievement of results and the attainment of success;
- successful innovating is a question of mentality, as well as a question of strategy;
- the further streamlining of the organization clarifies one's own position and promotes both satisfaction and quality awareness in the organization;
- the positive approach to one's own team organization and the emphasis on project-oriented work in separate groups, each with its own atmosphere.

In addition to the application of these points, the organizational culture depends, to a certain extent, on situational factors such as environment, leadership, education, and phase of life cycle. It is also important that an art manager draws a distinction between profit ('no market income means the death of the organization') and non-profit (with its invisible ties to a lot of general interest groups or stakeholders), and between production (product-oriented) and distribution (oriented on marketing) organizations. Finally, the legal form also influences the organizational culture, e.g. does the cultural organization have a union-structure with a democratic Bottom-Up climate or a Top-Down structure with an entrepreneur/owner?

All these factors accentuate the above-mentioned extent of the subject; it is and remains difficult to get a concrete grip on the significance of the organizational culture for insiders and outsiders.

Some authors have attempted to develop a certain systematicity in the approach to organizational culture. Tom Peters, in his *Thriving on Chaos*, has written a characteristically American standard work on organization culture.[24] He places organizational culture in the context of constant change, which is aimed at giving American businesses a competitive edge over Japanese businesses. His cultural revolution takes place in five management areas: Customer Responsiveness, Innovation, Power People, Leadership, and Systems for a World Turned Upside Down. The significance of Peters' approach is that the management (of large-scale organizations) is constantly supplied with suggestions for considering strategy development and organization structuring as a dynamic process.

According to Knut Bleicher, organization values and norms for the behaviour of members of the organization are explicitly laid down in company legislation and implicitly in an organizational culture.[25] Bleicher finds it impossible to set down the objectives of an organization without implicating the values advocated by individuals in the organization. This specific point of view turns organizational culture into an independent organizational issue.

In Bleicher's view, organizational cultures develop at various levels:
• The management fulfils a model function. Apart from personalities in the management, heroes also play a cultural role in the organization (e.g. the wonderful and admired actor of a theatre group);
• Meaningful interactive events establish values that fulfil a core function in the organizational culture (e.g. the joint achievement of success of an inspiring festival programme);

In addition, primary and secondary elements can be identified that influence the existing organizational culture. Primary elements are the instruments in the area of personnel planning (training, recruitment, and selection); the secondary elements refer to the hard management such as systems, structures and formal regulations.

An important distinction can be made between national, corporate and professional culture as figure 3.23 shows.[26] The national culture is connected with values and norms within a nation. Corporate culture is the norms and beliefs within one whole organization. Professional culture means norms and views within a group of the same profession.

Figure 3.23 Three levels of culture

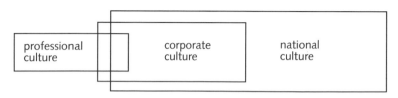

If there is an organization that works internationally with representatives from different national cultures, this organization should deal with these differences and the necessity of creating a strong corporate (organizational) culture. If there is a weak organizational culture and the differences of national cultures are intrusive, a strong professional culture

within a team or department can establish a common positive atmosphere. The most desired situation is a balanced relationship between the three cultures, in which national cultures are respected, organizational culture has a positive influence on realizing the mission, and professional culture motivates people to work out their plans.

Box 3.7 *Individual differences Across Cultures*
To recognize individual behaviour across cultures it is important to understand how the characteristics of a culture (of a country) affect the behaviour. With the support of Dutch researcher Geert Hofstede, we can identify five dimensions with two extremes. These dimensions are called Social orientation (individualism versus collectivism), Power orientation (power respect versus power tolerance), Uncertainty orientation (uncertainty acceptance versus uncertainty avoidance), Goal orientation (aggressive goal behaviour versus passive goal behaviour) and Time orientation (long-term outlook versus short-term outlook). Each culture can be located within the framework of the five dimensions. The results can be used to explain individual behaviour on issues of perceptions, attitudes, values, motivation, etc. Here are a few rough examples of Dutch culture. In the Netherlands people are strongly individualistic and less group oriented, they have a low power respect and do not accept Top-Down decisions easily, they have a moderate position on Uncertainty and Time orientation and are more or less passively goal oriented, i.e. much attention is paid to social relationship.
Hofstede's approach is very useful to artists, employees, art managers, students and teachers who are preparing for a long visit abroad. Maybe they will experience a culture shock but most of the individual reactions and attitudes can be seen as specific expressions of the five dimensions.
Sources: Geert HOFSTEDE, Cultural Constraints in Management Theories, in: Bob de WIT, Ron MEYER, *Strategy Synthesis, Resolving strategy paradoxes to create competitive advantages*, Int. Thomson Business Press, London, 1999; GRIFFIN (1999), pp. 152-155, Griffin indicates that he has changed some labels of the dimensions for mainly practical reasons (chapter note 30, p. 165).

3.5.2 How can we measure organizational culture?

If an art manager and his/her staff are responsible for the balance between a professional structure and a strong organizational culture, it is desirable to have an instrument to measure this culture.[27]

The method presented here assumes that organizational culture can be localised in terms of opposing concepts that form a dimension. We have adapted their results somewhat, enabling us to apply them to the cultural sector. The adaptation is especially aimed at acquiring a more or less integral view of the organizational culture, see scales a to g.

a	process oriented	———————	result oriented
b	people oriented	———————	task oriented
c	organizationally bound	———————	professionally bound
d	closed	———————	open
e	tight check	———————	loose check
f	pragmatic	———————	normative
g	single-dominance culture	———————	subcultures

a. Process – Result Dimension
The process-oriented approach means that the organization homes in on the working method. The converse side of this dimension is the importance of results. The way these results are achieved is not so important.

b. People – Task Dimension.
If leadership attends to individuals in the organization, it is people oriented. The converse side is paying attention to positions and functions that emphasize tasks.

c. Organizationally – Professionally bound Dimension
Organizationally bound, means a central position for the organization and a lower position for the professional work. Emphasizing professional work without paying attention to the interest of the whole organization.

d. Closed – Open Dimension
An organizational culture is closed if incoming artists, employees and volunteers have difficulty being accepted by the organization. An open organization gives newcomers the feeling that they are very welcome.

e. Tight – Loose check Dimension
In a tight check culture, each activity has to be checked by a leading person or a staff member of the technostructure. Loose check means freedom to organize within a certain framework.

f. Pragmatic – Normative Dimension
The pragmatic aspect is technically oriented to getting things done. In a normative approach, things can only be done by taking into account a set of norms regarding the production and distribution of cultural goods and services.

g. Dominance – Subcultures Dimension
If an organization has one clear organizational (or corporate) culture, this culture will dominate the norms and values of groups and departments. The converse is the dominance of subcultures within one organization and no universal culture.

Some practical examples show how these dimensions are used. The results of interviews and questionnaires can be indicated on the scales and discussed accordingly in management sessions, strategic groups and project teams.

The organizational culture of a festival organization:

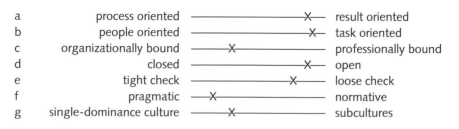

a	process oriented	——————————X—	result oriented
b	people oriented	——————————X—	task oriented
c	organizationally bound	———X—————	professionally bound
d	closed	——————X—	open
e	tight check	——————X—	loose check
f	pragmatic	—X—————	normative
g	single-dominance culture	———X——	subcultures

In the evaluation, it was suggested that the checks would have to be tightened up anyway because of the freedom suggested results in high costs. The festival should also pay more attention to dates and deadlines in which space for professional work has to be elaborated. This may entail a concession to the more general aspect of openness.

The same research was done with representatives of large museums:

a	process oriented	———X———————	result oriented
b	people oriented	———X———————	task oriented
c	organizationally bound	—————X—————	professionally bound
d	closed	——X———————	open
e	tight check	X———————	loose check
f	pragmatic	—————————X—	normative
g	single-dominance culture	—————————X—	subcultures

In response, the participants remarked that it was difficult to realize an open work atmosphere in the museums because each group or department fell back on its own professionality. They feel this organizational culture to be a well-controlled group of professional islands but without a corporate and stimulating identity. It was proposed that special meetings be organized to mobilize interest for each other's results, right across the lines of sub-cultures.

The final study involved a group of theatre managers. In this case, the aim was to gain insight into the culture of a group of theatre companies. This demonstrated that the seven dimensions can also be used to measure the culture within a sub-sector.

a	process oriented	———————X—	result oriented
b	people oriented	———————X—	task oriented
c	organizationally bound	——————X———	professionally bound
d	closed	—X———————	open
e	tight check	———————X—	loose check
f	pragmatic	——————X———	normative
g	single-dominance culture	——————X———	subcultures

They were under the impression that the production (result and task-oriented), necessarily obstructed an open organizational culture. The conclusion however, was that extra attention had to be paid to the support of newcomers (young actors, theatre technicians, office employees and members of the board).

Up to now, we have not looked in any detail at the question of who is specifically implicated in the cooperation culture. One can take legal relations between members and organization and arrive at the position that only members with an employment contract count.[28] Here, freelance employees only carry out specific work and cannot be considered as belonging to the circle of employees.

In our opinion, we are dealing here with an untenable position if we consider the cultural sector. Artists and other employees can be involved in organizations on the basis of standard employment contracts, but many other constructions have been developed in practice.
The following list makes this clear:
• agency staff; recruitment proceeds through employment agencies;

- stand-by staff; recruitment proceeds through one's own card files;
- freelance artists; the recruitment proceeds through internal registration systems or through employment offices;
- trainees from institutions in the field of culture and management;
- persons working on social schemes (work experience schemes, social work programmes).

Both in principle and in practice, these groups may be considered as belonging to the circle of employees working together, and they leave their unique mark on the organizational culture because of their various backgrounds. These are often part-time employees, and the sense of belonging to an organization will have to be enhanced with the aid of the organizational culture.

A special subject in the field of organizational culture is often left undiscussed in the general management literature. We are referring here to the large amount of voluntary work that is carried out in the cultural sector.[29]

Although specific research material is lacking, we dare to conjecture that without voluntary work, the cultural sector cannot function in its present form. An approach to organizational culture cannot ignore this important fact.

Following the American literature on art management (where the position of the volunteer is valued highly), we must make a distinction between volunteers who participate in the management, and volunteers who carry out the work. The volunteers in the management maintain the contacts between society and organization, while volunteers who work at the operational level are more focused on carrying out interesting activities. The latter group is in any case less interested in assuming general (management) responsibilities. In view of the importance of a qualitative contribution by the board of trustees, Brann Wry, a professor on art administration for the performing arts of the New York University, advocates setting up a special Board Development Committee, that takes care of the nomination, assessment and education of members of the board through sub-committees.[30] By paying a lot of attention to well-functioning boards, a contribution is made to an optimal environment for cultural organizations.

McDaniel and Thorn however, are not so optimistic about (American) board participation within a cultural organization.[31] In their experience board members have no work experience in the art world, do not understand the creative and artistic processes and bring in opposite approaches based on traditional management hierarchy, e.g. a bank organization or a large law firm, which do not suit the creative core.

The functioning of the board in general will be discussed in chapter 4.

3.5.3 Informal organization

Within the formal structure, people who work together build up an informal organization. Informal organizations develop along the lines of common backgrounds (region, language, religion, hobbies), desired or required behaviour (profession, education) or internal group developments (working on special assignments, staying in special locations). Griffin describes the informal organization as the patterns of influence and behaviour arising from friendship and interest groups in organizations.[32]
In his view, informal organizations develop through the employees' need for:

- participation in communication networks that provide information;
- social acceptance and the pleasure it provides;
- variation from routine work;
- security with a view to individual support.

Because of its informal way of working, the cultural sector encompasses a lot of informal organizations within formal structures. In a theatre company, the artistic director with a formal position knows that within his or her organization, prominent actors play a key role in the more informal organization. The same situation can be seen in a museum where well known curators have a recognizable, non-formal influence on the organizational processes within their organization.

The danger of informal organizations and their informal leaders is that they can undermine the formal structure, strategy and leadership of the organization. This occurs, for example, if informal leaders make it impossible for the official managers to do their job. Another example is spreading incorrect information via informal channels and platforms. These undermining acts work counter-productively as regards the division of activities (division of labour) and the coordination of these activities for achieving the organization's objectives (coordination). In such a situation the political configuration, as described by Mintzberg, is established. In fact two organizations have been formed. Figure 3.24 explains this with a diagram.

Figure 3.24 The formal and informal organization can be opponents

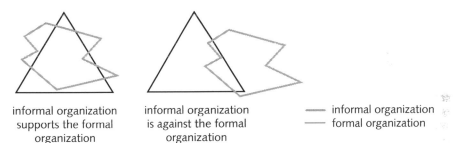

informal organization
supports the formal
organization

informal organization
is against the formal
organization

═══ informal organization
──── formal organization

However despite this danger, Griffin argues (in the 4th ed. of Management) for an open attitude towards the informal organization: 'The key point is that the manager must not ignore or try to eliminate the informal organization. It is important to recognize the informal organization and respect it for the power it has to accomplish positive as well as negative things. The truly effective manager is one who manages not just the formal organization, but the informal as well.'

3.5.4 Structure, culture and functioning

We regard cultural organizations as being professionally developed if there is a clear idea as to how this organization is structured, based on the division of labour and coordination and a strong organizational culture that supports the execution of the intended targets. If these main elements are ill defined and there is a lack of direction, Cummings and Huse refer to the organization as being *underorganized*.[33] They suggest that such organizations mainly operate in projects and new fields where relations between people

and groups have to be established and coordinated around complex and uncertain tasks. It is not difficult to add the cultural sector to the areas mentioned. However, with the help of the management theory, in this case focused on structuring the organization, the negative aspects of an underorganization, such as unclear role descriptions, lack of control and fragmented job responsibilities, can be swung in a more professional direction.

If an organization is well structured, we can see who is responsible for what, but the question of well-organized functioning on an input-output level, has not yet been answered. As we mentioned at the beginning of this book, functioning is increasingly becoming a separate area of the management theory (§ 1.1.2)[34]. Functioning of the organization means that an organization has a transparent way of working on the level of consultation, and that its working processes are efficient. A working process is indicated by a moving line that shows the process from beginning to end within the formal structure. Consultations are indicated by a web design.
 Figure 3.25 shows the functioning of the working process of a music school.

Figure 3.25 Functioning of the working process

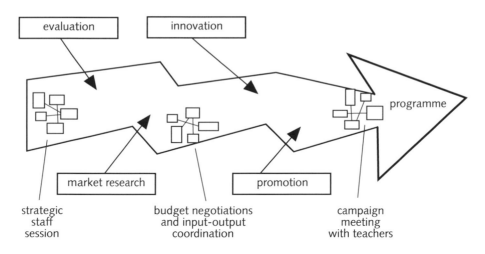

The advantage of designing the working process is that we can analyse problematic issues of this process in practice. For instance, if in this case pupils and their parents are complaining about the quality of some lessons we can ask the following questions:
1. Did the staff check the evaluation procedure?
2. Was the evaluation of a professional quality?
3. Was there a discussion during the input-output coordination?
4. Were the complaints put on the agenda of the teachers' meeting?

We can also use a circle to draw the working processes to explain how organizations function. Figure 3.26 gives information about the functioning of a cultural festival.

Figure 3.26 Functioning of a festival organization.

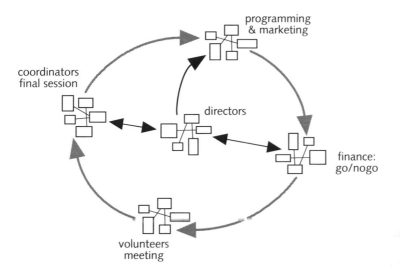

Within a department or a complex project organization, a stream scheme can show how the intended activities are connected. This model can also be executed with the help of ICT. Figure 3.27 illustrates an example of a project-organized celebration within an existing organization. To make it more complete, this scheme can also be combined with the project phasing as discussed in paragraph 3.4.1.

Figure 3.27 Stream scheme of project functioning

By using these kinds of illustrations of the working processes one can correct or augment these processes with new elements, which may be extra input or an extra consultation session. It is also possible to redesign the process, e.g. if we want to reduce its complexity or consultation moments.

To conclude, structure as the most dominant process, organizational culture, informal organization and functioning are the key words of how organizations are structured and how they function. Figure 3.28 integrates these key words and shows how an organization can become a *black box* if we cannot distinguish between the different levels of organizational substance.

Figure 3.28 The key lines of the structure and functioning of an organization

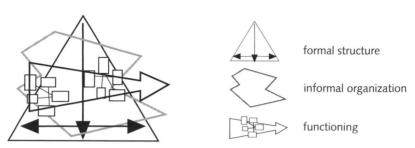

formal structure

informal organization

functioning

It makes clear that an organization (cultural or otherwise) has several organizational stories and that one should know when a specific story has to be told. The *narrative* competence of organizational storytelling, which is complex and not easy,[35] is certainly one of the responsibilities of art managers, as we will see in the next chapter.

Practical exercises

1. Research a 'weak' and a 'strong' organizational culture outside the cultural sector. Does your research give new insight into the subject of culture? Discuss the results with your fellow students.
2. What can the function of volunteers be in establishing a strong organizational culture within cultural organizations? If you do voluntary work, what is your experience with the organizational culture?
 Think about some projects you have been involved in recently. Find out their working processes and make an illustration of these processes. Ask your former project team members for a reaction.

Closing case *Re-structuring of a cultural centre*
Negotiations took more than two years but in the end, all the partners were enthusiastic about the result: a restructuring of cultural organizations in the northern part of the capital, which was established in mid 18th century. It was a public secret that cultural life in this region was underdeveloped in spite of the existence of a locally subsidized Museum of Folk Art with a unique collection, a locally subsidized cultural centre with 750 seats primarily for musicals and ballet and two state art education institutes (Music and Visual Arts). All these institutes are non-profit organizations and deal with financial and marketing problems. In the cultural centre, the organization is under reconstruction towards project organization (not yet realized).
Mr Gustav Kasseldorf, the new director of a hotel and cinema chain, has taken the initiative to renovate a hotel annex theatre (900 seats) and cinema (two halls) in the northern centre. These organizations have the same sorts of problems as the non-profit organizations: low-key cultural profiles and minimal

profitability. The director of the hotel chain has an academic cultural background at MBA level and is an expert in cultural development projects based on Public Private Partnership (PPP). His view was that if the existing cultural institutes would cooperate, the northern part of the capital would be able to develop an interesting cultural centre with two fine mainstays: art and entertainment, which would introduce an element of competition to the central city.

Mr Kasseldorf puts what he called three critical success factors on the negotiation table:

1. All the non-profit cultural organizations must have one spokesman who has the authority to make deals. The perspective must be one non-profit organization, one director and one supporting staff (programming, finance, marketing, and personnel) and a matrix structure to cooperate with the cinema and the hotel-theatre.
2. Local government must invest in the renovation of the northern centre, to the tune of EURO 200 million. This amount excludes the supposed support of the Heritage Fund to renovate the old buildings.
3. All the organizations must create a new non-profit innovative and entrepreneurial cultural organization with tasks in the fields of ticketing, art promotion and art services such as market research, art sponsoring under the supervision of Mr. Kasseldorf as general manager of this promotion institute. The overall annual budget will be EURO 0.5 million.
4. The whole project must be finished within 4 years.

The hotel and entertainment chain's counter-offer is:

1. An investment of EURO 25 million for the accommodation for the entertainment activities;
2. The rebuilding of the cinema into a multiplex of 10 cinemas. The City Council will give full support to these projects (permits, infrastructure), within the scope of the plan.

The City Council is very positive about this form of PPP but can invest no more than EURO 150 million, including the financial resources of the cultural Heritage Fund. The council also wishes to reiterate the need to cater for the diversity of cultures within this part of the city.

Mr Kasseldorf agrees with the financial policy under protest and on condition that his firm would not pay for the Multiplex plot.

The boards of Trustees of the non-profit cultural organization are also positive, as are the directors. Only the director of the museum is negative and strongly opposed because of his wish to remain independent. After a conflict with the board, the museum director resigns. Meanwhile one of Mr. Kasseldorf's staff members becomes interim manager of the museum with the permission of the local government. Another problem is the position of the art education institutes, which are nationally financed. The Minister of Culture is not politically in a position to participate within a local PPP-framework but signs a letter of intent, thus allowing the directors of the education institutes to cooperate with the local partners. The most important issues in the letter are:

1. Renovation of the theatre stage at the music school
2. The establishment of a new theatre education department
3. Construction of an exhibition hall at the school for visual arts.

Within a few weeks, Mr Kasseldorf will organize a brainstorming session with regard to the following organizational questions.
1. How will the new partnership with the hotel-theatre, multiplex, museum, cultural centre, a new promotion centre and two education institutes function?
2. What is the new organizational structure for the museum and the cultural centre?
3. What is the new organizational structure for the innovative art promotion organization (budget: EURO 0.5 million)?
4. Do we need a project committee to renovate the northern cultural centre?

The existing organizational schemes are as follows:

1. Local hotel and entertainment organization

2. Museum for Folk Art

3. Cultural centre (scheme not yet formally accepted by the trustees)

Case Assignment:

Suppose you work at Mr Kasseldorf's staff office. He asks you to write a report to discuss at the brainstorming session the questions mentioned.

Consider that you also have to deal with the following items:

1. Who should be invited to participate in the brainstorming session?
2. What will be the role of Mr Kasseldorf?
3. How can a positive and open brainstorm culture be created?
 What does your document look like?

Case references: Tomorrow belongs to Berlin, The European, March 15, 1998; BOEKMANSTUDIES, *Nieuwe partners in kunst, publieke-private samenwerking in de kunstensector*, Boekmanstichting, Kunst & Meer Waarde, Amsterdam, 1999.

1 This chapter is based on: Giep HAGOORT, *Cultural Entrepreneurship, an introduction to art management*. Phaedon, Culemborg, 1993, chapter 3. See also: William J. BYRNES, *Management and the Arts*, Focal Press, Boston, 1993, 87-111.

2 Ricky, W. GRIFFIN, *Management* (6th ed.), Houghton Mifflin Company, Boston, 1999, pp. 372-373; D. KEUNING, D.J. EPPINK, *Management & Organisatie , Theorie en Toepassing*, Stenfert Kroese, Houten, 1996, pp. 296-302; James Brian QUINN, *Intelligent Enterprise*, The Free Press, New York, 1992; see for a radical change of the traditional division organisation: Christopher A. BARLETT, Sumantra GHOSHAL, *The individualized corporation: a fundamentally new approach to management,* 1997.

3 GRIFFIN,(1999), pp. 322-351; D. KEUNING, D.J. EPPINK (1996), pp. 81-103; Henry MINTZBERG, *Mintzberg on Management, Inside our strange world of organizations,* Free Press, New York, 1989, pp. 95-115.

4 MINTZBERG (1989), p. 100.

5 This process is based on: KEUNING, EPPINK (1996), 109-119.

6 See different perspectives from: William J. BYRNES, Management and the Arts, Focal Press, Boston, 1993. pp. 87-111; Xavier CASTANER, The tension between artistic leaders and management in arts organization: the case of the Barcelona Orchestra, in: *From Maestro to Manager, Critical issues in arts & culture management,* Oak Tree Press, Dublin, 1997. Special issues about opera organizations: Tuomas AUVINEN, Opera house - A difficult thing to manage?, in: *AIMAC'99*, pp. 507-521; Joyce ZEMANS, Archie KLEINGARTNER, *Comparing cultural policy, a study of Japan & the United States,* Sage Publications, Walnut Creek, 1999, pp. 203-225.

7 GRIFFIN (1999), p.334.

8 B.C.J. LIEVEGOED, *Organisaties in ontwikkeling*, Rotterdam, 1984, pp. 44-54.

9 MINTZBERG (1989), pp. 281-300.

10 Th.B.J. NOORDMAN, *Kunstmanagement*, Vuga, Den Haag, 1997.

11 HAGOORT (1993), p. 11-14.

12 See also: Marja ERIKSSON, Patterns of management in four Finnish Festivals, in: *AIMAC'99*, pp. 32-41.

13 MINTZBERG (1989), pp. 93-300.

14 HAGOORT (1998), p. 59-66; see for a comparison between an orchestra and a professional configuration: CATANER (AIMAC'99), pp. 396-398; MINTZBERG (1989), p. 265.

15 See also: Gareth MORGAN, *Imagination; the art of creative management,* 1993.

16 Harold KERZNER, *Project management, a systems approach to planning, scheduling, and controling* (6th ed.), John Wiley and Sons, New York, 1998; Jan VERHAAR, *Project management, Een professionele aanpak* (2e druk), Boom, Amsterdam, 1999; Lucio ARGANO, *La gestion dei progetti di spettacolo, Elementi di project management culturale*, FrancoAngeli, Milano, 1997.

17 GRIFFIN (1999), p. 370.

18 Giep HAGOORT, Tijd voor projectarchitectuur, projectmanagement in de culturele sector, in: *Vakblad Management Kunst & Cultuur*, 4/1998a.

19 Igor ANSOFF, *Implanting Strategic management*, Prentice Hall, Cambridge, 1990, p. 207

20 GRIFFIN (1999), p. 580.

21 GRIFFIN (1999), p. 371; MINTZBERG (1989), p. 265.

22 GRIFFIN (1999), p. 170.

23 KEUNING, EPPINK (1996), p. 364; see also: David CRAY, Geoffrey R. MALLORY, *Making sense of managing culture*, Int. Thomson Business Press, London, 1998.

24 Tom PETERS, *Thriving on Chaos*, London, 1989.

25 Knut BLEICHER, *Das Konzept Integriertes Management*, Campus Verlag Frankfurt/New York, 1991.

26 Mathieu WEGGEMAN, *Leadership and cultures*, MA AMMEC-Guest lecture, Utrecht School of the Arts, 2000.

27 These dimensions, with the exception of dimension *g*, are mentioned by Keuning and Eppink and originally formulated by Hofstede, Sanders and Neijnen: KEUNING, EPPINK (1996), pp. 366-369.

28 KIESER, KUBICEK (1983), p. 12.

29 See also: Craig DREESZEN, Pam KORZA (ed.), Fundamentals of Local Arts Management, Arts Extension Service, Amherst, 1994, pp. 205-229; KOTLER, SCHEFF (1997), pp. 424-429; Janet SUMMERTON, Hidden from view: the shape of arts work and arts organizations in the UK, in: *AIMAC '99*, pp. 159-165.

30 Brann J. WRY, Arts Governance in the USA and the Netherlands, in: *Reader International Art Management Seminar*, New York University & Utrecht School of the Arts, 1995.

31 Nello MCDANIEL, George THORN, Arts boards, *Creating a new community equation*, Arts Action Issues, Brooklyn, 1994.

32 GRIFFIN (4th ed. 1987), p. 469 (in the 6th ed., the definition of informal organization was scratched)

33 CUMMING, HUSE (1993), p. 65.

34 There is a fundamental misunderstanding about the meaning of structure and functioning. Some writers (MCDANIEL, THORN (1994), ALLUIVSEN (AIMAC'99), Henry MINTZBERG, Ludo van der HEYDEN, Organigraphs: drawing how companies really work, *Harvard Business Review*, September-October 1999; GHOSHAL, BARTLETT (1997) criticized the formal structure as not being the reality of the organization. Structures (organizational schemes) tell us about formal coordination, functioning figures are necessary to know what the working processes are within the formal structures. We are dealing with two different themes, as explained in this paragraph.

35 See for an interesting contribution: Sara L. TALAS, The sense of organizing theatre: exploring repertoire decision-making in narrative perspective, in: *AIMAC'99*, pp. 617-627.

Values

Othello believes more and more that Desdemona is deceiving him and making love with Cassio. Iago piles up intrigue upon intrigue and draws misleading information from Cassio about the handkerchief while Othello listens from a secret place. Desdemona is now publicly disowned by her husband.

Desdemona and Emilia have a talk about love and conjugal fidelity. To Desdemona, it is impossible to deceive one's spouse while Emilia can imagine such a deed if the price is high enough.

But I do think it is their husbands' faults
If wives do fall. So that they slack their duties,
And pour our treasures into foreign laps,
Or else break out in peevish jealousies,
Throwing restraint upon us; or say they strike us,
Or scant our former having in despite;
Why we have galls, and though we have some grace,
Yet have we some revenge. Let husbands know
Their wives have sense like them; they see and smell
And have their palates both for sweet and sour,
As husbands have. What is it that they do
When they change us for others? Is it sport?
I think it is; and doth affection breed it?
I think it doth; is 't frailty that thus errs?
It is so too; and have not we affections,
Desires for sport, and frailty, as men have?
Then let them use us well; else let them know,
The ills we do, their ills instruct us so.

(ACT IV, 3)

4 Cultural Leadership

4.1 Art management and leadership

Learning questions
- What are the dimensions of leadership and management?
- What is coordination, what is decision-making?
- How would you describe personal management?

Key words

leader	art manager	effective people
manager	coordination levels	stress factors
entrepreneur	constitute tasks	burnout
employer	direct tasks	
managerial work	decision making process	

Opening incident: *On the Art of Leadership*

"By definition, a leader is someone who by force of example, talents or qualities of leadership plays a directing role, wields commanding influence, or has a following in any sphere of activity. The difference between a business manager and a business leader is that the former knows how to organize work so that is done efficiently, while the latter knows how to create enthusiasm about work so that it is done with commitment. Managers direct; leaders inspire. Leaders stimulate a collective desire to achieve high levels of performance, to serve the interests of both the company and the community, to provide benefits to others while fulfilling personal ambitions. Like the conductor of an orchestra under whose guidance musicians realize the full potential of a

composition, a business leader orchestrates the activities of large numbers of people working together toward a common objective.

The relationship between the business leader and the arts is part of an age-old tradition. The well-known examples of Pericles in Ancient Athens, Maecenas in ancient Rome and the Medicis in fifteenth-century Florence, are often cited as prototypical examples of roles that enlightened leaders have played in the cultural life of their times. In the United States, the great entrepreneurs of the nineteenth century used their position of leadership, along with their enormous wealth, to become the benefactors of such temples of beauty as the National Gallery of Art in Washington, D.C., the Metropolitan Museum of Art in New York and the Art Institute of Chicago."

Source: David Finn's quote, in: David FINN, Judith A. JEDLICKA, *On the Art of Leadership, Building Business-Art Alliances*, Abbeville Publishing Group, New York, 1998 (from the Business Committee for the Arts <www.bcainc.org>).

4.1.1 Dimensions of management and leadership

To discuss strategic and organizational issues it is impossible to ignore their relation with leadership. In chapter one we elaborated on the characteristics of artistic leadership. Here we have reproduced figure 1.12, which shows an artistic profile that can be considered within strategic and organizational decisions:

Figure 1.12 Elements of artistic leadership

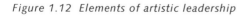
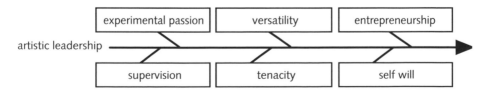

In chapter three we indicated the structuring of the cultural organization based on the division of labour and coordination. Coordination demands leadership and its functioning depends on situational factors. The model of Growth and Development of cultural organizations shows that the natural form of leadership changes according to the phases Idea, Structure, Strategy and Festival (see figure 3.11).

In the discussion about project management, we saw that project leadership is responsible for the several elements of organizational control and communication, internal and external. Finally, the quality of leadership oriented on the establishing of positive and productive norms also played a dominant role in organizational culture and informal organizations.

In this chapter, we will look at the leadership issues in more detail.

To understand the position and nature of leadership we have set the four different management roles within an organizational framework, as figure 4.1 shows.

Figure 4.1 Four general management roles

leader	manager
entrepreneur	employer

A manager is responsible for managerial functions such as finance, personnel and marketing. It is a more technical or functionally oriented job on the coordination level. An important attitude is to work with planning, deadlines and processes. A leader is a person who motivates people based on a visionary approach. A leader is more focused on ideas than on systems and procedures. An entrepreneur is environmentally oriented, always seeing chances and opportunities, more interested in strategies and innovations and less in structure. An employer has to take responsibility for the labour regulations, conditions and circumstances. This last role can also be played by an authority outside the company, e.g. the union of employers.

These four roles reflect the position of an art manager. Here the word art manager should be seen as a general notion (as in the title of this book). Its specific meaning and role depends on the context in which the word art manager (or leader) is used. One could say that words such as *manager* and *leader* are usually used in a wider context and indicate all the coordinative aspects that belong to *management* and *leadership*. In a strict sense, the *manager* is a professional manager in a particular area (marketing, production and finance) and *leader* is the person who motivates and supports people to execute activities properly.

The more specific distinction between the management roles helps us to analyze which role is needed in particular circumstances. Suppose the Board of Trustees of a museum wants to assess the functioning of its business leader. During the assessment, it becomes clear that the board wants a strategic and proactive style because of the increased turbulence in the environment. In fact, this board wants to extend the manager's action towards entrepreneurship, as indicated in figure 4.2.

Figure 4.2 Illustration of change in management roles

Henry Mintzberg has tried to formulate the basics of managerial work.[1] A manager (a person in charge of an organization or a sub-unit) has formal authority and status to manage an organizational unity to effect interpersonal relations, information and decisions and can be represented in ten roles.

The interpersonal roles are:
1. Figurehead, with a ceremonial character
2. Leader, as person responsible for people and work
3. Liaison, with functional contacts outside the direct hierarchy

The informational roles are:
4. Monitor, scanning the environment
5. Disseminator, to share information with others, including subordinates
6. Spokesperson, to the world outside the unit

The decisional roles are:
7. Entrepreneur, to harmonize the organization with its environment (with a lot of exchange projects)
8. Disturbance handler, to react to external high-pressure developments that infect the organization.
9. Resource allocator, in the fields of work, time, money, etc.
10. Negotiator, to reach results in specific - sometimes routine - situations.

To Mintzberg, management is an integrated job – i.e. one role cannot be divorced from the others and remain effective. He found out that some managerial work pays attention to specific roles without losing the integral framework: interpersonal roles for sale managers, decisional roles for production managers and informational roles for personnel managers to advise other managers and departments. An important conclusion is that with the help of the ten roles, art managers need to have insight into their own work to be truly effective.

Finally, a view from the cultural sector itself. John Pick, one of the founding fathers of art administration in Europe, prefers outlining management roles by using the positions and behaviour of the arts manager.[2] Pick sees four categories of behaviour:

a. as manager of routines
b. as troubleshooter
c. as entrepreneur and risk bearer
d. as idealist.

The last role requires some explanation. Pick mentions a number of people from the English cultural world that serve as an example. Their role in the management process is to inspire people who work hard under financially poor circumstances. After all, who can stand up to tough attacks from the outside? The fourth role is described by Pick as follows: It is an admirable quality; at the same time it is unteachable and may remain dormant until there is a crisis.

4.1.2 Coordination and decision making

Management in the sense of coordination is based on authority and is focused on getting things done. There are three kinds of coordination level within an organization.[3] First, there is the hierarchical manager (H) who is responsible for the whole organization of the unit. S/he has the formal authority to give orders to employees. S/he decides about personal functioning and how to judge and reward it. Second, we have the operational manager (O) who has the authority to give instructions as to where and when to work on an operational level, within the framework of the orders of the hierarchical manager. Third, there is the functional manager (F) who gives guidelines on how to work on a qualified, professional level. In the small-scale cultural sector, the three qualities of management usually come together in one person. In more large scale organizations like opera houses we see that the intendant (general manager and artistic leader) has the hierarchical power while the operational and functional power is concentrated on the sub-leader of a group of artists or instruments. The distinction of different coordination levels is important for knowing who is responsible for what on the management level. Figure 4.3 shows the different possibilities.

Figure 4.3 Hierarchical, operational and functional authority models.

Another useful distinction can be made between constitute management tasks (C) and direct management tasks (D).[4] The C-tasks create a strategic framework for the D-tasks. Here formulating goals and plans are a main responsibility. D-tasks are focused on the ongoing operational activities. The distinction between C- and D-tasks can help us to

develop coordination quality on several levels. In a cultural organization, we see that the general director and operational managers have C and D-tasks, while in large industrial companies only general managers have D-tasks. Figure 4.4 illustrates the differences.

Figure 4.4 C and D coordinative levels

cultural sector industrial sector

Several times, we have suggested that getting things done on the coordination level is mainly a decision-making process. According to the complex strategic decision-making model, we can see decision-making more generally as follows (figure 4.5).

Figure 4.5 The Decision-Making Model

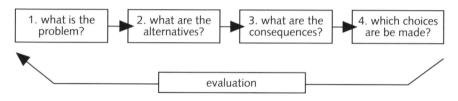

Based on this model, a manager without content skill can direct him/herself towards the process. A procedural approach may be required if the decision-making process is complex and many experts have to be consulted. In the cultural field the business leader sometimes plays a role of this kind to ensure that all parties involved in the organization have their say on the content of the decisions.

4.1.3 Personal management

How is it possible to create a balance between functioning as manager with formal status and being human with the emphasis on values such as integrity, trust and social justice? This question concerns many managers; independent of the field in which they operate. The American Stephen R. Covey says that managers should develop a set of fundamental principles, 'the seven habits of highly effective people', that enables them to deal with this question.[5]
These habits are formulated as follows:
1. Be pro active; take responsibility for your own situation
2. Know your own ultimate goals; create personal leadership
3. Start at the beginning; develop self-management
4. Create win-win situations; create interpersonal leadership

5. First understand, second be understood; communicate and empathize
6. Work synergetically; develop creative cooperation.
7. Be a self-innovator.

Managers who want to take these principles seriously need, in Covey's eyes, to start with their own personal identity and motives. From this independence, the manager can enter the outside world to look for mutual dependency. This fundamental and principal approach differs from the pragmatic way of thinking from the outside world, which is mainly focused on external issues such as formal positions and status. It is important for art managers who always work in a normative world with strong and continuous pressure to achieve.

The third habit, i.e. developing self-management, is an especially important issue in this framework. More concrete time management is the key word here. Time management can be described as the ability to prioritize within a limited period. Time management, which is personal and operational by nature, has two identities: doing what is important and doing what is urgent. Important issues are dealing with values and the need for realizing results: the internal factor. External urgent issues mean: 'take measures now or else…' Sometimes managers prefer to look for urgent matters which, while they might be exciting, are also often unimportant. It could mean that important activities, which may be difficult and complex, have to be postponed. Bad time management creates a permanent dilemma between urgent and important issues as long as the manager does not tackle them. In fact, s/he is a victim of diaries, agendas, deadlines and ambitions. The instrument of time management is the written 'day to day to do' list in which managers convert the planned or unplanned activities into a priority list: what is both important and urgent, has to be done, and what is unimportant and not urgent can be scrapped. These rivals are then prioritized in order of their nature of importance and/or urgency.

Bad time management causes stress but not always.[6] Sometimes stress is a part of the working process and some managers need this positive stress, which is called a stimulated 'work under pressure'. Stress with negative effects on health and relationships has to be avoided. To prevent negative stress a distinction should be made between some stress factors: task, physical, role and interpersonal demands as figure 4.6 shows.

Figure 4.6 Stress factors

Some tasks are more stressful than others are, e.g. that of an actor during the premiere. Some jobs are physically demanding like that of a theatre technician, who has to do a lot of lifting work backstage. Then there the role demands of an organizational culture with

high expectations like those of young art managers in a complex job. Interpersonal demands are focused on relationships and bad relations can complicate the situation, e.g. the business leader of a museum has a serious communication conflict with his/ her team members. All these factors, separately or together can bring negative stress if managers and/or employees cannot control them and feel pressured by the ongoing system.

Negative stress can result in burnout, which is a feeling of exhaustion over a long period of time. If a manager has burnout symptoms such as constant tiredness, frustration and helplessness, special (external) care is needed. Because of the negative effects on personal and organizational life, an organization should have monitoring systems, stress management ('Say No!') and health promotion ('Keep Fit!') programmes to prevent negative stress and burnout.

Practical exercises

1. Interview managers of cultural and non-cultural organizations. Use figure 4.7 and find out what the differences and similarities are. Can the sectors learn from each other?
2. Realize the following assignment in your team: analyze the interaction of the team with the help of the Blake-Mouton model. The results should be presented in a team meeting, followed by an open dialogue about the quality of teamwork and leadership.
3. Analyze your own time management. Check the following elements:
 • relationship between urgent and important matters
 • planning of day-to-day activities
 • priorities and disturbing factors
 • fun at work.
 What do you want to improve?

Closing case *Peter Sellars at the Adelaide Festival*

Peter Sellars, stage producer, theatremaker, opera director and former director of the Los Angeles (LA) Festival, was appointed new director of the small (and insolvent) Australian Adelaide Festival at the beginning of the Third Millennium. Sellars intends to stimulate discussion about local culture, contract young local art administrators to organize workshops all over the region, broach unwritten subjects and draw attention to the position of homeless people, Aborigines, multiculturalism and ecology.

In Sellars eyes, the Adelaide Festival in Australia should play a leading role in discussing urgent issues around the planet. By doing this, the Adelaide Festival will send out a signal to the whole world in the new millennium.

From the business side, Sellars stipulates that an interesting festival with its local roots has a positive impact on the economic development of the city centres with their struggle for survival. Cooperation with non-cultural firms is therefore important.

Case Questions

1. Point out which of the 10 Mintzberg roles are important to Mr Sellars' contributing to a successful Adelaide Festival.
2. Despite the small scale Adelaide Festival, the new director has a 'glocal' ambition. Which elements of artistic leadership are important to realize this ambition?
3. Analyse Peter Sellars' position on the aspects of management, leadership and entrepreneurship. What are the results?

Case reference: International Arts manager Magazine, *Direct impact, The Adelaide Festival's new director plans to catch the world's attention, inspired by sleeping in a park with Aborigines,* London, March 2000, <www.adelaidefestival.telstra.com.au>.

4.2 Leadership and teamwork

Learning questions

- Which styles of leadership can be considered?
- What are the elements of teamwork?
- How can labour participation be developed?
- What are the aspects of corporate and cultural governance?

Key words

people and task oriented	participating	innovation roles
task maturity	delegating	works council
situational leadership	stages of group development	governance
telling	learning environment	board of trustees
selling	team communication	creative processes

Opening incident: *A report of the works council on artistic misleadership*

In a special report the works council of a ballet company criticizes the qualities of the artistic leadership. Instead of encouraging them, the artistic leader demotivates the dancers by showing no interest. The dancers need respect but the only thing they hear is that the leader calls the group 'This f***ing company'. The works council sees artistic irresolution and a lack of artistic vision. 'Our artistic leader was a

prominent dancer but as a leader he misses leadership qualities', says the report. One of the council members regrets that the report is made public: 'we just started meetings with management to create better communication and now we are back to square one.' Another member says the report is still too soft. In her eyes, the artistic leader is a good person and she likes him but as a leader, he lacks many management skills. Another aspect she mentions is the position of the board of trustees, which has not been fully informed about the situation. The board thinks that it is quite normal for an artistic organization to function under pressure and that it is not easy to lead such an organization. The other dancers will only give comments anonymously: 'Our artistic leader has no artistic insight and his only reaction is: If you don't like it, you can leave.'

4.2.1 Leadership styles

In general cultural leadership motivates and supports people doing their job. In management theory, leadership can only be considered in concrete circumstances in which cultural values, environmental issues, organizational growth and development, tasks, experiences, organizational culture and the quality of the employees influence the way leadership is performed.

An important instrument for analyzing the specific styles of leadership is the Blake-Mouton Leadership Grid®, which is summarized in figure 4.7.[7]

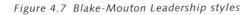

Figure 4.7 Blake-Mouton Leadership styles

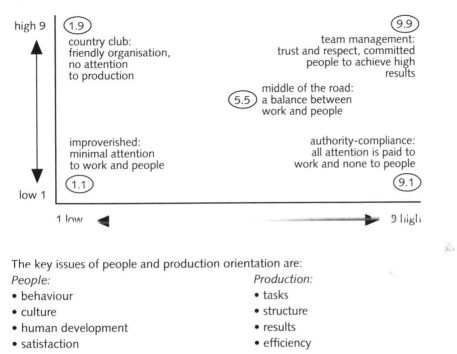

The key issues of people and production orientation are:

People:
- behaviour
- culture
- human development
- satisfaction

Production:
- tasks
- structure
- results
- efficiency

The ideal situation is leadership in a 9.9 Team management model in which the successful integration of the positive elements of people and production orientation is achieved. Nevertheless, sometimes a situation that is 'too friendly' and less production-oriented should be corrected by a temporary leadership style between 5.5 and 9.1, with the focus on production. After a while, when the situation is changed the style can be developed towards 9.9 within the 9.1, 5.5 and 9.9 triangle. The two directions (A and B) are indicated in figure 4.8.

Figure 4.8 Changing of leadership styles

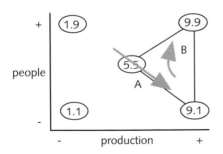

This model also helps the manager to diagnose specific circumstances and to answer the question of what aspects of leadership need attention. This manager can discuss the

expectations with his/her environment and confer about the desired style according to the particular circumstances.

If we look more closely at the relationship between leadership and the need of employees for support and guidance we can use the Hersey-Blanchard model.[8] The starting point for this model is the premise that the supporting or guiding style depends on the task maturity of the employees. If an employee has a very high maturity level, s/he has the ability and a willingness to do his or her job well. In those situations, leadership style is focused on *delegating* and less on support and guidance. If the employee has a low maturity level, the situation demands a strong guiding style with the accent on top down task instructions (*telling*). Between these two opponents the style can be *selling* (much support and much guidance) and *participating* (much support and less guidance). If a style is focused on much support (the last two) it is called relation-oriented. The main factors of this situational *leadership* are integrated in figure 4.9 which is somewhat geared to the cultural sector.

Figure 4.9 Task maturity and situational leadership (Hersey-Blanchard model)

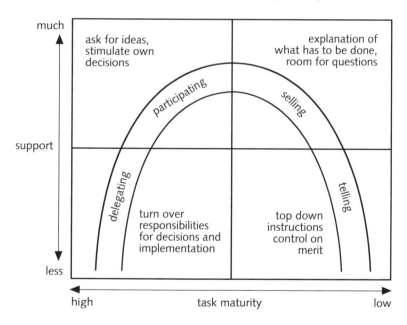

The most desirable framework for situational leadership is a learning environment because both parties, leader and employee, should develop their qualities. If a new manager is designated an established department with high task maturity the manager's superior should support this manager in his/her leading praxis. After a certain learning period, they can decide to delegate some responsibilities. If employees have a low task maturity level, a training programme can help them to reach a situation in which the leadership style can be more focused on participation. Suppose employees have a high task maturity but the manager leads his group with a Top-Down style and this manager

does not want to change his style (or does not want to learn to adapt the situational approach), there will be a serious communication and leadership conflict.

If an organization is in a deep crisis, e.g. audiences are abandoning the cultural organization, there is a conflict between the artistic and business leader or a main sponsor refuses to pay for the cultural programme, the situation will require strong leadership with a Top-Down style. In this situation task maturity, which is connected with the day-to-day work, will not be sufficient. Here the criterion of leadership style is a decision-making attitude to avoid discontinuity and to create a new perspective for the organization to end the crisis. After the crisis, the manager should evaluate the recent history with his or her employees in a more participative climate.

Box 4.1 *Leadership in a learning organization*
Dorian Maarse, senior lecturer in art management at the Utrecht School of the Arts researched the way managers of cultural organizations manage their group or department. Artistic leaders had no difficulty in taking artistic decisions because this is one of their responsibilities. A more complex issue was the way art managers guide their organization in the day-to-day practice. In many cases, the unspoken perception was that a manager always had to take Top-Down decisions. Team members did not appreciate that leadership style.
Dorian Maarse promotes a new idea of leadership, the leader as coach. This style emphasizes a supporting function that concentrates on the talents and qualities of the employees. In Maarse's eyes, this coaching style suits the cultural sector very well because of the high professional standards that are in the hands of artists and other professional workers. The concept of the leader-coach can be even more successful if the organization creates a learning environment in which new experiences lead to new knowledge that are shared on all levels of the organization. In this learning organization one learns from mistakes and is encouraged to take risks.
The following overview shows the differences between traditional leadership and *coaching leadership* in a learning environment.

Traditional style:	*Coaching style:*
• is authoritarian, takes Top-Down decisions	• supporting and facilitating
• no room for participation	• members' participation
• uses punish and reward systems	• stimulates new ideas
• creates dependent relations	• problem-solving competences
• no discussions about leadership	• leadership can be discussed.

Source: Dorian MAARSE, Lerend leiderschap, in: *Vakblad Management Kunst & Cultuur*, 3/1995.

4.2.2 Teamwork

Leadership cannot be seen as separate from the quality of cooperation within a group or team as we saw with project management (§ 3.4). There we also discussed a rationale for effective communication within a team: interpersonal attraction, group activities, group goals and instrumental benefits.

To understand how groups function it is important to consider the stages of group development as figure 4.10 shows.[9]

Figure 4.10 Phases of team development

Forming: basic rules are formed and team members take time to get to know each other; it is important to find out what is acceptable and unacceptable.

Storming: a group structure grows and interaction patterns are formed, majority and minority subgroups may arise.

Norming: roles of the members become clear, a sense of unity exists and leadership has an accepted function.

Performing: team structure is clear, teamwork has its maturity and all the members are focused on realizing team goals.

Communication within a team can have some forms which can be identified as Wheel, Y-form, Chain, Circle and All channel as figure 4.11 illustrates.[10]

Figure 4.11 Communication networks

| wheel | Y | chain | circle | all channel |

The Wheel form gives a centralized position to the leader. In the Y-form, we have two important members who interact more than the others. In the Chain-form, there is no cooperation: one member interacts only with the next member. A Circle form enables all the members to share information and cooperate. The All channel form is the most decentralized communication model in which all the members are equal with virtually imperceptible leadership.

There are some characteristics between activities, structure and culture. In a routine process, a centralized model is chosen because of its efficiency and accuracy. If the work is complex and the members need communication and information on different levels, a decentralized all channel, or self-managed, team model is effective.

These communication forms help the manager and his/her team to diagnose which form suits the situation. If a form does not meet the needs of the work, the team manager and the team members know that conflicts can be expected.

Box 4.2 *Eight informal innovation team roles*
Within a team process, individual team members play roles that can be seen as critical ingredients to achieving successful results. Eight roles can be distinguished that particularly apply to innovative teams:[*]
1. Product Champions: people with energy behind ideas; real believers who want to take risks to implement their own ideas (or those of others).
2. Sponsors: members who support the process of product champions; they link people in informal alliances to strengthen the team.
3. Inventors: people who create original ideas or concepts, mainly research-oriented.
4. Project managers: people who deal with performance, time and budget; they form a bridge between ideas and the organization.
5. Coaches: people who give guidance and assistance to other (less experienced) members; they are able to create empathy, optimism and tenacity.
6. Gatekeepers: people who monitor and communicate external trends.
7. Internal Monitors: people who review the creative climate of the internal organization.
8. Facilitators: members who take care of the collaboration process with an orientation on rapid result-oriented interactions.
In each (creative) team, these roles should be present. Members can play different roles in different situations. In a more formal climate, some roles are connected with existing positions such as those of project manager and coach. These roles can help the team to analyze their method of working and provide additional roles if they lack one or more of the eight roles.
Source: William C. MILLER, *The Creative Edge, Fostering Innovation Where You Work*, Addison Wesley, Massachusetts, 1988.

Sometimes conflicts, here described as disagreements between two or more team members, cannot be avoided. If a team or unit has to make a final decision, more opinions may be voiced. These situations will not damage the organization if there is a constructive climate, i.e. all members want the best arguments to prevail. In this sense, conflicts help to find the best solutions to collective problems.

In the cultural sector, which is strongly dominated by norms, conflicts about views, ideas and opinions form a common constituent of the working method. They give the cultural organization a dynamic atmosphere and a creative awareness. The responsibility of the art manager as team leader is to prevent negative aspects of conflict, e.g. disruptive personal relations and political party formation. These negative team developments cannot produce common solutions and will demotivate team members in the long run. In these particular situations, *conflict management* has two solutions, as figure 4.12 shows: one, to reach middle-range compromises, and two, to create win-win situations in which all the positive elements are combined. The choice depends on the willingness to look for common solutions (and disappointment if success fails) and the perspective for future cooperation (with the possibility of lost chances).

Figure 4.12 Conflict management to reach win-win solutions

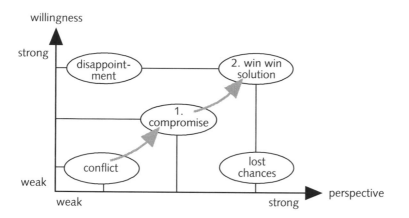

We should remember that there is a particular method of problem solving within complex situations, which is based on the respect and quality of the contribution of each member. In § 2.5.3 we discussed this method, which is called the Democratic Dialogue: an interactive, result-oriented method with the emphasis on solving problems by creating step by step actions, supported by each member.

4.2.3 Labour participation

Most (American) management books do not discuss formal labour participation within an organization. Labour participation means that the labour force participates in the formal decision-making process.[11] The idea of labour participation is the need for check and balance, often within larger organizations. It will partly compensate the Top-Down structures by giving influence to a group of representatives, the so-called *works councils*. This council has a threefold capacity:
1. To think with the management (by receiving information)
2. To discuss with the management (and give advice to the management)
3. To decide with the management (as part of the formal decision-making process)

In more formally regulated labour participation situations, e.g. in the Netherlands, the representatives of the labour force are elected by the employees and are entitled to influence the decision-making processes. Any general social measures that management wishes to implement, generally requires the agreement of the representatives. On other issues, (economic, productional and technical) management is required to ask for advice before taking decisions. In less formal structures there is a consultation procedure to take counsel on issues that will influence the labour situations.

Other forms of participation to steer the course of corporate strategy is creating stock ownership and establishing seats on the board for employees and their representatives.[12]

In the cultural sector, informal consultations between management and employees are praxis. Only in large cultural organizations (opera houses, entertainment companies) do we see more formal structures with legal regulations.

This situation differs from negotiations between employers and trade unions about labour conditions. These negotiations are not a part of the regular formal decision-making procedures within the organization infected by labour participation. Figure 4.13 shows how these situations can be seen.

Figure 4.13 Relations between labour representatives, trade unions and management.

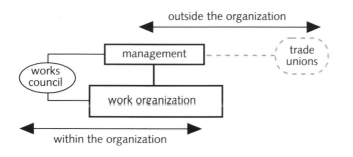

However, Alain Paul and Archie Kleingartner's research into the (informal) entertainment sector shows how experimental collective bargaining processes between employers and unions can transform the traditional method of strategic management within entertainment companies into a more flexible one.[13]

4.2.4 Cultural Governance

Corporate Governance - a concept that originated in the United Kingdom in the early nineties - is a quest to strengthen the quality and control of the functioning of the organization from the board's perspective.[14] With this feature in mind, corporate governance is a logical end to this paragraph about leadership and teamwork. Of course, if it is a question of flat organization with a hybrid character and a lot of self-managed teams rather than a classical top, middle and bottom structure, corporate governance will not only affect the top of the organization. Here corporate governance is concerned with how the organization as a whole functions in society and its societal responsibilities. In more traditional organizations, and possibly in many countries where the majority of the large cultural organizations has this structure, corporate governance also centres on the functioning of boards in relation to the general manager or CEO, who is responsible for the translation of strategies into operations. On this level, Corporate Governance can have two purports. One is that Corporate Governance has a special responsibility to the shareholders, i.e. the board has to control the financial and profit performances and perspectives. Another issue in this framework is the way general management takes care of the interests of the investors and shareholders above the interests of the social factor. The second purport is the wider issue of the board taking into account the interest of stakeholders, not only in financial terms, but also societally and environmentally. Ultimately, political and social views are the determining factors that are used to clarify the position of the board within an organization.

Another important distinction is profit and non-profit corporations. Corporate Governance in non-profit organizations demands special attention for societal issues, clients' needs and sponsors' interests. In this situation there is an inherent tension between the strategic position of the board and the organizational position of general management, which concentrates primarily on the operational effectiveness of the chosen strategies, the structuring of the internal organization and cooperation with its professionals and other employees.

In American society with its extremely limited governmental social, cultural and financial programmes, non-profit organizations in the fields of educational, humanitarian and cultural activities play a particularly important societal role either directly or indirectly, by giving grants. According to Michael E. Porter and Mark R. Kramer, this means that the discussion has to consider the strategic question of creating real value for society rather than solving social problems based on a historical agenda of *doing good*.[15] In the case of foundations that support others financially, this real value centres on (1) selecting the best grantees, (2) signalling other funds (and creating corresponding grants), (3) improving the performance of grant recipients (by learning from others) and (4) advancing the state of knowledge and practice. The need for new strategies in the non-profit sector demands a rethink of the governance systems. Porter and Kramer suggest that board meetings need to deal with overall strategic positioning, creating scope for decisions and assessing the outcome, and withdraw from the operational activities, leaving them to management and staff.

If we set these and other board issues into the non-profit cultural sector, we have to deal with the so-called *cultural governance*. Although the profit corporate governance and cultural non-profit governance have the same starting point, i.e. the quality of top management and the external functioning of the organization, there are also differences:

Corporate Governance (profit):	*Cultural Governance (non-profit):*
• economic results	• cultural results
• market orientation	• societal orientation
• paid board work	• voluntary board activities
• emphasis mainly on shareholders	• emphasis on stakeholders.

As a result of rapid changes in the political and socio-cultural environment, there is a general sense of urgency to formulate quality norms on cultural governance more explicitly. It is not sufficient that the Boards of Trustees of cultural foundations consider the budget and annual report; they are now expected to develop a pro-active attitude to guarantee that the cultural organization also has a cultural function for the future.

In a special report on Cultural Governance, a Dutch group of consultants and art managers made the following recommendations to improve the quality of board performance:[16]
1. A clear cut task division between board and general management and commitment about how to cooperate.
2. A distinction between control and support
3. Attention to the role of employer with respect to general management

4. Attention to the cohesion of the board, based on a written profile
5. Transparency about the way the control function of the board is executed.

If we look more closely at these recommendations, we see that the focus is the internal role of the board. According to Porter and Kramer we should also pay attention to the external functioning of the cultural organization and the specific responsibility of the board related to this issue. In addition to the recommendations, the board of a cultural organization will have to stimulate the organization to deal with future cultural values in the framework of a turbulent, digital and intercultural Global Village in which artists and other creative workers play a dominant role.

This creative role is taken by Nello McDaniel and George Thorn to argue that boards within cultural organizations cannot be considered separate from the artistic and creative processes led by artistic leadership.[17] If these non traditional and hierarchical processes are placed in the centre of a cultural organization board members can be asked more precisely to support the strategic and organizational activities with respect to their responsibility to the external legal and financial environment.

Box 4.3 *Governance in the Netherlands*
A Dutch Board of Trustees (*bestuur*) of a cultural foundation (*stichting*) usually has five to seven board members, which is far fewer than the American boards with between 15 to 45 members (or even more). These American boards also have several committees in the main areas of management such as executive, sponsoring and education while the most important board issue in the Netherlands is the division of the functions of chairman, treasurer and secretary and its relationship with the professional staff.
These remarks were made by Brann J. Wry, professor of the Performing Arts Administration Programme of the New York University in his comparative study on Arts Governance in the USA and the Netherlands.
Some of his observations concerning Dutch boards are:
• Boards (besturen) in the Netherlands are accustomed to regular advisory involvement and occasional management involvement, the latter in crisis or in transition.
• Dutch boards are in no way involved in artistic matters.
• Dutch board members are chosen for: Influence, Political Clout, and Ability in their fields.
• Fundraising is the least significant of Dutch board activities.
• Though government is interested in the quality of a board, it does not make nominations to boards nor comment on selection.
In his conclusion, Wry suggests that American boards have grown too big because they require too many staff and volunteers to keep them functional.
His advice to the Dutch boards is that they pay more attention to fundraising, which is now in the hands of professional staff. Because of the decline of subsidies and the necessity to generate income this board involvement is important for the future of Dutch art organizations.
Source: Brann J. WRY, Arts Governance in the USA and the Netherlands, in: *Reader International Art Management Seminar*, New York University & Utrecht School of the Arts, 1995.

Practical exercises

1. What are the differences and similarities between the responsibilities of a project leader and the manager of a department? Which position do you prefer in the cultural sector?

2. Suppose there is conflict between the artistic leader of a non-profit musical company and the chair of the board. The issue is that the artistic leader refuses to expunge some social-political oriented fragments of a modern opera performance. The chair is very enthusiastic about the artistic leader but fears the city's conservative majority. Can you formulate a kind of protocol for dealing with a conflict of this kind?

3. Analyze the position of artists' unions in a subsector (e.g. visual arts, museums, theatre, music, multimedia). What is their influence on cultural management? Do you agree with these positions? Is a works council an alternative for this influence?

4.3 C-Entrepreneurs hold the key to the future

Learning questions

- What is meant by cultural entrepreneurship?
- What are the characteristics of an Intercultural Network Organization?
- What is the competence profile of a C-Entrepreneur?

Key words

entrepreneurial style	core teams	strategic alliances
cultural entrepreneurship	coordination attitudes	c-entrepreneurs
interdisciplinarity	communication	intercultural society
artainment	creativity	
network organization	connectivity	

Opening incident: *Communal creators*

'However inscrutable their motives, in their aim to conquer time the ancient Egyptians succeeded. They still carry the plain message of man's power as communal creator. In 1215, according to the Arab chronicler Abd al Latiaf, Caliph Malek al Azis Othman was offended by these monuments of idolatry. As a work of piety, he assembled a large crew to destroy one of the smaller pyramids, the pyramid of Menkaure at Giza. After eight months' labour, his crew had made so little impression that he gave up. The mark of that hopeless effort is still visible in a smaller scar on the north slope of that pyramid. Since then, only the exploits of tomb robbers and the frolics of boisterous tourists tossing stones down from the summits have marred the pyramids' simple grandeur.'

Source: Daniel J. BOORSTIN, *The creators, a history of heroes of the imagination*, Random House, New York 1992, p. 89-90

4.3.1 Again: Art Management, Entrepreneurial Style

Maybe the first entrepreneurial art manager was a post nomadic artist-hunter who bartered symbols and decorations for food. In any case, as we saw in the first chapter, the cultural entrepreneur has his or her roots in very ancient times.

(In this last paragraph, we will broaden the entrepreneurial approach of organizing, distributing and educating within the framework of art and culture. We have already discussed Henry Mintzberg's entrepreneurial configuration (paragraph 3.3) in which the entrepreneur has a dominant position in strategy-making and organizational culture. We concluded that this configuration suits the cultural sector very well. In addition, one of the characteristics of artistic leadership was geared to an entrepreneurial style. It is therefore important to devote some time to another purport of this particular management approach.[18] In the management literature we find interesting writers who contribute to further reflection on cultural entrepreneurship, which is advocated here.

Peter F. Drucker believes, generally speaking, that it is essential that management and innovation are not separated.[19] Innovation does not refer to technology here, but to the societal functioning of the organization. The manager will, in Drucker's view, have to interpret his/her function as entrepreneur, as this entrepreneurship produces the desired innovation within the society.

S.K. Chakraborty also sees an added value in the concept of entrepreneurship, in comparison to the concept manager, and emphasizes here the creative capacity of an entrepreneur.[20] 'Managers maintain and impart stability to what an 'entrepreneur' creates. (...) Thorough purity and instinctive goodness and not two-minute skill, alone constitute the wellspring of such a style.' This gives entrepreneurship a normative character. For Chakraborty, elementary shortcomings of the manager-entrepreneur lie not in the economic, cultural or political field, but are more related to man's lack of goodness. We quote the Indian, Chakraborty, to indicate that entrepreneurship cannot be purely interpreted as free enterprise that is only aimed at economic profit (and occasionally uses the products from the cultural sector for that purpose).

Manfred F. Kets de Vries lists a few qualities of the entrepreneur: s/he is result-oriented, gladly assumes responsibility for his/her decisions, and hates boring and routine work. [21] Creative businesses have a lot of energy and a large dose of persistence and imagination which, together with a willingness to take reasonable, calculated risks, enables them to convert something which initially begins as a very simple and unclear idea, into something concrete. He concludes his remarks with the suggestion that managers should see the positive idiosyncrasies of the entrepreneur more as a challenge and should try to develop them: 'The simultaneous desire for danger and opportunities is essential to the entrepreneurial spirit, which ultimately is the life-line of every society.'

Jeffrey R. Cornwall and Baron Perlman define entrepreneurship as a style that is inextricably bound up with strategic management. [22] They consider that traditional management approaches fall short on aspects like strategy, environment research, effectivity, risk-taking and organizational culture, to allow the company to function well, both in the profit and the non-profit sector. In their view, entrepreneurship goes further than the rational application of management skills, as in traditional organizations: 'A successful entrepreneurial venture requires not only a commitment of money, knowledge, skills, time and energy, but also requires an emotional commitment. This can be referred to as persistence, passion, believing in your product or service, and so on. Whatever it is called, effect is a critical ingredient for entrepreneurial success.'

In the last quote, in which the personal approach is emphasized, we recognize the mission-driven art management, advocated earlier. If we combine several elements of entrepreneurship and adapt it for the cultural sector, a triangle can be constructed as figure 4.14 shows. It is based on passion and affection round a clear cultural vision, an external (market) orientation with an emphasis on innovation and a societal responsibility as Drucker indicated, which is principally intended for the cultural sector to stimulate a vital cultural climate.

Figure 4.14 Core elements of cultural entrepreneurship

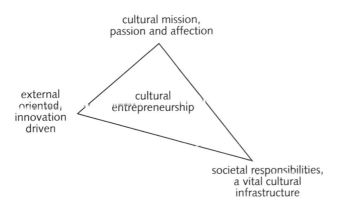

cultural mission,
passion and affection

external
oriented,
innovation
driven

cultural
entrepreneurship

societal responsibilities,
a vital cultural
infrastructure

This type of cultural entrepreneurship cannot be seen as separate from the traditional three management areas of strategy formation, organizational design and leadership (in a broad concept, see figure 1.2). These areas however, which need to be translated into individual competences, are more the cognitive aspects of the functioning of a cultural entrepreneur and should be integrated into the day to day practice.

Cultural entrepreneurship is not limited to small art and cultural organizations or to the top of large organizations but can also be realized on the middle management and project level. This may be referred to as *cultural intrapreneurship*. It has some specific characteristics and is *grosso modo* related to aspects of guerrilla art management as discussed in chapter two.[23]

Cultural intrapreneurship is focused on an integral responsibility on all sorts of levels within the framework of one organization. A cultural intrapreneur with his/her own budget, driven by a personal passion for culture and the mission of his/her unit, knows the exact limits of his/her intrapreneurship in relation to official systems and procedures. Cultural intrapreneurship can only exist if the art manager and his/her team have the self-confidence to conquer internal and external obstacles and to realize innovative situations that influence the cultural environment as a whole.

4.3.2 The future creates Intercultural Network Organizations (INOs)

Our discussion so far, albeit generally incomplete and fragmentary, has concentrated on the contours of a totally new art management concept. With an entrepreneurial and sometimes guerrilla style in mind, we emphasized the future oriented globalization and digitization of culture (*Dream Society*), an interactive and dynamic way of strategy formation and a festival approach of structuring cultural organizations, which can be seen as flexible and project-oriented hybrid organizations. Cultural production and distribution will experience these fundamental developments, alongside activities of artists and creative workers from all corners of the earth, which will have a great impact on the traditional cultural organizations as theatres, concert halls, museums and academies. These organizations will lose their leading position, which was strong and glorious in the 20th century. They dominated the cultural sector and standardized the way political systems commonly developed their cultural policy.

In the new millennium however, the established cultural organizations will be confronted by new organizational forms which are not based on traditional cultural sources such as theatre, music and visual art but on multimedial, multicultural and interdisciplinary relations between new media (e.g. the Internet), the nomadic cultural expressions of minorities and new metropolis street performances from non-traditional stages.

At the start of the third millennium our vocabulary is certainly left wanting, but we should realize that the typical contrasts of the last two centuries of high art-mass culture, subsidized art and cultural industry, profit culture and non-profit culture, professional art and amateur art, cannot be used to express the new and dynamic cultural developments.

We cannot find information about these new phenomena in the official cultural agendas but we can see it on the Internet, in the dynamic periphery of the big world cities, at huge disco/house parties - which begin when the traditional cultural centres close their doors - and in the middle of nowhere where new cultural tribes or villages create their own autonomous and possibly shifting story telling areas. Under these circumstances, organizations are truly intercultural because no one expert who was educated in the former millennium can claim the *artainment* expressions to be part of his/her discipline. Activities will be executed on a network base, as we mentioned when we discussed the hybrid organizations. These new forms, which we can call Intercultural Network Organizations (INOs) of the future, demand not only an entrepreneurial style but also totally new tasks and functions. Artists then become creative workers with a variety of artistic and cultural (half) products and services. They do still have an artistic competence but this intercultural competence – in the words of professor dr. Dragan Klaic, director of the Theatre Institute of the Netherlands[24] - is not always developed within an art academic structure such as art and film academies, music academies and theatre schools. The educational sites reflect the way intercultural expressions have been created: non-traditional, unexpected, group oriented, digitally connective, highly flexible and non-hierarchical. The way people of the INOs are dealing with art and culture reflects their working space. In the cultural tourism, artists' villages in Senegal, in the old industrial buildings of the Western countries, in the historical city centres and in the concrete but

lost parking bunkers of the newly created metropoles we see parts of the intercultural network functioning. People like a cultural variety that has a strong position in the sketchy and speedy world of the leisure industry.

One of the most interesting questions in the area of art management is how these INOs will be coordinated. Is there still artistic leadership as discussed in chapter 1? Can we see a formal strategic decision-making process? Do these INOs have a structure that is compatible with labour division and coordination? What are the coordination functions and what kind of people will coordinate an INO?

It is unsatisfactory to use general metaphors to answer these questions like many authors do. By comparing the new organization to a software programme structure, a tribe or a virtual team, in fact coordination questions remain unanswered. At best, they can help to find answers.

It will be clear that the basic form of INOs is a group of professional creative workers and artists based on self-management. We can also imagine that there is a core team that can grow with respect to flexible and irregular creative experts and supporting assistants if activities gather volume. These core teams have an unstructured coordination agenda that is the result of interactive communication with the internal and external environment.

The following three C(oordination)-attitudes can most probably be expected in this core team: creativity, connectivity and communication as figure 4.15 shows.

Figure 4.15 Coordination attitudes: creativity, connectivity and communication

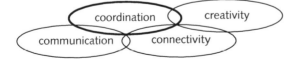

Creativity involves visionary artistic talent and an innovative way of problem solving. Connectivity stands for bringing the functional aspects together *grosso modo* in comparison with the work of the traditional manager. Communication means a combination of internal teamwork and external needs of the environment. This coordination concept is entrepreneurial and integral; all the management functions: production, finance, marketing, personnel, innovation are connected to realize intercultural team goals. The interactive strategic function is incorporated within dynamic strategic alliances that bear the remains of the dead headquarters. These strategic alliances are also built on teamwork just as the basic forms are. These INOs cannot exist without multimedia Information and Communication Technology (mm ICT). The mm ICT of the 21st century with its smartware, hardware, software and groupware takes the place of traditional 20th century management with accents on the individual manager and his or her Management Information Systems (MIS). Such an INO is also more fundamental than the concept of a *creative organization* which means in brief that the organization has an innovative culture, structure and strategy to create new working

methods and products.[25] Smart mm ICT delivers know-how on supporting activities, contains information about cultural and intercultural aspects and trends, and suggests which unknown core groups are probably interested in new projects. Even this smart mm ICT warns core teams to stop digital communication (as a result of the complex weight of words, social pressure, etc.) and organize real life events in which the participants enjoy their non-virtual communication and social presence. Figure 4.16 shows how INOs can be designed.

Figure 4.16 Intercultural Network Organizations (INOs)

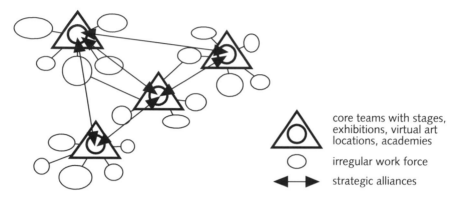

core teams with stages, exhibitions, virtual art locations, academies

irregular work force

strategic alliances

4.3.3 C-Entrepreneurs

The three coordination attitudes of the 21st century, Creativity, Connectivity and Communication, differ strongly from the traditional way of art management, even on an entrepreneurial level, which indicates the current transformational period. Figure 4.17 illustrates these periods.

Figure 4.17 Three periods of art management

Art and cultural organizations with underdeveloped or weakly developed management functions, up to about 1995	Art management, the entrepreneurial style in a period of transition about 1995 to 2005	C-entrepreneurial style within Intercultural Network Organizations from 2005
• attention to management functions • undeveloped strategic processes • weak learning practices • reactive management • historically oriented	• confrontation with the digital and global environments • entrepreneurship to innovate art and cultural organizations	• teamwork within an intercultural environment • dominant position of mm ICT • strategic alliances based on C-entrepreneurs with creativity, connectivity and communication attitudes

Separate functions and tasks, as we saw in the art and cultural organization of the 20th century, have disappeared. In flexible INOs it is not important who the artist and the manager are, but what are the team results and is the team culture entrepreneurial?

The members of the core teams are C-Entrepreneurs and have new tasks such as:
intercultural storytelling management,
intercultural research and development,
creativity training,
creative finance matching,
adventure development,
smart mm ICT programming,
multimedia missionary,
intercultural project organizing,
communication promotion,
intercultural engineering,
smart people coaching.

What should we do in practice with these signals of intercultural tasks and organization in the transitional period from the old 20th century to the new C-21st century? We cannot transform cultural organizations with our heads still in nebulous intercultural clouds and with our feet in the existing art and cultural organizations. The need for transition also depends on situational factors as we learned in the first chapter. What we can do however, is coach young art managers and train them in the direction of the entrepreneurial INOs. We can also ask ourselves to be aware of uncertain but totally different future images.

In the future, it will be quite common for C-Entrepreneurs to be found in all sectors of global society. Within communication, trade, education and charity sectors -private or public- the need for innovation will become increasingly strong and these sectors need new management approaches that reflect the C-Entrepreneurial style. We are entering the *creative wave* as we did in the last decades of the 20th century with the third wave which was called by Alvin Toffler the information wave (the first being the agricultural wave and the second the industrial wave).'[26]

In these sectors, we will have strategic alliances between art and cultural faculties and business schools to carry out their educational responsibilities for a vital and intercultural society, both locally and more distant.
　　The C-Entrepreneurs can develop their competences in educational networks, created by these alliances. Nevertheless, this educational position is uncertain because of the learning alternatives such as small multimedia firms, art guerrilla base camps and nomadic groups in the Global Village.

Box 4.4 *Future Oriented Profile of Competences (FOPOC)*
As a summary of the C-Entrepreneurial approach (creativity, communication, connectivity) an intercultural competence profile is presented in figure 4.18. On the basis of this profile we can examine the qualities needed to function in a Intercultural Network Organization. It is also possible to develop courses and training programmes and learning-by-doing plans to prepare management and teams to operate in an INO-environment.

Figure 4.18 FOPOC of an INO

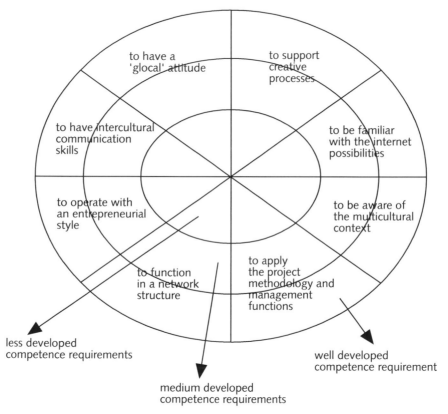

More individually, one can use FOPOC-INOs to measure the current qualities and to develop a learning plan to improve these qualities. Figure 4.19 shows a X-ray picture after interviewing a member of a project team.

Figure 4.19 X-Ray picture FOPOC-INO.

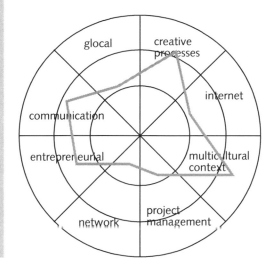

strong:
- intercultural aspects and intercultural vision forming

pay attention to:
- (project) managemnt issues
- functioning in a (digital) network environment
- international experiences

The new art managers of the transitional period (1995-2005) will be C-Entrepreneurs of an innovative intercultural world even if our current cultural organizations need professionalization of their management as a necessary and next step and for which this book aims to formulate entrepreneurial ideas and practical assistance.

Practical exercises and discussion items

1. Contact some small multimedia businesses and analyze their organizational structure. What kind of organizational forms do you notice?
2. Analyze the process of group development in a management team of a traditional cultural organization. What are your findings? Discuss the results with the general manager.
3. What is your idea of entrepreneurs in a creative environment? Do you recognize the qualities of the FOPOC-INO? Are art management schools currently educating C-Entrepreneurs? How do these entrepreneurs fit the current cultural praxis?

1 Henry MINTZBERG, *Mintzberg on Management*, The Free Press, New York, 1989, pp. 15-22.

2 John PICK, *Arts Administration*, London, 1980, p.13.

3 D. KEUNING, D.J. EPPINK, *Management & Organizatie, Theorie en Toepassing (6th ed.)*, Stenfert Kroese, Houten, 1996, pp. 127-129

4 KEUNING, EPPINK (1996), p. 119.

5 Stephen, R. COVEY, *The seven habits of highly effective people, Restoring the character ethic*, Simon & Schuster, New York, 1989. See also: Peter F. DRUCKER, Managing Oneself, Success in the knowledge economy comes to those who know themselves -their strengths, their values, and how they best perform, in: *Harvard Business Review*, March-April 1999, pp. 65-74.

6 GRIFFIN (1999), p. 464.

7 GRIFFIN (1999), p. 522, KEUNING, EPPINK (1996), pp. 477-478.

8 Harold KERZNER, *Project management, a systems approach to planning, scheduling, and controlling (6th ed.)*, John Wiley & Sons, New York, 1998, pp. 256-257; KEUNING, EPPINK (1996), p. 484.

9 GRIFFIN (1999), pp. 581-583.

10 GRIFFIN (1999), p. 555; KEUNING, EPPINK, p. 486.

11 See for the position of Dutch works councils: KEUNING, EPPINK (1996), Appendix 2.

12 Alan PAUL, Archie KLEINGARTNER, Flexible Production and the Transformation of Industrial Relations in the Motion Picture and Television Industry, in: *Industrial & Labor Relations Review*, Volume 47, number 4, July 1994, pp. 663-678.

13 PAUL, KLEINGARTNER (1994).

14 COMMISSIE CULTURAL GOVERNANCE, *Cultural governance, kwaliteit van bestuur en toezicht in de culturele sector, een pleidooi voor zelfregulering*, Stichting Kunst & Meer Waarde, Amsterdam, 2000.

15 Michael E. PORTER, Mark R. KRAMER, Philanthropy's New Agenda: Creating Value, in: *Harvard Business Review*, November-December 1999, pp. 121-130.

16 COMMISSIE CULTURAL GOVERNANCE (2000).

17 Nello MCDANIEL, George THORN, *Arts boards, Creating a new community equation*, Arts Action Issues, Brooklyn, 1994.

18 See for a basic idea: Giep HAGOORT, *Ondernemerschap als motor in bedrijfsorganisaties*, in: *Besturen en Innovatie*, Samsom, Alphen aan den Rijn, C 0200.

19 Peter F. DRUCKER, *Innovation and Entrepreneurship*, Harper & Row, New York, 1985; Peter F. DRUCKER, *The New Realities*, London, 1989;

20 S.K. CHAKRABORTY, *Management by Values, towards cultural congruence*, Oxford University Press, Delhi, 1991, p. 262.

21 Manfred F. KETS DE VRIES, *Prisoners of Leadership*, Paris, 1989 (De F Factor, p. 115).

22 Jeffrey R. CORNWALL , Baron PERLMAN, *Organizational Entrepreneurship*, Irwin, Boston, 1990. pp. 17-30. The writers distinguish three forms of entrepreneurship: individually, within an organization (*intrapreneurship*) and as organization.

23 See on intrapreneurship: Giep HAGOORT, *Ontwikkeling van ondernemerschap naar intern ondernemerschap*, in: *Besturen en Innovatie*, Samson, Alphen aan den Rijn, C 0200; Gifford PINCHOT III, *Intrapreneuring*, Harper and Row, New York, 1985.

24 Dragan KLAIC, *European Internationalism*, guest lecture MA AMMEC, Utrecht, 2000.

25 GRIFFIN (1999), pp. 470-474; J.B.R. GASPERSZ, *De creatieve organizatie*, Universiteit Nyenrode, Breukelen, 1999. See also: Suzy WETLAUFER, Common sense and, conflict, An interview with Disney's Michael Eisner, in: *Harvard Business Review*, Vol. 78, No. 1, January-February 2000, Boston.
26 Lydia A. KAN, New models for corporate/non-profit arts partnership, in: *AIMAC'99*, pp. 83-85; Michihiro WATANABE, Arts management and dilemmas in cultural policy, in: *AIMAC'99*, pp. 483-495.

The Deed

In the night which follows on from the talk between Emilia and her mistress, Othello strangles Desdemona. They were still having a confused quarrel about the lost handkerchief but Othello was convinced of the necessity of punishment and retribution. Emilia discovers that Desdemona has been killed and explains to Othello that he was totally wrong. So what of that handkerchief? Emilia took it from Desdemona's room at the request of her husband, Iago. Now she knows the fatal consequences.
Othello is desperate when he realizes how misled he was. In a moment of folly, Iago kills his wife to prevent her testifying against him. Iago is taken into prison and Othello disarmed. Somehow, he manages to take possession of a sword.

Behold! I have a weapon;
A better never did itself sustain
Upon a soldier's thigh: I have seen the day,
That with this little arm, and this good sword,
I have made my way through more impediments
Than twenty times your stop: but, O vain boast!
Who can control his fate? 't is not so now
Be not afraid, though you do see me weapon'd;
Here is my journey's end, here is my butt,
And very sea-mark of my utmost sail.
Do you go back dismay'd? 't is a lost fear;
Man but a rush against Othello's breast,
And he retires. Where should Othello go?

Now how dost thou look now? O ill-starr'd wench!
Pale as thy smock! when we shall meet at compt,
This look of thine will hurt my soul from heaven,
And fiends will snatch at it. Cold, cold, my girl!
Even like thy chastity.
O! cursed, cursed slave. Whip me, ye devils,
From the possession of this heavenly sight!
Blow me about in winds! roast me in sulphur!
Wash me in steep-down gulfs of liquid fire!
O Desdemona! Desdemona! dead!
Oh! Oh! Oh!

(ACT V, 2)

5 Appendix

**TGA-Case Study:
Cultural Strategic Dialogue in Practice**

Contents

A.1 Choice of organization and justification

Cultural Strategic Dialogue (CSD, § 2.5) is based on the principles of Strategic Management, the Interactive Approach (ISM, § 2.3). It incorporates the six key dimensions of strategy formation (§ 2.4) and the seven Cultural Tracks (§ 1.2). This appendix will describe a study of Cultural Strategic Dialogue in practice. The aim of the study was to examine how the interactive approach to strategy formation worked when applied in practice in a specific cultural organization. The results of the research are intended to lead to a clearer definition of the conceptual framework of strategy formation in the cultural sector. The practical study concerned the application of Strategic Dialogue in Theatre Group Amsterdam (Toneelgroep Amsterdam – TGA). The study, entitled TGA Strategy Project 1995, lasted for more than a year. After this period regular contact was maintained with the organization and there was reflection on the process which had taken place.

J.M.Hutjes and J.A. van Buuren have noted that there can be various reasons for focussing a study on a single organization.[1] As there can only be a limited generalisation of results it means that such a study will have a mainly 'illustrative effect' on the subject under consideration. The motives given by these authors for such a choice also apply in the case of the TGA Strategy Project. Because this kind of research has not been carried out before in the cultural sector, it was necessary to first concentrate on a single case in order to gain a full understanding of the issues involved in systematic, interactive strategy formation. This was the first time such information had been gathered and it could provide the basis for a follow-up study. Such a study prepares for later, more detailed research. Another reason for concentrating on a single organization was that the aim of the study was not to provide new information about the general issue of strategic management, since the study was limited to strategy formation in the cultural sector. A third motive had to do with the academic focus which was primarily on practical application.

The results of a single case-study provide insight into how Cultural Strategic Dialogue works in practice. It becomes evident how the various complexities in the relationship between cultural values and strategic management are dealt with in the application of Cultural Strategic Dialogue. In describing ISM it was stated that the strategic action researcher is actively involved in strategy formation. This involvement is not directed at the formulation of universal rules, but at combining general and specific knowledge within a plausible conceptual framework in order to solve a generally felt problem. Gareth Morgan has remarked of this type of research that it is not about providing numerous general rules but about acquiring insight into patterns in order to generalise from a situation, 'an insight which may be relevant for understanding a similar pattern elsewhere'.[2] Morgan associates the validity of research results with the context within which they were acquired. To reach a reliable result the researcher depends to a large degree on the reactions of fellow researchers and participants. Morgan also finds it important to use the technique of 'resonance'. The reactions of those directly involved indicate whether the information is useful or not. Morgan also points to the tension between the researcher and his or her surroundings, which has to do with the lack of clear evaluation criteria. He even calls this an 'ethical minefield' to underline the risks which can adhere to these emerging tensions: 'the only way in which an action learning researcher can protect himself against this, is by questioning everything he or she does as to whether it is ethically justified or not; being led by the intention of fully understanding the problem and by the courage to do what is necessary to bring the agreed task for which he or she has been appointed to a satisfactory conclusion'.

The criteria of validity and reliability, when related to reporting on strategy formation within a single organization on the basis of strategic learning research, imply that all the steps which have been taken during research are described as accurately and openly as possible. A second requirement is that criteria are formulated for testing 'insights into patterns'. For this reason the research report needs to minimally include: the starting situation, progress, specific questions, the way in which researchers have worked and which choices they have made in regard to approach, implementation and evaluation.

This prevents the researcher's involvement leading to a personal, unsystematic gathering of information, or 'slurring over results'— to use Morgan's words — when these are not in agreement with the researchers' perceptions regarding the conceptual framework which has been constructed. In accordance with the working methods of action research, whereby the reliability of the material is strengthened by including participants' reactions, a draft version of the research report was discussed with the members of the organization most closely involved, on conclusion of the study.

The art organization involved in this study was, as mentioned earlier, Theatregroup Amsterdam. TGA, founded in 1987, is the largest theatre group in the Netherlands with at least a hundred employees (permanent and free-lance), an annual budget of at least NLG 11 million (EURO 5 million) and an annual production of around four hundred, widely differing performances. The choice to study this organization was made on the basis of the research criteria for 'illustrative effect'. These criteria were:

1. The organization must be have a reasonably large size and it must contain recognizable departments and layers of management (top, middle, bottom) which are found in other cultural organizations as well as theatre. TGA is organized in five separate departments or services like many other orchestras, museums, theatres, concert halls, art schools, cultural centres and so on.
2. The organization cannot be a pioneering organization where strategic issues are easy to diagnose. The problems must involve complex strategic and structural issues. TGA had existed for eight years when the study began and from an organizational point-of-view was in an 'adult' phase.
3. The organization cannot be in the midst of an acute and all-dominating survival crisis in which there is little support for the current management and it is clear that large numbers of employees will need to be made redundant. In such crisis situations the necessary conditions for Cultural Strategic Dialogue are lacking. TGA has experienced no such crisis.
4. The organization must have a concrete reason for needing to formulate strategy. For TGA this was their intention to submit a four-year grant application to the Dutch government and the Amsterdam City Council. The request was for a structural grant during the period 1997–2000.

The results of the strategic action research are organised as follows. First the final report presenting the results of the project for both the company and researchers is reproduced in full exactly as it was sent to the company (paragraph A.2). The report, written almost two years after the formulation of the strategy, has been included to clarify the research results. After this a more detailed account is given of the context of the strategy project: a sketch of the organization and the progress of the project in terms of project phasing (paragraph A.3). After this the strategy process is described in terms of key dimensions, Cultural Tracks and Strategic Management, the Interactive Approach (ISM). In this paragraph the accent will lie on interpretation and reflection (paragraph A.4). Finally the results of the practical study will be established in terms of their 'illustrative effect' (paragraph A.5). Questions and discussions items will close this report (paragraph A.6).

A.2 The Final Report presented to the theatre company TGA

"To the Members of the company,

In November 1994, the first contacts were made regarding the TGA Strategy Project. In the summer of 1997, previous members of the Cross-Section group met to discuss the project report and consider the present situation. Meanwhile the company has produced more engaging performances, such as Een soort Hades, and we, the project researchers, are now engaged on new strategy projects. In this report I will review the results of the project, from the perspective of both the company and my own research. The purpose of this reflection is to inform you all about the most important elements of what has been learnt. I hope this letter will be regarded as a small token of gratitude for the helpful cooperation which was extended by the company to prof. Annemieke Roobeek (supervisor/researcher) and myself (researcher).

The aim of the project was to work together towards a new strategy plan for the period 1997—2000. An important starting point for this was Annemieke Roobeek's concept of Strategic Management, the Interactive Approach (ISM), a central point in which was working with a Cross-Section of the organization. This approach was intended to allow the company to experience new, open methods of cooperation which would have a positive effect on the functioning of the whole organization. During a general company meeting in June 1995, it was concluded that the existing organization needed to be changed. Young actors were finding it difficult to approach TGA, there was little communication between the different departments, a strong divide between actors and technicians and also some friction with the surroundings. But of course there were also strengths: TGA makes distinctive theatre, brings together great artistic talent, produces striking performances and fulfils a prominent place within theatre culture.

The strategy project has made a number of important improvements in the organization's ability to take advantage of existing and new artistic talents. But it has also become clear how difficult it is to maintain the newly-acquired skills of cooperation and communication and consistently stick to the new direct method of leadership. I will go on to explain both these points in more detail. The opinion of those directly involved is that the project has had a positive effect on their way of thinking and behaving within the organization. There is greater understanding of organizational structure, consultation has improved, there is a more open attitude within the company and better relations with the immediate surroundings. The intended product, a new strategy plan for the period 1997–2000 includes many plans for maintaining this course. This plan has received great acclaim both within and outside the cultural sector. Meanwhile the company has realised the first results of the strategy plan: four-year grants from the Dutch government and Amsterdam City Council; successful new experiences with the 'Theatre Factory' and 'Theatre Factory on Tour'; a solution to the bureaucratic obligation to tour and outside theatre bookings where the company has shown that they can do it 'differently and better'; and the universally praised youth performance Magic! which was produced as a fore-runner to Pierre Corneille's Zinsbegoocheling. Newcomers now

receive a much better welcome and there are spontaneous initiatives and opportunities, as shown by the music group Mook'M.

In the Summer of 1997 the feasibility of the new strategy plan was evaluated. It turned out that of the nearly fifty strategic proposals more than half had been realised and another quarter had been started. This is a very good result, especially in comparison with other strategy plans. Compliments are due in the first place to all company members.

However a number of matters have been less satisfactory. It has already been noted that it is difficult to put what has been learned into effect in the long term. From the most recent discussions in August 1997, it appears that once again there has been a lack of communication, principally with actors, about an important strategic choice: the move to a new building. The directors were involved in finding a new organizational form for the theatre and the company. Only a few people were aware of what was going on. There were also problems concerning the involvement, especially of actors, in the day-to-day running of affairs. They were unaware of various already realised, and shortly to be realised, changes while the strategy project was aimed precisely at interactive communication.

As a result of these experiences renewed actions were undertaken to sway developments in the desired direction. Thus all members of the company were informed in detail about the proposals in the new strategy plan which had already been realised in the Autumn of 1977; a number of actors took the initiative themselves to achieve better communication with the working organization and the idea was raised of starting a new Cross-Section specifically in relation to the new location.

The strategy project has also been productive in research terms. The project provided experimental ground for a number of new ideas regarding strategy formation in the cultural sector. It became apparent that the application of Strategic Management, the Interactive Approach is successful and working on this I have now developed my own approach, Cultural Strategic Dialogue, which allows the practical integration of cultural values within strategy formation. This last point was not emphasized at the time but was present in the background and receives a more prominent place in my final research conclusions. In my research report I look at how a cultural organization such as TGA can incorporate concepts such as 'artistic leadership' and 'multiculturalism' in new strategy. The fact that the Cross-Section devoted a relatively large amount of attention to artistic organization (Theatre Factory) and art policy (turning the 'obligation to tour' into a 'wish to tour' and attracting young people in a multicultural city) has, for example, to do with the integration of cultural values.

In addition a great deal of information has been acquired through experience which can be seen as new knowledge about interactive (dialogic) strategy formation in the cultural sector; this is knowledge which has never been expressed before either within or outside the Netherlands. This includes the way in which strategy formation can begin or the 'Strategic Motive', the way in which a cultural organization deals with its surroundings and its approach to strategy formation through multidisciplinary groups or

Cross-Sections representing governors, directors, actors, theatre technicians, designers, stage managers as well as studio and supporting staff.

The practical experience gained in combination with information from the literature will be presented in a book entitled Strategic Dialogue in the Cultural Sector ('Strategische Dialoog in de kunstensector'). Both Annemieke Roobeek and myself are convinced that artists, art managers and other professionals will show great interest in the concept of Cultural Strategic Dialogue. Various cultural organizations, theatres, museums, orchestras, theatres, film companies and so on will certainly be stimulated by our shared experiences to give form and content to their own visions of the future. You have contributed to this as guinea pigs and co-researchers. We hope to have made clear in this report that the benefit has been on both sides.

Finally the project has made one more important contribution. It has strengthened the conviction that the ultimate success of artistic expression cannot simply be derived from the quality of strategy formation. Artistic success depends primarily (and sometimes in highly unpredictable ways) on the interaction between individually-minded artists, programmers, designers, theatre producers and their public. Interactive strategy formation does, however, contribute towards fostering a professional attitude in the cultural organization as employer, allowing a structural place for the knowledge of all those involved. In this way a cultural organization can show the world what broadly-shared artistic direction it intends to follow and how it can itself create the conditions to achieve its goals. By continuing to learn from these and other new experiences, the arts sector including TGA will be able not only to imagine but also to direct the future.

With kind regards,
also on behalf of Annemieke Roobeek,
Giep Hagoort.

A.3 The context

The context for the TGA Strategy Project 1995 will be described on two levels. First a short sketch of the company will be given (paragraph A.3.1). This allows the reader to place the strategy project in its 'natural surroundings'. After this follows an account of the project's progress through its various phases (paragraph A.3.2). This description of the context will not deal with the methodical application of Strategic Dialogue, which is reserved for paragraph A.4.

A.3.1 Sketch of TGA

Origins
On the initiative of the Dutch government and Amsterdam City Council, Theatre Group Amsterdam was formed in 1987 from two existing theatre companies: the Public Theatre

(Publiekstheater) and Central Theatre Group (Toneelgroep Centrum). TGA was located in the Amsterdam City Theatre (Amsterdamse Stadsschouwburg) which, as a municipal institution, had its own programming and organization. TGA was responsible for a number of performances in the main theatre (including premieres). Gerardjan Rijnders was asked to take up the position of artistic leader. Gerrit Korthals Altes, at that time business manager of the Public Theatre, continued in this function in the new company. Rijnders is one of the leading theatre directors and playwrights in the Netherlands.[3] As artistic leader he had the task of creating a profile for the new theatre company. He accepted the Amsterdam City Theatre location, but wanted the company to eventually have its own location. In 1992, in preparation for a structural grant application for the period 1993—1996, the Arts Council (Raad voor de Kunst) gave a positive evaluation of the company's policy as implemented up to that time:

Theatre Group Amsterdam is one of the leading companies in the Netherlands. The company has acquired its own self-evident position. The power of the company lies in its many-sidedness, coupled to a conscious regard for quality.[4]

TGA's productions, their directing, acting and staging are famous, making the company market-leaders in terms of artistic quality. The professional press adds to this that the quality of the dramaturgy (Janine Brogt), graphic design (Studio Anthon Beeke), theatre design (Paul Gallis) and casting (Hans Kemna) have contributed greatly to the company's position.

New Theatre
On 1 September 1993, a year after receiving a second structural grant and two years before submitting a new application, the artistic leaders (Titus Muizelaar had now joined Gerardjan Rijnders) made an abrupt announcement of their departure in a board meeting. Their stated reason was the fact that the company still had no theatre accommodation of its own and the artistic leaders considered this to be a necessary condition for the further artistic development of the company. TGA's board refused to accept this announced departure because they were convinced that it would threaten the future of the entire company. The board agreed to the realisation of the company's own theatre within a few months.

Business manager Gerrit Korthals Altes tracked down a factory location and in the Spring of 1994 TGA moved into the Transformer Room of a disused gas factory (Transformatorhuis, Westergasfabrieksterrein), where the first premier took place in November of that year. The terrain lies in the west of Amsterdam, near the centre. Because of the limited space in the new location the company's offices and studios continued to be housed in the City Theatre where space was also reserved for rehearsals and performances. A location in North Amsterdam containing the decor studios was also maintained. Moving into an already existing location remained a temporary solution according to the artistic leaders. The intention was still to occupy a theatre which was completely their own, containing at least two halls, and to end the divided location.

In 1995 the City Council of Amsterdam decided, as a follow-up to earlier studies and plans, to conduct a feasibility study into a completely new location for the company under the heading 'New Theatre'. On the basis of the information gathered, the Council decided that the option of a new building was financially impossible. Meanwhile new developments took place at the City Theatre where the director left, due in part to the Amsterdam Arts Council's negative evaluation of its programming. This departure made it possible to look into a shared organization of theatre building and theatre company, preceded by a study into renovations in accordance with TGA's ideas.

The company
TGA's mottos are 'It is certain that nothing is certain' and 'Making theatre in the broadest sense of the word'. This approach means that it is difficult to place TGA in a single genre. The productions most closely approach the category: 'complex and unconventional' and, to a lesser degree, 'complex and conventional'. Complex implies diverse, unexpected and out of the ordinary. Unconventionality can be seen as the degree to which common and accepted forms of theatre are missing in the repertoire.

TGA's productions attract around 80,000 theatre-goers a year.[5] In Amsterdam around half this number of people attend all performances by the company. A good six percent of performances take place abroad, in Europe. As well as its main output, stage performances, TGA also produces:
1. audio-visual productions (one a year on average);
2. translations (for its repertoire);
3. publication of its stage texts;
4. educational activities and courses for the public;
5. lectures and contributions to discussions;
6. incidental radio and TV-appearances.

As well as NLG 9.6 million (EURO 4.4 million) a year in grants (NLG 5.6 million (EURO 2.5 million)) from Amsterdam City Council, NLG 4 million (EURO 1.8 million) from State funds), TGA generates NLG 1.9 million (EURO 0.9 million) of its own income (= 17 % of total costs).

The press openly wonders whether the grant amounts should be maintained now that TGA has opted for its own location and ties to the City Theatre have been reduced. In the 1993–1994 season NLG 150,000 (EURO 68.182) was cut from TGA's grant in favour of the City Theatre in order to fill the 'empty spaces' in the theatre's main programme.

Internationally the company attracts great attention. Various foreign podia are eager to programme the leading Dutch theatre group with its 'montage performances'.
In view of the structural financing of the period 1997–2000 a strategy plan needed to be set up. This strategy plan needed to be presented to both funding sources before 1 January 1996.

Context
TGA belongs to the subsidized theatre sector in the Netherlands.[6] The structurally subsidized companies in this sector produce around 4,500 performances each season.[7]

During the 1994–95 season, 859,463 seats were sold for these performances. Three of the companies in this sector are city companies (Amsterdam, Rotterdam, The Hague) which means that they receive city as well as state contributions to operating costs and that a large proportion of their productions have to take place in the City Theatre. Because of the national subsidies these companies are also obliged to perform outside their home town (the so-called 'obligation to tour'). Dutch companies – in contrast to those in other countries – do not have their own theatre.

The State awards an annual NLG 50 million (EURO 23 million) in grants to promote theatre culture.[8] The structural grants are made directly from the Ministry of Education, Culture and Sciences to the theatre company, partly on the basis of an independent quality evaluation by the Council for Culture (Raad voor Cultuur), until 1995 known as the Arts Council (Raad voor de Kunst). As well as the subsidized sector there is also a free sector. This sector includes commercial initiatives by independent producers. In practice this generally means a fairly simple repertoire of classics or modern classics aimed at a broad public.

In the 1994–1995 season there were a total of 14,260 theatre performances, attended by more than two million people. If we compare this to TGA's figures, then it appears that TGA was responsible for 3 percent of the total productions and attracted 4 percent of the total number of theatre attendances. As a proportion of the subsidized sector these figures are around 9 percent both for productions and attendances. These figures do not reflect TGA's qualitative position. From an artistic point-of-view TGA leads the market, judging by the amount of media attention its artistic achievements and potential receive from the national and professional press.

Theatre distribution in the Netherlands is mostly organized by regular theatres, which are generally maintained with the help of local council grants.[9] Exceptions to this are the constructions known as PPP (Public Private Partnership) where the State finances the artistic programme and commercial catering organizations take care of the running and maintenance of the building. A few large-scale theatres (usually showing musicals from the 'Western' repertoire) are run along completely commercial lines without subsidies of any kind.

In 1995 an exploratory study was carried out to inform government policy development in the performing arts sector (Cultural Planning 1997–2000). It looked into the 'possibilities for the maintenance and strengthening of the societal position of the performing arts in the near future'.[10] The study's main point was that central government should direct itself more towards strengthening the market and expanding the concept of artistic quality for the benefit of a broader public. The report has been criticized by different branches of the profession. The most important objection has to do with the main idea of increased market orientation and the scant attention paid to the artistic and cultural importance of the performing arts. In general the main thrust of this criticism was objection to the shift of attention from subsidized autonomous performing arts production, to the development of an instrument to compel a more market-oriented approach in subsidized theatre.

In the same year (July 1995) the Ministry of Education, Culture and Sciences published a policy paper entitled 'Armour or Backbone' (Uitgangspuntennotitie Pantser of Ruggegraat) which outlined the basic principles for cultural policy in the period 1997–2000.[11] Although this paper paid no specific attention to theatre, it mentioned the following subjects which are relevant to this sector:
- supporting young people in cultural choices;
- paying attention to the existence of immigrant cultures;
- supporting cultural directors in their striving for quality and authenticity.

As well as these and other subjects an argument was put forward for a new balance between private and public financing. There was to be more emphasis on the marketing and promotion of subsidized theatre.

Theatre finds itself in a context of growing competition. Not only from within the sector itself, but also from the ever-growing volume of available entertainment, including non-traditional podia, and especially through substitution. From a study into the growth and influence of the media such as TV and video it appears however that, although there has been a slight fall in attendance, professional theatre has not suffered greatly from this competition. What has happened is a shift towards an older, more highly-educated public in relation to the proportion of young people. The fact that subsidized professional theatre attracts fewer people can be explained by diversification; producers are keen to experiment, while the public has other preferences. The same study also signals a change in recent years; ticket sales in subsidized theatre are on the increase again.

A.3.2 The progress of the Strategy Project
The progress of the project will be described according to the phases shown in Figure A.1.

Figure A.1 Progress of the TGA Strategy Project 1995

Phasing Main Points in the Chronology and Phasing of the TGA Strategy Project 1995
Initiative...Preparation...Development...Production...Execution/Functioning...Follow-up...

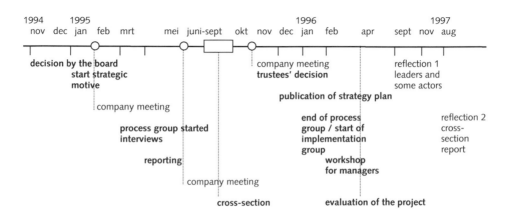

Initiative Phase
The initiative phase, which ran from November 1994 to January 1995, consisted of a number of talks with the directors and a brief study of sources. Discussions with the directors led to a declaration of intent to set up a joint interactive strategy project. The initiative phase ended with a green light from the governing body and an exploratory document, the 'Initiative Report', which would later serve as the outline for the project plan. After the signal to go ahead from the board, which was also based on a positive reaction from the Works Council (OR), a broad start was prepared in the form of a company meeting at which the strategy project would be presented. The initiative phase coincided with the Strategy Motive and the ordering of the core dimensions. Figure A.2 shows the position of the strategy project within the organization.

Figure A.2 The Position of the Strategy Project within the organization

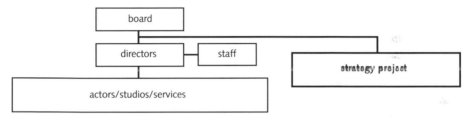

Preparatory phase
This phase took place in February. An information brochure for the company was prepared, based mainly on exploratory material already presented to the board with the addition of some signals which had been picked up. The principle of Strategic Management, the Interactive Approach was explained as well as the demands this approach would make on the company's cooperation. More information about the brochure was given and questions were answered at a specially organised company meeting. During this meeting company members were also presented with a number of publicly-made statements about TGA in a written questionnaire, in order to discover the direction of (strategic) thinking within the company quickly.

Development phase
The development phase ran from March to June and started with the institution of a special process group, which also functioned as project group. The project researcher and supervisor were mainly engaged in researching specific sources and conducting interviews with company members in different positions and functions within the hierarchy of the organization; fifteen people were selected for interviews in advance and five volunteered. At the same time discussions were also carried out with the departments of dramaturgy, and marketing and education, and meetings and performances were attended. Researchers also travelled with a group of actors and technicians to one of the performances outside Amsterdam.

This phase was rounded off with a company meeting at which the results of the report *Drama of the Crow's Nest* were reported and discussed, and there was a global exploration of strategic themes for the future.

Production phase
In September and October 1995 the strategy plan was set up, which focussed more closely on the methods of Strategic management, the Interactive Approach. In concrete terms this meant that a group representing a Cross-Section of the company (the 'Cross-Section') now assumed responsibility for trying out new, interactive forms of cooperation directed towards the realisation of the strategy plan. The composition of the Cross-Section is represented in Figure A.3.

Figure A.3 Cross-Section of TGA

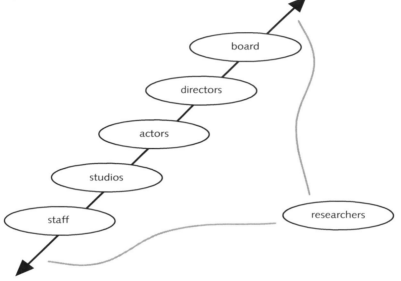

Various duos within the Cross-Section carried out tasks related to different aspects. In the beginning the results were exploratory but by the end of the project the course to be followed for each aspect had been established. The production phase was rounded off with a discussion of the contents of the project plan during a specially arranged company meeting on 20 November 1995. At the meeting there was broad approval for the course which had been taken and the intentions in the strategy plan. Enough grass-roots support had been created to pay more intensive attention to artistic reorganization. In order to realize the proposed organizational changes, the researchers advised taking on external support in the area of human resources management. During a specially arranged public forum different paragraphs of the audience were asked to react to the new policy line.

Execution/Functioning [Implementation] phase
This phase ran from November 1995 to April 1996. The new working methods started by the Cross-Section were continued by the Implementation group. There was a special workshop for managers and an interim human resources manager came to support the organization. The first policy measures were turned into concrete activities: new artistic methods and a reorganization of consultation procedures.

Follow-up phase

In April 1996, an evaluation was held with members of the Cross-Section. After this a meeting to reflect on the project was held with the managers in 1996 and with previous members of the Cross-Section in 1997. During these meetings the project results were discussed and where necessary points for improvement formulated. During the last meeting the draft text on running a strategy project according to the principles of Strategic Dialogue was also discussed. In the Autumn of 1996, the financiers (the Dutch government and City of Amsterdam) agreed to continue their structural financing of the company, based on the advice of the National Council for Culture (Raad voor Cultuur) and the Amsterdam Arts Council.

A.4 Interpretation and Reflection

A.4.1 The importance of the conceptual framework

In the previous paragraph the factual progress of the project was sketched. After this outline sketch it is time to turn our attention to the way in which the conceptual framework (Strategic Dialogue according to the principles of Strategic Management, the Interactive Approach) actually functioned in a practical situation. This insight, gained through reflection and interpretation, can provide the basis for further improvement of the concept.

First the Strategic Motive will be discussed (paragraph A. 4.2), followed by the five other key dimensions (paragraph A.4.3). These key dimensions will be systematically examined against two evaluation questions:
1. What positive experiences were obtained in relation to the key issues? (results)
2. What striking or unusual experiences occurred in the application of these key issues? (notable experiences)

For clarity's sake a very brief summary of the key issues including the Cultural Tracks will be given. The Cultural Tracks will also be discussed separately during the retrospective consideration of what has been learnt about the input to the strategy process in paragraph A.4.4. This will also be the aim of the discussion of Strategic management, the Interactive Approach in paragraph A.4.5.

A.4.2 The Strategic Motive: Results and Points of Interest

The essence of the Strategic Motive (key dimension 1) is orientation: describing in advance those factors which may promote or hinder the success of strategy formation. The Strategic Motive begins with an understanding of the underlying reasons for the strategic process. The Strategic Motive should also pay attention to relevant Cultural Tracks (Historical Analysis and Artistic Leadership) and finally it maps out the Strategic Rhythm, the Strategic Sketch and possible resistance to change. The Strategic Motive is brought to a close with the development of a 'process architecture' which orders the variable key dimensions and includes them in a project based on the principles of Strategic Management, the Interactive Approach (ISM).

Reasons: Results
- Researchers and directors had an open discussion about the formal pretext for the project (producing a strategy plan for the period 1997–2000) and organizational problems (desire for a new building, rising age of company members, the need for new initiatives from actors and clarification of artistic and business leaders' responsibilities).
- This discussion showed that there was commitment to the general thrust of the project: the need to improve existing ways of working. The organization needed to be more adapted to meeting artistic goals.
- There was a shared realization of inadequate communication with the 'outside world'. During the first talks the researchers gained the impression, also held by the directors, that the organization tended to react defensively to criticism from outside.
- The researchers probed further into a possible hidden agenda but the open nature of the initial discussion, meant that no 'hidden' reasons were detected. These did not emerge later in the project either.
- Directors and researchers agreed that from their perspective an interactive strategy project along the lines of ISM had a good chance of success.

Reasons: Notable Experience
- At the start of the project there was no interactive contact between the researchers and the different paragraphs of the company. There was no chance for instance to gain extra information about the results of the written questionnaire carried out at the start of the project. The questionnaire was only used internally by the process group and researchers for evaluation purposes and later on to structure interviews. Answers to the questionnaire showed that there were doubts about the functioning of the leaders in relation to the company's future.

Historical Analysis
The essence of this track is that strategy formation must be fully anchored in a historical view of the Arts, which provides insight into the role and meaning of one's own artistic choices; the Strategic Motive gives a first impression of this artistic positioning.

Historical Analysis: Results
- The researchers' assumption that artistic policy was firmly rooted in theatre tradition proved to be correct, although TGA's diverse repertoire made categorisation into a specific genre impossible. This assumption meant that the researchers did not focus primarily on the artistic reasons behind choices.
- The researchers judged that the task which TGA had set itself was clear. This task was 'making theatre in the broadest sense of the word' starting from the principle that 'nothing is certain'. This statement should be seen in conjunction with the many statements made by the company in their own magazine and during interviews with the press. This judgement proved accurate throughout the process as can be seen by the text of the new strategy plan which continues to elaborate on this theme.

Historical Analysis: Notable Experiences
- The researchers' judgement that a strong historical sense of one's art-form feeds strategy formation needs some further explanations. Such a historical sense had certainly been a support to the company when others had doubted their artistic direction. However it eventually proved inadequate for supporting the development of new cultural themes, such as the relationship between theatre and multiculturalism.
- Can a 'task with explanation' be compared to a cultural 'mission'? The researchers agree that a mission can take many forms as long as clear value-oriented norms are set. The practical study proved this. If the mission is unclear much more time needs to be allowed for a clearer formulation. The formulation of the mission was not discussed in the process group. Due to its importance for a cultural organization, however, this issue should probably always be included on the agenda.

Artistic Leadership

The essence of this track is responsibility for the quality of artistic coordination, as judged by six criteria, see § 1.2.8. During the Strategic Motive quality of artistic leadership needs to be examined to avoid Cultural Strategic Dialogue being overshadowed by the malfunctioning of the artistic coordination.

Artistic Leadership: Results
- From the beginning there was open communication with the researchers about the artistic leadership. In a first, frank discussion with the researchers, the artistic leader let it be known that he had strong doubts about continuing in his position. These uncertainties had mostly to do with his need to follow an individual artistic direction, unencumbered by responsibility for the company.
- The decision made with the artistic leader that before the company made decisions on a number of essential points about the startegy (June 1995), he would provide clarity on whether he would stay or not, proved a good one.

Artistic Leadership: Notable Experiences
- In spite of clear agreements about the period allowed for coming to a decision, this was an uncertain element in the strategy process, which proved a great threat. Because of the artistic leader's dominant position, an incidental remark about his possible departure could disturb the whole process.
- The possible departure of the leader also overshadowed questions about the quality of leadership. Although the results of the questionnaire, in which there is much criticism of the leadership were known to the researchers, their attention at this stage was directed more towards the results of his possible departure. It would have been better to pay more attention to the functioning of the artistic leadership as well.

Strategic Rhythm

The strategic rhythm reveals the organization's experiences in the area of strategy formation. It is one of the bases on which decisions can be taken about what and how much needs to be learnt.

Strategic Rhythm: Results
- The researchers gained a good picture of strategy formation in the past as compared to the desired attitudes according to the principles of ISM. This is made clear in the following overview.

Actual experience	**Desired strategy guided by ISM**
Top-down	Horizontal
Informal/ad hoc	Open /systematic
One-sided focus	Integrated approach (strategy and organization)

This comparison guided the researchers in making interventions.
- Ansoff's 'turbulency measurement' (§ 2.4.3) provides insight into the relation between turbulency and the existing and desired management approaches. The context in which this organization found itself was moderately changeable (fairly straightforward although challenges were increasing rapidly) and moderately transparent (the speed of change was not surprising; limited information about changes and context). According to this evaluation of turbulency the organization scores a three to four, which indicates a pro-active style of management with much attention to the public (marketing). On further examination the organization has a pro-active style in relation to artistic questions (sometimes creating its own level five turbulence through its position as market-leader) but the overall 'grand' strategy seems much more reactive (or even defensive) and suggests level two turbulency. This conclusion was actively communicated to the directors and later within the company helping to form a basis for the necessary changes.

Strategic Rhythm: Notable Experiences
- It was difficult to determine one specific dominant school of strategy in strategy formation. Existing strategy formation, top-down but informal, had characteristics of various schools: certainly an entrepreneurial school as far as the artistic leadership was concerned, but also a cultural school in which implicit strategy formation was propelled by a strong sense of artistic values and norms. The project showed that strength was found to lie in a combination of the strong points of different schools: an entrepreneurial artistic leadership, based on views of how a certain course should be followed together with professional cooperation. In the beginning this approach was applied very effectively, during implementation less effectively.
- The difference between actual and desired strategic behaviour may have been signalled and discussed, but the translation of this difference into action was at first restricted to the process group. During a company meeting a few months later, this was changed by involving more company members in leading, and reporting on, discussions and so on.

Strategic Sketch

No process begins with a clean slate regarding the future course. What are the main points mapped out earlier, perhaps informally, by the organization?

Strategic Sketch: Results
- Research into the strategic sketch led to an immediate and unambiguous conclusion: the organization has a deep and long-standing need for a new location. The current location was only the first step on the way to a completely new and well-fitted out theatre. This did not imply a fundamental change of the mission but the fostering of an ambition rooted in thinking about innovative theatre.
- Another clear point to emerge from the strategic sketch was the directors' and board's statement on the financial position; in the future the company would need to continue relying on government funding in order to make their own, non market-oriented form of theatre, the basis for which was and would continue to be 'not-for-profit'. This statement was a clear condition for the strategy process, which needed to be respected.
- The researchers' concluded that within strategy formation most ideas demanded 'expression' rather than 'creativity' and this was felt from the start to be accurate. This led to the conclusion that energy should not be wasted on formulating completely new directions. The emphasis would lie on providing a strategic framework for the many existing intentions, suggestions and ideas in order to formulate these ambitions more clearly and to contribute in a concrete way to the continuity of the organization.

Strategic Sketch: Notable Experience
- The researchers found it difficult to work with Mintzberg's concept of 'strategic patterns' (§ 2.3) as it provided too little structure for strategy formation. Mintzberg is concerned with various ideas and existing measures, with no structural strategy framework.

Resistance
Does the organization realise the need for change and where resistance is to be expected?

Resistance: Results
- The growing realisation that the organization was facing important changes meant that the subject of 'resistance' was a main focus of discussions with the directors and process group from the start. This approach made it possible to broach the subject and optimalize the ISM approach: the passive attitude in the company and, as noted by the directors, worry about job security needed to be transformed into an alert, active attitude, directed at self-management.
- In the process group the fact that the need for change may not have been universally shared was openly discussed. A few actors and technicians found it difficult to leave the trusted City Theatre surroundings and were certainly not looking forward to a move. When strategic choices were being made, conflicts might arise with these members. The researchers concluded from this that they should attach great importance to achieving interactive insight into the strengths and weaknesses of the organization as a source of change. Partly for this reason, all members were enabled to influence the analysis during the company meetings, two of which were planned in advance and one of which was spontaneous.

Resistance: Notable Experience
During the Strategic Motive phase no analysis was made of the relationship between the theme of resistance and the generally known uncertain future of the artistic leadership. Due to the dominant position of this leadership within the organization such an analysis would have been desirable, especially since the written questionnaire held at the beginning of the process gave no clear indication about possible resistance to change.

Organization of the process: results
- The Strategic Motive provided practical guidelines for designing an effective process architecture according to ISM. This meant that the core dimensions could be flexibly applied and that Strategic Dialogue could really meet the particular needs of the situation. The process architecture is represented schematically in figure A.4.

Figure A.4 Process Architecture Including Time Indication

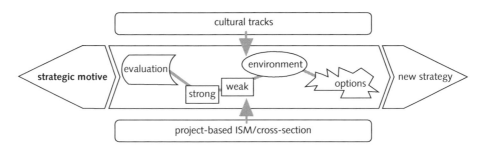

- If we compare the core dimensions with the standard order in paragraph 2.4 we see that the strengths and weaknesses analysis has been brought forward and that the formulation of options directly precedes the new strategy. This choice was made possible by the knowledge that a strengths and weaknesses analysis contributes to the realization that strategic changes are necessary.
- The meaning and position of the key dimensions was clearly indicated from the start of the strategy project. The overview shows how this took place in the action research and why the order was changed (later developed into a plan which was included in the project plan).

Key Dimension	Concrete activities	Justification
2. Evaluation	Interviews, study of sources, second company meeting	Evaluation gives an opportunity for reflection; position is same as in original model
3. Study of context/- surroundings	Briefly during interviews, second company meeting and especially in the Cross-Section	The limited experience demands a directed approach which will produce enduring results; this subject is less suitable for an interview method

4. Formulation of options	Exploration during second company meeting	As in the model
5. Strengths and Weaknesses Analysis	Through interviews and rounded off during the second company meeting	Because of the limited experience with strategic processes the strengths and weaknesses analysis was linked to the evaluation; in this way those involved have the maximum chance to use their experience.
6. New Strategy	Through the Cross-Section and rounded off during the third and last company meeting	As in the model

- Within the process group there was open discussion about the desired qualities of external researchers/researchers. In the project plan different criteria for success were formulated. One criterion concerned avoiding 'jargon', which might arouse irritation in the company.

Organization of the Process: Notable Experiences
- In the non-profit sector borad members rather than directors bear final responsibility for the continuity of the company. One member of the Board of Trustees took part in the project process but otherwise the Board's position was hardly touched on. This threatened the project in a number of ways. At first the board doubted the feasibility of a democratically functioning ISM, because of the dominance of the artistic leader. The artistic leader himself, however, emphasized that due to the pressure he experienced a new culture of cooperation was both necessary and desirable.
- The project plan said little about the shape of the 'learning organization' at the start of the process. This is mentioned explicitly for the first time at the company meeting held five months after the start in preparation for the 'Cross-Section'. The researchers were reticent on this matter.
- The researchers could have interpreted the comment about 'avoiding jargon' as the pretext for a short training in setting up and implementing interactive strategy projects. After all, jargon is for the most part simply the strategist's knowledge. For the moment, however, it was decided to make do with referring to publications by the researchers and distributing some photocopies of professional articles among the process group members.
- The researchers dealt with the project plan rather loosely. The plan was only made definite in April. A clearer line could have been followed at an earlier stage, based for instance on the checklist of the Strategic Motive.

A.4.3 Other key dimensions: results and issues

Key Dimension: Evaluation
The core dimension evaluation involves exploring insight into the success, or lack of it, of current activities and the operational effectiveness of the strategy. In relation to the

Cultural Tracks, the main accent lies on the degree of realization of the balance between tradition and innovation.

Insight into the Success of TGA: Results

- In getting to know the company a written questionnaire was conducted to find out members' opinions about the organization. The results gave the process group a fairly accurate picture of these opinions. A third of the company had doubts about the direction which was being followed; this in turn was linked to uncertainty about the future of the artistic leadership. There were similar doubts about the identity of the company.
- Insight into the importance of the performances, as well as the studios and theatre design, can be gained from theatre critics' reviews. The general tone of these is positive to very positive. A few reviews are negative. Where this is so, the critic wonders rhetorically whether the negative quality is associated with the weak position of the company.
- The method which was followed quickly produced a reliable picture of the operational effectiveness of the strategy. It became clear that an important factor, particularly in bridging the difference between present and desired activities, was the possession of one's own theatre.

Insight into the Success of TGA: Notable Experiences

- Along the way it became clear that there was little discussion within the organization of the company's artistic achievements, or marketing and education, except incidentally and informally. New productions, the functioning of guest directors, the choice of co-producers were not evaluated by the artistic leaders, let alone assessed against the original strategy plans. This lack of evaluation was related to the lack of adequate evaluation skills. Within the strategy project it became obvious that the leaders themselves should provide an example of the way in which an open evaluation of artistic and other achievements could take place. Although this principle was emphasized in the later phase of the project, it was only after several months that such an evaluation could be organised.
- In the key dimension Evaluation (coupled to the keydimension Strengths and Weaknesses Analysis) none of the discussed instruments from chapter 2 were used, for example a portfolio for each core activity. Insight into the core activities consisted in this case of the main impressions gained from interviews and a few written sources. Because a general understanding of effective functioning developed and there was growing awareness of the need for structural improvement, there was no further research into this area. If a common understanding had not developed, then research using the instruments discussed would have been needed.

Artistic Innovation: Result

- An awareness of the balance between tradition (active participation in theatre history) and innovation (experimental breaking of boundaries) came in the first place from members of the organization. The researchers had only a marginal role in evaluation. On the basis of the sources used (interviews, documents) the researchers found that neither within nor outside the organization was there any doubt about the innovative character of the group, from an artistic perspective. The researchers also found the

balance between tradition and innovation belonging to this track present in the company.

Artistic Innovation: Notable Experiences

- A few actors had difficulty in actually labelling the character of the organization as innovative. They were critical of the term. On the one hand this had to do with the idea that the organization could appear arrogant to the outside world if it called itself innovative. On the other hand these actors were not happy with the idea that the company should only profile itself as innovative, when it had such a broad repertoire. The researchers described the term 'innovative' as 'the internal ability to plan and implement innovation under one's own strength'. They also emphasized that the organization had to solve strategic and organizational problems through innovative artistic potential.
- The terms 'innovation' and 'change' caused some problems. A new element was the expectation that this could raise in the public's mind, which in turn would put too much pressure on the company. For the researchers (and later the Cross-Section) the discussion was not only about tactics; innovative ability is important for the changes which the organization faces.

Key Dimension: Strengths and Weaknesses Analysis

The strengths and weaknesses analysis was mainly directed, as far as the Cultural Tracks were concerned, towards the artistic processes in the organization (also towards artistic creativity and artistic leadership). The main emphasis in the study of the organization was on results obtained from the functional areas. In comparison to the model, this key dimension was brought forward because the researchers had the impression (on the basis of information from the Strategic Motive) that the strengths and weaknesses analysis – combined with evaluation – would promote more systematic strategic thinking within the organization.

Artistic Process (Together with Creativity, Leadership and Functional Areas): Results

- The Strategic Motive proved a good basis for exploring dissatisfaction about the organization and leadership in the strengths and weaknesses analysis. It was possible to base much of the report (Drama of the Crow's Nest) on company members' actual words taken from interviews. From these texts great concern emerged about the way in which the artistic leadership operated within the organization. The reason for deciding to take part in co-productions was not clear, heavy work pressure led to insufficient working out of ideas, it was also felt that there was exploitation of actors and technicians and it was emphasized that artistic ambitions were much wider than the company's technical and organizational possibilities. Further subjects were the lack of internal artistic cooperation, insufficient use made of actors' ideas and the overburdening of the artistic leadership.
- The researchers concerned themselves with asking the right questions and structuring the information. In the report the following impression was given of the organization's strengths and weaknesses, also in relation to the functional areas.

Strong Points Mentioned by Those Interviewed:
TGA is the absolute top as far as talent is concerned

The group's strength lies in diversity, individuality and reliability

TGA offers many possibilities, especially in the person of Gerardjan Rijnders

TGA is the most innovative company which means it's fun and varied

The composition of the company in combination with Gerardjan Rijnders and Titus Muizelaar makes TGA the best group.

It is the only large company which is not (formally) organized into a hierarchy

The quality of the decor studio is internationally renowned.

The technical team is flexible, professional, diverse and can manage a great deal.

Weak Points As Experienced by Those Interviewed (Arranged According to Functional Areas):

Communication: 'We are not open and personal relations are complicated; people are worried about their position; there are too many meetings. We don't meet effectively. Things tend to get discussed in corridors or bars.'

Production: 'Our common methods of work are not flexible; there is a gap between artistic organization and policy.'

Marketing: 'We have no integral marketing and sponsorship strategy. We still have a lot to learn about commercial marketing.'

Finance: 'We don't work with budgets and clearly defined responsibilities. The attitude is: there's always more. Departments are not linked to each other by a network. Artistic decisions (often hasty) are not worked out financially.'

Personnel policy: 'There is no care for people in spite of the risks we take. Too much is produced, leading to people being exploited. Actors circulate too little. There is a small artistic elite but little innovation in the layers under it. Newcomers find it difficult to settle in the group; there is too little coaching. Failure to function satisfactorily is interpreted as personal failure.'

- The information gathered, made recognizable through the use of people's actual words, clarified the researchers' tasks. Which questions would lead to the improvement of the organization? In the report the researchers gave their conclusions about the results of the strengths and weaknesses analysis in combination with the evaluation and the results of the written questionnaire. The most important conclusion was that uncertainty and weak organization placed the company in a 'strategic danger zone'. Unless shared ambitions were formulated the future of the company would be threatened.[12] It was not just a worrying situation, but an acute crisis. This was also true in relation to the fact that the strategy plan for the coming four years needed to be presented to the financiers (state and local). The researchers added to this that the positive and strong points of the organization were a good starting point for new strategy. But all members had to be willing to support the new approach. This view was supported by the company. As a result, the researchers suggested the following steps:
 - making artistic choices explicit;
 - developing ways of caring for each other;
 - continuous evaluation;
 - increasing the involvement of the public;
 - bringing together reflection and innovation.

 These points were put on the Cross-Section's 'to-do' list.
- For the first time the organization worked with multidisciplinary working groups to

discuss reporting. This method of working was valued according to a check made by the process group. The communication process, which was centred on a shared evaluation of the organization, gained in strength. A great deal of attention was paid to the artistic leadership: the arrival of a second artistic leader (Titus Muizelaar) was intended to improve communication and organization.

- When those concerned realised that their 'single loop' learning no longer produced improvements, they saw the need for change. Radically different conceptual frameworks and methods of work had to tried out. The turning point in this case came when insight was gained into the strategically vulnerable position. In the first exploratory talks with the leaders (during the Strategic Motive) these elements were globally discussed. In time, various things were confirmed by the company and gained more clarity and importance.
 The researchers concluded that in spite of the vulnerable situation there were the necessary conditions for a successful start to the Cross-Section.
- There was clear support within the company for setting out on a new course which involved continuous learning
- There was increasing approval for the ISM approach; all people asked to join the Cross-Section responded positively.

Artistic process: notable experiences
- The researchers had to be continually alert to the development of negative feelings among members. There was some criticism of the talk about strengths and weaknesses in multidisciplinary teams. One actor commented that it had a 'seventies ring' because 'the artistic leader just does what he wants anyway'. Other comments were made about a 'pseudo-democratic feeling'. What was the best way to deal with this informal criticism? The process group decided to take this criticism seriously and pay attention to it through short interviews in the special Strategy Newsletter.
- The key dimension Strategic Motive produced essential information about all relevant factors at the start of the process. It was clear however that this information would have to be continually supplemented. From the preparatory research it emerged that existence of problems does not in itself immediately lead to the idea of a 'strategic danger zone'. The gravity of the situation was only realized during the round of interviews.

Key dimension: study of the environment

In the study of the environment the main emphasis lies on examining notable trends. At the same time it has to be established how turbulence will affect the strategy. In relation to the Cultural Tracks this key dimension firstly implies the multicultural context as well as the general artistic interest.

Trends and turbulency: results
- The organization's lack of attention to its surroundings (Strategic Motive) coupled to the necessity of understanding the context made it clear to the researchers that intervention was definitely needed here. This mainly took place through the presentation of information about current trends (cultural competition in production and distribution, internationalization, interactive media, declining subsidies/own

sources of income, new administrative relations due to municipal reorganization) and bringing issues and dilemmas to people's attention.

- The researchers gradually increased the company's own activities towards their 'surroundings'. In this way attention to the surroundings was gradually improved during the project. A multidisciplinary team (in preparation for the Cross-Section) explored the theme of 'surroundings' in terms of a number of aspects relating to politics, culture, technology and internationalization. This group warned, rightly, that the coming strategy plan (according to suggestions then circulating) could contravene existing eligibility requirements for government subsidies. Later a special duo from the Cross-Section was formed and produced a short text about notable trends in the surroundings. The duo concluded that in looking strategically to the future, the organization should take the initiative in the debate, shifting the emphasis from defensive to offensive. At the same time the duo argued that grants to TGA could be seen by the State as a 'choice for adventure'. These approaches were included in the text of the strategy plan.
- During the Strategic Motive the researchers assessed the turbulency level. The estimate appeared to be fairly accurate. In the later study of the surroundings carried out by the duo no new unexpected trends turned up. The statement about the relation between turbulence and management approach also turned out to be valid, moving from reactive to pro-active.

Trends and turbulency: notable experiences
- The company's lack of orientation towards its surroundings led to problems during the interviews: those interviewed had difficulty imagining relevant current trends. The questions were therefore limited to more open questions concerning the interviewee's ideas about the surroundings. The general feeling within the company was summed up by the following remark:
TGA's individuality comes first; there is little influence from outside.

On the one hand this can be interpreted as a conscious strategic attitude in regard to the surroundings: it is not our surroundings which determine what we do, but we who confront others with our ideas. On the other hand this implies a denial of external influence on the thought and actions of the organization. Both views existed in TGA, producing an ambiguous relation to the surroundings. For the researchers it meant that they needed to make clear to those involved that the final text of the strategy plan should present a clear picture of the relationship between the organization and its surroundings.
- Although in the professional practice of strategy formation a study of the surroundings and the use of the necessary techniques is taken for granted, in the TGA project this aspect of the study was missing from the preparatory phase. Only in the Cross-Section was a good selection of trends and guiding statements produced. This led the researchers to conclude that when they signalled an under-developed skill they should have started to implement a suitable technique much sooner, perhaps supported by short training sessions.

Multicultural context: result

- The need to pay attention to aspects of the multicultural society were emphasized both within the company and by the researchers. A multidisciplinary team reacted to the term multiculturalism, by saying: *TGA is white!* Questions posed by the researchers to the group were: How does the organization communicate with the multicultural society? Is there any cooperation with multicultural organizations? Could TGA possibly have its own multicultural theatre? The Cross-Section also drew the conclusion that the organization lagged behind multiculturally. The report made by the duo looking into 'publics' had more to say about this and pointed out the changing composition of the population. The conclusion was that more attention needed to be paid to the link between demand and supply while maintaining the principle of autonomy of artistic work.

Multiculturalism: notable experience
- In the discussion in the Cross-Section about the text of the strategy plan the question was raised of whether the performances offered should a priori be directed towards ethnic groups. A majority felt that this wold be in conflict with the company's artistic autonomy and wanted changes in production to depend on artistic developments within the company. The discussion in the Cross-Section continued with the idea that the desired attention for young people could also include attention to young people from ethnically diverse backgrounds. This was based on the positive experience which TGA had had in the past with youth productions. The text in the strategy plan was written in this spirit. In this sense the Cultural Track was developed to a limited degree in regard to the content of the Democratic Dialogue (§ 2.5.3). A further clarification of the internal debate never took place. The paragraph on Cultural Tracks (A.4.4) will deal further with this point.

General cultural interest: result
- How does a subsidized cultural organization give form to its relations with the bodies which act as financiers? Through the formal pretext of strategy formation (submitting a grant proposal and a four-year strategy plan) the process was partly directed towards a more certain relationships with the financiers, in the case the State and the City of Amsterdam. The obligation to tour imposed on companies by the State in order to spread theatre culture through the country, evoked wary responses from theatre producers (too many lost hours and too many uninterested theatre directors). The organization also resented the growing tendency in grant policy to force institutions to take account of 'market forces'. In reaction, the artistic interest was still taken seriously but it was decided to go into the offensive and give an individual interpretation to this obligation: a concentration of performances in a limited number of major cities in the Netherlands. This approach was seen by the organization as a chance to emphasise other aspects of artistic interest: cultural education and more involvement of the public in the performances.

General cultural interest: notable experience
- Within the company, subsidies were seen as the necessary financing of independent theatre. What struck the researchers was the unbusinesslike way in which the authorities and the organization dealt with each other in discussions about conditions.

There was no open dialogue about differences of interest. During the whole process there was only one occasion (on TGA's initiative) when there was informal discussion of the company's new ideas. As a follow-up to this, the new strategy plan will state the need for a 'professional relationship' with the authorities.

Key dimension: Formulation of Options

The demand for rich future opportunities directed towards changing the sector is the main concern in this key dimension. From the discussion of the Cultural Tracks it appeared that due to the societal position of the arts and culture, options needed to be formulated within the track of cultural credit.

Formulation of Options: Results
- The Cross-Section group was able to sketch clear future possibilities (as defined by Hamel and Prahaled, § 2.2.4), which taken together would distinguish the organization from others.:
 1. The development of a new method of work: the Theatre Factory option (see excerpt below from Strategy Newsletter) in which performances were prepared and performed in the company's own location, according to members' individual ideas and under their own conditions without planning pressure from theatres.
 2. The transformation of the obligation to tour (performing in many places and regions) into a 'desire to tour'; the presentation of the TGA-repertoire in a number of major cities in the Netherlands and Flanders.
 3. Strengthening ties with the new local media by, for example, producing a soap series and making an interactive website on the Internet.
- The researchers had by this time adopted Mintzberg's pattern recognition as a tool. This instrument helps in the formulation of strategic options, which are closely linked to the ideas already mentioned as being present in the informal organization.
- Another more internally directed strategic pattern was the lowering of the average age by taking on a group of recently graduated actors. Such patterns were experienced by the researchers as indicative of the priority of the directors and governors to structurally renew the company.

About the Theatre Factory:
"We have a Theatre Factory on the Haarlemmerweg. Between sixty and ninety performances are produced here in a limited period of five to six months in a compact, direct and thus efficient manner. First a committee is formed. From that moment on everyone can submit their wildest ideas to the committee. Pieces, ideas or performances are produced right away at the location. When the period has ended the artistic result is assessed as well as the experience which has been gained through this new method of production. "
(Titus Muizelaar in Issue 2 of the Strategy Newsletter)

Formulation of Options: notable experiences
- It was necessary to pay attention not only to the general acceptance of the new strategy but also to a careful analysis of the support available for each option individually. During a company meeting (before the Cross-Section) many questions

were asked for example about the Theatre Factory option. At first this idea belonged only to the artistic leaders, the artistic staff and some actors. The tour obligation option, on the other hand, had a great deal of support; most of those present were annoyed about having to undertake touring which they found to be artistically pointless.

- That a strategy cannot be divorced from an informally conceived future opportunity would seem to be self-evident, but it can also lead to misunderstanding. Problems arose when the Cross-Section started to meet about the linking of the strategy project to the option of the Theatre Factory. Critics found that the researchers were too 'eager' about the Stage factory because it suited 'their' project. This association was seen as a threat: criticism of the new strategy (especially from a few actors) could mean that the stage factory idea would be discussed in a negative light. The report Theatre Factory as Driving Force, in which the researchers set out the relationship between the strategy project and the Theatre Factory, served to increase this perception of eagerness. Gradually awareness developed that the new project was completely in tune with the content and form of the new direction. The Theatre Factory was included in the final version of the strategy plan.
- This criticism showed that when it started, the strategy project was not integrated into daily events and the project was sometimes seen in this phase as a 'research project by outsiders'.

Cultural Credit: results
- Cashing on in cultural credit was one of the most important points in the Cross-Section. The need for more clearly-defined financial management even led to the hiring of an external expert on the researchers' initiative. This enabled a special duo from the Cross-Section to acquaint themselves with the scope of this aspect of management. This broadened the attention to financial management.
- A relatively great deal of attention was paid to procedures and responsibilities. The result was that the new strategy plan contained agreements about budgets and control for each production and department.

Cultural Credit: notable experiences
- Although this track should chiefly be concerned with cashing in on cultural capital, In fact it followed a different course more concerned with methods. Much less attention was paid to extending and strengthening financial resources.
- During the Cross-Section the researchers were confidentially informed of an unexpected increase in debits, amounting to about NLG 500.000,– (EURO 227.272). An important cause of this appeared to be the reporting system. The fact that it did not function effectively meant that timely checks and adjustments were not possible (see further § A.4.4).

Key dimension 6: New Strategy

This key dimension, the final part of the Cultural Strategic Dialogue, presented the 'what' and 'how' of the organizations's strategy: its ambitions and intended changes which would bring the vision of the future closer. All the Cultural Tracks play a role here in principle. The results are laid down in a strategy and implementation plan. In this

dimension the concept of the experienced 'learning organization' helps to keep the organization strategically alert and flexible.

Strategic plan: results

- A Cross-Section is directed at both results and new forms of working. In the Cross-Section, duos explored various new strategy aspects and turned these into pilot texts. This formed the basis for a list of activities which was discussed during a company meeting.

 The results of the Cross-Section were presented in the form of a strategy plan to a specially convened company meeting. The strategic plan, contained a directed vision of the future in regard to several major elements, such as new working methods in the Theatre Factory, an independent variation on the obligation to tour, a detailed working out of the digital highway and the plans for a new theatre. The plan also contained various policy measures in major management areas, such as: marketing, types of public, finance, human resources, organization.

- The criteria of coherence, harmony and advantageousness meant that the researchers were actively responsible for guiding the process to arrive at the strategy texts. This was mainly achieved by presenting the Cross-Section with alternatives where dilemmas had not led to a concrete result, for example in the area of organizational structure and cooperation.

- The strategy plan 1997–2000 received a positive endorsement from the financiers based on Arts Council recommendations. They agreed to renew their subsidy to the company for a further four years. When the requested extra funds for company priorities failed to materialize, the organization itself assumed responsibility, financing several major priority targets. The professional press also reacted positively, in as far as their comparison with other strategy plans was favourable.

Strategy plan: notable experiences

- Special attention was needed for transforming strategy intentions into actions. To what degree should the Cross-Section be responsible for this? The procedure followed in the action research was the following: the Cross-Section produced texts which outlined the direction to be followed and discussed coordination. Dramaturgist Dirkje Houtman worked the texts into a strategy plan under the guidance of the process group; the artistic leaders wrote the introduction and the researchers checked the content and process. Finally the company gave its approval. In retrospect the company found that this approach was insufficiently interactive. They felt that they could have started to tackle some dilemmas themselves at an earlier stage, for example the multicultural issue.

- The advisors to the financiers (the National Council for Culture and the Amsterdam Arts Council) directed their recommendations chiefly towards the creative position of the artistic leader/founder and paid hardly any attention to the strategic functioning of the cultural organization (the relation between micro and macro levels, the effect of interactive strategy formation, the importance of cultural dimensions as emphasised by the company). This approach should have been explained in more detail to the outside world.

Target Changes: Result
- After the Strategic Motive it became increasingly clear that strategy needed to be strongly directed towards change. Three main target changes were distilled from the final strategy plan:
 1. Finding a theatre for the company which would enable a more creative, less bureaucratic manner of planning, programming and producing, i.e.cutting loose from a forced planning by the obligation to tour and the City Theatre programming.
 2. Realising a new way of working for actors and technicians, i.e. enabling them to break free of their rigid activity plans which took little account of those involved in implementation.
 3. Engaging with new publics in a more intensive and inspiring way in the company's own theatre, the major cities and international contexts, i.e. breaking with the company's customary practice of output and consumption.

 During the process these aims were communicated increasingly clearly (in meetings and newsletters) and therefore evoked no resistance when they were formally established.
- The directors supported the changes without reserve. This also held for the board of trustees and the member of the work council.

Target Changes: Notable Experience
- In the company's broad support of the target changes, no special attention was paid to the actors. Due to the fact that actors' involvement was of great importance in introducing the Theatre Factory and a different method of touring, the researchers had to be extra careful that there was satisfactory communication with this group.

Implementation: Results
- Agreements about implementation were made throughout the dialogue from the conviction that implementation of a new strategy starts at the moment the Strategic Motive is explored. As well as the meetings of the Cross-Section, the company meetings can also be seen as source of implementation. The last company meeting led to the ideas about implementation being more clearly defined, through questions and suggestions from the whole company.
- During one of the last meetings of the process group, the formal implementation plan was agreed on and an implementation group initiated. The plan consisted of two main aims:
 1. Realisation of the priority list from the strategy plan 1997–2000
 2. Introduction of organizational changes.

 The working methods of the Implementation group formed a continuation of the experiences of the process group and the Cross-Section. This implied:
- Mobilization of knowledge from different layers;
- Working in projects;
- Independent working in pairs.

 Agreements were also included about contingency plans if government grants were lowered. Social guidelines were also formulated to guide the organizational changes. The implementation group consisted of member of the Cross-Section and new members, under the leadership of the second artistic leader.

- At the end of the process three follow-up meetings were held, mainly with previous members of the Cross-Section. During the first meeting (three months after the rounding-off of the strategy plan) everyone was very satisfied with the strategy project, even though problems were looming over implementation. During the second meeting (eight months later) attention was paid to the climate of cooperation. Although those present were pleased with the structuring of consultation and tasks, and the realization of several important strategic points (the Theatre Factory, performing in major cities) communication about changes was insufficient. The third meeting (a year later) concerned the discussion of the researchers' final report and the realization of the strategy plan. The organization and management seemed to have become remarkably more transparent 'under their own strength' but there was still insufficient communication with actors about current strategy issues, such as the new theatre and a follow-up to the Theatre Factory. An inventory of policy results produced a high score. Of the almost fifty actions mentioned in the plan, 86 percent had already been realized or set in motion. There will be a further consideration of the continuing effect of the strategy project in the discussion of ISM (§ A.4.5).

Implementation: Notable Experiences
- In the later phases of the process the researchers noticed a certain hesitation on the part of the leaders. Too little attention had been paid to the relationships between the Cross-Section and middle management. For this reason, in February 1996, a special workshop for managers/leaders was held. The direct reason for this was a comment by the second artistic leader that shouldering the implementation process had become too arduous and was taking place at the expense of his artistic functioning as director and actor. An important aggravating factor was his experience that he was usually alone in continually having to fulfil an example function in the innovations in TGA. The workshop made use of the concept of unwritten rules as described by Scott Morgan and mentioned in § 2.6.2).
- The specially arranged workshop with the managers/leaders made it clear that there was a difference between the Cross-Section and the managers in their approach to the changes. Although various leaders had been active in the Cross-Section, managers as a whole were never addressed as a group during the process, in relation to a different method of leadership, which would fit into the aims of the changes. It was not so much a question of lack of information among the managers as of a lack of ability among the leaders (at middle-level) to realise new aims in a changing situation and to lead these transparently in sub-processes, while still themselves in the process of learning.
- At the end of the project the appointment of a temporary external human resources manager was delayed. This appointment was considered by the researchers and the process group as an absolute condition for the realization of organizational improvements. The delay happened perhaps because the researchers had not explained the final report to the board in person.
- The researchers noticed during evaluation meetings that there was a lack of initiative in dealing with situations in the area of communication. At the level of analysis (what has been achieved, why do some things work well and other not) the company assumed a professional attitude and there was a noticeable improvement since the

beginning. But when the problem was finding an effective manner of communication there was too little action. Too much store was placed on the temporary human resources manager, in the hope that he or she would play the same intensive role in process and content as the researchers had during the strategy project. Although the tasks of the temporary manager had been well-structured, there were differences in expectations and perspectives within the company.

- The construction of 'implicit implementation', the idea that the interactive Cross-Section would automatically lead to interaction during implementation, was not entirely justified. Implementation of new policy had to be explicitly presented to the whole organization in separate sessions directed towards creativity. The nature of Cultural Strategic Dialogue (which here implied shared responsibilities, flexibility and orientation towards results) made it possible to take direct measures the moment implementation was found to be inadequate.
- The transformation of 'implicit' into 'explicit' implementation caused a delay which affected the communication about the changes within the company.

A.4.4 Cultural Tracks in retrospect

In the discussion of the key dimensions, several Cultural Tracks have already been mentioned. These were tracks which received special emphasis within a certain key dimension. As noted before and it should be quite emphatically repeated here, the formulation of the tracks only received its definitive form during the writing of the final text of the research results. Because of this limitation it is necessary to be somewhat reticent in drawing general conclusions.

Historical analysis
On the basis of information given about the repertoire of the company, this track was strongly represented in the organization under study. In accordance with the findings as mentioned in § 1.2.2, this meant that artistic and socio-artistic choices were strongly linked to theatre history. The decision that the company needed a theatre of its own was not an artistic leader's whim – as sometimes reported in the media – but was rooted in a genuine attempt to leave an imprint on the course of theatre history. The cultural track of historical analysis can enrich the development of artistic dialogue, both internally and externally. In this dialogue choices can be justified and counterarguments elicited. There was no direct, verbal dialogue in TGA. Dialogue mostly took place indirectly through the company's performances and statements.

The duo from the Cross-Section who were responsible for making proposals for initiating artistic dialogue within the company found it difficult to make concrete proposals. The emergence of the Theatre Factory was seen as a platform for discussion.

The actors mentioned during interviews that reviewers, theatre scholars, policy-makers of whom it might be expected that they are knowledgeable about theatre history, were unable to comprehend the direction taken by the theatre group. They often found discussions disappointing because of a lack of understanding. According to the actors reviewers did not contribute to a real dialogue, rooted in theatre history, but had

preconceived ideas about TGA. The actors saw the continuing negative publicity surrounding TGA as proof of their standpoint.

At the same time TGA's strong sense of history had supported the company in dealing with criticism from the surroundings. If this realisation had been lacking there would have been a greater risk of internal conflict as a reaction to external pressure. The problem remains that the company has to operate in a context in which it would seem that a common historical sense cannot be taken for granted. The strategic action would be to stimulate the surroundings – and particularly reviewers – to become less prejudiced and react more openly.

The historical sense gave no support to new developments such as the multicultural context. From the TGA case study it can be concluded that a sense of history fulfils an important role in relation to the company's own development in theatre tradition, but that this sense can also close off the company from the outside world. One solution could be not to distinguish historical analysis as a track in isolation from new developments but to search for analogies and possible connections.

Innovation
The search for a balance between continuation and transformation of theatre tradition through exploration and the breaking of boundaries is explicitly and emphatically present in TGA. This innovation, which makes history both inside and outside the Netherlands was initiated by Gerardjan Rijnders (montage performances, integration of stage and media, exploring the boundaries of text, image and acting) and through the Theatre Factory it has gained a dynamic organizational basis in the whole company.

In regard to this cultural track it is justified to conclude that artistic innovation is a key concept in the company's artistic existence and that in strategy formation extra attention should be paid to whether it is sufficiently valued by the external surroundings, through attendance and financial support. The strategy plan includes various initiatives directed towards the public and the official authorities, relating to TGA's position towards artistic innovation, also in the future.

Because tradition and innovation go hand in hand in TGA, there were no situations in which the cultural organization was solely directed to either one or the other. In chapter 1, it was noted that attention should be paid to both elements in strategy formation. In view of some actors' fear of actually mentioning innovation it could be that cultural organizations concentrate less on innovation in view of the lack of public interest and prefer to stay with a traditional production or programme. Although this aspect cannot be viewed separately from the Cultural Credit track it is precisely the combination of tradition and innovation which gives an organization cultural vibrancy.

Multicultural context
In relation to the multicultural track it was already mentioned in § A.4.3 (key dimension: Environmental Research) that the company sees the multicultural context in opposition to the autonomy of the art work. Nothing was added to the content of the strategy process

within this track. On the one hand there was little experience in the almost completely white company of working in a multicultural context ('the main point is to make interesting theatre'), on the other hand there were no methods available for moving the Cultural Strategic Dialogue to a higher level. For this reason too, the researcher's suggestion to make the multicultural debate a central theme in the group's ten-year jubilee celebrations (in 1997) was not taken up in the group. This shows the damaging effect of not having explicitly formulated the multicultural track at the start of the strategy project. It is true that from the start the fact that TGA operated in a multicultural society was pointed out in documents but this was never developed further.

The fact that this cultural track remained simply an intention was made clear by the auditions for a youth performance in Autumn 1996 where on 'qualitative grounds' only white youngsters were selected. This was in spite of the earlier formulated 'mortgage on the future' which promised that the multicultural society would be approached mainly through youth performances. A positive sign was that the young public at these special performances was very mixed, that the reactions were very positive and that the young people found the performance by their peers very enjoyable.

If we look at Justavsen's dialogue principles (§ 2.5.3) it can be seen that the researchers drew insufficient attention to 'an exchange of ideas and arguments between all the members' and 'Each member should be able to understand the themes'. In a well-organised dialogue, other issues could also have been tackled, such as the degree to which the assumed multicultural context really influenced or should influence the artistic and organizational strategy of the theatre group.

What approach could nevertheless have served to complete the strategy formation in such situations? This might have been accomplished by distinguishing between short-term and long-term actions and activities. In the short-term it is necessary to gather individual experiences and ideas within and outside the company and to organize the multicultural debate through concrete tasks. In the long-term, on the basis of shared insights, this could mean for example co-productions with non-Western theatre directors.

Cultural Credit
The Cultural Credit track is directed towards making effective use of cultural credit. At the start of the project it became clear that through the unexpected debits (see § A.4.3), financial reserves built up in the past would quickly disappear. The researchers accepted the business director's decision that the financial situation was too complex to deal with in the Cross-Section. In retrospect this attitude should be queried. According to views on Cultural Strategic Dialogue it would have been more obvious to raise the issue of the financial position precisely in the Cross-Section. The dilemma between cultural and economic capital was now dealt with insufficiently. Moreover there was no chance for a shared knowledge of this area to develop, while this is exactly the knowledge which is needed to determine the company's long-term financial position. Insufficient definition of the Cultural Credit track affected the position of the Theatre Factory within the new strategy, which had only an artistic and not a financial base. It would seem justified to conclude that the role of 'scapegoat' was not fully undertaken. (see § 1.2.5).

According to Bourdieu this function of the cultural entrepreneur is an undervalued but necessary one within the arts. This meant that the financial possibilities of the Theatre Factory were not fully explored and so may lead to renewed financial shortfalls.

How can TGA use its cultural capital more fully? The categories introduced in § 1.2.5 can help in finding an answer, as shown in figure A.5. The diagram shows among other things various lines of thought, such as the movement from large theatre productions to producing media products which are better financed. But there is also an artistic disadvantage to this: the mass media public wants more accessible material. It is up to the artistic leader to decide the extent to which this line of thought should be followed.

Figure A.5 Diagram of Possible Movements of Cultural and Economic Ambitions.

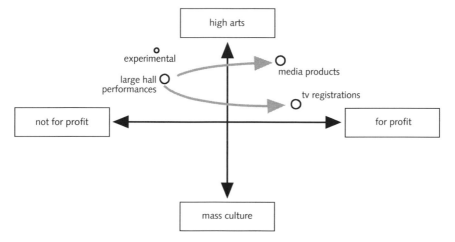

In has been pointed out that this track was not pursued more fully because of the researchers' priorities. If the project had concerned a profit organization then this strategic question would naturally have assumed a higher priority. External expertise would have been more urgently sought than was now the case. Because of the debits and the uncertainty surrounding the new theatre, the strategy plan did not propose a very 'challenging' financial plan, especially since it would be necessary to make up for previous debts in the new four-year period. A more challenging strategy is set out in the implementation plan in which it is determined that the board members need to be involved in finding new financial sources, especially in view of the new theatre.

As a result of the experience gained in action research the position of the Cultural Credit track in Strategic Dialogue needs to be questioned. In view of the changes taking place in the subsidizing of cultural organizations (a shift to market forces) the importance of this track, balancing between art and economics, needs to be addressed during the Strategic Motive.

General Cultural Interest
In view of the intentions set out in the strategy plan for educational theatre, youth performances and the transformation of the obligation to tour into a desire to tour, the relationship between TGA and the government can be described as mainly instrumental. There were no cultural-political confrontations about the government's attitude to issues such as cultural political freedom for instance.

The importance of market values promoted by the government elicited a cultural political reaction from the theatre group, who wanted to use grants to make interesting theatre, which in their opinion did not consist of following market trends.

The earlier mentioned transformation of the 'obligation to tour' into a 'desire to tour', exchanging many regions for a number of major cities, was not entirely without risk, seeing that the geographical spread of culture is an important aim of Dutch cultural politics. Here the company broke radically with existing grant conditions and a challenging approach was chosen in accordance with the company's artistic principles: moving away from the company's own theatre to communicate with the existing and new (multicultural) public in a number of major theatres in the Netherlands and Flanders, whose directors had shown an active involvement in the group's artistic mission.

Artistic processes: own space
The answer to the urgent, and strategic, question of how the organization could be brought more into balance with artistic processes was found in the construction of the Theatre Factory: a multidisciplinary way of working in the company's own theatre accommodation to arrive at a repertoire on the basis of individual creativity. What did not appear at all in the dialogue about artistic processes was the role which the company's own location would play in the development of artistic organization and creativity. Nowhere in the literature, or the professional press, is the location of one's own theatre so experienced and emphasized as it was in TGA. From the start of the strategy project the company's own location was an overriding issue. The introduction of the Theatre Factory killed two birds with one stone: a new TGA location was given importance and a new way of working was introduced.

If we examine all the cultural tracks mentioned in § 1.2 from this point of view, then the concept of location deserves an explicit mention in strategic arts management. It would be an omission not to associate the possession of one's own location with the cultural track of artistic processes. In fact this link is not a new or contemporary element but an important condition for artistic success. In the artists' histories, we see that Shakespeare and his fellow players aimed for their own location and found this in the Globe theatre; Rembrandt's studio was an important condition for a leading production, education and business firm; the building of the Teyler's Museum, the oldest museum in the Netherlands, can even be seen as a unique spatial description of its story. The choice to have one's own location and determine its function is thus essential. The artistic processes track can therefore more aptly be formulated as 'artistic processes in one's own space'. The TGA example can help us to ascribe meaning to this part of strategic art

management. These are Titus Muizelaar's words on the new theatre included in the TGA-strategy plan 1997–2000:
The makers create the space in which they want to make as many people as possible share in the ideas which live there.

The Theatre Factory played an important role in the cultural track of artistic processes although this should not be seen as the dominating element. The Theatre Factory was a project in which organization could be coordinated more satisfactorily with artistic ambitions and the artistic creativity linked to these. If the idea of the Theatre Factory had not succeeded the Cross-Section would have worked intensively at finding an alternative form of coordination. In this alternative process more attention would have been paid to explicitizing the company's repertoire formation, co-producing, setting up multimedia-programmes and finding international exchange programmes. Because of the dominant position assumed by the Theatre Factory there was not enough time to work on alternatives. Reflecting on this situation it can be stated that artistic processes invite one to think mainly in terms of alternatives because in this way the organization gives maximum stimulation to artistic creativity. A few multidisciplinary groups could have been given the task, for example, of designing a completely new own building by means of visual resources,[13] bearing in mind the demand that the supporting organization is at the service of artistic processes.

Artistic leadership
The unambiguous importance of artistic leadership in cultural organizations has often been mentioned. All people interviewed confirmed this. The uncertainty created when a current artistic leader is not sure of his plans for the future is abundantly clear. During the interviews (March/April) it was not clear what decision Gerardjan Rijnders would take. At the beginning of the production phase he let it be known that he would remain as artistic leader for a further four years (1997–2000).
In retrospect actions relating to the track of artistic leadership were insufficiently consistent with the principles of democratic dialogue. At the start it was agreed that the artistic leader should be granted a period in which to reach a decision about staying or leaving. When the artistic leader agreed to stay for a further period, more attention should have been paid to the way in which this leadership was to be realized, especially in regard to the position of the 2nd artistic leader.
Because of the importance of artistic leadership for a cultural organization it can be stated in retrospect that within the Cultural Strategic Dialogue the future artistic leadership must always be fully clarified. Artistic leadership, after all, assumes qualities which emphatically aim at a long-term effect: artistic control, artistic endurance and artistic entrepreneurship. These elements are difficult to link to a period of three or four years.
In artistic leadership a top-down approach is ruled out except in times of acute crisis. The artistic leadership takes decisions in cooperation with the direct surroundings: artists, cultural professionals and managers. The failure to make choices is also blamed in the first instance on the artistic leadership.
This poses questions: what should the composition of the artistic staff be? What artistic ambitions encourage eventual newcomers? How does the organization treat people who have taken the artistic lead during a certain period? If it is clear what an organization

understands by artistic leadership, then these additional questions can be answered more effectively, as long as they are not seen separately from the strategic ambitions of the organization. The answers must be found within the framework of the strategy to be formulated.

If answers to these and other questions about artistic leadership are not found, then a cultural organization is jeopardizing its entire future. Without a satisfactorily functioning artistic leadership, strategy pales or becomes technocratic, which is hardly beneficial for the general artistic climate. An exception can perhaps be made here for non-productive institutions such as museums, theatres and art academies. These organizations can function for a short time without clear artistic coordination in expectation of new artistic leadership. For festivals the jeopardy rule applies: a festival derives its importance from the artistic judgement that important art has been shown, and not from its mere existence.

Conclusion

The Cultural Tracks can provide insight into the cultural positioning of an art organization. In this way unique strategies come into existence in which the cultural dimension is not blunted but accentuated. On the basis of the information provided, the Cultural Tracks as ascertained by the researchers in the Strategic Motive, can be set against the situation at the end of the project, as expressed in the strategy plan 1997–2000. The comparison is expressed in figure A.6 (on a five point scale, 1 = very minimally developed, 5 = very fully developed).

Figure A.6 Development of Cultural Tracks within TGA

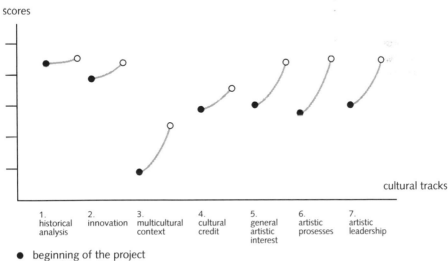

scores

cultural tracks

| 1. historical analysis | 2. innovation | 3. multicultural context | 4. cultural credit | 5. general artistic interest | 6. artistic prosesses | 7. artistic leadership |

● beginning of the project
○ end of the project

The comparison shows that within each track there was development but also that in spite of this improvement several tracks (Multiculturalism and Cultural Credit) still lag behind. The next step, which was not explicitly carried out within the action research, could consist of comparing one's own score with that of other cultural organizations operating in the same cultural sphere ('cultural benchmarking').

A.4.5 Strategic Management, the Interactive Approach

This paragraph will concern itself with the role of Strategic Management, the Interactive Approach (ISM) in strategy formation in TGA. This evaluation will be ordered according to three points.
1. Links between the micro- and macro-level, between issues of internal organization and societal developments
2. The functioning of a Cross-Section as the key team in the 'Laboratory for the Future' where work takes place on strategy formation and implementation in an innovative and interactive manner.
3. A combination of process and content-directed supervision on the basis of process architecture oriented towards strategic action research, which combines local and general information in order to find solutions for current strategic issues.
Re point 1:
Within the strategy project various activities and transitional moments were included in order to provide the strategy formation with more relevance for the society as a whole. These moments are shown in the overview. From this overview it can be seen which internal organizational problems underlie the micro-macro links and what relation there is with the societal order. The formulation in this overview is derived where relevant from the government paper on culture Armour or Backbone (Pantser of Ruggengraat), published by the Ministry of Education, Culture and Science.

Strategic Transition	Organizational Problem	Societal Order	Relevant New Strategy
Performing in a limited number of cities	Waste of time and artistic energy through performing in many regions	Spreading culture and attention for the importance of regions for art and culture	By transforming the 'obligation to tour' into a 'desire to tour' the organization realizes its societal responsibility towards the spreading of culture through society.
Organization of the Theatre Factory	Present organization is insufficiently adapted to artistic ambitions	Humanizing of labour relations, need for new forms of cooperation to combat technocratization of work	Theatre Factory breaks monodisciplinary work forms and introduces interdisciplinary method of work which mobilizes individual ideas.

Interaction with public in own city and major cities	Insufficient communication with the public	Increase public's involvement in cultural developments, risk of cultural dullness through media	Broad supporting programme round the performances enables public to actively engage in current theatre culture, plus the organization of public panels
In approaching the public, giving priority to young people (in a multicultural city)	Own public rising in age	Attention to art education, supporting young people (also from ethnic groups) in finding an individual path.	The organization of youth performances and extending educational work in schools

The four inter-related themes show that we are concerned here not simply with 'strategy intentions' which may or may not be heeded. On the contrary, these are enduring actions for change which are implemented as soon as they are formulated.

Re Point 2. ISM – Cross-Section As A Laboratory for the Future
In an ISM laboratory connections are made between general knowledge based on academic study, and the local knowledge present in the organization concerned. The organizational form is the Cross-Section, which on the one hand broadens the base for strategic decision-taking and on the other enables experiences to filter through to the whole organization.

What was TGA's experience of action research with an ISM approach?
The evaluation can be found in the results of a written, non-anonymous questionnaire which was carried out among the members of the Cross-Section (1=low, 5=high). Members are very positive about the 'coherence of the activities' in the strategy plan (score: 4) while the strategy plan itself is seen as a 'directed vision of the future' (score: 3.7). Lower results are obtained for 'clarity of artistic choices' (score 3.3) and 'justification in business and economic terms' (score: 3.2).

In the information given about 'clarity of artistic choices' the members comment that the strategy plan in itself does not contain any artistic choices but enables innovation in the artistic organization. Artistic choices in the company depend on decisions about the repertoire, the guest directors and the designers. These choices, especially as far as repertoire is concerned, were central to the old strategy plan 1993–1996, but are absent from the 1997–2000 plan. From some additional comments made by artistic staff it would appear that more clarity in relation to artistic choices is unnecessary because of the new working methods in TGA. Artistic choices are naturally discussed here because of the interactive dialogue. A certain amount of scepticism can be heard from the technical department. Now that the artistic direction is not expressed in concrete artistic choices but evolves in a flexible fashion, technicians lack a framework for their work. This scepticism is a signal which should not be ignored in the implementation phase. In the

near future the new approach will need to be better communicated to technical staff. The basis for this has already been laid during the project and especially during the company meetings. The result supports the conclusion that management and project researchers should have intervened more forcefully on this point. ISM has proved a valid alternative for traditional top-down decision-making.

The content of the strategy plan, is the result of the work carried out by the duos in the Cross-Section. The options especially were formulated for the most part by the duos themselves and were worked out in more detail in the new organizational plans.

Board members Directors accepted the content of the plan in its entirety, which meant that the strategy plan could be submitted as a formal grant request for the period 1997–2000 to the financiers (the Dutch government and city of Amsterdam). This method of working implied a radical break with the past. In the past decisions were taken at managerial level more or less informally. The members of the Cross-Section were very positive about the new approach to process (score 4.3): presentation, interviews, company meetings, Cross-Section, working in duos, final decision-making in the Board of Trustees. Additional comments made it clear however that there was some dissatisfaction with the composition of the Cross-Section; it was felt to be a form of control from above. The composition of the Cross-Section was not really a top-down decision. It was based on the result of talks between directors and researchers, who carried out interviews with members of the organization. The interviews gave the researchers a good picture of the quality and diversity which could be used in the Cross-Section. Within this approach many names were mentioned and a definitive list was chosen. The criticism shows that the method of selection needed to be better communicated. Comments were also made about the hesitant start to the project. The researchers also experienced this hesitancy, even a slight degree of suspicion, at least in the first company meeting. They found this quite logical however, because of the newness of this form of strategy formation. A certain reserve has been signalled at the start of earlier ISM projects too.

Continued Effects/Learning organization
The continued effects imply maintaining the way of working as practised in the Cross-Section and during company meetings. In the short term, immediately after the end of the project, good results were obtained on:
- the successful start of the Theatre Factory including its open way of working;
- transformation of the 'obligation to tour' into a 'desire to tour';
- the setting up of an Implementation group;
- changes in the organization.

The way of working as a whole was positively evaluated (score: 4.1). There was a comment that uncertainty, or even resistance, arose in having to develop an idea with which one had no affinity. To find out about the continued effects of the project those involved were asked, in accordance with the ISM approach, to maintain their way of working in their own surroundings during the process. The reactions here were quite positive (score 3.7). There was also a positive evaluation, although less so, for the involvement of others in the process (score: 3.5). The managers were also included in the evaluation. Everyone was asked about the clarity of an open, direct style of leadership.

The evaluation here was moderate (score: 3.0). Individual comments made clear that:
- many things are still vague
- there are efforts, but still few results
- there isn't an open style; ego's are too big
- more time is needed for this.

The leaders of the Cross-Section were asked whether they were able to carry out a more open and direct style of leadership. Here too the score was moderate: 3.0. Comments here were:
- a start has been made
- it seems, paradoxically enough, that you have to force this

Finally there were questions about the implementation. First a general evaluation was asked (agree/disagree) with the statement: 'The members of TGA are willing and able to achieve the future scenario (as envisioned in the strategy plan)'. Here too the score was moderate (3.0). The following comments were made about this:
- we are doing what we can
- able: maybe, willing: still much cynicism;
- try, you can't say it's possible, but people are behind it;
- plan is too ambitious and isn't staffed sufficiently.

The general feeling about the implementation was the same (score: 3.1). In regard to less positive evaluations the following was said:
- It takes too long;
- I still have to see it;
- It's a big question-mark.

The moderate scores for leadership and implementation lead here too to the conclusion that an explicit implementation strategy needs to be followed. Two approaches are possible to the evaluation of this in a reflective sense.
1. The ISM Strategic Dialogue is a radically new manner of thinking and acting. The researchers should consciously set this process in motion but must also let go; in a learning organization those involved must be able to raise their level of organization themselves on the basis of their own experience.
2. The ISM Strategic Dialogue needs, because of its exploratory and radical character, an intensive and planned follow-up. Only at a later date can a careful process of letting go take place.

The results of the first approach are that the organization is, to put it extremely, left to its fate after the first impulse, in the knowledge that the implementation will take place at a slower tempo than the ISM process. A positive point here is that the organization directs the implementation itself. The second approach implies that the letting go should also be a part of the action research and that implementation is a shared process of gaining knowledge, which benefits the quality of the implementation.

These two approaches were not discussed during the project. The active introduction of the implementation meant that the emphasis lay mainly on the first approach. Eight months later (1996) it became clear once again that active supervision was desirable. At

the request of the researchers a session was organized for managers and a few actors. It was apparent that the priority still lay on improving the artistic organization. The researchers found a strong point to be the way those present were able to describe and analyse their own organizational development. Those present were positive about the structuring of tasks, responsibilities and consultation among the supporting staff. There was still some dissatisfaction about the quality of communication between actors and organization. The implementation of the improvements in this area were not always positively evaluated.

The general conclusion is that the strategy project and the Theatre Factory which emerged from it have led to a more transparent and enterprising company. During the last session, a year later (1997), the lack of communication between office organization and the actors was once again the subject of discussion. The organization has once again found itself in deep water as far as finding its own theatre is concerned: the possible merging of the company with the City Theatre is a complex process. The directors appear to be approaching this subject in too isolated a fashion and failing to use the available knowledge within the company. The researchers find that there is too little alertness when it comes to developing individual learning ability. 'Double loop' learning is particularly slow in the area of communication. TGA often falls back on an analytical attitude without members being able to reach a solution.

A small Cross-Section is planned to deal with the subject of the company's own theatre and a follow-up to the idea of the Theatre Factory in order to clarify the company's strategic behaviour. A small committee (director, head of dramaturgy, an actor and researchers) made an inventory of what had been realised of the almost fifty strategic proposals. It has already been mentioned that many of these had been realized. The following scores relate to all professional areas of the cultural organization: working processes, finance, organization, personnel activities, marketing. Sixty percent of all strategy plans have been realised and 26 percent have been initiated. The result can be seen in the following overview.

Percentage	Status
13	Realized
34	Realized/repeated
13	Realized/reorientation
26	Initiated
02	No action undertaken
12	Other ...

This inventory led to an increased belief in people's own capacities. Agreements were made however to put renewed energy into interactive communication. An agreement was made that actors would shortly make plans for improvement.

Figure A.7 shows the development of the continuing effects. At the start, during the Cross-Section, people had great belief in their own power. During the evaluation dissatisfaction was signalled about the implementation of new forms of communication.

At the first session after this evaluation there was satisfaction about the restructuring of the supporting organization, but the communication gap between actors and organization seemed to have grown. At the second and last session this gap had not yet closed. People's belief in their own strength had grown however, due to the realization that the organization was able to accomplish new strategy under its own strength.

Figure A.7 Continued Effects of the Strategy project

degree to wich method of work continued

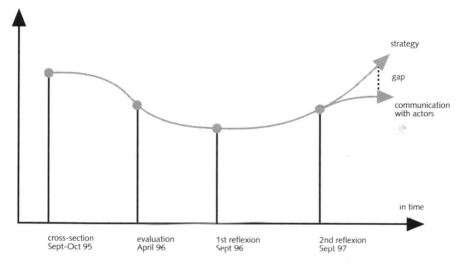

| cross-section | evaluation | 1st reflexion | 2nd reflexion |
| Sept-Oct 95 | April 96 | Sept 96 | Sept 97 |

Cross-Section
The Cross-Section has an essential role in the concept of ISM. All disciplines are represented in the Cross-Section. Members work hard at developing ideas; new interactive ways of strategy formation are tried out and norms are developed for future functioning. The concrete method of work which was followed consisted of:
1. duos develop ideas which have emerged from company meetings;
2. group discussion of questions and dilemmas and establishing possible solutions;
3. thinking together about improvements in the functioning of artistic work.

A total of five meetings each lasting a few hours were held within a period of six weeks. The meetings were led by a fixed chairperson, who also chaired the representative Works Council.
 Halfway the Cross-Section threatened to be overwhelmed by a sea of papers. Those involved signalled this problem themselves quite effectively. As a result the meetings were brought back into a creative dialogue climat with discussions questions. On several occasions the hexagon technique was used, whereby associations with a topic are evoked in cretaive fashion. The working method of the Cross-Section scored high (3.9); it was found to be educative, efficient and effective. In the additional comments on the evaluation answers, several dilemmas were mentioned: speed versus depth; lack of knowledge versus effectiveness. Those asked also judged positively on the criterion that

the plan should be the result of an approach from the bottom up (score: 3.7). Additional comments mentioned the difference between 'direction' (score: 5) and reality (score: 3) and the experience that ISM 'in a certain sense was itself imposed from above'.

From the comment that 'Bottom-Up' is imposed from 'above' it appears that ISM can lead to confusion if it is unclear that the Cross-Section represents all layers in the organization. Alternatively: if the bottom level doesn't comply then by definition there can be no interactive project. In spite of this democratic stipulation, ISM was not experienced in this way by some people. Repeated explanation of the aim of dialogue can provide clarity in such a situation.

Finally a comment about the composition of the Cross-Section: it should be guarded against that the group is too homogenous in its thinking. For dialogue it is necessary that there is a clash of opinions and visions, and that the group finds a new shared vision together. Such a composition was achieved in TGA.

Re Point 3: Role of the researchers on the Basis of Action Research.
In the discussion of the process supervision in relation to ISM two areas of expertise were mentioned as being necessary. (1) The researchers understood complex, interactive strategy projects. The proof of this is that they were able to intervene adequately when problems loomed and anticipate tricky situations, which could be threatening. (2) The researchers faced no difficult situations arising from hierarchy or functionality.

At the beginning most interventions were applied to ideas (strategy) and process (through producing brochures and the agenda for the Cross-Section). Later there were more process-directed interventions. Interventions on the level of idea mostly took place through the Cross-Section and the duos working within this.

A reservation which can be made about the previously sketched process is that the strategic researchers continually have to make decisions. Creating a process architecture (structure) which allows integral supervision is a difficult task. In the structuring of the dialogue individual preferences were also taken into account, as already mentioned.

The researcher must continually keep an eye on the power relations in the company. By explicitizing responsibilities, formal and informal positions are made clear and undemocratic influences (ie influence outside the democratic dialogue) are kept to a minimum. Control and influence are also exerted through the structuring of information. As long as this control is based on shared knowledge it is desirable and manageable. It becomes more difficult when the researchers' opinions come to dominate the process. This can happen when 'normative situations' occur and views about social order are involved. This is where the Strategic Motive can provide guidance. The aim there is not only to determine a possible direction but also to fit the starting question or views and methods of the action researcher into a shared plan of interactive strategy formation.

The members of the Cross-Section were very positive about the role of the researchers (score: 4). Additional, occasionally critical, comments were:

- Good balance between 'this is the way it ought to be' and 'find out for yourselves';
- The right approach as it turned out; in the beginning a bit 'soft', later a shared tone;
- The boy scout positive tone was sometimes a bit hard to take; guiding and supporting role completely fulfilled; we couldn't have done without;
- In the beginning a bit too directive;
- I can't think of any good alternative.

These comments make clear that at the beginning of the process two completely different worlds, each with their own language, were meeting: the theatre group and the researchers. The comments about the 'soft sector', for example make clear that the theatre group thought mainly in terms of production while the researchers stressed the need for communication and dialogue as conditions for successful strategy formation. From the beginning creating a new language of cooperation needs to have great priority in an ISM project.

A.5 Illustrative effect: mapping the results

The objective of this case study was to determine through strategic action research how the interactive approach to Cultural Strategic Dialogue worked in a specific art organization. What illustrative effect can be formulated? What clarification of Cultural Strategic Dialogue do the results provide?

From the action research it appears that Cultural Strategic Dialogue was applied to good effect in all aspects. The general conclusion is that interactive strategy formation based on Strategic Dialogue according to the ISM approach is possible within a cultural organization. However it is also clear that the quality of the application was uneven. This last paragraph will deal with the question of what we have learnt from Cultural Strategic Dialogue. After a general discussion, the following issues will be dealt with: key dimensions , Cultural Tracks and ISM. Finally a number of comments will be made about the project method itself.

Directors, actors, staff from all layers of the organization and researchers changed the organization from a closed to an open organization by means of Strategic Dialogue. At the start of the project, under the guidance of its artistic leader, the organization confronted the world with striking performances but there was no effective interaction between the organization and its surroundings.

The newly acquired openness applies to the company's ideas (a new direction as expressed in the strategy plan 1997–2000) and the way in which people work together within the organization. Within Cultural Strategic Dialogue the interactive ISM Cross-Section fulfilled a key function which provided a clear vision of the future according to the judgement of those involved. This vision of the future was implemented immediately after the process ended and greeted with approval by the financiers. When these financiers failed to provide extra money for the financing of strategic priorities, the company was able to finance these innovations itself, even if selectively.

During the evaluation emphasis was placed on the sustained effects of the results throughout the organization. Changed approaches in middle management lagged behind those of the Cross-Section. This middle layer had been insufficiently involved in the innovations at the start of the process. A quick reaction to this was made through Cultural Strategic Dialogue.

Problems in implementation arose in communication with actors. Although many elements of the strategy plan had been realised, the actors' involvement in the building of the new organization was insufficient by the norms of Cultural Strategic Dialogue (derived from ISM).

Figure A.8 shows the strategic position around 18 months after completion of the strategy plan.

Figure A.8 Development of Strategic Position

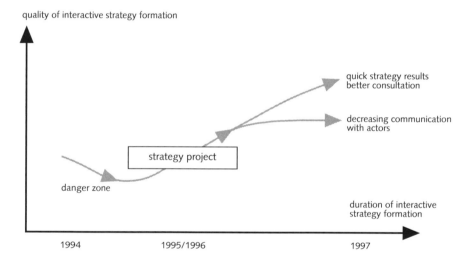

The practical research did not consider the application of Cultural Strategic Dialogue in other sorts of cultural organizations, although the choice for a theatre organization was motivated by its general applicability. However, the progress of the strategy project did not provide any grounds for limiting the learning experience to a theatre group or production organization. The artistic theatre process represents, in an abstract sense, all professional judgements and actions directed towards the manifestation of artistic utterances. This process emerges from the same sense of artistic autonomy (as sketched in chapter 1) which also applies to the organized production of films, visual art and design, compiling exhibitions and festivals as well as podium programmes, presenting ensemble music, lending out art and the collective practising of amateur art. The form of the organization is an extension of the artistic judgement. Decor studios can be compared in this respect with the restoration studios in a museum, the dramaturgist with the professionals responsible for the production and distribution of artistic products, a

director with artists/teachers in art education. For all these cultural organizations Cultural Strategic Dialogue shows how the continuity of the organization is promoted through interactive strategy formation.

What illustrative effect can be formulated more explicitly?

A.5.1 Illustrative Effect of the Key Dimensions

Strategy formation is an iterative process (black box); in practice it does not necessarily follow the general pattern. Discussion of practice leads to the conclusion that the order of the key dimensions in Strategic Dialogue should be regarded as variable. The introduction of the Strategic Motive showed how the 'black box' character of strategy formation could be approached: gaining a quick impression of the experiences, possibilities, perspectives and problems which could hinder strategy formation. It was also important that other strategic themes and core dimensions were placed in a proper perspective in the Strategic Motive, which in turn was itself an important element in the interactive process architecture.

Once the process architecture had been developed, it could be closely followed. Where weak spots were detected such as the hesitant start and gaps in organizational implementation, suitable measures were found within this architecture. In regard to the order of the core dimensions as these are positioned in the standard model, it can be noted that these may partly coincide in practice. This happened especially in the case of the evaluation and the strengths and weaknesses analysis and had to do with the organization's limited learning experience in the area of strategic processes.

Although the literature contains many instruments for analysing the separate dimensions, in practice these were only used as a global frame of reference. This had in part to do with the introduction of a complex strategy project in an organization with little learning experience. Moreover not enough analytical instruments have been developed specifically for the arts sector. The more research takes place into strategy formation in this sector the wider the range of operational instruments will be.

As far as the sixth key dimension (new strategy) is concerned implementation needs to be emphasized more than was previously intended. Cultural Strategic Dialogue makes it possible to realize strategy initiatives successfully in the short term. If the new strategy contains approaches which could be wrongly or incompletely interpreted by the surroundings then interactive communication needs to be developed and applied at an early stage.

A.5.2 Illustrative effect of the Cultural Tracks

Cultural Tracks have been developed to give content to the process of strategy formation and to prevent the surroundings from being an over-riding factor, so that other specific cultural values are subordinated to pressure from the surroundings. Although the tracks in this study only reached their final formulation after the event, there was a similar 'sense of direction'. Strategic Dialogue was so structured that Cultural Tracks had a

legitimate place in strategy formation. But because their actual formulation only took place later, this element was of a different order than research into the application of the core dimensions.

Within this limitation the following findings can be reported:
- If there are insufficient ideas about a cultural value (for example in the case of the multicultural context), then it will be difficult to make well-founded strategic choices. In the formulation of important cultural values (for example in relation to the Cultural Tracks) the researchers can explicitly question whether these values have been understood. If the answer is negative then there needs to be additional exploration of existing artistic sources.
- Cultural values can be threatened in the strategy process if there is insufficient application of the dialogue form. Stumbling blocks such as the sensitive nature of the subject or a one-sided fixation on positions need to be cleared up through effective structuring of the dialogue.
- On one important point, as we have seen earlier, there needs to be some clarification of the Cultural Tracks: these involve not simply the value of artistic processes but the possession of one's own space in which these processes take place. Although this point is not mentioned in the strategic management literature, this factor seems to be of fundamental artistic importance in the cultural sector.

In the action research no new cultural values were discovered. However, the limited nature of the study means that it cannot be concluded that the seven existing Cultural Tracks are now definitive. Here, the conclusion to chapter 4 should be repeated, namely that new or variant Cultural Tracks may yet be found.

The final conclusion: the presence of Cultural Tracks does indeed lead to value-oriented strategy formation within an arts organization; Cultural Tracks make the strategy more complete even if their application may sometimes produce tensions.

A.5.3 Illustrative effect of Interactive Strategic Management

The strategy project contributed to the general knowledge about ISM. Experience shows that ISM can be successfully applied in the Arts sector and that those involved find this approach useful. ISM enabled jointly formulated options to be anchored in the organization in a quick and effective manner. An illustration of this is the fact that 18 months after the end of the strategy project 60% of the policy measures had already been realized and a further 26% had been initiated. The strategic action research has made it clear that new information forms a controlling framework for new activities as well as new behaviour. This last was important for the follow-up phase in which the ISM approach led to new impulses which previous members of the Cross-Section were quick to pick up on.

The relationship between the Cross-Section and middle management needs to be better positioned within ISM. Although ISM already realizes active involvement from this management level (selective participation in the Cross-Section, participation in central

meetings) steps should be taken to avoid it becoming isolated during the functioning of the Cross-Section, especially when important changes are taking place. It cannot be taken for granted that there will be a transfer of positive influence from managers who participate in the Cross-Section. Special workshops should be held for these managers during the process rather than in retrospect, as happened in the study.

Another point which has been learnt is that the Cross-Section needs to be explicitly embedded in larger meetings (company meetings, public panels and so on) and that non-members should also be able to contribute through the multidisciplinary teams. At the same time the application of ISM has confirmed the conclusion that in principle all topics can be the subject of strategy formation, although a specific method of treatment may needed for strategically sensitive subjects. An attitude of loyalty and integrity on the part of directors and governors will help to sustain the strategic results and enable an organization to face an uncertain future with societal responsibility.

A clearer picture has also emerged of the intervening role of the researchers within strategic action research. Figure A.9 shows the tasks and responsibilities of the researchers. A continuous thread in this task is integration: integrating general and specific knowledge, micro and macro levels and the Cultural Tracks, as well as integrating strategy formulation and implementation, and hierarchical and functional positions in new work forms. The strategic action researcher is continually switching between different types of interventions, especially in interaction with the participants in the strategy project

Figure A.9 Interventionist integration-directed role of ISM supervision

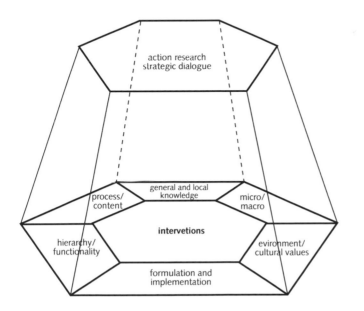

The model should not create the impression that Cultural Strategic Dialogue can only be carried out under scientific conditions, or, in other words, that the dialogue can only take place according to the approach described here, under the guidance of external researchers. Depending on the size of the organization and the issues involved (checked during the Strategic Motive) another possibility is a project-centred approach led by the organization's own supervisors. However these supervisors need to be able to assume an independent attitude, and have a basic knowledge of strategic management and experience in intervening in interactive strategy processes. These supervisors can take the model as a starting-point for explicitizing their integral responsibility within Cultural Strategic Dialogue.

A.5.4 Further findings on the project methodology

Although no explicit research goal was formulated for the methodology of project management within the action research, a number of experiences produced interesting information, in relation to their role in the whole process. The literature on management, as we have seen, pays little attention to the application of the methodology of project management within strategy formation. In the TGA action research this methodology was applied where phasing, planning and introductory reporting were concerned. Partly on the basis of project methodology an organizational form developed in which processes of production, control, communication and decision-making could be made transparent by the process group and/or the supervisors. In this respect the project-centred approach contributed to result-oriented working and minimized organizational insecurity.

Project management in combination with Cultural Strategic Dialogue could be worked out more fully in two particular aspects. First, the Strategic Motive should emphatically be concluded with a pilot project plan, to be made definite in the preparation phase. Second, the functioning phase must include an implementation plan which comes into operation immediately after the result has been established in the form of a strategy plan. Cultural Strategic Dialogue must not be allowed to assume an unstructured form at these points.

Because it also involved research the project took longer than strictly necessary for a strategic result. The extra time was needed to make a detailed documentation of events and situations and for discussion between the researchers and the organization.

These remarks on the project methodology conclude this report on the illustrative effect of the empiric research.

A.6 Questions and discussion items

A.6.1 Process

1. The board of trustees was not strongly involved in the strategic project. Only one board member participated in the Cross-Section and at the final stage the board made a formal decision to accept the strategic plan. Discuss this involvement in relation with 'cultural governance' from § 4.2.4.

2. Suppose the board of trustees was not satisfied with the internal process. What kinds of instruments do they have to intervene?
3. The supervisors of the strategic project were external action researchers. Would this supervision function if the supervisors were internal staff members? What are the success criteria for internal staff members?
4. The use of the Internet was not so prominent in the strategic process. Can you mention some way of strengthening the process by adapting digital possibilities?
5. The financing government (national, local) are not members in the Cross-Section. Can you mention the pros and cons of such a participation?
6. The works council agreed with the strategic project. Its chairman participated in the Cross-Section. Why is it important that the labour representatives agreed with the proposal? Do the artists unions have a share in the process?
7. What can be done to stimulate the middle management of a cultural organization to be active in the strategic process?
8. If both artists and artistic leaders participate in strategic Cross-Sections, what kind of agreements have to be made to ensure equal contribution?
9. In the TGA-case within the Strategic Motive the other strategic key dimensions were put in order without using clear analytical instruments. Much depended on the interaction between the researchers and the group. Give your comment on that more or less spontaneous way of working.
10. At the end of the strategic project communication problems between the directors and the actors arose again a little. What can a cultural organization do to keep the involvement of artists with strategic choices alive?
11. Formulate your own main process points which are important to you for developing strategic projects.

A.6.2 Content

12. Suppose that the Cross-Section analysed that the subsidy will be cut for 50%. In what way would this outcome influence the strategic choices?
 Can you give some suggestions to solve this problem?
13. The Cross-Section created a total new way of producing by means of the Theatre Factory and the Theatre Factory on tour. Can you find alternatives for these innovations to improve the artistic organization?
14. The artistic leader was (and still is) a very innovative theatre maker but had no ideas to innovate the theatre organization. What can be done to solve this paradox in general?
15. The problem of the multicultural track (within a white theatre organization in a multicultural city as Amsterdam is) was that researchers and Cross-Section members had no intercultural competences to start an Open Dialogue on this issue. Can you formulate some approaches to solve this problem.
16. In the strategic plan strategic alliances were only mentioned but not made concrete. Suggest some strategic alliances for the TGA in the frame work of the case and formulate some future ambitions. Are they artistically oriented, business oriented, both?
17. Within the strategic project the Cross-Section did not discuss the quality of artistic leadership. Find out the reason for this. How should the Cross-Section put this cultural track on the strategic agenda? Was it necessary?

18. In the Strategic Plan the Internet options were mentioned as a possibility to promote the theatre performances. Suppose the management asked you to do some proposals to work out this 'fallow land'. What do you suggest? Also give some suggestions to implement your ideas.

19. In 1999 a new artistic leader, the prominent Belgian theatre maker Ivo van Hove, was appointed. This artistic leader – with a quite different style and and new artistic ideas – prioritised the internationalisation of the theatre group. With your knowledge of the TGA in mind (see the case study), what do you suggest to stimulate the internationalisation of the company? Formulate an implementation plan to realise these new ambitions.

20. The board of trustees asked this new artistic leader to develop a new strategic plan for the period 2001–2004. Within a short period of time he published his new plan based on a Top-Down approach. A core issue of the plan was to stop the Theatre Factory experiment and to concentrate the performances on the large theatre halls ('Schouwburgen'). Can you imagine why he choose this Top-Down approach?

21. The Strategic Motive is an interactive Content and Process oriented dimension at the beginning of a strategic formulating process. Try to find out (hypothetically) whether this first step will function in your organization. Write a (virtual) Initial Report report of the results and discuss it with the management team or staff. What are the learning experiences?

If you have comments on the TGA-case or remarkable experiences with (non) interactive strategic processes in the cultural sector, please email them to:
<giep.hagoort@central.hku.nl>.
 Thanks for your cooperation.

1 J.M.HUTJES and J.A.van BUREN, *De gevalstudie: Strategie van kwalitatief onderzoek*, Boom/Open Universiteit, Meppel/Amsterdam/Heerlen, 1992.

2 Gareth MORGAN, *Imaginization; the art of creative management*, San Francisco, 1993. Morgan uses the term 'action learning' as a somewhat freer form of action research, p. 310–312.

3 Nico van ROSSEN, *De Roos en de rede, over Gerardjan Rijnders*, International Theatre and Film Books, Amsterdam, 1992, p. 9–52; Gerardjan Rijnders, *Toneel*, International Theatre and Film Books, Amsterdam, 1992.

4 RAAD VOOR DE KUNST, *Kunstenplanadvies 1993/1996: Theater*, Den Haag, p.8–10.

5 TGA-Jaarverslag 1993–4

6 Hans van MAANEN, *Het Nederlandse Toneelbestel van 1945 to 1995*, Amsterdam University Press, Amsterdam, 1997, p. 145–265. The figures in the sketch are not based on this book.

7 VERENIGING NEDERLANDSE TONEELGEZELSCHAPPEN, *Mythes en feiten over het Nederlandse toneel*, VNT, Amsterdam, 1995, p.3 (figures generally refer to 1994–1995).

8 MINISTERIE VAN VOLKSGEZONDHEID, WELZIJN EN SPORT, *Rijksbegroting* 1995, tweede Kamer, vergaderjaar 1994–95, 23 900 hoofdstuk XVI, nr. 3, p. 67.

9 MINISTERIE VAN WELZIJN, VOLKSGEZONDHEID EN CULTUUR, *Cultuurbeleid in Nederland*, S.l. 1993, p. 147-164.

10 BERENSCHOT, *De podiumkunsten na 2000: naar een nieuw beleid*, Berenschot, Utrecht, 1995, p. 4–5, 74.

11 MINISTERIE VAN ONDERWIJS, CULTUUR EN WETENSCHAPPEN, *Pantser of Ruggegraat: Uitgangspunten voor cultuurbeleid*, Sdu, S.l., 1995.

12 This judgement is also based on the evaluation of the organization against the four effectiveness criteria as as mentioned in § 1.1.2.

13 As TGA theatre technicians constructed a theatre boat in the past!

Back

The authorities take away the leadership of the general awaiting trial in Venice. In his statement, Othello asks those present to consider him as an honourable murderer. All Iago's plotting surfaces deed by deed. Finally Othello realizes his blindness to the intrigues and speaks his last words.

Soft You; a word or two before you go.
I have done the state some service, and they know't;
No more of that. I pray you, in your letters,
When you shall these unlucky deeds relate,
Speak of me as I am; nothing extenuate,
Nor set down aught in malice: then must you speak
Of one that loved not wisely but too well;
Of one not easily jealous, but, being wrought,
Perplex'd in the extreme; of one whose hand,
Like the base Indian, threw a pearl away
Richer than all his tribe; of one whose subdued eyes,
Albeit unused to the melting mood,
Drop tears as fast as the Arabian trees
Their medicinable gum. Set you down this;
And say besides, that in Aleppo once,
Where a malignant and a turban'd Turk
Beat a Venetian and traduced the state,
I took by the throat the circumcised dog,
And smote him, this *(Stabs himself)*

I kiss'd thee ere I kill'd thee; no way but this,
Killing myself to die upon a kiss.

(ACT V, 2)

Lists

List of Figures

List of Boxes

LIST OF LITERATURE

AIMAC, *Proceedings '99*, Helsinki School of Economics and Business Administration, Helsinki, 1999.

Svetlana ALPERS, *Rembrandt's Enterprise, The studio and the market*, The University of Chicago Press, Chicago, 1990.

Paul van AMEROM, *Lerende organisatie/kennismanagement*, Research paper, Utrecht School of the Arts, 2000.

Igor ANSOFF, *Corporate Strategy*, Penguin books, Harmondsworth, 1987.

Igor ANSOFF, *Implanting Strategic management*, Prentice Hall, Cambridge, 1990.

Lucio ARGANO, *La gestione dei progetti di spettacolo, Elementi di project management culturale*, FrancoAngeli, Milano, 1997.

Chris ARGYRIS, *On Organizational Learning*, Blackwell Publishers, Cambridge, 1992.

Tuomas AUVINEN, Opera house – A difficult thing to manage?, in: *AIMAC'99*, Helsinki, 1999.

Benjamin M. BANK, Valerie B. MORRIS, Strategic management in non-profit arts organizations: an analysis of current practice, in: *AIMAC'95*, Parijs, 1995.

Christopher A. BARLETT, Sumantra GHOSHAL, *The individualized corporation: a fundamentally new approach to management*, 1997.

Bryan W. BARRY, *Strategic Planning Workbook for Non profit Organizations*, Amherst H. Wilder Foundation, New York, 1994.

William J. BAUMOL, William G. BOWEN, *Performing Arts: The Economic Dilemma*, M.I.T. Press, Cambridge, 1981.

Paola BECK, *The arts & Culture Management Programme in South Africa*, Conference paper Arts Centre Management Training, Johannesburg, 1999.

Françoise BENHAMOU, *L'économie de la culture*, La Découverte, Paris, 1996.

Knut BLEICHER, *Das Konzept Integriertes Management*, Campus Verlag Frankfurt/New York, 1991.

Margaret A. BODEN, *The creative mind*, Little, Brown and Company, London, 1990.

BOEKMANSTICHTING, *Trading Culture, Gatt, European cultural policies and the transatlantic market*, Boekmanfoundation, Amsterdam, 1996.

BOEKMANSTUDIES, *Nieuwe partners in kunst, publieke-private samenwerking in de kunstensector*, Boekmanstichting, Kunst & Meer Waarde, Amsterdam, 1999.

E. BOEKMAN, *Overheid en kunst in Nederland*, Bijleveld Utrecht, S.a.

Herman E. BOLHUIS, Vicente COLOM, *Cyberspace Reflections*, European Commission, DG XII, Social Research Unit, 1995.

Edward de BONO, *Lateral thinking for management*, Penguin books, Londen, 1971.

Peter B. BOORSMA, Annemoon van HEMEL, Niki van der WIELEN, *Privatization and culture, Experiences in the Arts, Heritage and Cultural Industries in Europe*, Kluwer Academic Publishers, Dordrecht, 1998

Daniel J. BOORSTIN, *The Creators, a History of Heroes of the Imagination*, Random House, New York, 1992.

Pierre BOURDIEU, *Opstellen over smaak, habitus en het veldbegrip*, Van Gennep, Amsterdam, 1989.

Pierre BOURDIEU, *The Field of Cultural Production*, Polity Press, Cambridge, 1993.

Guido De BRABANDER, Abbiek DESMET, *Bedrijvige muzen, het management in de musea en de podiumkunsten in Vlaanderen*, Ministerie van de Vlaamse Gemeenschap, Frank Baert, Brussel, 1998.

Truus BRONKHORST, Truus Bronkhorst tells Bronkhorst Truus, in: *Theaterschrift* 3, Brussel, 1993.

William J. BYRNES, *Management and the Arts*, Focal Press, Boston, 1993.

Andrew CAMPBELL, Kiran TAWADEY, *Mission & Business Philosophy: Winning Employee Commitment*, Heinemann Professional Publishing, Oxford, 1990.

Xavier CASTANER, The tension between artistic leaders and management in arts organisation: the case of the Barcelona Orchestra, in: *From Maestro to Manager, Critical issues in arts & culture management*, Oak Tree Press, Dublin, 1997.

Manuel CASTELLS, *End of the Millennium, The information age: economy, society and culture*, Volume III, Blackwell Publishers, Malden, 1998.

Jo CAUST, Is the audience more important than the arts?, in: *AIMAC' 99*, Helsinki, 1999.

S.K. CHAKRABORTY, *Management by Values, towards cultural congruence,* Oxford University Press, Delhi, 1991.

Eve CHIAPELLO, *Artistes versus managers, Le management culturel face a la critique artiste,* Métailié, Paris, 1998.

Paula CLANCY, *Managing the Cultural Sector, Essential Competences for managers in arts, culture and heritage in Ireland,* Oak Tree Press, Dublin, 1994.

Mary CLOAKE, Management, The Arts and Innovation, in: *From Maestro to Manager* (1997)

COMMISSIE CULTURAL GOVERNANCE, *Cultural governance, kwaliteit van bestuur en toezicht in de culturele sector, een pleidooi voor zelfregulering,* Stichting Kunst & Meer Waarde, Amsterdam, 2000.

Jeffrey R. CORNWALL , Baron PERLMAN, *Organizational Entrepreneurship,* Irwin, Boston, 1990.

COUNCIL OF EUROPE: *European Programme of National Cultural Policy Reviews;.* S.a.

COUNCIL OF EUROPE, *Cultural Policy in the Russian Federation,* Council of Europe, 1997.

Stephen, R. COVEY, *The seven habits of highly effective people, Restoring the character ethic,* Simon & Schuster, New York, 1989.

David CRAY, Geoffrey R. MALLORY, *Making sense of managing culture,* Int. Thomson Business Press, London, 1998.

CULTURELINK, Network of Networks for Research and Cooperation in Cultural Development, *Cultural Centres in Central and Eastern Europe,* special issue, 1995.

Thomas G. CUMMINGS, Edgar S. HUSE, *Organization Development and Change,* West Publishing Company, St Paul, 1993.

Milton C. CUMMINGS, Richard S, KATZ, *The Patron State: Government and the Arts in Europe, North America and Japan,* Oxford University Press, New York, 1987.

David A. DECENZO, Stephen P. ROBBINS, *Human Resource Management* (6th Ed.), John Wiley & Sons, New York, 1999.

Paul DIMAGGIO, *Managers of the Arts, Careers and opninions of senior administrators of U.S. art museums, symphony orchestras, resident theatres, and local arts agencies,* NEA/Seven Locks Press, Washington, 1988.

Yves L. DOZ, Gary HAMEL, *Alliances Advantage,* Harvard Business School Press, Boston, 1998.

Craig DREESZEN, Pam KORZA (ed.), *Fundamentals of Local Arts Management,* Arts Extension Service, Amherst, 1994.

Peter F. DRUCKER, *Innovation and Entrepreneurship,* Harper & Row, New York, 1985.

Peter F. DRUCKER, *The New Realities,* Heinemann, London, 1989

Peter F. DRUCKER, *Managing for the Future; the 1990s and beyond,* Truman Talley Books, Dutton, 1992.

Peter F. DRUCKER, Managing Oneself, Success in the knowledge economy comes to those who know themselves -their strengths, their values, and how they best perform, in: *Harvard Business Revieuw,* March-April 1999.

Marja ERIKSSON, Patterns of management in four Finnish Festivals, in: *AIMAC'99,* Helsinki, 1999.

Graeme EVANS, The arts organisation: managing change or changing the management, in: *AIMAC '99,* Helsinki, 1999.

Yves EVRARD (coörd.), *Le Management des Entreprises Artistiques et Culturelles,* Economica, Parijs, 1993.

David FINN, Judith A. JEDLICKA, *On the Art of Leadership, Building Business-Art Alliances,* Abbeville Publishing Group, New York, 1998.

Marion FISCHER, Hermann RAUHE, Andreas Joh. WIESAND (Hg), *Arts Administration in Europe, Training for Tomorrow,* ARCult Media, Bonn, 1996.

Marian FITZGIBBON, Anne KELLY (ed.), *From Maestro to Manager: Critical Issues in Arts & Culture Management,* Oak Tree Press, Dublin, 1997.

FOUNDATION SPECIAL PROJECTS, *Holland Kiev Cultural Festival 1992,* Utrecht, 1993.

J.B.R. GASPERSZ, *De creatieve organisatie,* Nijenrode University, Breukelen, 1999.

Nelly van der GEEST, *Starting points for intercultural education,* Utrecht School of the Arts, Centre for Intercultural Studies, Utrecht, 1999.

Margot GERENÉ, *Het opstarten van een strategieproject,* Thesis Utrecht School of the Arts, 1996.

Brewster GHISELIN (ed.), *The creative process,* New American Library, Berkeley, 1952.

Ricky W. GRIFFIN, *Management* (6th ed.), Houghton Mifflin Company, Boston, 1999.

Ron GROVER, *The Disney Touch: How a Daring Management Team Revived an Entertainment Empire*, Business One Irwin, Homewood, 1991.

Pierre GUILLET DE MONTHOUX, *Estétique du management, Gestion du beau en du sublime de Kant à Gadamer*, L'Harmattan, Paris, 1998.

Giep HAGOORT, *Cultural Entrepreneurship, an introduction to arts management* (Draft), Phaedon, Culemborg, 1993.

Giep HAGOORT, *Entrepreneurship as motor in governmental and not for profit organizations*, Research paper (summary), Utrecht School of the Arts, 1994.

Giep HAGOORT, *The Complex World of Cultural Organizations*, Research paper Utrecht School of the Arts, 1994a.

Giep HAGOORT, Cultuur op de electronische snelweg - een strategisch management game, in: *Vakblad Management Kunst & Cultuur*, Amsterdam, 2/1995.

Giep HAGOORT, *Bericht aan de digitale onderklasse*, HvU Press, Culemborg, 1996.

Giep HAGOORT, *Strategische Dialoog in de Kunstensector, interactieve strategievorming in een kunstorganisatie*, Eburon, Delft, 1998

Giep HAGOORT, Tijd voor projectarchitectuur, projectmanagement in de culturele sector, in: *Vakblad Management Kunst & Cultuur*, 4/1998a.

Giep HAGOORT, *Kunst en management*, Research paper, Utrecht School of the Arts, 1999.

Giep HAGOORT, *Strategievorming bij kunstenaarsinitiatieven*, Research paper, Utrecht School of the Arts, 1999a

Giep HAGOORT, *Verzelfstandiging culturele instellingen*, Research paper Utrecht School of the Arts, 2000,

Giep HAGOORT, Ontwikkeling van ondernemerschap naar intern ondernemerschap, in: *Besturen en Innovatie*, Samson, Alphen aan den Rijn, C 0200.

Giep HAGOORT, Joost SMIERS, *In dienst van de gekte, bevindingen over twee jaar onderwijs in kunstmanagement*, (Centrum voor Kunstmanagement), Utrecht, 1986.

Gary HAMEL, C.K. PRAHALAD, *Competing for the Future; Breakthrough strategies for seizing control of your industry and creating the markets of tomorrow*, Harvard Business School Press, Boston, 1994.

Arnold HAUSER, *Sozialgeschichte der Kunst und Literatur*, Verlag C.H. Beck, München (Dutch version, 1975).

Deborah HAYES, Proactive Crisis management strategies for arts organisations, in: *AIMAC'99*, Helsinki, 1999.

James HEILBRUM, Charles M. GRAY, *The Economics of Art and Culture: An American Perspective*, Cambridge University Press, Cambridge, 1993.

Dick HENDRIKS, Grondslagen marketing in the cultural sector, in: *Handboek Management Kunst & Cultuur*, Samsom Stafleu, Houten, 1990.

Kees van der HEIJDEN, *Scenarios, The art of strategic conversation*, John Wiley & Sons, Chichester, 1996.

Tem HORWITZ, *Arts Administration: How to Set Up and Run a Successful Nonprofit Arts Organization*, Chicago Review Press, Chicago, 1978.

Jan HULSKER, *'Dagboek' van Van Gogh*, Meulenhoff, Amsterdam, 1970.

J.M.HUTJES, J.A.van BUREN, *De gevalstudie: Strategie van kwalitatief onderzoek*, Boom / Open Universiteit, Meppel, 1992.

Rolf JENSEN, *The Dream Society, how the coming shift from information to imagination will transform our business*, McGraw-Hill, New York, 1999.

Annukka JYRÄMÄ, Johanna MOISANDER, Knowledge and Expertise in the contemporary art markets, in: *AIMAC '99*, Helsinki, 1999.

Lydia A. KAN, New models for corporate/non-profit arts partnership, in: *AIMAC'99*, Helsinki, 1999.

Harold KERZNER, *Project management, a systems approach to planning, scheduling, and controling* (6th ed.), John Wiley and Sons, New York, 1998.

Manfred F. KETS DE VRIES, *Prisoners of Leadership*, Paris, 1989.

D. KEUNING en D.J. EPPINK, *Management & Organisatie: Theorie en Toepassing*, Stenfert Kroese, Houten, 1996.

Alfred KIESER, Herbert KUBICEK, *Organisation*, Walter de Gruyter, Berlin 1983.

Dragan KLAIC, Close Encounters, European Internationalism, in: *Theater*, Vol. 29, no 1, Duke University Press, Durham, 1999.

Arjo KLAMER (ed.), *The value of culture, On the relationship between economics and arts*, Amsterdam University Press, Amsterdam, 1995.

Archie KLEINGARTNER, The Five 'R's' of managing Creative Employees in the entertainment media, in: *Management development in a creative environment*, Utrecht School of the Arts, 1991.

Susumu KOBAYASHI, Toshie YAMAZAKI, Survey on the status quo of arts management training in Japan: training conditions from the participants' perspective, in: *AIMAC'99*, Helsinki, 1999.

Philip KOTLER, Joanne SCHEFF, *Standing Room Only, Strategies for Marketing the Performing Arts*, Harvard Business School Press, Boston, 1997.

Nina LEBEDEVA, Sustainable partnership: Culture and arts in the preparations of St. Petersburg's tercentenary and creation of a cultural policy, in: *AIMAC'99* Helsinki, 1999.

Jay Conrad LEVINSON, *The Way of the Guerrilla, Achieving success and balance as an entrepreneur in the 21st century*, Houghton Mifflin Company, Boston, 1997.

B.C.J. LIEVEGOED, *Organisaties in ontwikkeling*, Lemniscaat, Rotterdam, 1984.

Friedrich LOOCK (Hrsg.), *Kulturmanagement, Kein Privileg der Musen*, Gabler, Wiesbaden, 1991.

Jean-Francois LYOTARD, Defining the postmodern, in: *The cultural Studies Reader*, Routledge, London, 1993.

Hans van MAANEN, *Het Nederlandse Toneelbestel van 1945 to 1995*, Amsterdam University Press, Amsterdam, 1997.

Dorian MAARSE, Lerend leiderschap, in: *Vakblad Management Kunst & Cultuur*, 3/1995.

Klaus MANN, *Mefisto, Roman einer Karriere*, Verlag Ellermann, München, 1976.

Nello MCDANIEL en George THORN, *Rethinking and Restructuring the Arts Organizations*, Fedapt, New York, 1990.

Nello MCDANIEL en George THORN, *Toward a new arts order: Process Power Change*, Arts Action Issues, New York, 1993.

Nello MCDANIEL, George THORN, *Arts boards, Creating a new community equation*, Arts Action Issues, Brooklyn, 1994.

Nello MCDANIEL, George THORN, *Arts Planning, a dynamic balance*, Arts Action Issues, Brooklyn, 1997.

Henry MILLER, Reflections on writing, in: *Ghiselin, 1952.*

William C. MILLER, *The Creative Edge, Fostering Innovantion Where You Work*, Addison Wesley, Massachusetts, 1988.

MINISTERIE VAN ONDERWIJS, CULTUUR EN WETENSCHAPPEN, *Cultural Policy in the Netherlands*, Sdu, Den Haag 1998.

MINISTERIE VAN ONDERWIJS, CULTUUR EN WETENSCHAPPEN, *Culture as Confrontation, Principles on cultural policy 2001-2004*, Zoetermeer, 1999.

Henry MINTZBERG, *Mintzberg on Management, Inside our strange world of organizations*, Free Press, New York, 1989.

Henry MINTZBERG, *The Rise and Fall of Strategic Planning*, Prentice Hall, Hertfordshire, 1994.

Henry MINTZBERG, Bruce AHLSTRAND, Joseph LAMPEL, *Strategy Safari. A Guided tour through the wilds of strategic management*, 1998.

Henry MINTZBERG, Ludo van der HEYDEN, Organigraphs: drawing how companies really work, *Harvard Business Review*, September-October 1999.

Ritva MITCHELL, Rod FISCHER, *Professional managers for the arts and culture? The training of cultural administrators and arts managers in Europe, trends and perspectives*, Circle/Council of Europe, The Arts Council of Finland, 1992.

Dirk MONSMA, Kwartaalboek van een veranderaar of het weven van een web, in: *Vakblad Management Kunst & Cultuur*, Amsterdam, 4/1998.

Gareth MORGAN, *Images of Organization*, Sage Publications, London, 1986.

Gareth MORGAN, *Imaginization; the art of creative management*, San Francisco, 1993.

Rosabeth MOSS KANTER, Barry A. STEIN, Todd D. JICK, *The challenge of organizational change; how companies experience it and leaders guide it*, 1992.

John NAISBITT, *Global Paradox, the bigger the world economy, the more powerful its smallest players*, William Morrow and Company, New York, 1994.

NATIONAL GEOGRAPHIC SOCIETY, *Global Culture*, Vol. 196, No. 2, August 1999, Washington, 1999.

Nicholas NEGROPONTE, *Being digital*, Coronet Books, London, 1995.

Th.B.J. NOORDMAN, *Kunstmanagement*, Vuga, Den Haag, 1997.

Philo ONGERING, *Creatief Denken*, Lezing Utrecht School of the Arts, February 18, 1998.

Iouri ORLOV, Dynamic of theatre offer in Moscow, in: *AIMAC'99*, Helsinki, 1999.

Alan PAUL, Archie KLEINGARTNER, Flexible Production and the Transformation of Industrial Relations in the Motion Picture and Television Industry, in: *Industrial & Labor Relations Review*, Volume 47, number 4, July 1994.

Tom PETERS, *Thriving on Chaos, Handbook for a management Revolution*, Pan Books, London, 1989.

John PICK, *Arts Administration*, E.& F.N. Spon, London, 1980.

Gifford PINCHOT III, *Intrapreneuring*, Harper and Row, New York, 1985.

B. Joseph PINE II, James H. GILMORE, *The Experience Economy, Work is theatre & every business a stage*, Harvard Business School Press, Boston, 1999.

Patricia C. PITCHER, *The Drama of Leadership*, John Wiley & Son, New York, 1997.

Sybren POLET, *De creatieve factor: Kleine kritiek der creatieve (on)rede*, Wereldbibliotheek, Amsterdam, 1993.

Michael E. PORTER, *On Competition*, Harvard Business School Press, Boston, 1998.

Michael E. PORTER, *The competitive advantage of nations*, MacMillan Press, Hampshire, 1990.

Michael E. PORTER, Mark R. KRAMER, Philanthropy's New Agenda: Creating Value in: *Harvard Business Review*, November-December 1999.

Stephen B. PREECE, Strategic management types and the performing arts organization: an adaptation of the Miles & Snow typology, in: *AIMAC'99*, Helsinki, 1999.

James Brian QUINN, *Intelligent Enterprise, a knowledge and service based paradigm for industry*, The Free Press, New York, 1992.

Jennifer RADBOURNE, Margaret FRASER, *Arts management, a practical guide*, Allen & Unwin, St Leonards, 1996.

Hermann RAUHE, Kulturmanagement als management für Kunst & Kultur, in: *Kultuurmanagement, Theorie und Praxis einer professionellen Kunst*, Walter de Gruyter, Berlin, 1994.

Hermann RAUHE, Christine DEMMER (Hrsg.), *Kulturmanagement, Theorie und Praxis einer professionellen Kunst*, Walter de Gruyter, Berlin, 1994.

Annemieke J.M. ROOBEEK, *Een race zonder finish: De rol van de overheid in de technologiewedloop*, VU Uitgeverij, Amsterdam, 1988.

Annemieke J.M. ROOBEEK, Technologie en democratie, Inaugurele rede Nijenrode Universiteit voor bedrijfskunde, in: *PEM*, 1991.

Annemieke J.M. ROOBEEK, Strategisch Management van Onderop, in: *Ecocratie, Op weg naar waarde-vol Op-organiseren*, Van Arkel, Utrecht, 1994.

Annemieke J.M. ROOBEEK, 'Strategic action research' in de praktijk, in: *De toekomst van de sociale interventie*, Wolters-Noordhoff, Groningen, 1995.

Annemieke J.M. ROOBEEK, Mariska M.F. de BRUIJNE, *Strategisch Management van Onderop: Een action research projekt over democratisering van de strategische besluitvorming in de Nederlandse industrie*, Universiteit van Amsterdam, Amsterdam, 1993.

Nico van ROSSEN, *De Roos en de rede, over Gerardjan Rijnders*, International Theatre and Film Books, Amsterdam, 1992.

ROTTERDAMSE KUNSTSTICHTING, Med urbs vie, Rotterdam, 1993.

Gerardjan RIJNDERS, *Toneel*, International Theatre and Film Books, Amsterdam, 1992.

Richard E. SCHNEIDER, Mary Jo FORD, *The Theatre Management Handbook*, Betterway Books, Ohio, 1993.

Gary SCHWARTZ, *Rembrandt: zijn leven, zijn schilderijen*, Gary Schwarz, Maarssen, 1984.

Peter SCOTT MORGAN, *The Unwritten Rules of the Game*, McGraw-Hill, London, 1994.

Peter SENGE, *The Fifth Discipline, the art and practice of the learning organization*, Doubleday, New York, 1991.

Peter SENGE, *The Fifth Discipline Field Book: Strategies and Tools for Building a Learning Organization*, Doubleday, New York, 1994.

Roger SESSIONS, The composer and his message, in: *Ghiselin*, 1954.

William SHAKESPEARE, *The Tragedy of Othello, The Moor of Venice*, Penguin Group, New York, 1998.

KLaus SIEBENHAAR, *Kultur & Management, Positionen, Tendenzen, Perspectieven*, Nicolai, Berlin, 1992.

Joost SMIERS, *Cultuur in Nederland*, 1945-1955, SUN, Nijmegen, 1977.

Joost SMIERS, *Rough Weather. Essays on the Social and Cultural Conditions for the Arts in Europe in the 1990s*, Utrecht School of the Arts, 1995.

Joost SMIERS, A Choice of no Choice for Artists and Third World Countries, in: *Iwalewa Forum*, 3/99, Bayreuth, 1999.

Joost SMIERS, Marieke van SCHIJNDEL, *Ruimte aan verscheidenheid, Kunst en kunstonderwijs in lokaal en mondiaal perspectief*, Utrecht School of the Arts, 1999.

Carl Arthur SOLBERG, Kultex - Export promotion of culture products from Norway, in: *AIMAC'99*, Helsinki, 1999.

Terry SULYMKO, Business is the Best Art, in: *AIMAC'99*, Helsinki, 1999.

Janet SUMMERTON, Hidden from view: the shape of arts work and arts organisations in the UK, in: *AIMAC'99*, Helsinki, 1999.

Abram de SWAAN, *Perron Nederland* (Alles is in beginsel overal), Meulenhof, Amsterdam, 1991.

Saara L. TAALAS, The sense of organising theatre: exploring repertoire decision-making in narrative perspective, in: *AIMAC'99*, Helsinki, 1999.

Don TAPSCOT, *The Digital Economy: Promise and Peril in the Age of Networked Intelligence*, The McGraw-Hill Companies, 1996.

Charles TAYLOR, *Multiculturalisme*, Boom, Amsterdam/Meppel, 1995.

Ben TIGGELAAR, *Internet Strategie, Concurrentievoordeel in de digitale economie, theorie & praktijk*, Addison Wesley, Amsterdam, 1999.

Alvin TOFFLER, *The Third Wave*, Morrow, New York, 1980.

UNESCO, *Our Creative Diversity:* Report of the World Commission on Culture and Development, Paris, 1996.

UTRECHT SCHOOL OF THE ARTS, *Uit de kunst geregeld*, Utrecht, 1999.

Lydia VARBANOVA, Privatization of culture: comparative analysis of arts sectors in selected Central and Eastern European countries, in: *AIMAC'99*, Helinki, 1999.

Jan VERHAAR, *Project management, Een professionele aanpak* (2e druk), Boom, Amsterdam, 1999.

VITRUVIUS, *The ten books on architecture*, translated by Hicky Morgan, Dover Publications, New York, 1960.

Harold L. VOGEL, *Entertainment industry economics: A guide for financial analysis*, Cambridge University Press, Cambridge, 1993.

Michihiro WATANABE, Arts Management and dilemmas in cultural policy, in: *AIMAC'99*, Helsinki, 1999.

Mathieu WEGGEMAN, *Leadership and cultures*, MA AMMEC-Guest lecture, Utrecht School of the Arts, 2000.

Suzy WETLAUFER, Common sense and conflict, An interview with Disney's Michael Eisner, in: *Harvard Business Review*, January-February 2000, Boston.

Jeannette WETTERSTRÖM, In search of strategy: some reflections on a case study at the Royal Opera in Stockholm, in: *AIMAC '95*, London, 1995.

Bob de WIT, Ron MEYER, *Strategy, Process, Content, Context*, West Publishing Company, St Paul, 1994.

Bob de WIT, Ron MEYER, *Strategy Synthesis, Resolving strategy paradoxes to create competitive advantages*, Int. Thomson Business Press, London, 1999.

Michael J. WOLF, *The Entertainment Economy, how mega-media forces are transforming our lives*, Random Houde, New York, 1999.

Brann J. WRY, The relation between education and practice in arts management in the U.S.A., in : *Workdocument Arts Management; escaping from the bounds*, Utrecht School of the Arts, 1990.

Brann J. WRY, Arts Governance in the USA and the Netherlands, in: *Reader International Art Management Seminar*, New York University & Utrecht School of the Arts, 1995.

Frank ZAPPA, Peter OCCHIOGROSSO, *The Real Frank Zappa Book*, Poseidon Press, 1989.

Joyce ZEMANS, Archie KLEINGARTNER (ed.), *Comparing Cultural Policy, A Study of Japan and the United States*, Altamira Press, Walnut Creek, 1999.

Index

Colophon

Concept and text Giep Hagoort

Consultations Paula Beck (South Africa), Carla Delfos, Ad Huijsmans, Archie Kleingartner (USA), Gerardo Neugovson (consultant, Argentina), Joost Smiers

Support/suggestions Paul van Amerom, Theo van Ballegooy, Barba Bezemer-Szefke, Frans Bosboom, Annelies Boutellier, Marijke Broekhuijsen, Danielle Cuppens, Ingrid ten Donkelaar, Han van Doorn, Ria Douma, Marijke Faber, Nelly van der Geest, Bert Groenemeijer, Margot Gerené, Maarten van Helden, Jaap Klazema, René van der Kolk, Guilly Koster, Betty Kriekaard, Dennis Langenhuizen, Maswabi Legwale (South Africa), Dorian Maarse, Marieke Maat, Eva van der Molen, Dirk Monsma, Dieneke Naeyé, Philo Ongering (1960–2000), Emile Orzechowski (Poland), Marjanne Paardekooper, Remi Seelaar, Arienne van Staveren, Constance Uitenbogaard, Bora van Ulden, Trudy Verhoeff, Astrid Vrolijk, Wim Warmer, Katrien van Weel.

Students and participants art and media management Utrecht School of the Arts

Co-Production Utrecht School of the Arts, Uitgeverij Eburon

Illustration cover Joke van den Berg

Photo cover Marco Hofsté

Editing (excl. case study) Babel/Laura Haseley, Gill Bromiley

Graphic Design Via Traiectum/Erik Uitenbogaard (BNO)

Publisher Eburon

Case Study TGA (part of the Ph.D. research)

Research and text Giep Hagoort

Promotor Nyenrode University Annemieke J.M. Roobeek

Supervision Utrecht School of the Arts Joost Smiers

Reading committee Ton Hokken, Gerrit Korthals Altes, Philo Ongering (1960–2000), Wim Warmer

Research Assistance Paul van Amerom (research, editing), Renée Baeten-Jonkers (interviews), Joke van den Berg (cultural dialogues), Martine van Dijk en Margot Gerené (TGA-Strategy Project 1995), Dorian Maarse (Case Study), Constance Uitenbogaard (Organisational affairs), Karen Zieleman (Research literature)

Staff School for Arts and Media Management Paul van Amerom, Daniëlle Cuppens, Marijke Faber, Ad Huijsmans, Dorian Maarse, Ferry Simonis (tot 1996), Mieke Vink-Sluis (tot 1999). Secretary: Ingrid ten Donkelaar, Els Schravesande (tot 1996), Riekske Wagner (tot 1997).

Cross-Section TGA Janine Brogt, Han Ellenbroek (Chairman) Fred Goessens, Dirkje Houtman, Gerrit Korthals Altes*, Gijs de Lange*, Frans Lommerse, Ruben Lürsen, Lia Merhottein, Bert Middelweerd*, Titus Muizelaar, Roos Ouwehand, Hans Reesen, Gerardjan Rijnders*, Lineke Ryxman, Wilma Smilde, Wim van Vliet. Plus: Dirkje Houtman (final ed. strategic plan), (Rene van der Pluim, marketing), Giep Hagoort* (researcher), Annemieke Roobeek* (researcher/supervisor).

* Also member of the Process Group

Translation Liz Savage

Dutch nationality if not indicated.